MARRIED TO A DAUGHTER OF THE LAND

Married to a Daughter of the Land

❦

SPANISH-MEXICAN WOMEN AND INTERETHNIC MARRIAGE IN CALIFORNIA, 1820–1880

MARÍA RAQUÉL CASAS

UNIVERSITY OF NEVADA PRESS

RENO & LAS VEGAS

University of Nevada Press, Reno, Nevada, 89557 USA
Copyright © 2007 by University of Nevada Press
All rights reserved
Manufactured in the United States of America
Design by Barbara Haines

Library of Congress Cataloging-in-Publication Data
Casas, María Raquél.
 Married to a daughter of the land : Spanish-Mexican women and interethnic marriage in
California, 1820–1880 / María Raquél Casas.
 p. cm.
 Includes bibliographical references and index.
 ISBN-13: 978-0-87417-697-1 (hardcover : alk. paper)
 1. Interethnic marriage—California—History—19th century. 2. Mexican American women—
California—History—19th century. 3. Mexican American women—California— Social
conditions—19th century. 4. California—Social conditions—19th century. I. Title.
HQ1031.C38 2007
306.84'608968720730794—dc22 2006023847

University of Nevada Press, Paperback Edition, 2009

18 17 16 15 14 13 12 11 10 9 5 4 3 2 1

ISBN 13: 978-0-87417-778-7

CONTENTS

ILLUSTRATIONS

PREFACE

I HAVE OFTEN BEEN ASKED if this study falls within the realm of Latin American history or U.S. history. Simply stated, in this book the two fields connect and merge. The long, deep history of Spanish colonization continues to reverberate throughout the Southwest, a reality that scholars of U.S. history have too often ignored. My research in the history of the Spanish Borderlands led me to one of the most ignored subjects in this field, the stories of Spanish-Mexican women involved in interethnic marriages.

Growing up in a Mexican family in the San Joaquin Valley of California, I was constantly aware of interethnic, interracial marriages, but I was also aware of the different and highly gendered interpretations of these relationships. When a Chicano or Mexican man married outside his ethnic group, there was little comment or questioning of his motives, nor was his personal identity questioned. But when a Chicana or Mexicana married outside her ethnic group, especially to a Euro-American, she was described in many, mostly negative terms. Culturally, she was regarded as less Chicana because she was perceived as "trying to become white." This movement toward "whiteness" made her a cultural traitor in ways that men never were. Curiously, although intermarriage was not encouraged in my immigrant Mexican community, the prevailing cultural norms reminded all of us young people that marrying someone "lighter" was preferable to marrying someone "darker." These racial and cultural ideas confused me as a child and young adult, but I always knew they reflected the fundamental social and racial values of my community.

Later, as a young historian, I was attracted to seeking the origins of these racial, cultural, and gendered ideas. This book is the result. Cultural-studies theories argue that cultural identity is a process in a constant state of "becom-

ing" and "being" rather than an end product. If we are interested in process, then we must also be interested in practice, since personal or collective cultural identities happen within social practice. Therefore, intermarriage is precisely the kind of theme that provides continuity over the five centuries of European and New World contact, having helped to structure certain mixed cultural identities throughout the Americas.

Marrying foreigners made the Spanish-Mexican women in this study distinctive, indeed exceptional, within their cultural communities, but precisely because they were exceptions to so many sociocultural rules, historians can utilize this subgroup to examine questions about race, class, and gender in more intimate ways. While race, class, and gender analysis are at the heart of my study, I do not take a "just add gender and stir" approach. Instead, I incorporate relevant cultural theories, examine the politics of identity within the evolution of Spanish colonization, and use Chicana feminist theory to reveal the complexity of these women's histories and their active roles in the negotiation and transformation of two clashing cultures that are today being called Hispanic American and Euro-Anglo American. Social agency, identity formation, and contestations of power are embedded in these women's stories. Therefore, these women should be defined not only by their relationships to men, but by their relationships to economic, political, and cultural production.

By examining the individual and collective agency of these Spanish-Mexican women as both products and reproducers of their social world, we can gain a fuller understanding of female influence and self-identity in the production and transformation of nineteenth-century California society. How these women comprehended, interpreted, and signified their personal experiences, along with the meaning they imposed on their material and marital choices, illustrates how wonderfully complex, stressful, and contradictory cultural exchanges can be—even the most peaceful and successful ones.

In terms of methodology, this study is not quantitatively driven. The demographic and archival records supporting sustained statistical analysis are, in my opinion, too uneven to allow adequate discussion of what interests me most about these unions. Therefore, the study is highly interpretive and qualitative. Rather than collect statistics about the number and percentage of intermarriages, the ages of the men and women when they married, the number of children, and how long their marriages lasted, as some studies have done, I endeavor to provide detailed portraits of some individual Spanish-Mexican women engaged in intermarriage. Because the majority of women married to Euro-Americans failed to leave any written or historical accounts of their lives,

I place these women into a collective biography, or prosopography, allowing me to make the necessary connections between the personal and the collective utilizing Elizabeth and Thomas Cohen's approach of "exemplification," which basically argues that by closely examining "an event" we can trace the lines and contours of the grander sculpture. The microcosm thus reflects the larger social macrocosm. Because, as Peggy Pascoe writes, intermarriages are microcosms of greater social processes and practices and of making and remaking notions of race, gender, and culture in individual lives, as well as of significant changes at the level of social and political policy, studying intermarriage throughout time and place opens potentially rich veins of history to exploration.

Ironically, although I was first intrigued by this project for intellectual reasons, my family soon made it a very personal and necessary subject, as the majority of my brothers and sisters chose to marry outside our ethnic group and have turned our family into a miniature United Nations. My sister Analicia married a Euro-American, Jeffrey Zwiefel; my brother Enrique married an Indian Hindu, Apurva Uniyal; my other brother, Arturo, married a Chinese-Vietnamese, Quihn Trieu; and my sister Imelda married a Protestant Tejano, Jesús Aguilar. I hope this work helps my niece and nephews—Mariela, Andrew, Marcus, Matthew Evan, Nicholas, Namen, Diego, Joel, and any other future nieces or nephews—to understand their mixed but loving heritage.

Beyond my family, I owe many thanks to the numerous friends and colleagues whom I have gained both as a student and as a professor. Their friendship and encouragement made this book possible. I would especially like to thank the following people.

The entire History Department at California State University, Fresno, particularly Dr. Roger Bjerk, who wholeheartedly supported my undergraduate efforts and my eventual graduate history studies. Their efforts and ability to teach and educate the youth of the San Joaquin Valley goes largely unnoticed and unheralded. I hope my success and appreciation for all they did for me provides some small reward. At the University of California, Santa Barbara, I was introduced to first-rate Chicano scholars. It was there that I found my voice as a Chicana historian through Mario T. Garcia's unfaltering encouragement and helpful guidance; his support allowed for my continued success in graduate school and in academia. Because of him, I also had the privilege of attending Yale University, where I studied with Howard Lamar. Anyone who has worked with Professor Lamar knows of his intelligence, kindness, warmth, and his love of learning. I thank these two scholars for providing me with wonderful role models and immeasurably influencing how I think about

and understand the study of history and the importance of teaching. Vicki L. Ruiz, Chicana historian extraordinaire, is one of the kindest and most helpful of mentors to young historians. I am honored that she always saw the significance of this study, but even more important, that she has become my friend in the process. *Gracias, gracias, gracias por todo, mi querida amiga.*

Several institutions were also critical to this study. I would like to express my deepest appreciation to the entire staff of the Huntington Library, San Marino, California, particularly the staff in the reading rooms, where the greater part of research for this study was conducted. Their professionalism and enthusiasm make the Huntington an almost magical place in which to do scholarly research. I would also like to express my thanks to the staffs of the Bancroft Library, the Santa Barbara Historical Society, the Santa Barbara Mission, and the Los Angeles County Museum. To Carl Gutierrez-Jones and the Chicano Studies Program at the University of California, Santa Barbara, for providing me with a 2000–2001 postdoctoral research fellowship and to Jaime Escalante at the Chicano Studies Program of the University of Wisconsin, Madison, for hiring me as a visiting scholar from 1995 to 1996, I can only express my deepest gratitude for welcoming me into their communities, but most of all for their laughter and good cheer.

I thank Joanne O'Hare, director of the University of Nevada Press, for remaining enthusiastic about this project and for delivering the manuscript into the hands of editor Margaret Fisher Dalrymple. Margaret's comments, along with those of the anonymous readers for the University of Nevada Press, provided insightful questions and queries that greatly improved this work. Margaret's patience, thoroughness, and her own historical knowledge have sharpened and strengthened this work immeasurably. All mistakes are my own.

Because my family could not follow me to the various graduate schools I attended, my friends became like a family, and it is the following individuals who shared moments of frustration, misery, and joy whom I would like to mention and thank: Jeffrey Garcilazo, Diane Ybarra, Ernie Chavez, Ula Taylor, Rosanne Barker, Seth Garfield, Peter Carroll, Robert Belknap, Jonathan Holloway, Raul Ramos, Michael Powell, Alicia Rodriguez-Estrada, Miroslava Chavéz-García, Jenifer L. Stenfros, and Adrian Havas. But Seth Garfield holds a special place; he still laughs at all of my jokes and boosts my spirits when needed. *Te quiero como un hermano.* Regrettably, three of these dear friends and promising historians—Jeffrey Garcilazo, Michael Powell, and Jenifer L. Stenfros—did not live to see this book completed. I, and all who loved you, miss you terribly.

I am also thankful to my new academic family and home at the University of Nevada, Las Vegas—the most collegial history department any scholar could hope to join. Although all the faculty has been supportive, I would especially like to thank Greg Brown, Andy Fry, David Tanenhaus, Barbara Wallace, Paul Werth, Elizabeth White, Tom Wright, and David Wrobel, who read parts of the manuscript and provided important corrections and suggestions. In 1997 David Tanenhaus and I were both hired at UNLV; the following year, Greg Brown was hired. Since then we have fallen into the habit of regularly going together to lunch. After eight years I still enjoy sharing meals with them, and their wide-ranging interests, historical and otherwise, always enrich my intellectual and social life. Thank you, David and Greg.

Last but not least, I would like to thank the most important people in my life: my family. To my brothers and sisters, Imelda, Arturo, Enrique, Analicia, and Noelia, I can pay back many things, but I can never repay your unwavering love. The book is as much your accomplishment as mine; you were with me every step of the way. This book is dedicated to my parents, Juan Casas and, especially, Rosa Rodarte Casas, who died before it was completed. Both were raised on a small rancho in Zacatecas, Mexico, received a rudimentary education, and immigrated with four young children to Farmersville, California, in 1964. Their greatest aspiration was for their children to leave the orchards and agricultural fields in which they made their living. We did, but only because of their unconditional love and support. They accomplished the tremendous feat of raising six decent and caring human beings. I thank them for the lessons taught and will forever be proudest of just being their daughter. *Mamá y Papá, les dedico este libro por todo el amor y apoyo que nos han brindado a nosotros sus hijos. Nos enseñaron a sobresalir y nos dieron lo más importante, una familia unida. Mamá la llevo siempre en me corazón, la quiero y admiro más cada día, y siempre tendré el profundo orgullo de ser la hija de Juan y Rosa Casas.*

MARRIED TO A DAUGHTER OF THE LAND

Introduction

ON JUNE 27, 1874, HISTORIAN ENRIQUE CERRUTI interviewed the Californiana María Paula Rosalía Vallejo de Leese, known most commonly as Rosalía, asking for her opinion and views on the American conquest of California in 1848. Her response was short and to the point: "Those hated men inspired me with such a large dose of hate against their race that though twenty-eight years have elapsed since that time, I have not forgotten the insults heaped upon me and not being desirous of coming in contact with them I have abstained from learning their language."[1]

From 1874 to 1876 the Italian-born Cerruti, known as Henry by the English-speaking populace, assisted Hubert Howe Bancroft in his efforts to write the history of California by interviewing people with significant historical experiences. Cerruti collected the "dictations" of a number of Californios and Euro-American settlers. Fluent in Italian, French, and Spanish, Cerruti gained the confidence of several important Californios, particularly that of Mariano Guadalupe Vallejo and Salvador Vallejo, Rosalía's brothers.

Few families in northern California were as socially and economically prominent as the Vallejos, whose ancestors were founding members of the first Mexican settlements in California. Sergeant Ignacio Ferrer Vallejo arrived in San Diego in 1774, and in 1791 he married María Antonia Isabela Lugo in Santa Bárbara Mission. By 1792 the Vallejos were living in Monterey, and after Mexican independence Ignacio Vallejo was granted the 8,881-acre Rancho Bolsa de San Cayetano, situated approximately twenty-three miles north of Monterey. From the 1830s to the 1840s, the Vallejo sons expanded the family's land holdings to include the Rancho Petaluma (66,000 acres), Rancho Soscol

(80,000 acres), and the smaller Rancho Yulupa and Rancho Temelec. By the 1850s Mariano Vallejo alone claimed ownership of more than 175,000 acres of land in northern California, constituting much of what is now known as Sonoma County. With these vast land holdings came wealth and membership in California's elite social and economic class. It was into this elite society that Rosalía was born and raised.

Beyond their land and wealth, the Vallejo sons also gained prominence in the political and military arenas. Both Mariano and Salvador Vallejo became military officers. Salvador was named captain of the militia at Sonoma in 1836; Mariano served as commander of San Francisco's military force from 1831 to 1834, and in 1836 the governor appointed him California's military commander, a post he held until 1842. After the Mexican-American War, Mariano served in both the constitutional convention and the state senate. It was undoubtedly because of her brothers' social position that Rosalía was included in Bancroft's historical project.

Once given the opportunity to speak, Rosalía recounted that she did not passively accept these insults and that she had defied the invaders whenever possible. For example, when Rosalía was left alone after her husband was arrested by the Bear Flaggers, four Americans attempted to rob her family's Sonoma storehouse. She physically blocked the entrance, and only after the men threatened her at gunpoint did she reluctantly step aside. In another incident, after American forces had captured Sonoma and set up camp near the Vallejos' rancho just north of town, Captain John C. Frémont requested that Rosalía personally bring a seventeen-year-old Indian servant girl to the officers' barracks, obviously to be used for their sexual pleasure. Rosalía defiantly wrote back that she would not do so, regardless of the consequences. Since Frémont was unwilling to press the point, Rosalía won the round. In her opinion this specific incident provided ample evidence of the depraved and opportunistic motivations of the American conquerors. Later, Frémont exacted his revenge when he forced Rosalía to write a letter to Captain Padilla, leader of the local Californios still resisting the Americans and an acquaintance of the Vallejos, beseeching him to return to San Jose and not attack Sonoma. At the time both Rosalía's husband and her brother Mariano had been arrested by the invading Americans and would be detained for several weeks, leaving the Vallejo women, including her sister-in-law, Francisca Benicia Carrillo Vallejo, alone at the Rancho Sonoma, protected only by servants. Rosalía regretted writing the letter, but, as she explained to Cerruti, she was pregnant at the time, and when Frémont threatened to burn down the rancho buildings, including the

house with the women inside, she was forced to comply in order to protect her unborn child and her female relatives.[2]

Rosalía's enduring refusal to have any physical contact with the conquerors or to even to speak their hated language speaks volumes of her Californio loyalties against the Americans during and after the war.[3] However, if Rosalía hated Americans so intensely, one has to wonder how these feelings and attitudes affected her marriage to Jacob Primer Leese, an American merchant.

On April 13, 1837, the then-twenty-six-year-old Rosalía defied her family's wishes and married Jacob Leese "on the sly" in the San Francisco de Solano Mission in Sonoma. Her brother Mariano Guadalupe had become head of the household after their father's death in May 1832, and as such he favored the courtship of Timothy Murphy, an Irish trader involved in the Lima trade whom Mariano had established as administrator to the San Rafael Mission.[4] Refusing to obey her brother's wishes, Rosalía took advantage of Mariano's absence and secretly married Leese, an American trader from Ohio. Informing another American merchant of his marriage, Leese wrote: "I have the pleasure to inform you that I was maried to a young Lady, of monterey on the 12th of Last month in the mission of St. Solano it was Something of the Sly, But after the fation of us Yankeys in the Western part of the U.States. Cince my marriage it has create'd a great talk among the people of the country—which was inconcequence of its being done so Sly and not a custom of the Country but they are now getting quite tame on the subject and some says that it was *bien echo.*"[5]

Mariano never fully forgave Rosalía for her actions, and it remained a sore point between them for the rest of their lives. Little is known of Murphy, but judging Leese from his business correspondence and from this letter in particular, he was a literate but hardly an educated man. For any other Spanish-Mexican woman of that era, this clandestine marriage would have been considered highly irregular. For someone like Rosalía, it was an act of almost incomprehensible rashness and class irresponsibility. As part of the most elite segment of Californio society, women like Rosalía grew up in a close-knit community whose relationships were bound by kinship and reinforced through marriage. Selecting an appropriate mate was important for both males and females. So Rosalía's individualistic act not only cast a shadow on the Vallejo family name but potentially admitted into the family a stranger who did not share their elite social status.

Rosalía was by all accounts a highly determined, strong-minded woman. As a member of one of the richest, most politically influential, largest landhold-

ing families in northern California, she had grown up in relative prosperity and comfort, exemplifying the life experiences of the female ranchero elite. Her maternal grandparents were original Californio settlers, and both her father and her brothers, especially Mariano and Salvador, were influential politicians and community leaders, extending the family's social honor and prestige throughout California. The Vallejos, both male and female, were known for their wealth and influence, personal intelligence, talents, and strong personalities. Rosalía was described by William Heath Davis Jr., a San Francisco trader who was her contemporary, as "a tall, handsome, beautifully formed woman, full of vivacity and remarkably intelligent" but prone to sarcasm—seemingly a family trait.[6] Of the eight Vallejo sisters, none was more independent and high spirited than Rosalía. Fortunately for her, Rosalía's precipitous marriage did not estrange her and her husband from the Vallejo clan. The couple eventually purchased the Huichica grant between the Sonoma and Napa valleys, maintained an adobe and storehouse in Sonoma, and raised a family.

According to Hubert H. Bancroft, who, along with his two assistants, Enrique Cerruti and Thomas Savage, recorded scores of personal Californio narratives in the 1870s, Rosalía's *testimonio* was one of the shortest they collected; he deemed it too brief to be useful to his research and relegated it and Rosalía to the margins of California history.[7] Because Bancroft was attempting to write the complete history of California accurately, impartially, and in what he called "the spirit of fairness," his disregard for this particular account is understandable. Bancroft ceaselessly tried to acquire the writings of Californios, and when Mariano Vallejo presented him with a manuscript hundreds of pages long, Rosalía's six-page dictation must have seemed insignificant indeed. However, precisely because she spoke through clenched teeth, her brevity voiced a spirit of resistance that was overlooked in the 1870s and into the present.

Indeed, what Rosalía omitted in her account was as telling as what she chose to discuss. Among the personal details she failed to mention were her marriage and her husband. This omission may be attributed to Leese's abandonment of his family after the Mexican-American War, when his business ventures repeatedly failed. Rosalía's narrative raises numerous questions, but her life experience reflected one of the most neglected, unexamined topics in California history—the marriages between Spanish-Mexican women and Euro-American men.[8]

In this book I shall examine the historical experiences of Californianas who, between the 1820s and the 1880s, chose to marry Euro-Americans.[9] By focusing on these women, I offer a new, gendered perspective on nineteenth-

century California that develops and retells the story of ethnic encounters and conflicts while also offering new perspectives on analysis and inquiry.

Rethreading the strands of California history through the lives of Californianas married to Euro-Americans offers an intriguing new pattern that deepens our collective understanding not only of California but also of the Southwest in general. The subject of interethnic marriage in the American West is steadily garnering interest, and this study further illuminates the intersections of race, class, gender, and colonization and their influences on the social practices and lives of nineteenth-century Californianas.

James F. Brooks has argued that slavery and captivity in the Spanish Borderlands created a "pattern of cultural sharing through systems of violence and kinship" that "deepens our understanding of how 'mixed' groups became peoples in the Southwest and how ethnic communities themselves were historically and culturally sorted and produced."[10] In New Mexico the practice of slavery begun under Spanish rule still characterized this regional society well into the late nineteenth century, by which time the area was under the dominion of the United States. By tracing these legacies, Brooks bridges and connects these seemingly divergent histories.

Like slavery, patterns of intermarriage in the Spanish Borderlands also reflect a history of shared cultural systems of kinship and help to reveal how "mixed" groups of people evolved. However, previous studies of this phenomenon have undervalued the role that women have played in intermarriage, arguing that the ethnic identity of these Spanish-Mexican women was subsumed within their husbands' national identity and that these women willingly assimilated into and accommodated their husbands' culture and society. Recently, Brooks and a growing number of other historians examining the persistent legacies of Spanish-Mexican communities have questioned the nature of the U.S. conquest in the Southwest. Euro-Americans exerted predominant political and economic control, to be sure, but the cultural values and definitions of Spanish-Mexican honor, gender, kinship, and power lingered there until well into the nineteenth century.

Brooks finds that in slavery, the "ties between gender and power in the Southwest take more fertile meaning from the fact that the hapless women and children who became slaves also became the main negotiators of cultural, economic, and political exchange between groups." My own research, focusing primarily on women as negotiators of these exchanges, reclaims and includes back into the folds of Chicana history the Spanish-Mexican women who *chose* to marry "outsiders." But rather than "write about these relationships in terms

that imply that women, worth nothing, married men worth something, and that Spanish-Mexican women gained mobility as their Euro-American men in turn gained entrance into Spanish-American society," I will establish the women's worth as agents of cultural change.[11]

Besides removing these women from "outsider" status, my study also discusses how Spanish-Mexican Californianas came to be empowered over other men and women—specifically Amerindians—throughout the eighteenth and nineteenth centuries.[12] When the Spanish conquered what was to them a new world, they classified indigenous women as "daughters of the land" and at times implored their men to marry these newly acquired "daughters." This attitude toward and promotion of marriage with indigenous peoples varied considerably across New Spain and across the centuries of Spanish hegemony. At times officials advocated intermarriage, at other times they condemned it, depending on local conditions. For Amerindian women their status as the original "daughters of the land" momentarily privileged them over some of the married and lower-class Spanish women who could not conceivably bring land or property into a marriage, as was the case in California during the initial wave of conquest. Indian women's association with the land as its daughters and the Spanish crown's desire to stabilize and control the frontier provided brief moments of access to greater social status for a few Amerindian women by making them desirable mates in marriage.

However, by the nineteenth century Spanish-Mexican Californios were using the term "daughters of the land" to refer to their own California-born daughters, and Amerindian women were reclassified and lowered in social status to being merely Indian. This shift and appropriation of colonial language and metaphors is significant, because it bookends the rather rapid cultural shifts in Californio society that make California distinctive from older Spanish Borderland settlements. For example, in New Mexico "the exchange of women through systems of captivity, adoption, and marriage provided European and native men with widely understood symbols of power with which to penetrate cultural barriers" and helped "knit diverse peoples in webs of painful kinship." For almost three centuries, slavery and sexual relations between Spaniards and Amerindians fostered a "pattern developed through interaction into a unifying web of intellectual, material and emotional exchange within which native and Euro-American men fought and traded to exploit and bind to themselves women and children of other peoples. As these captives became cousins through Native American and Spanish–New Mexican kinship structures, they too became agents of conflict, conciliation, and cultural redefini-

tion."[13] First settled in 1769 and conquered in 1848, the Californian settlements developed patterns similar to those of other borderland communities.

There were significant differences, however, between the practical consequences of intermarriage in these two regions. In New Mexico the marriage of Europeans to "daughters of the land" brought value and wealth to the women and their families, whereas in California the opposite occurred. By the nineteenth century, land rather than human capital was the main source of wealth and status in California. Here, the redefined "daughters of the land" had Spanish-Mexican faces, and their identities and relationships, both familial and social, were upheld by Spanish kinship structures. Euro-Americans tied themselves to this society through marriage, so "being married to a daughter of the land" in California implied a whole complex of gendered, race, class, and economic relationships between women and men.

It is not unimportant that the Spanish-Mexican settlers appropriated and employed the term they originally used for indigenous women and remade it to suit their changing social and cultural ideals. By supplanting the primordial, powerful association that indigenous people had with the land, Spanish-Mexicans continued the language of conquest, manipulating historical processes to assert their continued presence on the land through claiming a more "natural" relationship like the ones they had erased when they conquered other peoples. Becoming children of the land implied a timeless and natural association with the land, legitimizing their acts of violence, conquest, and eventual development of the land for their own economic and social advantage. After the Mexican-American War, invading Americans would use the same tropes and motifs. It is not inconsequential that several "pioneer" societies called themselves the sons and daughters of the West; in California the most notable such organization is the Native Sons of the Golden West. Of course for them "native" meant the men and women who had arrived during the Gold Rush of 1849, but like the Spanish-Mexican settlers, they constructed an identity that was a powerful reminder of their "natural" claims to the land. But before the Mexican-American War, Euro-American men engaged in other forms of association with "daughters of the land" through intermarriage.

Before the Mexican-American War there were roughly two hundred Euro-American men legally married to Californianas. A few of these men wrote and published accounts about their lives among the Californios. After the war Bancroft categorized these marital unions solely as a means to solidify trading alliances between the expanding mercantile capitalism of New England traders and the agro-pastoral economy of the Californio elite. In a categoriza-

tion that would last well into the late twentieth century, Bancroft wrote of how frugal, enterprising, English-speaking men married Californianas, joined the Catholic Church, acquired considerable property, and inevitably brought "the whole trade of the town into their hands." Bancroft, who was reflecting nineteenth-century socioracial ideologies, asserted that Californianas before the Mexican-American War readily preferred Euro-Americans as mates and partners because of the physical, moral, spiritual, and cultural deficiencies that the women were alleged to perceive among their own Californio menfolk. After all, Bancroft claimed, in Latin and "other savage countries," women were "not treated with the greatest respect." Given the supposed cultural and physical inferiority of the Californios, "it was a happy day for the Californian bride whose husband was American."[14] Interethnic marriages thus became, for Bancroft, one of the most persuasive metaphors of peaceful and beneficial conquest by Euro-Americans.

The ensuing history of California, as written by Bancroft and other Euro-American historians, was the oft-told tale of the Californio elite's steady political and economic decline and the inevitable rise and expansion of American control over the conquered land. More to the point, it was a tale told by and about men, either Spanish-Mexican or Euro-American, with little regard for or inclusion of the other historical actors and subjects involved in the story, specifically women and their multifaceted lives. By creating such a male-centered history, many of the roles and actions of Californianas were largely ignored, misinterpreted, or misunderstood by both societies. In this version of history, interethnic marriages were typically categorized as highly successful unions with few if any tensions, conflicts, or stresses.

But the narratives and actions of Rosalía Vallejo de Leese and other Californianas contradict these generalized assumptions. In her narrative Rosalía chose not to mention her marriage or her life with Jacob Leese, most likely because he abandoned his family a decade after the Mexican-American War, after he had invested and lost all of his and Rosalía's capital in a colonization project in Baja California. By 1876 Rosalía's brother Mariano was financially supporting her and her children. She had paid a high price for her earlier independence and self-determination.

In the twentieth century American historians heavily revised and challenged most of Bancroft's racially and culturally biased interpretations, but the topic of intermarriage has yet to be reinterpreted. Historians in the 1960s and 1970s constantly repeated the litany of these foreigners' swearing allegiance to the Mexican Republic, converting to Catholicism, marrying local women,

obtaining legal land grants, and with "their working knowledge of Spanish, and their understanding of the local manners" earning "full acceptance into the elite." After the Mexican-American War, Euro-American men quickly returned to their cultural roots and negotiated the United States' conquest of California by effectively reintegrating into American society, something their male Californio in-laws were unable to do.

In the 1980s a "feminine perspective" was interjected into the topic in an effort to more fully understand the position and contributions of Spanish-Mexican women in the Southwest, However, these studies, shaped by the then-current paradigms of acculturation and assimilation, concluded that it was the women, being the more passive in terms of gender and inferior in terms of culture, who changed. According to Sandra Myres, intercultural marriages were fairly common occurrences in early California, although she does not qualify this statement and define how common it actually was for Californianas to intermarry, and "throughout the Southwest for some Hispanic women, marriage to an American brought improved social and economic status and started the process of assimilation between the two ethnic groups." In the first monograph on Mexican—specifically New Mexican—and Euro-American intermarriage, Rebecca McDowell Carver discusses several reasons why intermarriage occurred: a society steeped in a tradition of racial and cultural assimilation, economic advantage, and the possibility of social upgrading that encouraged Mexican women to "cast beckoning smiles in the direction of the Anglo newcomers." Other scholars have argued uncritically that the marriage of a Californiana to a Euro-American began the "Americanization of their children," since "marriage to an Anglo started the process of assimilation for Spanish-speaking women and their offspring."[15]

Ironically, Chicano scholars often failed to challenge these Anglo American interpretations. During the 1970s, with the development of militant Chicano cultural nationalism, Chicano scholars narrowly defined which historical topics should be discussed and how they should be discussed. For these Chicano nationalists, the Mexican-American War was a painful reminder of the conquest of Mexico, when the Spanish conquistadors brutally imposed their will and authority over the defeated Mesoamericans. Reviling the Indian allies and cultural brokers who aided the Spanish conquest, Chicano and Mexican historians were especially contemptuous of Malatzin Tenepal, more commonly known as "La Malinche," the Aztec woman who, as Hernán Cortés's trusted interpreter, facilitated and negotiated the alliance between the Spanish and their Mesoamerican allies. Racial mixing for Mexicans, and consequently for

Chicanos, was fundamental to the formation of their ethnic identity, because historically and metaphorically Mexican mestizos were born of an Indian mother and a Spanish father through sexual intercourse, whether voluntary or not. Miscegenation was the act of powerful males taking women from powerless men. For Mexicans and Chicanos, pride in their miscegenated background was counterbalanced by shame that it resulted from a devastating military and cultural conquest. Under the symbol of "La Malinche," sexual alliance with the conquerors stigmatized women. These attitudes are best represented in Tomás Almaguer's *Racial Fault Lines,* in which he claims that women married to Euro-Americans were merely "tribute" and "exotic" prizes for the conquerors and that "Mexicanized gringos" were cultural mediators who protected and encouraged the selective assimilation of Californio elites into the dominant Euro-American culture.[16]

Chicana scholars also marginalized Californianas who intermarried with foreigners. In *Telling Identities,* Rosaura Sánchez defined these particular women "as concessions made to men, as human capital." Since some of these women individually chose their specific mates, they "could be said to be complicitous in helping to open doors for those who would eventually betray and dominate the Californios." But Sánchez also points out that some Californianas married to Euro-Americans resisted the American invasion, thereby deepening the complexity of these women's experiences and demonstrating that intermarriages seemingly played no great social role in California society.[17] In *Refusing the Favor,* Deena González briefly examines intermarriages in Santa Fe, New Mexico, revealing that regional differences render this subject even more problematic. Similar ethnic/racial groups and economic and political forces were in effect in New Mexico as in California, but the outcomes were dramatically different. For example, González finds that in the 1850s, approximately 100 out of 239 Euro-American men, mostly trappers and traders who had decided to settle in New Mexican communities, were married to New Mexican women, but statistically, this also meant that only 2 percent of New Mexican women were married to Euro-American men.[18] This point is significant, because it epitomizes the way in which historians have projected their ethnocentric cultural attitudes toward intermarriage. A significant minority of Euro-American men married into Indian and Spanish-Mexican communities in the Far West, but only a slight minority of Indian and Spanish-Mexican women chose to intermarry. Therefore, any examination of the practice of intermarriage based on gender and ethnicity must be nuanced. Depending on the gender of the partner, intermarriage as a social practice potentially had a variety of meanings.

To draw only one conclusion from the phenomenon—that Spanish-Mexican women were merely sexually drawn to "white" men—erases the complex cultural lives of these women.

Of the New Mexican intermarriages, the most common alliance "was formed between working-class Spanish-Mexican women and Irish immigrant men, and both tended to be Catholics." In the census of 1860 none of the women listed as married to a Euro-American were "paired up with proprietors, property owners, merchants, other businessmen, politicians, or federal appointees." It is significant that these marriages did not instigate upward social mobility for the women as previously assumed. Indeed, in terms of acculturation the Euro-American husband and resulting children became Hispanicized.[19]

Deena González provides one of the clearest critiques of the existing historical literature on intermarriage in the Spanish Borderlands and demonstrates why the phenomenon must be reexamined, especially since "western frontier historians have chosen to write about these relationships in terms that imply that women, worth nothing, married men, worth something, and that Spanish-Mexican women gained mobility." To correct this historical misinformation, González suggests that historians focus on the women's class, religion, and ethnic status in order to obtain a more accurate picture of these intermarriages. She recommends that scholars invert gender categories rather than focus on Euro-American immigrant men and that future studies of intermarriage attempt to unravel "the intimate encounters between Spanish-Mexican women and Euro-American men" and "look at them from a southern perspective, through a Mexican, but not a European, focus, and from a gendered perspective, through the eyes of resident women but not sojourning men. It thus becomes a way to 'other' those who have traditionally been 'othered,' whose actions have been explained entirely as if conquest is a foregone conclusion or have been interpreted by historians who willingly accept a hegemonic enforcement of colonization even in their studies on interracial relations. In the case of intermarrying women, this is neither desirable nor necessary."[20]

Clearly, a closer examination of intermarriage as the intersection of race, class, and gender is needed in order to understand what exactly was taking place within these unions throughout the Southwest. The issue of class is of particular interest within intermarriages, although most of the documents and archival records discuss the conditions and actions of only the most elite Californios. Like racial ideologies, ideas of class were more fluid along the Spanish Borderlands than elsewhere in Spanish America. However, by the 1820s ownership of land in its many forms came to demarcate the differences between elite

and nonelite. Although my discussion of intermarriage favors the most elite women simply because we have more abundant records of their lives, it nevertheless considers ways in which concepts of gender and class developed within this particular society and thus does not totally ignore lower-class women or Amerindian women.

Only a few hundred intermarriages between Californianas and Euro-American men occurred in California between 1820 and 1880, raising the question of why we should study these unions. For that matter, why study marriage at all? Recent works on marriage in American life have carefully traced the legal changes within this "peculiar hybrid." Because marriage is both a publicly ordained civil contract uniting a man and a woman and a highly regulated private agreement, the standards of control imposed on marriage in its public and private dimensions have been central in framing polity over time. As Nancy F. Cott says, "the structure of marriage organizes community life and facilitates the government's grasp on the populace."[21]

It is essential that any discussion of intermarriage between Euro-American men and Spanish-Mexican women begin with a description of the very different laws and traditions governing marriage that prevailed in their separate societies. It is these laws and traditions that shaped the expectations and behavior both of the parties entering intercultural marriages in the Southwest and California and of their families and friends. And these differing concepts of marriage were an inherent part of the two societies, stemming, on the part of the Euro-American men, from ancient British common law and the traditions of Germanic northern Europe, as translated into the legal codes of the United States, and on the part of the Spanish-Mexican women, from equally ancient Roman law and its subsequent interpretation by Spanish and then Mexican courts. Everywhere in the Western world in the nineteenth-century, being married brought with it "a host of property rights, obligations, losses, gains, immunities, exemptions, remedies, and duties." Under British and U.S. law, marriage transformed a man into a husband; however, a woman became not only a wife but also a *femme covert,* a legal dependent "covered over" by her husband. Hendrik Hartog argues that "the fundamental legal divide" in the nineteenth-century U.S. legal system was the defined boundary between the married and the unmarried. Married couples had a singular identity under the law, but the husband's identity structured and intertwined around the wife's, never the other way around. This singularity, needless to say, was filled with potential emotional, social, and legal pitfalls that led some couples to dis-

solve their unions. The nation has always had a stake in defining legal unions and their proper dissolution, but under the British and subsequent U.S. legal systems, coverture burdened women when they sought to separate from or divorce their husbands, tried to protect their property, or sought custody and authority over their children. Legal challenges to coverture initiated by women influenced and helped transform U.S. legal codes in the nineteenth century.[22]

Unlike British and U.S. law, Spanish and later Mexican law allowed women to retain a separate legal identity when they married, so that although the concept of coverture also existed under Roman law, it was less burdensome than the common-law version. As legally recognized persons, wives could buy, purchase, inherit, or maintain separate property and could enter into contracts and sue in court—rights denied them in common-law jurisdictions. Under Spanish-based legal codes, husbands had superior property rights within the marriage system, and as the heads of households they controlled the children, made decisions regarding the couple's communal property, and could control, though not alienate, certain segments of a wife's separate property. A Spanish-Mexican wife generally needed her husband's approval when she signed or entered a contract, but depending on the woman and the situation, this approval was not a universal practice.

The legal dimensions alone make these intermarriages interesting, and describing how Euro-American husbands and Californiana wives adjusted to the different legal structures and gender roles in which they found themselves is an important part of this story. But it is not the whole story. Euro-American and Spanish-Mexican societies both had clearly defined and articulated ideas of race, class, and gender, and the differences between these ideas and the ways they developed caused constant misunderstanding between the two clashing groups. By examining these misunderstandings, we can see that the agency of women in the negotiation of cultural contact and conflict was broader and more dynamic than previously supposed.

Not surprisingly, the language, anxieties, and tensions surrounding race have dominated the topic of intermarriage. From the beginning of nationhood in the United States, there was a generally negative and prohibitive view toward racial amalgamation. More recently, attitudes toward intermarriage have been dramatically changing. After almost three centuries of denouncing racial mixing and trying to ignore the extent of mixing that actually occurred, the nation is slowly coming to terms with its multiracial past and proving Mark Twain's adage that "familiarity breeds contempt—and children." In the 2000 U.S. federal census, roughly 10 percent of the population self-identified as be-

ing of mixed race or ethnicity. Currently, debates over issues of defining a core culture, power, race, ethnicity, and multiculturalism have increased interest in the study of racial mixing, both past and present.

Because of historical silence, the fact that most African Americans, Latino Americans, Filipino Americans, and millions of whites have multiracial backgrounds is obscured, while the majority of North Americans continue to speak of race merely in "black" and "white" terms. Indeed, most people in the United States define intermarriage as a predominately black/white experience, even when statistical evidence indicates a higher intermarriage rate between other racial and ethnic groups. For example, in the 1980s only 3.6 percent of African American males and 1.2 percent of African American women were married to Euro-Americans, yet by the 1970s 16 percent of all married Chicano males were married to non-Chicanas and 17 percent of all Chicanas were married to non-Chicanos.[23] Racial and ethnic intermixing may be one of the great themes of world history, but some peoples have intermixed more freely than others for very important historical reasons.

In a seminal essay Gary Nash argues that the United States must confront its "hidden history" of "*mestisaje.*" Moreover, by using the term *mestisaje* to characterize the nation's racial mixing, Nash is making a clear call to historicize our racialized past not in isolation but in comparison to other colonizing efforts around the world, particularly areas affected by Spanish colonization. In terms of race and history, the United States has much to learn from its southern neighbors, whose tri-racial mixture of Indian, European, and African was integral to the development of their national and cultural identities.[24] This is not to say that South American countries are entirely devoid of racism and racial hierarchies, past or present, but Nash maintains that if the United States continues on the path toward *mestisaje,* it must examine and become familiar with other multiracial societies. The inability of Euro-Americans to understand the racialization process of the Spanish New World offers a challenge and opportunity for Chicano/a and Latin American historians to take part in a meaningful dialogue on race.

The history of "race" and of "the West" cannot be separated. The first European encounters with New World inhabitants effectively promulgated a system of classification for all humankind, but this racializing process occurred under two distinct systems—either through association, as followed by the British, Dutch, and Germans, or through assimilation, as followed by the Spanish and French. In the British colonial empire, race was an either/or binary proposition. Different races could associate but never racially merge. Ideas of racial

purity defined "amalgamation" as a dilution, so mixed persons were regarded as inherently inferior and as alien to the British definition of "whiteness."

The racializing process that prevailed in the Spanish colonies began not in 1492 but much earlier, in the eighth century, with the conquest of Spain by Berbers and Arabs from North Africa. Traditions of conquest, colonization, and assimilation slowly developed after the Ommiad caliphate established control over most of the Iberian Peninsula. For the next seven hundred years, Spaniards and Moors, Christians, Jews, and Muslims created a multiracial, multicultural society through warfare and intermixture.

By the eleventh century, tiny Christian kingdoms on the fringes of Islamic Spain began the "reconquest" of the peninsula. The subsequent centuries of warfare, both between the Christian Spaniards and the Muslim hegemony and between factions within each of these groups, allowed the Spanish to assimilate certain outsiders and to develop ideas of "otherness" and a language of conquest and race that were later transferred to the New World.

After seven hundred years, the Spanish concept of race meant more than skin color and phenotype. Spanish peninsular racial categories also encompassed ideas of honor, status, and prestige. In general, the whiter the skin, the greater the claim to honor and social status—that is, to "pure" blood untainted by Moorish or other non-European ancestry.

The concept of race was highly fluid in Spanish frontier settlements, unlike the more rigid notions that prevailed in peninsular Spain and in the British colonies and their successors in the United States.[25] Moreover, although all Spanish colonial peoples spoke the same language of racial distinction and phenotype, there were regional differences. Currently, Latin American and Southwestern historians are emphasizing the importance of understanding specific localities and their peculiar distinctions within the development of these larger cultural and social systems.

The concatenation of race and power was in play throughout the Spanish colonial New World, but depending on time and place, definitions of race were locally reconfigured to reflect community practices and the power relationship between elites and nonelites. This fluidity influenced the behavior and attitudes of Spanish colonial peoples to the point that marriages should also be examined in terms of personal and racial strategies.

The challenge for colonial Latin American and Spanish Borderlands scholars is to correctly understand how individuals defined and applied meaning and significance to their local racialized societies. The definition of race throughout the Spanish New World was a negotiable matter from the seven-

teenth century onward. Because individuals understood the local construction and usage of the concepts of race, class, honor, and prestige, they were highly conscious of how to climb the social ladder. Marriage to a "lighter" person was a common strategy throughout colonial Latin America. Women as well as men understood "whiteness" as cultural capital, but the exchange rates varied according to time and place. Therefore, examining the marital choices of the Californianas in this study adds to the general discussion of race in the Spanish Borderlands.

In discussing identity, I am referring to the historical and cultural consciousness of Californianas. Like their male counterparts, they were highly invested in the construction and maintenance of a collective Californio identity that by the 1830s was interchangeable with the previous self-referring term of *gente de razón*—literally, people with reason—which distinguished them from the Indians, defined as either *gentiles* (that is, unbaptized) or *neófitos* (baptized).[26] One identity did not displace the other, but this name change marks an important historical and cultural shift. California historians have repeatedly traced the decline of the Californio male elite, but recent studies assert that this decline was neither uniform nor linear. Depending on their location, some Californio elites managed to share social and political control until well into the 1880s. In Santa Barbara under the leadership of the Carrillo brothers, Californios often voted as a bloc, thus extending the presence and power of the Californio community. In San Francisco, on the other hand, Euro-American control was established quickly, and the influence and presence of the Californios were almost entirely erased. Protected and sheltered in their private domestic sphere, Californiana women were buffered from the political decline, but they too suffered the economic and social disruptions that are belatedly being examined in recent California histories.

By examining intermarriage both before and after the Mexican-American War, we can also study how cultural coalescence developed over time. Vicki L. Ruiz applies this term primarily to immigrants, but it can also be applied to intermarriage, because many of the same principles are utilized. According to Ruiz, through cultural coalescence "immigrants and their children pick, borrow, retain, and create distinctive cultural forms. There is no single hermetic Mexican or Mexican American culture, but rather permeable *cultures* rooted in generation, gender, region, class, and personal experience." Similarly, trying to apply a strict typology to intermarriage obscures "the ways in which people navigate across cultural boundaries as well as their conscious decision-making in the production of culture."[27] The way in which their identities and practices

shifted and transformed over time indicates the historical and cultural consciousness of these women and especially tests the notion that they completely acquiesced to their husbands' national loyalties. Rather than saying that it was a happy day when a Californiana married a Euro-American, a more appropriate statement might be, happy was the day for the Euro-American who married a well-connected Californiana and was willing to accommodate himself to her family and culture.

The Mexican-American War and subsequent conquest of California and the Southwest by Euro-Americans fundamentally changed the social context of interethnic marriages. Perhaps after the war the notion that women willingly married Euro-Americans for greater social and economic privileges may hold true, but simply comparing and contrasting marriages before and after the war mistakenly promotes the idea that it was the women who made the major concessions and transformations, which, as this study shows, was not the case. Many of the women, especially the elite, managed to maintain personal cultural, economic, and legal resources that mitigated their declension into the lower social strata, a point that is too often ignored. Women who chose to marry Euro-Americans during the 1820s and 1830s had little presentiment that conquest would occur; therefore, a more sophisticated narrative is needed to describe their personal and marital strategies. Race and class are the most important elements in discussing these unions from the Euro-American perspective, but my study examines both partners in terms of class. Although Bancroft pointed only to the most successful marriages between merchants and elite Californianas, implying that this was the universal pattern within interethnic unions, before the war a substantial number of interethnic marriages involved fur trappers, common sailors, adventurers, and deserters from merchant ships—in other words, men who were definitely not of the elite and were perhaps of questionable character and morals. Like marriages everywhere, most succeeded but many failed. Some Californianas even separated from and divorced their "white" husbands.

Many social, economic, political, and historical factors have relegated Mexican American women's stories to "remain in the shadows" of U.S. history, to use Ruiz's words. I hope in this study to join and support her efforts by removing at least one shadow from the collective stories of nineteenth-century Spanish-Mexican and later Mexican American women's lives.

CHAPTER I

❧

Spanish Women as Cultural Agents from Medieval Spain to the New World Frontier

*A*LTHOUGH THIS BOOK IS A VERY SPECIFIC STUDY of a certain place and time, we should not forget the important and relevant issues embedded in the subject of intermarriage as a whole. In its broadest context, intermarriage, or sexual union with an outsider, stranger, or "alien other," lays bare the racial, religious, and sexual anxieties of all societies in their efforts to define, maintain, uphold, and regulate the boundaries of ascribed group identity. By its very nature, intermarriage challenges, contests, and disrupts the collective cohesion of self-defining groups. From ancient times to the present, intermarriage has been a universal aspect of human societies, and, consequently, legal and social prohibitions against these unions reflect the ways societies treat those different from themselves. Intermarriages do not necessarily need to be sites of cultural conflict or socioracial anxiety, but socially and culturally they were—and still are—often linked to negative, destructive, and marginalizing outcomes and experiences.

Nowhere has the persistent and troublesome nature of intermarriage been greater than in the consequences of European conquest and colonization throughout Asia, Africa, and the Americas, beginning in the fifteenth century and extending into the early twentieth. It is within this long, deep historical moment of European colonization that the phenomenon of intermarriage in nineteenth-century California must be understood. Comprehending how identities shift and the mechanisms that accelerate, contribute to, and facilitate these shifts is central to redefining and reconditioning our "knowledge system," perception, interpretation, and definition of race and ethnicity.

Because most people in the United States are overly familiar with the English colonization process, which discouraged interracial and interethnic unions,

my study draws on the overlooked heritage of Spanish colonization, which fostered racially mixed societies in the Caribbean, elsewhere in the Americas, and in Asia. Rather than seeing Californianas in isolation, it is important to recognize them as the last generation of women engaged in a process of Spanish colonization that began in the eighth century on the Iberian Peninsula. For seven hundred years, Spanish Catholic society continually refined its strategies for resisting and then ousting the entrenched invaders, the Muslim Moors. In this lengthy process, the role of Spanish Catholic women as settlers and colonizers gradually changed. Comprehending these strategies in medieval Spain is the first stage of understanding the Californianas and how they understood their legal rights, marriage, kinship, and social relationships and, ultimately, what shaped their understanding of their own cultural identity.

In theoretical terms the study of intermarriage has been dramatically reconceptualized away from the structuralist theories of Claude Lévi-Strauss, who posited that in precapitalist societies intermarriage functioned as an instrument of alliance formation between less powerful political groups and more powerful allies. To Lévi-Strauss intermarriage was a stabilizing factor in moments of political transition, with women becoming the means by which men literally and symbolically maintained peaceful relations with outside groups. With the growth and advancement of cultural studies, the view of women's role in intermarriage has widely expanded. For the purpose of this study, I draw on the works of Pierre Bourdieu, Hommi Bhabha, and Robert J. C. Young. Rather than emphasizing the utilitarian role of women in intermarriage, these scholars shift the focus of the unions to a larger cultural and gendered perspective, where they examine individuals within prevailing cultural and behavioral practices and the particular societies' derived social meaning. For example, Bourdieu's discussions of strategies and agency in investigating social life and of cultural logics as a dialectic between outside observers and native conceptions is particularly relevant to the study of intermarriage. Indeed, he defines matrimonial strategies as "the product, not of obedience to a rule but of a feel for the game which leads people to 'choose' the best match possible given the game they have at their disposal, that is, the aces or the bad cards (especially girls), and the skills with which they are capable of playing."[1] As my study shows, Spanish-Mexican colonial women were avid matrimonial cardplayers.

Bhabha, on the other hand, is mainly interested in cultural hybridity and how it subverts the authority of colonialism. His idea of a "Third Space" where

"the 'hybrid' moment of political change" moves away from a subjective, binary position of the "Self" and the "Other" and emerges into "something else besides which contests the terms and territories of both" addresses this process. Ambivalence marks the "Third Space," because it ensures "that the meaning and symbols of culture have no primordial unity or fixity; that even the same signs can be appropriated, translated, rehistoricized, and read anew."[2] Race as such a cultural sign within colonialism greatly influences the development of hybrid identities; therefore, *mestisaje* is one of the conditions that need to be constantly read anew precisely because of their ambiguous state and multifaceted meanings. For Bhabha, understanding this in-between state is crucial to understanding how colonial identities are formed. Because Europeans derived truth and consciousness mainly through vision and visual representations, race and phenotype played crucial roles in the imposed taxonomies and hierarchies developed throughout their colonies. The definitions of Europeanness and whiteness were rewritten through colonial exchanges to exclude the "darker" peoples of the Americas, Asia, and Africa, but mestisaje continually challenged these definitions of identity and even of whiteness itself.

For Robert J. C. Young, race is the most elemental category of nineteenth-century colonialism. He regards the colonial process as a "machine of desire" fascinated with the frenzied "interminable copulation, of couplings, fusings, coalescence, between races," and he notes how this form of sexual exchange "and its miscegenated product, which captures the violent, antagonistic power relations of sexual and cultural diffusion, should become the dominant paradigm through which the passionate economic and political trafficking of colonialism was conceived."[3] Colonial economics thus involved not only the exchange of goods, but also the exchange of bodies, so women become central agents in "any theory of reproduction."[4] Once sexuality was perceived by the colonizers to lie at the core of race, culture, and colonialism, women became central to the historical, colonial narrative.

In comparing New World colonizing practices and experiences of the Spanish and the English, the differences and outcomes are obvious. However, both powers initially faced two challenges: first, how to transport their distinctive European institutions and societies to the new colonial sites and replicate them there, and second, how to manage and control an expanding frontier zone. Both powers succeeded in these efforts, and women and marriage played critical roles in their larger colonizing processes. A consideration of the evolution of and differences between colonization and marriage policies under the Span-

ish and British legal systems helps to explain some of the main differences between these two societies and cultures.

Unlike the Euro-Americans, who by the 1820s were eagerly distancing themselves from their colonial past and redefining themselves as a self-reliant, democratic, ambitious people (in contrast—as they saw it—to the backward, traditionally minded, submissive Spanish and French colonials, who remained shackled to royal authorities), Spanish colonials kept refining and reforming their own cultural identities over time and space. Californianas in the early nineteenth century were not merely the great-great-granddaughters of the conquest of Mexico, but were also the last generation of women who valiantly made their lives on violent frontiers, supported by rights and privileges that their Spanish forebears had painstakingly negotiated and defended in order for their families to survive and thrive in medieval frontier zones.

Throughout early modern Europe, marriage and the family were used as metaphors for proper church and state governance. In sixteenth-century England, with the ascendancy of Anglo-Saxon Protestant culture, common law held that "domestic relations" ordered not only relations between husbands and wives, but between masters and slaves; therefore, marriages were best characterized as "little commonwealths."[5] As dependent subjects within these "little commonwealths," wives were expected to rely on their husbands to protect and rule their interests and to represent them in public. Social customs and cultural constructions prescribed that all women become wives at some point in their lives, and under the British legal system women and wives became a conflated social and legal category. By the eighteenth century, the English defined marriage as "lifelong, faithful monogamy, formed by mutual consent of a man and a woman, bearing the impress of the Christian religion and the English common law in its expectations of the husband to be the family head and economic provider, his wife the dependent partner."[6] Marriage turned a man into a husband and a woman into a wife, as well as defining how men participated in the civil and political world as heads of households and owners of property. For some men, marriage assured them of citizenship and expanded their participation as members of the body politic. The Church of England maintained that Scripture and Christian doctrine dictated that men hold authority over women and that a proper marriage required the masterful husband to control and protect his submissive wife, servants, and obedient children. Marriage, as both a private and a public institution, symbolized larger community ties; once a couple initiated the ceremony of marriage, a seemingly private act, they appeared before the public, who in turn recog-

nized and supported the couple's bond and commitment, welcoming them into the community at large. Marriage thus became not only a reflection of two individuals' commitment and bond to each other, but also reflected the community's self-interest in maintaining social control.[7]

Other European societies also instigated and implemented marriage policies to control the reproduction and formation of a body politic and to define communal belonging. Moreover, in modern nation-states citizenship symbolized proper authoritative roles and established racial and ethnic boundaries. Who was allowed, as well as who was *not* allowed, to marry whom influenced the development and definition of "the people," reinforcing the idea that proper marriage could only take place between intraracial and intra-ethnic groups. Interethnic marriages did occur on occasion in European countries, but it was in the New World and in other colonial societies that marriage policies dramatically shifted to meet the changing racial and social environment. Rarely have historians of the United States emphasized the interconnectedness of marriage and frontier expansion, nor did Euro-Americans in the nineteenth or early twentieth century understand the competing marital systems they encountered as they moved westward across the continent, quickly dismissing alternate systems as either primitive, as they described the practices of Native Americans, or inferior, as they deemed those practiced by the Spanish-Mexicans and the French.

In the standard U.S. historical narratives, whenever marriage, English women, and the "American frontier" are discussed, the commentaries primarily revolve around how the shortage of women in frontier communities opened up marriage markets, so a single woman was assured of finding a mate regardless of her class. Consequently, women became wives at a younger age than in England and spent most of their lives in a family unit. The scarcity of females forced colonial authorities to entice and import women to the colonies, but these recruiting efforts often proved futile or largely unsuccessful. Not that the English were very innovative in their recruiting efforts: in Virginia, they imported single women and auctioned them off for eighty pounds of tobacco each; in very rare cases, single women in New England received title to tracts of land, but this practice quickly fell into disfavor. In order to settle the frontier while maintaining a fixed and cohesive definition of English identity, the colonial authorities preferred to attract and recruit men with wives through the practice of granting married men larger land grants than single men received.[8] The structures of what a proper family and marriage meant to the English were quickly transported and implemented in the colonies; it was families that

would settle the Anglo American frontier. Indeed, defining and controlling the legal and public status of unmarried, single women—*femmes soles*—proved a thorny issue for British colonial authorities.

From the sixteenth to the eighteenth century, British custom and law regarded private and public space as "realms of activity in which both men and women participated." Therefore, unmarried women in British and colonial society literally embodied a cultural contradiction and existed in a liminal state.[9] If they were single and without a male intercessor, either a husband or a father, women could make contracts, own and devise property, head a household, and enter into expanded economic activities, which was especially the case for widows. While single women's legal status was relatively unambiguous, their social and economic activities were filled with cultural tensions, because they challenged the prescribed notions of masculinity and femininity. Possessing female bodies, women were naturally defined as dependent and domestic. However, with no male authority to check or represent her in public, a single woman who worked outside the home, made contracts, legally represented herself, or petitioned to protect her legal rights challenged the patriarchal order. But since it was mainly in urban areas that single women could eke out a living if they chose to remain unmarried, and since few single women were attracted to make their lives on the frontier, the relative absence of single women outside settled towns conditioned how Anglo Americans along the frontier culturally defined proper women's roles.

After the American Revolution, westward expansion, as outlined by Thomas Jefferson's Ordinance of 1785, was primarily concerned with establishing self-government, building a nation of freeholders, and encouraging male settlers to move west. From 1785 to 1890, when according to Frederick Jackson Turner the American frontier supposedly ended, the United States was transformed into a collective society and culture; developed its unique characteristics of optimism, self-reliance, rugged individualism, and economic opportunism; and forged the institutions of democracy and equality. According to Turner's thesis, the frontier was an ever-shifting line that separated civilization from wilderness. It was also a place and a process in which competition over resources and between invading and invaded peoples followed various stages of development that ended in the establishment of urban, populated areas. By 1890, when America's frontier line was said to have been erased, Turner maintained that civilization had spread from the Atlantic to the Pacific and that conquered peoples were on their way toward extinction or were reluctantly being assimilated into American society. Women, while valued as reproducers

and helpmates in transforming the wilderness into a more civilized setting, played a marginal role, their experiences overshadowed by masculine interests and goals. Settlers and their families were considered the natural means of expanding the nation's economic, territorial, and political interests, but women as wives were deemed to play an insignificant role in the greater historical and national movements. Single and unmarried women as settlers were rare, and the scarcity of women ensured that women married and remarried quickly along the frontier.[10] The dominance of Turner's thesis in western studies is unquestionable, but the issue of intermarriage leads both to a critique of the thesis and to a new emphasis on processes that are overlooked by it.

Although a tremendous amount of revision has occurred in rewriting the history of women in the West, within the general American psyche the image of "white" western women has undergone little change from what Dee Alexander Brown typified in his classic 1958 work *The Gentle Tamers*. Accordingly, "white" women's "only real reason for going west was to found a new home, and the dream of many an emigrating female was a snug log cabin nestling in some pleasant valley." Once settled on the frontier, women's natural "maternal force against which the males' brute force could not contend . . . ultimately brought the Wild West under complete domination of the female sex." Because of their scarcity, women were treated as "white goddesses" who developed a taste for the privileges their idealized status afforded them.[11] To Brown and other historians of his generation, the West became the most favorable social and political climate for American women.

Although historians have repeatedly challenged these outdated narratives, the stereotypes, myths, and images of Euro-American women persist. Anglo Americans need to be reminded that Spanish women were also settling west of the Mississippi and implementing their own cultural ideas of domestic ideology and race. Spanish-Mexican women also emigrated to the frontier in search of homes and security, but an adobe with Indian servants and land rights to a rancho were the hopes and ideals of these women. Why they had such a different understanding of the frontier from their Anglo American counterparts must be understood from the Spanish point of view. For eighteenth-century Spanish settlers, the frontier was not a mere line, but a zone of interaction "where the cultures of the invader and of the invaded contend[ed] with one another and with their physical environment to produce a dynamic that is unique to time and place."[12]

The marriage and colonization practices intrinsically intertwined in Spanish culture were very different from those of the British. Because Spain had

been engaged for seven hundred years in expelling the Moors from the Iberian Peninsula before encountering New World peoples, intermarriage as a form of negotiation and accommodation had long since emerged as a crucial element of Spanish medieval identity and culture. Spain's constant contact with different racial, religious, and cultural groups made the definition and implementation of racial categorization and the country's particular social system easily translatable into the New World. Whereas the British found intermarriage with the indigenous peoples they encountered distasteful, the Spanish, through centuries of practice, more easily accepted and incorporated new peoples. That is not to say that these relationships were entirely peaceful and harmonious, but Spain's lengthy and continuous experience with cultural accommodation, acceptance, and racial/cultural mixture in order to maintain physical control over conquered lands strongly influenced the cultural practices of Spanish frontier societies.[13]

By the time Spanish colonies were established throughout the New World, women had become integrated participants and intermarriage a valued practice that supported and sustained military and political control over conquered lands and peoples. Within this historical narrative, Californianas' ideas of marriage and all that it symbolized were layered by ten centuries of frontier practices. As such, intermarriage was an "interior frontier" connoting distinctions within a territory, location, or empire.[14] If the British saw marriages as little commonwealths and therefore a metonym for their biopolitics of empire at large, then ideas of interior and external frontiers are apt characterizations for Spanish ideas of marriage. In both cases the rules and rituals defining and controlling domestic arrangements were linked to the achievement of public order and imperial expansion.

The similarities between Reconquista Spain—the era between 700 and 1492—and the Spanish conquest of Mexico are tremendously important to understanding how women shaped and influenced the development of frontier societies. The notion that warfare and defensive strategies were exclusively male domains has been steadily challenged. Increasingly, historians are as interested in studying the difficulties surrounding peaceful settlement and its maintenance, which often proved a more difficult undertaking. In both the Reconquista of Spain and the conquest of Mexico, women joined men in seizing, defending, governing, and ultimately transforming frontier lands into communities.

One of the most important characteristics of Reconquista municipal populations was their social, cultural, and geographical mobility. As war swept over

the Iberian Peninsula, control shifting from Muslim to Christian or from Christian to Muslim hands, and as a Jewish minority maintained relationships with both cultures, people intermingled culturally and mixed racially to varying degrees. Indeed, prior to 900 many of the mothers of the emirs and their children, the caliphs, were Christian women from the north of Spain. For roughly five hundred years, the southern regions of Spain became Arabized to the point that in Córdoba a hybrid group of Mozarabs—Arabized Christians—emerged. Mozarabs nominally maintained their religion but had closer cultural affinity to the Arabs. For their part, the Jews were easily distinguishable from their Muslim and Christian neighbors and were less likely to intermarry, but they were allowed to live within Christian or Muslim urban areas, albeit in segregated sections (aljamas) of the towns. Within Christian Spain, Jews were encouraged to become urban dwellers. In some towns Muslim, Christian, and Jewish communities grew side by side. By the twelfth and thirteenth centuries, the world created by these Muslim, Jewish, and Christian peoples as they commingled languages, religions, food, clothes, architecture, and every other social and cultural aspect of their lives made Spain "the ornament of the world."[15]

After seven hundred years of practice, it is not surprising that the Spanish were the most effective European colonizers in terms of establishing defensive colonial settlements. Women were integral to these developments. Frontier warfare, whether in Spain or in its colonies, had two elements: conquest and colonization. The former was fundamentally a male prerogative, but the latter could not succeed without female participation.

During the Reconquista, the Christians followed a twofold policy of conquest and colonization. Generally speaking, town building—the most effective means of transforming a Muslim area into a Christian stronghold—occurred only after the Muslims were displaced through successful warfare and defensive and strategic citadels had been established in the abandoned territories. Then settlers moved into these self-governing municipalities (*villas*) under royal control, and eventually some of the municipalities grew into thriving cities. The permanency of these villages and municipalities depended on the active recruitment of armed men, and the rulers, both secular and religious, granted exceptional privileges in order to entice settlers. Preference, of course, was given to the men, but towns often encouraged clerics and widows to settle. Authorities preferred to recruit married men, who were the most logical settlers since their wives would be not only colonizers, but also the mothers of future defenders. Many authorities also gave sanctuary to men who

had kidnapped their women if they stayed and helped settle the town. By the early eleventh century, Spanish colonization was a highly militarized process, and Spanish Christian society could only be described as a society based on warfare. To be sure, men outnumbered women in the early stages of municipal settlement, but the women's desirability as residents can be seen in the formulation of the legal rights and privileges (*fueros*) granted specifically to them.[16]

Towns, by or with the approval of the crown, generally assured and protected the settlers' civil liberties, including ownership of property, justice administered by local officials and town courts, restricted taxes, guarantees against outside interference, and exemption from seignorial obligations if they applied. During the twelfth and thirteenth centuries, the children of the original settlers demanded and were granted *fueros extensos,* which basically extended to them the same rights enjoyed by their mothers and fathers. Women were recognized as legal persons, so the development and protection of the fueros mitigated traditional patriarchal authority over medieval Spanish women. These fueros protected the women's economic and property interests; moreover, the extent and number of fueros grew as conditions changed along the frontier.[17]

As frontier areas became more settled, successive generations of settlers, regardless of gender, came to see themselves as protected citizens with all the rights and privileges this condition implied. But gender did divide men and women in terms of rights and privileges. For example, a married couple could become citizens of a town, but only married men whose wives resided in the town and who owned a horse could become magistrates (*alcaldes*), were eligible for certain tax reductions, or could enclose a meadow or obtain other grazing privileges as a means of expanding their economic fortunes. From the eleventh century onward, the crown granted fueros to bachelors on the condition that they marry and establish residence in frontier towns. Along with the royal incentives, towns themselves encouraged bachelors to settle by rewarding men who married "daughters of the town." The advantage of marrying a townswoman depended on the wealth of her family. Most towns recognized ownership of a house within the town as the basis for full citizenship, and because daughters could own or inherit homes, wealthy daughters had the greatest marital advantages. For this reason, bachelors who had distinguished themselves in battle were careful to select their wives from the lower noble class rather than from the peasant or artisan classes. Beginning in the Visigoth period, from the fifth to the early eighth century, Iberian societies solidified the practice of bestowing full inheritance rights on women, a practice that became law in 1240 under the Fuero Juzgo and in time was extended through-

out the Spanish territories. Sons and daughters inherited equally, and because women could inherit real property, their roles as wives and citizens made them crucial and persistent agents in the colonization process.[18]

For medieval Spanish women, marriage was the most desired status, but marriage practices transformed over time to accommodate shifts in Spanish society. Both secular and ecclesiastical authorities recognized marriage as a sacrament that could only be dissolved through death, but they disagreed over the principle of individual free will in contracting marriage. The church championed couples and protected them from being forced or circumscribed by outside influences, namely their parents or kinsmen, whereas secular authorities saw marriage as a means of stabilizing the social life of their municipalities. Secular municipal authorities supported advantageous marriages, especially as dictated by parents and at the expense of the children's individual choice. From the twelfth to roughly the seventeenth century, the church and the secular authorities engaged in struggles over the issue of valid, legal marriage. Increasingly during the same period, conflicts between parents and children over marriage choice were dealt with in public arenas.

Women along with men protected their class privileges as these developed in the municipalities. Women's social honor and proper sexual behavior were the means by which they distinguished themselves in their local communities, and women—as well as men—protected themselves and their good names at all cost. Whether through a well-placed slap against a man or woman who spread lies, gossip, or slander to dishonor their good name or through charging such persons in front of a civil court, women protected their personal and public honor. The social constructions of female virtue, honor, sexual chastity at the time of marriage, and proper public behavior initiated in medieval Spain have remained prescribed and valued female cultural traits in Hispanic societies up to the present.[19]

By the end of the fifteenth century, townswomen had, as Heath Dillard notes, "assumed indispensable biological and economic functions as well as most significant social and even moral responsibilities in the settlement of highly privileged townships." Over the centuries, generations of women had helped to transform the Spanish frontier from military outposts to thriving towns, while steadily garnering increased social and economic status in municipal society. The stress of constant warfare made marriage more egalitarian in medieval Spain, and by the end of the twelfth century, municipal authorities were actively protecting women's interests. Spanish medieval women, as Dillard notes, "asserted and expected their fellow townsmen to defend their

highly advantageous privileges as colonizers, not merely as wives and mothers but as municipal citizens with substantial stakes in the harmonious and cooperative development of their community."[20]

Once the expulsion of the Muslim Moors became a certainty, women began to face challenges to and possible erosions of their legal and social privileges. During the thirteenth century, the municipalities solidified their authority over Spanish society and began to reorganize themselves away from active warfare and toward greater patriarchal authority and order. This shift strengthened and supported the corporatist view of Spanish society, in which groups such as the nobility, clergy, military, guilds, hidalgos, and women were hierarchically arranged and individuals were deemed unequal based on these social categories.

The need to maintain social order demanded a legal system that categorized and distinguished the newly emerging society. The divisions in Spanish medieval frontier society included the differences between minors and adults, nobles and commoners, legitimate and illegitimate children, Spanish and non-Spanish individuals, and men and women. Within each category, qualifications and considerations based on personal and social honor mitigated how each individual was treated within the legal system. The greater the potential for the loss of honor by either men or women, the greater the need to protect and uphold it by whatever social or legal means available. Proper sexual behavior was defined through gender and class, dictating the levels of self-control that individuals needed to maintain in order to remain within proper Spanish society. For example, single and widowed women were granted more rights than married women, and "decent" women, usually defined as single virgins or "honest" wives and widows, were legally protected, whereas "loose" women, usually defined as women who were known to be prostitutes, promiscuous, or sexually "out of control," were often denied legal protection. Because women were considered entirely responsible for their sexual behavior, if they were accused of adultery, illicit sex, or licentiousness they were harshly punished, whereas men accused of the same sex acts went unpunished. For example, a woman could be jailed for prostitution, but a man who solicited a prostitute was not punished. Ultimately, women as wives were encouraged to be subordinate to their husbands, since their obedience guaranteed social cohesion.[21]

As part of this cultural shift, new laws governing a range of social practices, including new marriage policies, were legislated between 1256 and 1265. Part of a comprehensive legal code known as the Siete Partidas, these laws dictated the civil and canonical procedures necessary for a couple to marry. In medi-

eval Spain single men and women had been allowed to enter into contracts of *barraganía,* or quasi marriages that established households but included no promise to wed in the future. If the arrangement failed to satisfy either partner or if the couple decided to end the arrangement, a notary could terminate the contract. The flexibility of these unions allowed individuals to negotiate their relationships, especially in frontier areas. However, as the power and authority of the crown and the church expanded, interest in regulating marriage increased. By the late Reconquista period, marriage was seen as a means to facilitate the maintenance of Christian control.[22]

Under the Siete Partidas, women were both protected and made increasingly inferior within the institution of marriage. In its efforts to eliminate barragania, the church held that it was precisely the promise to marry or the private exchange of vows that established legitimate bonds. Couples could perform secret legitimate marriages, but they could not live together or have legitimate sexual relations unless they promised to marry. Any other type of arrangement was declared illegitimate. For women, this change protected their honor if they were seduced through a promise of marriage and subsequently engaged in sexual relations; furthermore, the change protected any children born to these unions from being declared illegitimate. The Siete Partidas provided that women as individuals could freely chose their mates as long as they were unrelated to one another, but once they entered the state of matrimony, the law dictated that husbands should govern and be lords over their wives, extending the language of governance to the domestic level. Thus, households were to be governed by male heads, but they in turn were subject to the absolute monarch and to the state. Under the Siete Partidas, the idea of *patria potestas* (paternal authority) was reinforced, giving fathers the right to kill adulterous daughters, sell their children in cases of extreme poverty, and have complete authority over their wives. By the late thirteenth century, women were needed less as settlers and more as proper wives subservient to their legitimate rulers, their husbands. The patriarchal rights and privileges of husbands were further strengthened by the Council of Trent (1545–63), which declared as Catholic doctrine that only Catholic priests could officiate over legitimate marriages. The solidification of patriarchy, however, was counterbalanced by older Spanish legal traditions of inheritance and by fueros that were particularly relevant in the issue of legitimate and illegitimate births.

After the Council of Trent, the Spanish church and the crown debated issues involving the rights and honor of legitimate and illegitimate children. Because issues of legitimacy destabilized growing corporate ideals, the Spanish

legal system devised two new tools to handle illegitimacy: the *cédula de gracias al sacar* and statutes regulating *limpieza de sangre* (literally, purity of blood). Both these legal determinations basically dealt with issues of honor. In Spain *gracias al sacar* decrees extended preconciliar marriage practices protecting certain illegitimate children, the *hijos naturales*. For example, if lovers who had promised to marry engaged in sexual relations and had a child, then married, a gracias al sacar decree established the legitimacy of the child's birth and its right of inheritance. The child was also granted the same social status as its parents. British practice, on the other hand, dictated that any child born out of wedlock was illegitimate, even if the couple eventually married. Thus we see the layering of old and new marriage practices in Spanish culture.

However, while flexibility characterized Spanish attitudes toward illegitimacy, limpieza de sangre decrees reflected the growing racial inflexibility of Spanish culture.[23] When the Spanish spoke of having *sangre limpia*—clean, pure blood—they meant being able to demonstrate the absence of any Muslim or Jewish ancestry. After the expulsion of the Muslims and Jews in 1492, limpieza de sangre decrees became desirable for elite families. As a corporate society, Spain in the late Middle Ages made honor and status practically synonymous concepts. After the Council of Trent, theologians and political theorists advanced the notion of patriarchal families, the hierarchy of status based on corporate definitions, and the importance of lineage and legitimacy in individuals' social position, male or female. In the socially homogeneous Iberian Peninsula, honor, race, and legitimacy helped stabilize elite families and the crown. When these complex ideas were transplanted to the colonies, they helped create a decidedly different yet similar type of Spanish society in the New World. Whereas the concepts of gracias al sacar and limpieza de sangre grew increasingly rigid in Spain, in the colonies these ideas and definitions remained in constant flux well into the nineteenth century.

The Spanish-Muslim frontier had vanished in the Iberian Peninsula by the end of the fifteenth century, but the new overseas colonial frontiers reinvigorated a variety of social attitudes, including those surrounding the legal and social position of women. Relying on their centuries-old cultural practices of warfare and settlement, the Spanish in the New World encountered similar situations and conditions that facilitated their political and military control over conquered indigenous peoples. They also encountered significant differences.

By the twelfth century Mesoamerica had, as Michael E. Smith and Frances F. Berdan note, experienced "a significant constellation of processes" that

included "an unprecedented population growth, a proliferation of small polities, an increased volume of long-distance exchange, an increase in the diversity of trade goods, commercialization of the economy, new forms of writing and iconography, and new patterns of stylistic interaction." Therefore, the fifteenth-century Spanish conquistadors did not merely invade a territory—they integrated the diverse regions of land and people who made Mesoamerica into a single world system.[24] Rather than facing invading and entrenched enemies, the Spanish conquest of America was challenged by the problem of controlling an estimated 25 million indigenous subjects. The crown facilitated this second conquest by creating a new administrative body, the Council of the Indies, and granting it authority over New Spain. Central Mexico at the time of conquest was a highly stratified political confederacy in which Aztec overlords controlled dispersed cities, towns, and villages. Spain rewarded its Indian allies who swore loyalty to the new rulers through the appointment of kingships (*tlatoques*), allowing the kings to name caciques who oversaw one or more villages. This policy allowed Spain to placate its new subjects and to retain a facade of the older political system to which most indigenous peoples were accustomed. Similar to the accommodation of Jewish and Muslim communities in medieval Spain, the conquistadors accommodated the indigenous Mesoamerican nobility by allowing them to retain their property and initially exempting them from paying tribute. This situation would change over the succeeding generations, but initially these strategic concessions allowed Spain to claim authority and repress anti-Spanish revolts and rebellions with minimal cost to the Spanish crown. Precisely because the Mesoamerican nobles were critical allies and were allowed to maintain their wealth, several high-ranking Spanish conquerors married into the Indian nobility. Numerically, however, there were few of these elite marriages. The majority of mixed Spanish-Indian unions involved lower-status Spanish men and indigenous peasant women.

Marriage soon became another tool of conquest and settlement for the Spanish overlords. When Spanish women traveled to the New World, they too anticipated the creation of a more hospitable environment for themselves and their families—a desire the Spanish crown reinforced by declaring that all married men, "even if they are Viceroys, Judges, Governors, or would go to serve us in any post and offices of War, Justice and the Treasury," had to take their wives with them to New Spain.[25] Because of the dearth of Spanish female settlers in the first fifty years of colonization, Spanish authorities implemented policies to encourage females as settlers, just as medieval towns had done in the Iberian Peninsula. The traditional fueros granted to peninsular women

were extended to the Americas, so that women's legal rights were protected and the public/private space where women traditionally negotiated personal agency was held intact. The pressures to settle reinvigorated the need for women as settlers, and within the first generation Spanish women had made their presence felt in the new colonies.

By 1539 there were 13,262 Spanish emigrants in the New World. Of these, 845, or 6.5 percent, were women, 252 of whom were married and 457 single. Early records document numerous women's business and economic activities as they entered into contracts; bought, sold, and rented property; and cared for their households in the absence of their husbands. Just as the New World provided new economic and social opportunities for adventurous Spanish men, adventurous Spanish women sought similar rewards and found them. Spanish colonial enticements for women were remarkably successful, unlike the initial efforts of the British colonies. In 1542 the solicitors of Mexico City contemplated founding two convents, because so many legitimate and illegitimate daughters of honorable Spaniards were unable to find suitable mates. By 1553 the Council of the Indies was petitioned to do something about the excess number of young women in both Mexico and Peru.[26]

By 1560 the number of Spanish women migrating to the New World reached 28.5 percent of total emigration, with 40 percent of them married or widows and 60 percent single.[27] These numbers would only increase in the next two centuries, and by the eighteenth century the gender ratio between men and women had balanced out. However, unlike the multicultural environment of Reconquista Spain, by the late 1500s Spanish authorities in the New World had created a Catholic, corporatist hegemony in the territories they controlled.

While old racial and cultural identities were erased, new identities had to be created in dealing with the indigenous Mesoamericans. These new social constructions resulted from some fundamental questions: were the Indians even human, and what rights could they be granted? In terms of marriage policy, these questions also involved whether Indians could legitimately intermarry with Spaniards. The crown and the church quickly decreed the Indians to be human and in need of Christianity to save their souls: in 1512 the crown passed the Laws of Burgos, declaring the Indians' legal status to be equal to that of orphans or widows, making them the legal wards of the crown and the church; and in 1537 Pope Paul III declared Indians to be human in the papal bull *Sublimis Deus*.

The first generations of conquistadors, however, challenged these decrees and actively worked against the legal and religious protection of their Indian

subjects.[28] Through the resuscitation of the *encomienda* (a feudal arrangement by which the crown granted land and labor rights to an individual in return for military protection of that land) and the *repartimiento* (a grant of labor rights for the improvement of corporate lands)—two systems used early in the Reconquista that had slowly withered into disuse by the fourteenth century in Spain—the first generations of conquistadors became *encomanderos*. In time the encomanderos accumulated riches not through land, which the crown had wisely begun to claim as its own rather than granting land rights to individuals, but through labor. Just as the encomiendas had previously acculturated Muslims and Jews into Spanish Christian society by providing them with military protection in exchange for labor and tribute, the holders of encomiendas in New Spain were legally bound to protect and Christianize the Indians.

Under the new lords of the Americas, the two systems quickly became the sites of quasi enslavement and racialization, since Indians were defined as being naturally inferior to Spaniards. When the encomienda and the repartimiento were transported to the New World, both institutions coerced forced labor tribute from Indian subjects. There were significant differences between them, however. The encomienda, according to David J. Weber, "represented the survival of a feudal institution through which the king or his representative rewarded subjects who risked their lives in frontier warfare. Accorded the privilege of collecting tribute for a lifetime, encomenderos could often pass their encomienda on to their heirs for two generations. In exchange, encomenderos were obliged to provide military service for the crown and to assume responsibility for the natives' defense and spiritual welfare." The repartimiento, on the other hand, was "a time honored institution by which Spanish officials distributed native men to work on a rotating basis at tasks deemed to be for the public good." Unlike the encomienda, under the repartimiento natives forced into compulsory labor

> were to receive wages and the law set limits on the length of their service
> and the type of work they could be compelled to do. In practice, however,
> Spanish officials commonly ignored these legal safeguards. On the frontier,
> as throughout the Spanish Empire, Indians were unpaid, underpaid, paid
> in overvalued merchandise, unfed, underfed, kept for longer periods of
> time than regulations permitted, and pressed into the personal service of
> individuals who confused their own good with the public weal. Illegally,
> soldiers and settlers used the repartimiento to force natives to take turns
> at tending herds and tilling fields, cutting firewood, serving in non-Indian
> households, and hauling cargo as human pack animals.[29]

Both the encomienda and the repartimiento were abusive systems that the crown attempted to police with little success. In the New World, both systems, the latter more than the former, flourished in the borderlands.

Marital status also influenced the size and amount of privilege involved in land tenureship, since married men received larger grants than single males. Unmarried merchants, furthermore, were given only three years of trading privileges and were encouraged to marry quickly.[30] The encomienda system had died out by the seventeenth century, but it left behind a legacy of social and economic inequality.

By the seventeenth century, race had become the most defining cultural marker in Spanish colonial society. Initially, the crown and the church did not outlaw intermarriage. In 1503 both institutions advocated that "said Indians marry their wives in the eyes of the Holy Mother Church; and that they also seek to have some Christian men marry Indian women, and Christian women Indian men."[31] When Spanish women did marry Indian men, the men were almost exclusively members of the elite within their indigenous communities. However, the majority of intermarriages occurred between Spanish men and Indian women.

With the blessing of the church and the state, the first generation of invading Spanish men married elite indigenous women, thus acquiring land for themselves. But once land and resources became scarce and settlement was a foregone conclusion, Spanish men preferred to marry Spanish or mestizo women. Furthermore, in 1575 the crown reversed its advocacy of intermarriage and began instituting laws that punished elite Spanish men who married Indian women. Increasingly, the crown preferred that administrative offices in New Spain be held only by *peninsulares* (persons born in Spain) or criollos (persons of Spanish parents born in the colonies). By the 1580s all government employees were banned from intermarrying in order to reinforce their loyalty to the crown and to discourage potential colonial rebellions and revolts. By linking marriage, race, elite status, and government service, the Spanish government created a transported ruling elite loyal to the crown. Military personnel, however, were exempt from these antimixing laws, because hundreds of years of racial/ethnic mixing in Spain had proved that low-ranking soldiers also advanced Hispanic acculturation, Christianization, and royal authority.

In terms of gender and race, these laws regulating mestisaje announced another fundamental shift in Spanish colonial society: the emergence of a *casta* population based on mixed racial categories and phenotype. Through formal marriages, concubinage, and sexual relationships based on violence and force,

Spanish men, Indian women, and African men and women created a multira-
cial, largely mestizo casta society in which personal and public honor, status,
and prestige were largely based on skin color. At the top of the racial ladder
were the Spaniards, who were automatically categorized as white or as gente
de razón, and at the bottom were African slaves, always referred to as *negros*
(blacks).[32] In certain regions, however, Africans were valued over Indians, fur-
ther indicating how fluid the racial hierarchy was throughout New Spain.[33] In
the middle were the full-blooded Indians, defined as *gente sin razón* (people
without reason). As these three racial groups intermixed, the task of defin-
ing and maintaining a clear color line became increasingly complex. Certain
mixtures easily fell into prescribed categories: a mestizo was a person born of
Spanish and Indian parents; a mulatto was of Spanish and African parents.
But with every succeeding generation, racial mixing created subsets of people
whose existence made classification ever more difficult. For instance, in what
category did a person of one-quarter Spanish, one-half Indian, and one-quar-
ter African ancestry fit? By the eighteenth century, there were at least sixteen
to twenty distinguishable casta groups in Mexico. These casta categories were
meant to establish greater racial and social order, but the challenge of keeping
track of all the various possible mixtures of people of *color quebrado* (broken
color) consistently destabilized colonial Spanish racial ideology.[34] Determin-
ing a person's social status and prestige, taking race into consideration, was not
simply a matter of adding one plus one. Rather, it involved a highly subjective,
complex social equation in which self-identity and racial/cultural identity re-
mained contested terrain. In time, however, all Spanish colonial societies spoke
a similar language of racial distinction and racial inferiority and superiority.

To this day, Mexico is predominantly a mestizo society, but in frontier so-
cieties race was even more fluid than in older established centers. In the capi-
tal and the larger cities, greater political and social control over the populace
lessened racial anxiety, but on the frontier, the need for settlers, whatever their
phenotype, made rigid enforcement of the color line less likely. Racial mix-
ing was occurring throughout New Spain, but the highest level of mixture
took place in the frontier regions—a pattern that would continue well into the
nineteenth century. Another important demographic pattern in frontier re-
gions was the constant peopling of new settlements from other racially mixed
frontier communities rather than with settlers from central Mexico or the
capital. For example, the majority of settlers and soldiers of middling and low
rank were drawn from the racially mixed region known as Nueva Vizcaya, the
original northern borderland of the Spanish Empire in New Spain.

Covering today's Mexican states of Chihuahua, Durango, Aguascalientes, and Zacatecas, Nueva Viscaya was first settled in 1546 after the discovery of silver in Chihuahua and Zacatecas. Presenting stiff armed resistance, the Chichimecs, the original inhabitants, kept the Spanish at bay for almost fifty years. Only through a dual policy of full warfare that legitimized the capture and enslavement of the Chichimecs and pacification by means of *reducíon*—forced Christianization through Catholic missions built near Indian villages—did the Spanish finally exert full control over the territory by 1591.

The silver mines throughout the region attracted settlers, and within a century there were several large frontier towns. Furthermore, African slaves were brought in to labor in the mines. By 1646, 127,891 colonists and Christianized Indians resided in Nueva Viscaya. Of these, 102,289 were Christianized Indians, 16,230 Spaniards, 1,082 mestizos, and 8,290 *afromestizos*. By 1785 Nueva Viscaya's urban population had become even more mixed: 34.8 percent were categorized as *españoles,* 45.7 percent as mestizos, 6.0 as Indian, 12.9 as mulattos, and 0.6 as slaves.[35] As these numbers indicate, the majority of Nueva Viscaya's population, whether civilian or military, was mixed, but even the category of españoles probably included persons of mixed race. By the eighteenth century, racial discrimination against darker persons created conditions in which individuals attempted to pass whenever possible for more elevated castas in myriad social activities. As Ramón Gutiérrez points out, the fluidity of colonial society made the declaration of phenotype extremely subjective, as comments "that a person 'appeared to be,' 'was reputed to be,' or 'was known to be' of a certain race indicted the degree to which racial passing existed on this remote fringe of northern New Spain and how complicated it was to maintain order in the classification system. Adding to this racial fluidity along the frontiers was the practice of allowing lower castas who either performed heroic acts or possessed special skills to change their racial classification."[36] In certain parts of the frontier, mestizo and casta artisans who were cobblers, blacksmiths, tanners, and carpenters were reclassified as criollos.

Like race, the colonial honor code was also fluid and had a specific language. At times honor could be used interchangeably with race, since racial categorization also helped define the level of *cualidad* (quality) and social status that a person could achieve. Numerous works have discussed the concept of honor as status or virtue, sexual, private, and public, but Ann Twinam offers a more holistic definition: "Honor was profoundly important because it rationalized hierarchy, the division of Hispanic society between a privileged few and a deprived majority. It established a distinctive agenda of discrimination,

because those who possessed it were privileged with special access to political, economic, and social power and they maintained their superior rank by discriminating against everyone else." Within Spanish societies, ideas of honor were involved in every aspect of social life, including "courtship, sexual intercourse, pregnancy, and marriage, as well as in race, birth, access to political office, and employment."[37]

By 1680 the growing inequalities in colonial New Spain forced the newly reformed Council of the Indies to pass new legislation known as the Recopilación de Leyes de los Reynos de las Indias, which reorganized administrative offices as well as social and racial policies in order to better control the peoples and expanding territories of New Spain. These laws would govern the Spanish colonies until 1776, when another legal and administrative reform was initiated.

In the meantime, Spanish-Mexican frontier societies developed a regional identity distinctive from that of the capital and that of central Mexico. The northern borderlands were organized around warfare, and in no other place or time did the Spanish face greater difficulties in establishing and maintaining settlements. Rather than living in settled agricultural communities like those in central Mexico, the indigenous tribes on the northern borders were largely nomadic. The Spanish defined them as *indios bárbaros* (barbaric Indians). Catholic missionaries, in their attempts to establish the kingdom of God on earth, expanded the religious frontier when they ventured into Florida, Texas, and New Mexico and began a Christianizing effort among the nomadic peoples of the North, but even when the church sent out missionaries to aid, and in some places to spearhead, the exploration and settlement phase of colonial control, the remoteness and distance from settled areas hampered the advancement of Spanish settlement in the northern borderlands.[38]

In both New Mexico and Texas, Catholic missions were the primary frontier outposts of the Spanish Empire, because missions cost less to maintain than presidios (military forts) and settlements. The crown also encouraged wealthy individuals to finance private *entradas* (initial expeditions) into unconquered territories. New Mexico's first civilian settlement was financed through a private entrada. Had the missions' pacification efforts proven more fruitful, the crown could have avoided building and subsidizing further fortifications, but in 1680 a series of Indian revolts from Florida to New Mexico forced the crown to reevaluate and reconfigure the role its presidios played along the empire's northernmost borders. The Pueblo Revolt of 1680 was especially troubling and helped to coalesce the need to build a string of presidios to conquer the indios bárbaros.

By 1680 Santa Fe and Albuquerque, New Mexico, were the largest Spanish settlements north of Chihuahua. After a brutal suppression of the Pueblo Indians, a thriving colony consisting of several Spanish-Indian villages developed in New Mexico, but Spanish-Indian relations were tumultuous. Settlers living on the frontier relied on private or communal defense, and the crown would only send soldiers and expend royal monies in times of crisis. When the Pueblos, led by the charismatic Popé, unified their resistance after decades of sporadic acts of rebellion, a unified, full-scale offensive was launched against the Spanish settlements. In the aftermath, 400 of the 2,500 Spanish settlers were killed, every Spanish building was destroyed, all the Spanish fields and crops were burned, and religious objects and images were desecrated. Retreating to El Paso, the survivors barely held their ground and survived while the Indians reasserted their control over the northern frontier for the next twelve years. In 1692 the Spanish crown not only launched a military offensive to pacify the Indian rebels, but initiated an investigation that revealed the inherent weaknesses of civilian and missionary efforts. By the 1690s the Spanish began to build a series of presidios to establish a defensive ring against the encroaching English, French, and Russians and the indios bárbaros.

The need and primacy of the presidios along the northern frontier followed the familiar pattern of providing a military presence and official Spanish authority. However, the need for a stable military community necessitated the recruitment of women, which assured the continued protection of the fueros and the social privileges of Spanish-Mexican women.[39]

In Spain's northernmost frontier, presidios were more than just military installations. According to Max L. Moorhead, they exerted "a pervasive influence on the political, economic, social, and even demographic development of its environment." After 1680 the presidios established and nourished the rudiments of Spanish civilization in North America when they evolved "to the nucleus of a civilian town, a market for produce of neighboring farms and ranches, and an agency for an Indian reservation."[40] Similar to the Spanish medieval towns' survival tactics, reproduction and conquest were only assured if women also migrated north into the borderlands of Spain's expanding colonial holdings. As Antonia Castañeda points out, church and crown subsidized the colonization of California, and it is not surprising that both agreed on the primacy of attracting artisan families as soon as possible after its conquest. Church authorities were particularly adamant in recruiting women, because "women were essential to the material advancement of the frontier. The work of pacifying and Christianizing the natives required that Indian women be taught

and disciplined in the rudiments of civilized life that pertained to women, particularly the domestic arts and womanly virtues. The crown sought industrious Spanish women to instruct neophyte Indian women in cooking, cleaning, sewing, soap-making, small husbandry, and sundry womanly duties."[41]

Learning from previous mistakes and shortcomings in its colonization practices and strategies, in 1769 the Spanish crown initiated the settlement and physical control of Alta California under new administrative reforms that began in 1760 and culminated in the Bourbon Reforms of 1776.[42] Time would show that improved organization could not deter or overcome the inherent weakness in Spanish military, economic, and colonization policies, but certain innovations were introduced in California. Like other Spanish colonies before it, California reflected the essentially reactive and defensive nature of Spain's policy toward its European rivals, using peripheral colonies and settlements as the first line of defense against encroaching French, English, Russian, and finally U.S. interests. However, these peripheral settlements were chronically undersupplied, and struggles between local needs and royal desires proved contradictory. Spain's attempts to forestall foreign threats by occupying more and more territory further drained its shrinking economic and military resources.

In California, when Spanish officials finally decided to establish a permanent colonizing presence along its northernmost border in order to bar Russian and English encroachment, they introduced two innovative policy adjustments. First, at no other time or place along the Spanish borderlands were military, ecclesiastical, and civilian forces so cohesively united to achieve successful colonization. Second, in terms of gender, California marked a critical break and evolution within Spain's colonizing policies as the presence and cooperation of women were critically targeted to assure success. Women were for the first time systematically included and considered necessary individuals in the anticipated success of this last colonizing effort. As core members of the settlement program, Spanish-Mexican women brave enough to venture into Spain's final North American frontier were privileged over Amerindian women from the very beginning. Although the majority of Spanish-Mexican women settling in California were impoverished and drawn from the lowest rungs of Spanish-Mexican frontier society, in this new region their racial and social capital rose.

When Spanish-Mexican women traveled to California, Spanish marriage policies were closely linked with colonization policies under the Recopilación de Leyes de los Reynos de las Indias and the Bourbon Reforms of 1776. Although a century separated them, both the Recopilación de Leyes and the

Bourbon Reforms reflected the shifting social agendas of the crown. Through both of these reforms, the crown essentially reorganized colonial society by prioritizing national security and mandating the strengthening of the military along the frontiers. Concentrating on the development of state militia and the professionalism of frontier troops, the Bourbon Reforms also introduced new political, administrative, and economic practices, as well as expelling the Jesuits from Spain and the Americas in order to establish royal authority over matters previously reserved to the Catholic Church. To further weaken ecclesiastical authority, the 1776 Royal Pragmatic on Marriage granted greater power to fathers over their children when questions of "unequal" marriages arose. Citing a variety of "defects," such as race, illegitimacy, and consanguinity, fathers could appeal to royal authorities to prevent clerics from performing any "unequal" marriages. Prior to the seventeenth century, the primary objective of marriage legislation was upholding the Council of Trent's definition of marriage as the free consent between two individuals and its decree that parents could not force their children into marriage or impede them if marriage was freely contracted. From the sixteenth to the seventeenth century, according to Patricia Seed, "the Spanish Catholic Church in the New World not only failed to support parental attempts at exercising control but frequently intervened outright to prevent parental interference."[43]

The solidification of patriarchal authority both in Spain and in its colonial societies weakened ecclesiastical and secular support for individualistic marriages. Economic considerations and the maintenance of social status lay behind most cases of parental pressure in marital choices. Higher-status families, as Asunción Lavrín notes, increasingly used their sons and daughters as pawns to advance the family's fortunes and "to reassert the desirability of equality, or at least symmetry, in the choice of a marriage partner and in the process of family formation."[44] In effect, the new law directly contradicted the Council of Trent's support for individual choice but did not change the mandate that legal marriages had to be officiated by a Catholic priest. In order to maintain the status quo and the authority of the emerging social elite against upwardly mobile mixed peoples, the new law also mandated parental consent for the betrothal and marriage of individuals below the age of twenty-five and provided that marriage without a parent's consent was grounds for disinheritance. But as with all the other Spanish legal reforms and recodifications, the fueros and rights of inheritance granted to women were largely preserved and continued to provide avenues through which women could challenge various masculine authorities.

Another indication of how marital ideology was intensely modified to fit colonial conditions was the integration into the colonizing policy of the concept of *unidad doméstica* (domestic unity). To counteract the potentially destabilizing effects of the long-term, long-distance separation of men in the colonies from their families, Spanish-Mexican couples were commanded to reunite as quickly as possible. Recognizing that successful colonization meant transplantation of Spanish institutions, the authorities planned the building of pueblo, presidio, and mission communities to mutually support public and private harmony. Fearing the destabilizing possibilities that single males posed along the frontier, especially their participation in illicit sexual relations, the church and the crown desired to stabilize conjugal relationships as quickly as possible. The two institutions would support and reinforce the stability and growth of families just as families would support and obey the church and the state. Successful marriages were deemed a crucial building block in the process of successful long-term colonization in California.[45]

In 1768 the Spanish authorities received news that Russia had begun to establish colonies along the Pacific coast of Alta California. A year later, on May 14, 1769, a small force of soldiers and Franciscan friars established the first Spanish-Mexican presidio and Catholic mission in Alta California in present-day San Diego. Between 1769 and 1784 four presidio and mission settlements were established—San Diego, Monterey, San Francisco, and Santa Bárbara—along with the four additional missions of San Gabriel, San Antonio de Padua, San Luis Obispo, and San José.

These sites were the roots of California settlement, but because no women joined the initial military and missionizing forces, sexual violence against Amerindian women broke out all along the California frontier. Sexual foraging and acts of rape continued the pattern of the Spanish in the New World: rape was considered an act of war and was used to conquer and colonize Native peoples who resisted the Spanish. Historians Antonia Castañeda and Douglas Monroy examine how the "brutal appetites" of the soldiers upset and threatened the success of colonization. The level of sexual violence inflicted on Amerindian women by presidio soldiers alarmed church officials, who vociferously reported to the crown acts of sexual violence, including numerous raids on Indian villages in search of Amerindian women, as well as rape, abduction, forced habitation, and the murder of Indian men who attempted to protect the women.[46]

The mission fathers considered these acts especially detrimental to their Christianizing efforts, and they quickly petitioned the crown to punish the

offending soldiers and offered the most reasonable solution: send marriageable female gente de razón settlers to the frontier. Chastising military authorities for the lax punishment of guilty soldiers, the church also petitioned the crown to foster and encourage marriage between soldiers and neophyte—that is, recently converted—Amerindian women, the original "daughters of the land." Church officials anticipated that these sanctioned permanent unions would engender a trusting and enduring bond between the Amerindian communities and the Spanish intruders, and they proposed economic incentives in order to foster the marriages. The incentives included retirement from the army, a grant of land near the woman's mission, a seaman's salary for two years, and five years of rations.[47] Importation of single, marriageable women to the colonial settlements was also proposed to check the rapes and sexual violence committed by the soldiers.

California's strategic importance encouraged officials to authorize and pay for *pobladores* (town settlers) to settle in California in 1775. Traveling from Tubac, Arizona, Juan Bautista de Anza led a party of 240 people, including children, from Sinaloa, Mexico, to the San Gabriel Mission. The majority of the men were soldiers, but a number of pobladores and their families joined the expedition. In terms of marriage, twenty-nine of the thirty-four women on the de Anza expedition were wives of soldiers and three were married to pobladores. Only two single women joined the expedition, one a widow, María Feliciana Arbollo, and the other the teenage sister of one of the pobladores. The average age of the married women was twenty-eight; all had married in their midteens. At the time of the expedition, they had been married for an average of twelve years and had given birth to an average of four children. Most of the women were in the middle of their childbearing years, and eight of the thirty-two women were or became pregnant during the journey; five had miscarriages, and one woman, Manuela Ygnacia Pineuleas, died in childbirth. No extended families joined the expedition, and as a result the wives were highly self-reliant and the older children were pressed into needed labor for household tasks. In terms of race, the majority of settlers and soldiers were castas and second- or third-generation frontiersmen. Juan Bautista de Anza was himself a third-generation presidial officer. Like their parents and grandparents before them, these intrepid individuals would define their social and personal worth based on the standards and ideas of their particular adopted communities.[48]

Following de Anza's colonizing expedition, which effectively doubled the Spanish-Mexican population in California, in 1781 Fernando Rivera y Moncada led another royal expedition of sixty soldiers, pobladores, and their fami-

lies to the San Gabriel Mission settlement. In 1782 a third expedition settled Santa Barbara, and in the same year a contingent of settlers from San Gabriel founded Los Angeles. After 1781 a Yuma revolt closed the Sonora Trail, forcing immigration and all forms of communication between Nueva Vizcaya and Alta California to move by sea. This isolation favored the growth and power of the missions over the presidios and the civilian population. Although royal and military authorities recognized the need for civilian settlers, the recruitment and immigration of all settlers—single women especially—remained a trickle well into the nineteenth century, even after the Sonora Trail was reopened. This relative isolation, however, did not deter population growth. In 1790 the Spanish-Mexican population numbered 990. Through natural increase, Spanish-Mexicans numbered 1,800 by 1800; in 1821 the total reached 3,200.

Castañeda reveals how marriage policies in colonial Monterey were critical to the efforts of establishing cultural hegemony along Spain's expanding military frontiers. Through social legislation and regulations, marriage as an institution was modified to accommodate frontier conditions. Unfortunately for the Spanish officials, economic incentives were largely ineffective in encouraging Spanish-Mexican men to marry the most available single women, the neophytes. In Monterey from 1773 to 1798, of the twenty-seven marriages performed at the mission, sixteen, almost 60 percent, were intermarriages. From 1798 to 1821, however, no interethnic marriages occurred in Monterey. These statistics verify the frontier marriage pattern that began in 1517. Even with a heavily unbalanced sex ratio, Spanish-Mexican men still preferred marriage with Spanish-Mexican women rather than with Amerindian women. However, continued sexual relations between Spanish-Mexican men and Mesoamerican and Amerindian women through force or concubinage contributed to the growing presence of a mestizo population.[49]

Ironically, by 1790 the church began reversing its policy of granting land to interethnic couples. In 1795 the church convinced secular authorities that "neophyte women who married Spanish-mestizos no longer had the same rights as Amerindians who remained in the mission."[50] The land was instead to remain in patrimony for those neophytes who remained in the mission. Because neophytes were considered to be in a constant state of instruction in Christianity, their Indian identities were regarded as permanent. Women who altered their social category by removing themselves from the ranks of "daughters of the land" and becoming more fully Christian through marriage to a Spanish-Mexican Christian male were denied their patrimony. By 1790 the church's new policy of maintaining and developing the amount of acreage

within the missions took precedence over promises made to the neophytes. For neophyte women, this reversal in marriage policy had the unfortunate effect of removing the only privilege that had momentarily elevated them to a more equal standing with the newly arrived Spanish-Mexican women. After 1795 a few more Native American women managed to slip into the higher social class, but they never reached the percentage of interethnic unions of colonial Monterey. These policy changes further indicated the end of the initial colonizing efforts and the solidification of Spanish hegemonic control. By the time Euro-Americans arrived in California in the eighteenth century, Spanish-Mexican women were referred to as "daughters of the land" and marriage had entered into a new phase of social and cultural negotiation.

In 1800, if a California "daughter of the land" had been able to converse with a medieval Spanish "daughter of the town," the two would have been struck by the obvious differences between them. Centuries of commonalities united Spanish women as they traveled from Spain to the New World, but the original "daughters of the town" would have been shocked at how the legal, social, and cultural concessions granted them had slowly but steadily been modified to protect women so racially different from themselves. Indeed, "daughters of the town" would have remarked on the others' closer resemblance to Moors than to any Spaniards. They might have marveled at the fact that these women spoke Spanish, were Catholics, behaved with honor, and considered themselves superior to the Indians beneath them. But once the Californianas began to discuss their personal stories of how they survived in frontier communities, how they took advantage of the opportunities that marriage and family kinship provided, how they recognized their social and reproductive value in frontier societies and the meaning and personal agency it gave to their lives, the two groups' relationships would have seemed less alien to each other. In sharing their experiences, they would also have observed that like all daughters, they eventually became wives and mothers. The role that marriage played in their lives would have provided the connective link to their different cultural and social experiences, even though five hundred years of history separated them.

CHAPTER 2

※

Class and Marriage Choices

IN ONE OF THE FEW STUDIES that center on women and intermarriage in North America, Sylvia Van Kirk's *Many Tender Ties* lays much of the groundwork for further research on the topic. Van Kirk's study examines intermarriage between Native American women and Euro-American men. Within the Canadian fur trade, women not only facilitated economic transactions, but were crucial to the evolution of a *métis* society. The parallels between Canadian fur-trading and California rancho society are worth noting. According to Van Kirk, the rich social history of the fur trade has been largely ignored. Historians have studied the fur trade primarily as an economic activity, overlooking how it "generated a distinctive regional way of life" and "patterns of work, family life, modes of transport, and items of food and clothing." In addition to the economic interdependence generated by the trade, Indians and Europeans engaged in significant cultural exchanges. Intermarriage and the development of a métis society were its cultural legacies.[1]

The similarities between Native American and Spanish-Mexican women involved in intermarriage are significant, particularly the economic and collaborative roles that women played in incorporating their husbands into specific cultural exchanges. Both Canadian Native American women and Californianas became "women in between"; however, in terms of Canadian colonization, the French and English treated the Indian women as colonized subjects, savage "others," who became acceptable mates only because of the lack of "white" European women. Indeed, one of Van Kirk's most compelling discussions notes the decline in social status of Indian wives and their métis daughters once Euro-American women arrived and permanently settled along the Canadian frontier.[2] This was not necessarily the case in California, where

two European colonizers with similar ideas about race and gender exerted their control and influence over the conquered Indians. The construction of "Indian" identities and the means used to subjugate and control these indigenous peoples differed greatly between Canada and California, so social practices also varied. Nonetheless, the practice of intermarriage provides a connective tissue between local histories and colonizing patterns. Understanding how individuals negotiated issues of identity, race, class, and gender in these specific frontier locations has to be established before meaningful comparisons can be made. Although intermarriage and mestizaje were accepted social practices, the fact that California's society was a racially mixed one, with European definitions of property, gender, and race, made the Californianas radically different from the Canadian Native women.

The Californios' and the Euro-Americans' views of marriage and particularly of intermarriage make the Spanish Borderlands a more complex site. In one of the few works on interfaith marriages in the nineteenth century, Anne C. Rose notes that Catholics and Jews frequently worried and publicly debated the issue of interfaith marriages, yet Protestants did not do so. Rose argues that "declining to mention strangers in their midst protected an impression of seamless hegemony and exerted pressure on mixed families to honor Protestant norms."[3] The supposed superiority of Protestantism mitigated the anxieties of many Protestants, who assumed that the children and families resulting from interfaith marriages would accommodate to Protestant norms. However, when Protestants were in the minority and it was they who had to accommodate to Catholicism, the subject of intermarriage takes an interesting turn.

In this chapter I examine three specific marriages in terms of these cultural and personal negotiations, particularly marriages among the first generation of Protestant Euro-American merchants. Studies in nineteenth-century American masculine culture reveal the linkage between an evolving market economy and ideas of rugged individualism, as well as how the scientific and popular ideas of the time associated masculinity with economic behavior. Nineteenth-century models of male behavior depicted capital accumulation as an overt symbol of positive masculinity. In work, leisure, and sex, "a new value system, based on the sanctity of the individual and his right to make his own choices in politics, economics, and religion, emerged in the early nineteenth century."[4] Private property, aggressive entrepreneurship, the cult of the individual, and opportunities to succeed in capital accumulation became badges of the emerging Protestant middle class, especially for artisans, shopkeepers, merchants, speculators, investors, and bankers. In the 1820s middle-class Euro-Americans began

the construction of a gender ideology in which ideas of manhood allowed men to "claim certain kinds of authority, based upon their particular type of bodies."[5] Conversely, this gender ideology "celebrated true women as pious, maternal guardians of virtue and domesticity" but at the same time taught the men "to build strong, manly 'character' as they would build muscle, through repetitive exercises of control over impulse. The middle class saw this ability to control powerful masculine passions through strong character and a powerful will as a primary source of men's strength and authority over both women and the lower classes. By gaining the manly strength to control himself, a man gained the strength, as well as the duty, to protect and direct those weaker than himself: his wife, his children, or his employees."[6]

While class and gender linked physical bodies and social identities to cultural power and privilege, the category of race gained increased importance as the century progressed. From the 1820s through the 1840s, race marked the electoral privilege that gave "white" men universal suffrage. But by the 1890s "whiteness," when linked to ideas of "manhood," also expressed notions of civilization and of white supremacy over "darker" races.[7] This attempt at establishing "hegemonic masculinity"—a term that scholars of gender have recently begun to use to describe this dominance—was not a static process. The images of white manhood that became institutionalized in the nineteenth century to justify the appropriation of power, resources, and privilege were challenged by subaltern groups continuously contesting "hegemonic manhood by disrupting and recasting white myths of western masculinity."[8]

When Euro-American men first traveled to California and established residence, bringing with them these notions of white manhood, they had yet to establish white hegemonic masculinity. Expanding new markets encouraged the first wave of Euro-American traders and merchants into the West, but personal and business success demanded accommodation to local conditions. Commercial markets and the marriage market thus became inextricably intertwined. By examining some of the first wave of interethnic marriages, we can establish changing patterns and determine what the ascendancy of the United States meant for those involved in intermarriage.

Born in 1809, María Teresa de la Guerra y Noriega was a third-generation Californiana and a direct descendant through her maternal lineage of two of the founding families of the pueblos of San Diego and Monterey. Her great-grandparents, Francisco Salvador Lugo and Juana María Rita Martínez, had immigrated with their five children from Sinaloa, Mexico, in 1775 and settled

in Monterey, Alta California. A dominant marriage pattern in the initial stage of settlement involved intrapresidial marriages; a Lugo daughter and granddaughter both married presidial officers.[9] María Teresa's father, José de la Guerra, on the other hand, was born in Spain into the lower nobility but spent his adolescence clerking for his uncle Pedro Noriega in Mexico City. Turning his back on trade, the sixteen-year-old José enrolled as a cadet in the San Diego Company in 1798, and by 1808, recently married, he was transferred to Santa Barbara. Named as *comandante* of the Santa Barbara presidio in 1817, José also engaged in trade, supplied by his uncle in Mexico City.[10]

Race, aristocratic lineage, and relative economic wealth placed the de la Guerras within the most privileged social, economic, and racial class. Within the presidio, physical sites reinforced the social hierarchy that placed them at the pinnacle of this small community. Typically, quarters for married soldiers consisted of a single room measuring about twenty-one feet by twenty-four feet, but as comandante José de la Guerra received twice as much square footage and was eventually granted the use of additional land outside the presidio for a dwelling, escaping the presidio's cramped quarters. Beyond providing better living accommodations, land tenure outside the presidio assured the accrual of other status-defining cultural markers, particularly access to Amerindian labor. The de la Guerras employed Indian servants, whether from the nearby mission or from a neighboring *ranchería* (Indian settlement), for both domestic housework and as field hands and herders. This economic standing guaranteed that the female de la Guerras also supervised Amerindian labor in carrying out their day-to-day housework.[11]

A growing family and a constant flow of visitors and house guests increased Antonia de la Guerra's (Teresa's mother's) need for household assistance. Dining with the de la Guerras in 1841, William Dane Phelps remarked that at the "table are generally seated about 20 persons, while on the floor, on mats, in different parts of that large dining hall, are groups of grandchildren setting or lying down to their meals, with an Indian girl appointed to the care of each one."[12] In a country without hotels or other public accommodations, the generous hospitality of the gente de razón substituted for public lodgings and added to the womenfolk's household duties. Elite ranchero households counted not only immediate family members but, at times, numerous visitors, as well as Indian servants.

It was undoubtedly Amerindian servants who provided the labor for three of the most arduous female household tasks. Elite women supervised Indian servants in the preparation of food, freeing themselves for other household

duties. Californios typically ate four daily meals: *desayuno,* which came at daybreak and consisted of hot chocolate and tortillas; *almuerzo,* eaten between eight and nine o'clock in the morning, usually consisting of eggs, beans, and tortillas; *comida,* the noonday meal; and finally, *cena,* supper. The last two meals usually involved some form of *guisado* (meat stew) accompanied by various side dishes.[13]

One of the most time-consuming household tasks for Californianas involved sewing, "which was by no means a light task, for there was a great deal of embroidery about the clothing of both men and women, as well as bed-linen; and all of this was the work of their hands."[14] The love of richly ornamented clothing made sewing a highly prized skill, a valued talent for women, and a sign of one's being civilized. "The most frequent purchase," according to Lisbeth Haas, "of wealthy landowners and Californio workers alike was cloth: finer cloth—woollen cloth, printed cotton, embroidered muslin, silk, and linen, plus thread of all qualities, stockings, and silk handkerchiefs—for the wealthy; less expensive varieties of cloth, as well as shoes and pants, for workers."[15] According to José del Carmen Lugo, "when the missions were able to obtain goods through commerce carried on with ships, they began to give the Indians calico, muslin shirting, shawls, and large striped and flowered handkerchiefs in bright colors, these latter pleasing the Indians greatly."[16] Elite *rancheras* were taught sewing skills, but they utilized Indian labor to lighten their household burdens. Mission fathers often hired out eight- to ten-year-old female neophytes to gente de razón households; once the girls had been taught to sew and to perform other domestic chores and had reached marriageable age, "the same mission Fathers would persuade certain Indians to ask for the girls' hands in matrimony in order to bring them back to the mission. That was why one would always find excellent seamstresses among the Indian women."[17] Because dress was a significant social marker for all Californio classes, Indian women with sewing skills had access to the materials, quite literally, that could distinguish them from the neophyte women who received only simple coarse cloth petticoats and cotton shirts.[18] Wearing a finer grade of cloth or embroidered clothing allowed Indian servants to position themselves closer to Spanish standards and thus to rise within the social hierarchy of Californio society.

Teresa de la Guerra, like her mother, learned to instruct and supervise Amerindian servants not only in food preparation and sewing, but in the other common household tasks: laundry, ironing, baking bread, and making soap and candles. It was also her duty to teach her servants to behave in a Christian

manner. She thus prepared herself for the role of mother and wife—presumably to a presidial officer, following the example of her mother and grandmother. But by the time Teresa reached marriageable age, there were other options available.

In June 1822, William E. P. Hartnell and Hugh McCulloch, both Englishmen, arrived at the port of San Diego. They were the first officially recognized foreign traders to take advantage of the more liberal commercial policies of the newly formed Mexican Republic. As agents of the John Begg Company of Santiago, Chile, both men were well integrated into the coterie of foreign traders engaged in the complex trading system that involved the products not only of South America but of Europe, China, the Pacific Islands, California, and the United States. Hartnell's fluency in Spanish and his understanding of Latin American social customs convinced McCulloch that Hartnell should serve as the resident manager and he as supercargo. Through Hartnell's efforts, the head of the missions, Fray Mariano Payeras, granted their firm a license to negotiate individual three-year contracts with each mission. In exchange for the now-abundant hide and tallow surpluses from mission herds, the padres received "scarce mission supplies, ranging from gold and silver thread, window glass, and violins to trousers, garden tools, tea, and coffee," along with personal gifts of cigars and other difficult-to-obtain luxuries that eased the personal relationships between the traders and the mission fathers.[19] For three years, the company of Hartnell and McCulloch monopolized the mission trade. However, its success was short lived; by 1826 competition from Boston-based firms had driven it out of business.

In the flush of initial success and having for several years desired a wife, Hartnell took deliberate steps to further integrate himself into the local community. In 1823 he submitted a letter—the accepted tradition among the elite at the time—to José de la Guerra, proposing marriage to the then fourteen-year-old Teresa. Hartnell completed his religious conversion to the Catholic faith on October 13, 1824, and the couple was married on April 30, 1825. Teresa was seventeen, Hartnell twenty-seven.[20]

His religious conversion and marital choice initiated a growing estrangement between Hartnell and his English family. Throughout his stay in South America, Hartnell had actively sought out female companionship, although at that time he clearly indicated his preference for marrying within his own racial group. Writing to his sister Hannah from Chile, he asked, "if you know any pretty girl that wants a husband, pray send her as I am almost dying for a wife, and should find some difficulty in meeting with one here unless I were to turn

Catholic, and that I know you won't give your consent to."[21] Reiterating the same sentiments to his brother Nathaniel, he went so far as to state, "I am as great an enemy to poverty as you are, and I assure you that you need be under no apprehension whatever of my taking a wife from amongst the daughters of the men of Chile; I had rather marry a plain English country lass; than the daughter of the greatest Nabob of Chile or Peru."[22] Even though he found the girls of Santiago "very pretty and partial to Englishmen," they unfortunately happened "to be rather 'pyebald.'" This "pyebald" condition, however, did not keep him from seeking out the young women's company. He boasted to his brother that he visited few families, but "those I do visit are houses where my countrymen don't frequent, and then I have all the fun to myself."[23]

Of course beauty is in the eyes of the beholder. In Faxon Dean Atherton's opinion, Californianas were "clumpfooted, straight haired, beef eating and knowledge eschewing damsels of the land," unlike the Chilean women, whom he regarded as the prettiest and most interesting ladies he knew, and "one at least is far beyond comparison with the prettiest of even my own U.S. America."[24] Atherton also commented on the propensity of married foreigners to assist unmarried foreigners in finding a wife, but he questioned whether it was from benevolence or rather regret that they had "sprung their traps without catching the prize they had anticipated."[25] He feared it was the latter.

The numerous personal accounts of various traders involved in the American and Latin American trade reveal a tight-knit collegial world; drinking binges, excessive dinners, and gossip characterized these transplanted heterosexual male–centered communities. For example, William Atherton wrote to Hartnell after he had left Lima:

> I will tell you how we pass our time on high days and Holidays—Pic Nics have been introduced as a most excellent remedy for killing Sundays, when we all go out to some Chacra [farm] where we send our dinner the day previous, and remain there till evening when we return livened with the effects of generous Wine, which make some of our companions visit those shops in which you used to spend so much of your time. —On Xmas day we had rather a grand dinner when 104 Britons sat down to beef and pudding. After taking a small portion of wine (say six bottles each) we retired to the race ground where hunting and racing become the sport, but the ground was so covered with 'tulips,' that it was dangerous to ride about, amongst whom was 'Sturdy Mac laying on his back,' old Reed the same, and many more of our neighbours. The young men of this no longer dull city have also their paseos, and we enjoy our Pic-Nics regularly—Wyld and

myself gave one sometime since when only two arrived in Lima that day. Poor Armstrong fell off his horse 17 times and myself only 7—and the rest of our friends averaging each 13 falls in a distance of five miles.[26]

These Englishmen viewed themselves as superior to the native population, but their actions often belied their image of themselves.

Although many European and Euro-American traders lamented the lack of "proper white" English or American women, Hartnell eventually became engaged to a Miss Lynch in Lima. According to Susanna Bryant Dakin, "since his fiancée was an 'English rose' of background and religion similar to his own, no barrier loomed to prevent the marriage, none save the lover's chronic lack of funds." So Hartnell set sail to California.[27] The question then arises, why did Hartnell not marry Miss Lynch if she represented a solution to his ethnic and cultural dilemma? In all likelihood, Miss Lynch's sexual behavior, not her racial identity, kept Hartnell from following through with the marriage. In 1827, after returning to Peru to dissolve his business ties with John Begg, the now-married Hartnell renewed an intimate relationship with the still-single and sexually available Miss Lynch. This association was blatant enough to cause his friend David Spence to inquire, tongue in cheek, "By the by, How did you escape that English wifie of yours? I have as yet keeped it all quiet but I have for satisfaction enclosed a letter I had the other day from Mrs. Hartnell. Some good friend has been kind enough to let her know about your being prisoner in Lima."[28] As his friend and confidant, Spence kept Hartnell's affair quiet but knew that Hartnell was accepting Lynch's "wifely" attentions. Lynch's "whiteness" apparently had not engendered a sufficient sense of obligation on Hartnell's part for him to marry her. For all his talk of turning down daughters of Peruvian nabobs, Hartnell's position as a bookkeeper, with its limited chances of advancing in the firm, made the possibility of his marrying into a wealthy South American family improbable. California, and specifically Teresa de la Guerra, represented his best opportunity for financial advancement and personal fulfillment.

Aiding Hartnell's proposal of marriage was Teresa's seeming lack of Californio suitors, indicating a dramatic departure from the practice of child betrothal for a female gente de razón. The lack of elite women in the late eighteenth century had forced adult men to contract with parents of very young girls in the hope of attaining a wife. During the initial settlement stage, the dearth of marriageable women was so extreme that a twenty-six-year-old soldier, Ygnacio Vicente Ferrer Vallejo, became betrothed to his future wife,

María Antonia Isabela de Lugo, on September 2, 1776, the day of her birth. It was reported that he was literally on hand when his future wife was delivered.[29] As late as 1811, another soldier, Manuel Gómez, married ten-year-old María Francisca de Rosario Estudillo after she had given birth to the first of their five children. The marriage register commented that the couple had already celebrated their betrothal and were in the process of contracting marriage.[30]

After the Mexican-American War, popular accounts often exaggerated the pattern of Californiana child brides, frequently using this as evidence of the backward and autocratic nature of Californio fathers. In the initial stage of colonization and settlement, many girls did marry as early as thirteen or fourteen; however, by 1790 the average marriage age for women was seventeen. Husbands on the average were almost eleven years older than their wives, and men tended to marry in their mid- to late twenties. By the mid-nineteenth century, women customarily married in their late teens to early twenties, while the average age for men dropped by three years, making the average age discrepancy between husbands and wives 8.9 years.[31] In the 1820s marriage choice was still dictated by parents, but child betrothals had noticeably declined. By the time Teresa and her age cohort reached sexual maturity, they may not have actually chosen their husbands, but they could at least influence, if not veto, their parents' choice of mates.

After the wedding Hartnell and Teresa established a household adjacent to Hartnell's warehouse in Monterey. Teresa gave birth to their first child, Guillermo Antonio, during the first year of marriage and was pregnant again by the end of 1826. She would endure nineteen pregnancies, but only six children survived into adulthood.[32] Unfortunately for the Hartnells, the initial promise of economic security failed to materialize. Several factors stymied Hartnell's efforts. Competition from several U.S. firms, especially the Sturgis and Bryant Company, and increasingly strained business ties with John Begg, which terminated in financial bankruptcy, further aggravated Hartnell's financial woes. Forced to negotiate the final terms of business dissolution, Hartnell traveled to Peru in March 1827. According to Teresa, her husband's failure resulted not from his lack of effort or judgment but rather from the protection and favoritism that Governor Argüello gave to John Bautista Rogers Cooper, "who proportioned advantages and conceded privileges which were negated to other traders," and to the defection of David Spence, "who having married into the very powerful Estrada family, left his employers and took advantage of his mercantile knowledge" and "little by little lessened the accounts upon which rested the hopes of Hartnell and his partner."[33]

During her husband's final trip to Peru, Teresa undertook the expansion of the family's living quarters, tearing down partitions and converting the two-room building into one large *sala* (living room). Two new wings were added to the house, one the new family sleeping quarters and the other the kitchen and dining area. The project demonstrated Teresa's adeptness in supervising Indian labor. It was she who commissioned the design of the new home and employed Mission Indians—the same labor source that had built her husband's warehouses—to make the adobe bricks and do the construction.

In the early stages of her marriage, Teresa also had access to European servants. In 1825 John Begg's Liverpool partner, a Mr. Brotherson, had sent out one Mr. Tivy, a master carpenter, John Wade, a cooper, and Lawrence Long, a salter, with the intent of producing salted beef for market. With the assistance of his father-in-law, Hartnell rented a rancho for the John Begg Company and purchased cattle, but the workmen complained about the inferior raw materials available for the salting process, and the venture failed. Tivy decided to remain in California and sent for his wife and three children to join him in establishing a dairy on the company's land. From this farm Tivy furnished the Hartnells with butter, cheese, milk, and cream, an obvious aid to Teresa's household management.[34]

Irrespective of the firm's failure, Hartnell maintained strong personal relationships with the mission fathers and continued to trade and to invest in various ships' cargoes. When the *Danube* was wrecked near San Pedro in 1829, Hartnell's career as a trader ended in personal bankruptcy. This financial blow made land ownership imperative in order to stave off further economic hardship. Having fulfilled two of the customary requirements—conversion to Catholicism and marriage to a Californiana—Hartnell sought naturalization in 1830. As a Mexican citizen, he arranged with the Soberanes family in 1831 to acquire a share of their Rancho del Alisal. He had finally become a ranchero, "although not entirely in the way [he] would have chosen." He recognized his limited knowledge of ranching, so advice from his in-laws proved invaluable. Hartnell explained to his father-in-law that the arrangement with the Soberaneses granted him equal rights to the land and gave him permission to pasture cattle, to build a house, and to plant as many grapevines and orchard trees as he needed. In exchange Hartnell was to help the Soberaneses during the planting season, committing himself "to all expenditures for the sowing that we do together and at the time of the harvest I get back the value in produce of the amount I put in at seed-time, and this surplus must be divided equally between us." In closing he remarked, "so we shall soon see if as a Rancher I

have the same ability, or better say lack of ability, that I showed as a Trader."[35] Hartnell's continuing failures and subsequent reliance on his father-in-law's economic and social associations strained the relationship between the two men.

Marriage, as this case indicates, did not automatically guarantee land acquisition. The importance of the Rancho del Alisal to the Hartnells' social prestige cannot be underestimated, because landholding stopped their social descent. Economically, the family constantly struggled but never fell into the lower stratum of society.

In order to broaden his economic opportunities, Hartnell opened the Seminario de San José, California's first organized school, in Monterey to supplement the family's income. Prompted by a number of prominent Californios, specifically his father-in-law and Governor José Figueroa, Hartnell provided the school that the community had long wanted and woefully needed. Contradicting popular Euro-American prejudices that cast Californios as anti-intellectuals who happily accepted—indeed, preferred—their state of indolence, numerous personal narratives repeatedly mention the Californios' desire for better educational facilities. Willing adults, often women or mission fathers, tutored many children in the basic subjects of reading, writing, and mathematics in settings that were referred to as schools by some Californios, but these "schools" were too often temporary and insufficient to meet the needs of the local community. Especially in the early stages of settlement, education was so scarce that when María Ramona Noriega was buried on September 3, 1820, the priests noted in the register that she was "a woman of some attainments for her circumstances and time as she taught all of her [eleven] children to read and write."[36] Apolinaria Lorenzana remembered that in San Diego, when Josefa Sal became a widow, she opened her home as a school "to teach the little girls to read, pray, and sew." Even though Lorenzana herself was self-taught, in time she also "taught to read the children of one or other sex whose parents beseeched me to teach."[37]

María Inocenta Pico de Ávila was sent to Monterey to live with her aunt in order to be taught by Doña María Antonia Buelna, but she later commented that few of the girls completed even these rudimentary studies, because at that time the Californios had the "awful custom of marrying the girls at a young age whenever they were asked for their hands in marriage." Gender segregation was prevalent in Californio society, and whenever possible children were segregated by sex and taught by different instructors.[38] Too often, however, a pueblo had only one or two teachers, making sex segregation unlikely. A few of

the most elite Californio sons were sent to Europe, Mexico, or the East Coast to receive a university education, but the majority of children had little access to education beyond the most basic level. Those who attained even the simplest skills distinguished themselves: reading and writing, like richly ornamented clothing, established and maintained class distinctions.

Beyond providing a valued service to the colony, Hartnell also anticipated that the school would provide a stable income for his growing family. For Teresa, the prestige of opening California's first school was offset by the fact that her household burdens were thereby doubled. Along with providing care for her growing family, she now had ten new boarders to feed, care for, and wash up after. Although the census of 1834 shows no servants in the Hartnell household, it does mention several *criadas* (female servants) living in the courtyard whose pay consisted of being provided three meals a day. These women undoubtedly assisted with the domestic chores.[39] An account of Teresa's day-to-day activities does not exist, but the obvious household pressures belie the popular accounts of frivolous Californianas whose every need was lavishly provided for by their Euro-American husbands. During Hartnell's tenure as a schoolmaster, the family's well-being rested equally on Teresa's labor. Even after the school relocated to the countryside, thereby lowering its cost, "the profits were so small that they did not satisfy the aspirations of the professors."[40]

Still hoping to find some dependable source of revenue, Hartnell accepted the position of tax collector from the new California governor, Don Juan Alvarado, a cousin of the de la Guerras. In 1839 the same governor appointed Hartnell as *visitador general* (inspector) to the missions. An annual salary of two thousand pesos was promised, but he never received the full amount. Like his business ventures, his public service failed to provide a stable income. Hartnell's work as visitador general and his constant absence from home were particularly taxing for Teresa, who was forced in his absence to supervise, maintain, and control their household. With her husband traveling from "one point of Alta California to another," Teresa declared that "no living person could form any approximate idea of the sufferings the position of Visitador General of the missions placed on Don William Hartnell"—and by extension on her.[41]

The end of the Mexican-American War opened some potential economic opportunities for Hartnell, and in 1847 he was appointed the official American translator of Mexican laws into English. Three years later, the governor of California, General Bennett Riley, commissioned Hartnell to translate into Spanish all laws passed by the California Congressional Congress of 1850.[42]

In a larger cultural context, Hartnell's experiences reveal the precarious position of the first generation of Euro-American settlers as the forces of change washed over California. Hartnell's linguistic skills proved useful to the invading foreigners, but they counted for less in subsequent years. Indeed, unlike preconquest Californio society, in which the ability to read and write made foreigners acceptable and valued members of the community, often allowing them to hold positions such as *juez de paz* (justice of the peace) or other lower administrative roles, the new Anglo society featured widespread literacy. Hartnell quickly applied for American citizenship to protect his land grants, which now consisted of two city properties and two smallish ranchos, but even with citizenship he failed to make significant economic gains after the American conquest.

William Hartnell's financial failures eventually strained the relationship between Teresa and her family. Throughout his life, José de la Guerra had extended a helping hand to his son-in-law, but upon his death all assistance ended. In his will José excluded Teresa from inheriting an equal share with her siblings, because "I have already delivered to her at her request as much as it was my intention to leave her in my will," and he failed to mention Hartnell at all.[43] This treatment was in contrast to the obvious warmth that José exhibited toward another foreign son-in-law, Alfred Robinson, to whom he left eight hundred head of cattle rather than to his daughter Anita, Robinson's wife, since his "intention in making this bequest to my son-in-law is to benefit my said grandchildren . . . and because I have entire confidence in the honor and rectitude of my said son-in-law, Mr. Robinson, I desire, direct and order that the said number of cattle be delivered to him personally that he may manage them as his own property."[44]

In terms of gender and intermarriage, the de la Guerra family reveals a significant pattern. Certain Californio families were open to marrying foreigners, and in rare cases such as that of the de la Guerras, the majority of their daughters did so. The de la Guerras, Bandinis, and Alvarados intermarried extensively with foreigners, but many prominent families—including the Argüellos, Lugos, Peraltas, Cotas, and Picos—had no intermarriages or perhaps only one daughter who married outside her ethnic group. In the case of the influential Estrada family, for example, David Spence was the only foreigner to take advantage of their familial and business alliances through marriage. Clearly, the reasons certain women married foreigners after the 1820s have to be contextualized.

Because of the prominence of the de la Guerras, historian Hubert Bancroft

interviewed several members of the family, including Teresa Hartnell and Angustias de la Guerra Ord. Several Euro-Americans acquainted with the de la Guerras remarked on Teresa's dislike for writing and scholarly pursuits and on how her almost yearly pregnancies made her less vivacious and outgoing than her younger sisters, and they often compared her unfavorably to Angustias.[45] There is little self-reflection or personal assertiveness in Teresa's *narración,* which was dictated to Enrique Cerruti; rather, most of it pertains to Teresa's account of the French agent Eugène Duflot de Mofras's visit in 1842.[46] Almost as an afterthought, Cerruti asked about Teresa's family. In discussing it, she identifies her sisters solely in terms of their successful marriages. For example, Teresa mentions Angustias's marriage to "the distinguished doctor" James L. Ord, who first came to California as a member of the American Flying Artillery. Upon retiring from the military, Ord "dedicated himself in Monterey to his profession which provided a very comfortable existence and permitted the accumulation of a more than regular fortune."[47] Teresa fails to mention Angustias's earlier marriage to Don Manuel Jimeno, whose death left Angustias economically compromised and the sole provider for four children. Nor did Teresa discuss Angustias's estrangement from Ord in the early 1870s on grounds of adultery or their eventual divorce. Teresa's failure to mention Angustias's first marriage is made more obvious by Teresa's description of her third sister, María Antonia, the widow of the Spanish merchant Don Cessin. Left with four children, María Antonia remarried, becoming "the wife of Don Gaspar Oreña, rich merchant and Hacendado of the city of Santa Barbara where she still resides surrounded by a numerous family and all the commodities that a colossal fortune and a tender husband could provide for her."[48]

The marriage of Teresa's youngest sister, Anita, to Alfred Robinson was of special interest to Cerruti. In 1846 Alfred Robinson's *Life in California* was published in New York. Cerruti was interested in the Californio reaction to Robinson's book, a popular work among Euro-Americans. Teresa remarked that "since she knew so little of the English language she could not judge its merits." She remembered, however, that both her brother Pablo and Mariano Guadalupe Vallejo had disputed Robinson's accounts of California events and actors. Vallejo was especially cutting and, according to Teresa, thought "travels in California seemed more a work done to win oneself the goodwill of . . . persons of value rather than a serious history capable of transmitting to posterity a faithful memory of the events he had witnessed." Robinson was, nevertheless, "as a father and husband . . . unimprovable, proverbial in his good faith, beloved by all the members of her family and relatives, . . . his wife was

all one could desire, . . . he was always willing to do anything to make them happy."[49] Teresa's emphasis on her sisters' marital happiness indicates that she considered material wealth and emotional comfort crucial to being successful as a wife and as a woman. Unable to boast of a husband who could provide a "colossal" or a "more than regular fortune," in her narración Teresa gave vent to the economic deprivations and public humiliations she had faced in her lifetime. Unlike those of some of her brothers-in-law, Hartnell's infidelities continued throughout their married life. According to Dakin, after Hartnell died on January 30, 1854, Teresa allowed Hartnell's three-year-old illegitimate son to attend the funeral.[50]

After Hartnell's death Teresa constantly struggled to pay the increasing taxes on the family's three tracts of land, the Rancho Todos Santos, Rancho del Alisal, and Rancho Cosumnes. Beginning on May 31, 1856, and into the late 1860s, Teresa was frequently in court paying back taxes. In 1856 she owed the amount of $115.38; in 1857, $66.88; in 1858, $82.35; in 1861, $447.07. By 1862 her son Guillermo Antonio Hartnell owed $718 in back taxes. Although she makes no mention of it in her narración, in June 1861 Teresa married Manuel Matarana. In her second marriage Teresa was clearly a greater, if not an equal, participant in running and maintaining the ranchos. Why she chose to marry this particular man is unknown, but she faced economic hardship in this marriage as well.[51] Throughout her married life Teresa adhered to her community's proscribed cultural role of wife and mother, fulfilling her various obligations to the best of her ability. She bore her first husband's children, maintained an orderly household, was a gracious host to all visitors, and conducted herself in a controlled, irreproachable manner. For Teresa, marriage to a Euro-American maintained her racial status, but material and marital tensions abounded.

Born on the Comicrabit ranchería around 1808, Victoria Bartolomea Comicrabit belonged to a generation that underwent the full cycle of Hispanization. The ranchería's proximity to the San Gabriel Mission assured that its inhabitants were forced into the daily religious rituals and agricultural cycles dictated by the authoritarian fathers. Following the prescribed doctrine for female neophyte children, Victoria was allowed to live with her parents until the age of six or seven, when she was removed to the *monjería* (nunnery) of the mission. There she was schooled in the principles of Christianity and was taught to read and write while learning fundamental Hispanic household skills such as cooking, sewing, washing, and gardening. While at the mission, she received special attention from Eulalia Pérez, the mission's *llavera* (key keeper), who chose

Victoria as one of her assistants.[52] According to Native American scholars, through kinship ties Victoria was an elite within the San Gabrieleño people, which explains Pérez and the mission fathers' interest in the girl.

Victoria's association with Eulalia Pérez proved beneficial at various levels. Born in the frontier town of Loreto, Baja California, Eulalia was typical of most Californio settlers. She had married in her late teens and was a mother by the time she and her husband settled in San Diego in 1802. Later, as a widow with six children, Eulalia began her employment as the principal cook for the San Gabriel Mission in 1818. She eventually oversaw the entire production of the mission: her tasks included supervision of all food preparation; the cutting, sewing, and distribution of neophyte clothing; the wine pressing and olive crushing; and all the mission factories, including the leather works, which produced everything from shoes to saddles. Outside the mission, Eulalia "delivered supplies to the troops and Spanish-speaking servants. These consisted of beans, corn, lentils, candles, soap and lard."[53] Pérez embodied the experiences of working-class Californianas, and her rise to a supervisory level came through dedicated labor and individual skills, which the fathers of San Gabriel Mission rewarded by granting her full title to a parcel of mission land, the Rancho San Pasqual.[54]

Upon reaching sexual menarche and encouraged by the fathers to marry a fellow neophyte, Victoria Comicrabit married Pablo María of the neighboring Ytucubit ranchería. According to traditional San Gabrieleño marriage customs, Victoria and Pablo María, as kinsmen, would never have married. Before the Spanish invasion, traditions of exogamy and taboos against incest encouraged individuals to marry partners from neighboring villages. Since disrupting familial and household organization was one of the most effective steps in dismantling Native American resistance, the mission fathers routinely forced neophytes to marry those whom they, the fathers, deemed suitable. Marriage, however, did not remove Victoria or Pablo from service to the mission, and Victoria continued to assist Eulalia. In 1822, at the age of fifteen, she gave birth to her first child, Felipe. Three more children—José Dolores, María Ygnacia, and Carlitos—followed. As thoroughly Hispanicized neophytes, and with Eulalia's assistance, Victoria and Pablo María received their entitled *parajes* (plots of land), the Rancho Santa Anita and La Huerta del Cuati, from the San Gabriel fathers. Beyond the potential economic advantage that the land brought to the couple, in sociocultural terms these parajes symbolized their movement away from "heathenism" and closer to the "civilized" ranks of the gente de razón.[55]

The exact number of female neophyte landowners is uncertain, but J. N. Bowman has found that during the Mexican period only sixty-six women were granted legal rights to land that were subsequently upheld during the American period. Of these sixty-six, only three "Indian" women, as the Euro-Americans termed them, joined the rolls of landowners.[56] Like Victoria, the other two women were neophytes, indicating the importance of mission ties for certain individuals, but little is known of them beyond their legal petitions for land. As Pablo's wife, Victoria would have remained in historical obscurity, but after his death in 1835, widowhood and landownership mitigated the fathers' influence, and Victoria's decision to remarry was her own.

Her second husband, Hugo Reid, was born in Essex Milchin, Renfrew County, Scotland, in 1810. He went to Mexico during the mid-1820s where he and an associate, William Keith, established a trading house in Hermosillo, Sonora.[57] On an apparent whim, Hugo traveled to California in the summer of 1832 and became acquainted with the foreign traders residing in the Los Angeles area. In 1834, speculating that greater profits might be found in California, the two men, along with California trader Jacob P. Leese, who would later marry Rosalía Vallejo (see introduction), established a small *tienda* (store) selling sundry goods in the Los Angeles Plaza. Accused of abetting the Apalátegui Revolt—a short-lived Sonoran emigrant uprising—and alarmed by Leese's "incurably quarrelsome nature," Reid lost interest in California and left within the year.[58] When Hugo Reid met Victoria Comicrabit is unknown, but according to Dakin, news of Victoria's widowhood quickly brought Reid back to California, and they married in September 1836. Reid had struck upon the most convenient method of gaining land.[59] Victoria's land turned Reid into a ranchero. Soon after their marriage Reid purchased several more acres of land near the San Gabriel Mission, where he built a house for the family, naming the place "Uva Espina" (Gooseberry). From there, he managed the two other properties.

Genuine affection seems to have existed between Victoria and Hugo, as evidenced by Hugo's adoption of all four of Victoria's children. By acquiring Hugo's European surname, Victoria and her children continued their transition and fuller integration into the elite gente de razón class. Marriage to a European furthered the socioracial distance of Victoria's family from their Indian ethnicity and strengthened all the Reids' social ties with the gente de razón.

For Reid, the adoption of Victoria's children had another social benefit: as a parent, he could utilize the *compadrazgo* (godparenting) system. Formally a

symbolic religious relationship, compadrazgo was also a means of acquiring fictive kin through relationships of reciprocity. When parents invited certain individuals or couples to serve as godparents at the baptism of their child, they were simultaneously honoring them and requesting them to become their *comadre* and *compadre* (literally, comother and cofather). As coparents, called *padrinos* by the baptized child, the godparents were obliged not only to see that the child fulfilled all Catholic sacraments, but also to step in whenever the parents were unable to meet their parental duties. Socially and economically, visiting and gifting further strengthened the relationship between the adults as well as between the child and its godparents.

In general, compadrazgo exchanges in most Catholic countries occurred between couples of similar racial and socioeconomic backgrounds, but whenever possible, lower-class, lower-caste couples petitioned individuals of a higher social stratum to serve as godparents in an effort to reconfigure or level vertical or asymmetrical social relationships. Through compadrazgo, Reid strengthened and solidified his friendship and business dealings with Abel Stearns, the most successful foreign merchant in Los Angeles at the time. When Reid requested Stearns's presence at the confirmation of Victoria's youngest son, Carlitos, telling him that "my comadre is so slow about these things that I am obliged to use other measures to accelerate our compadrasgo," Reid was simultaneously trying to persuade Stearns to join him in the purchase of Rancho Alamitos.[60] The social intimacy and affinal alliances symbolized in compadrazgo were cultural traits quickly mimicked by the Euro-American immigrants, and one should not ignore how these two former Protestants enthusiastically recast their social personalities in Catholic terms.

Reid's correspondence clearly reveals that Victoria was an active partner in the maintenance and supervision of the two ranchos; indeed, because of Reid's bouts of illness, Victoria's supervisory training and experience were highly useful, if not essential, to managing the couple's properties. At various times throughout their marriage, chronic stomach pains completely debilitated Hugo. Writing to Stearns on June 29, 1841, that he was alone and bedridden while all the others were engaged in bringing in the wheat harvest, Reid tells how Victoria was overseeing the work. She had earlier sent word that it would take all of the following week to complete the harvest and had informed him that "it is hard because in some places they absolutely have to pick it by hand and I have told them not to waste any. Nevertheless there are more ways than one to kill a dog according to the proverb of those gentiles called English."[61]

While Reid supervised Rancho Santa Anita, Victoria managed the Huerta

del Cuati, or at least the vineyard, which by 1844 contained 22,730 grapevines with room to expand to 40,000, along with 430 various fruit trees.[62] In another letter to Stearns, Hugo writes, "Please let Jim [the Reids' majordomo] have the cuñeta [barrel] filled with Brandy—it perteneces [*sic*] to my wife's line of business—You and I will settle in the afternoon its price as it is a cash account."[63] When necessary, Victoria dealt directly with merchants, writing to Abel Stearns:

> My dear Sir, Having received your message through Don Mariano Roldan, requesting my sending the rest of the aguardiente [locally distilled brandy], panocha [brown sugar cakes shaped like cones] which I had taken a few days ago from your home. Of the said panocha it seems to me that it has been paid for; and of the aguardiente it is true that I said I wouls [*sic*] sell it for you but as I found myself unable to pay the servants: I took the said aguardiente, however if you are in such need of it; please send word with the driver; I myself will go to the city and give over the aguardiente.[64]

In all likelihood the aguardiente was used as payment for Indian labor at the Huerta and at Rancho Santa Anita. Like other rancheros, Victoria and Hugo exploited Indian labor, using alcohol both as payment and as a means of maintaining dependent relations with the workers. The Reids' use of alcohol is evident in the itemized account Hugo related to Abel Stearns concerning a certain Alejo, who in the two months he worked for the Reids purchased rum five separate times, twice "for the medical attendants of his wife."[65]

Given her exploitation of fellow San Gabrieleños, which reinforced the social inferiority of missionized Indians, how did Victoria negotiate her shifting racial identity? Her marriage to an obviously white man deepened the patina of her Hispanicization, but neither she nor her children could completely forget their racial origins. Victoria's "Indianness" caused people to remark on the uniqueness of this union. For example, in 1844 William Heath Davis noted how the Californians "seldom intermarried with the Indians; but they mixed with them to a certain extent; and in visiting the Missions, one would sometime see fine looking children belonging to the Indian women, the offspring of their association with California men."[66] After visiting the Reids and enjoying their hospitality, Heath was "surprised and delighted with the excellence and neatness of the housekeeping of the Indian wife, which could not have been excelled. The beds which were furnished us to sleep in were exquisitely neat, with coverlet of satin, the sheets and pillow cases trimmed with lace and highly ornamented."[67] Viewing Victoria as an exception to Indian femaleness, Davis

recognized and mentioned her wifely talents, but she remained nameless and shadowed by her relationship to Reid.

The most intimate personal account of Victoria and her racial dichotomy came from Laura Evertson King, whose article "Hugo Reid and His Indian Wife" was intended to defend Hugo Reid, who she felt had been unfavorably characterized as very eccentric in Thompson and West's *History of Los Angeles County*. "If my memory does not play me false," the then middle-aged Mrs. King wrote, "he was not eccentric, unless his marriage with an Indian woman could have been considered an eccentricity. He might have 'gone farther and fared worse,' as she was a noble woman in many respects, but being an Indian, her noblest characteristics were left to be discovered by those who loved her and who knew her best."[68] Clearly defining herself as someone who loved Victoria, King championed and described her in eloquent and respectful terms. She pointed out that Victoria was very conscious of the fact that "through" her, Hugo had "acquired his wealth, and through her he was enabled to write his essays on the life and customs of the Indians of the San Gabriel Valley."[69]

Laura Evertson King was a young child of perhaps eight or nine when she first met Victoria. Her family had moved from Virginia to California in 1849, settling near the San Gabriel Mission. Still grieving over the death of her daughter, María Ygnacia (see below), Victoria formed a strong emotional attachment to the little girl. Victoria expected "Lalita," her pet name for Laura, to visit every day, or "she would send her servant to see what kept me from her." Unlike Davis, Laura describes a simpler, more intimate household. Often spending time in the attic, where Hugo Reid's English books and periodicals were kept, Laura would descend to find Victoria seated on the ground, directing an Indian servant in the making of tortillas. While the meal was simple, Victoria was "dressed in a costly gown of black satin, with an embroidered shawl of crepe around her shapely shoulders, [and] daintily taking the broiled beef in her fingers, she would give me a lesson in Indian etiquette. Not all the dainty dishes of a king's banquet could equal the unforgotten flavor of that simple supper."[70]

Beyond having affection and regard for Victoria, King also contextualizes the woman's shifting identity. She notes that everyone called her "Doña Victoria," with the privileges and respect such a name should invoke, yet King could not completely erase Victoria's ethnicity. She could argue for Victoria's nobility, generosity, and good manners, legitimizing the title of "Doña," but no costly gown could completely cover Victoria's "Indianness." As long as Hugo Reid's social position remained intact, Victoria occupied a social space

that subsumed her ethnic identity. Hugo's economic opportunities may have rested on Victoria's contributions, but Victoria's social identity solidly rested on Hugo's.

Curiously, the identity of Victoria's daughter, María Ygnacia, reflected an even greater ethnic fiction and elasticity. While both Davis and King reduced Victoria to being a mere "Indian wife," Davis radically rewrote and transformed Ygnacia Reid's racial identity, going so far as to ascribe a fictitious paternity to her. He described her as "a beautiful girl of about eighteen, born some years before their marriage, of another English father. She was English in feature, with blue eyes and auburn hair, very luxuriant."[71] No mention was made of Ygnacia's brothers, even though Carlitos was still residing with the family in 1844. Unwilling to conjure up a blue-eyed Indian male, Davis conveniently omitted the brothers. For Davis and his contemporaries, acceptance of Ygnacia's conflicting and contradictory social presence had to undergo deep social and racial rationalizations.

Forced to interact socially with Ygnacia and Victoria, the Euro-Americans needed to create a psychological distance from the common, demeaned Indians in order to maintain their peace of mind. The Euro-Americans' dilemma was clearly one of race, and they failed to grasp the full complexities of the Spanish Borderlands caste system. The development of a caste system by its very nature denotes a racialized and racist society, but unlike the more rigid black-or-white (to state the obvious) Anglo American model of race, the Spanish colonial experience resulted in a more nuanced, complex social equation. Concepts of cualidad and *nobleza* (nobility) were mitigating factors in the social and legal principles granted to persons. In the California context, neophytes could elevate themselves to something closer to a Hispanicized person and receive degrees of social privilege. Californios were generally reluctant to grant this prestige, but the social mechanisms to achieve it were in place, and a few Native Americans managed to take advantage of these social dislocations. Considering Native Americans in general as racial inferiors, Euro-Americans could and did make some exceptions, as in the case of Victoria and María Ygnacia, but their ambivalence still seeped through.

More than any other members of the family, Felipe and Ygnacia benefited from Reid's patriarchal protection. The social doors of Californio society were fully opened to Ygnacia. Indeed, few barriers seemed to hinder her social activities, and a deep friendship between the Bandini and the Reid womenfolk was especially important. Ygnacia become a frequent visitor at the Bandini home and often accompanied the younger Bandini sisters to local social events.

Various accounts by American soldiers stationed in southern California during the Mexican-American War mentioned the loveliness of the Bandini sisters and of a certain "half-English, half Indian" young woman whose companionship was as greatly appreciated as that of her Spanish-Mexican friends.[72]

The depth of this affectionate bond was touchingly exposed when Ygnacia lay dying on May 30, 1849. A heartbroken and resigned Victoria requested her comadre, Arcadia Bandini de Stearns, to come as quickly as possible and to bring a coffin, because she feared that Ygnacia would not live until sunset. She also requested "six pounds of wax candles for the funeral, twelve yards of white satin, some colored ribbon that we can use, lace and any other thing that you think we may need, because María Ygnacia says that she wants you, comadre, to fix the coffin. She says that she wishes to wear her white net dress to the grave."[73] Had she survived, Ygnacia would undoubtedly have preferred to marry a Californio, as did her brother Felipe.

Felipe Reid's marriage to María de la Resurección Ontiveros, daughter of Juan Pacífico Ontiveros and Juana Marina Osuña, on August 18, 1843, was the most remarkable example of social acceptance for Victoria's children.[74] In the Spanish Borderlands, few Spanish-Mexican women married "full-blooded Indians," and the women who did generally belonged to the lower working class. According to surviving marriage records, only forty-four odd marriages occurred between Indians and Spanish-Mexicans between 1769 and the 1860s. Of these, only four involved an Indian male and a Spanish-Mexican woman—an 11 percent rate compared to the dominant pattern of Spanish-Mexican men marrying Indian women (an 89 percent rate). Fewer Spanish-Mexican men married Indian women during the nineteenth century: only nineteen marriages were recorded between 1800 and 1870, whereas twenty-five marriages were recorded between 1769 and 1800. The Ontiveros were a middling landholding family who had settled in the Los Angeles region in the first wave of Spanish settlement. María de la Resurección was the only female in her family to intermarry with a Native American; however, by 1843 Felipe was not strictly speaking an "Indian." Culturally Hispanicized, Spanish speaking, having received some formal education, and employed by William Hartnell in managing the family properties, Felipe looked and comported himself more in the manner of a Californio elite than a neophyte. How acceptable the son of Pablo María would have been to the Ontiveros is a matter of speculation, but clearly Victoria's children moved vertically within the community's social ranks rather than declining into the ranks of dispossessed neophytes.[75]

Lamentably, Ygnacia's death and the Reids' steady economic decline

heightened a growing estrangement between Hugo and Victoria. The Reids' matrimonial happiness paralleled Hugo's economic successes and failures. Wishing to become a successful trader and ranchero like his compadre Stearns, Hugo purchased and refitted the cargo ship *Esmeralda* for the China trade in October 1841. The venture failed, and when the *Esmeralda* redocked in San Pedro, Reid was accused of smuggling. Settling the smuggling charges and disposing of the cargo at a loss, he needed capital. This situation forced him to sell Rancho Santa Anita.[76]

After the *Esmeralda* fiasco, Reid hoped to tend to his ranchos; however, his election to the position of juez de paz for the pueblo of San Gabriel kept him away from his properties and his wife. Forced to handle civil disputes as well as attend to the secularization of the San Gabriel Mission, Hugo hired his friend Jim McKinley as majordomo in his absence. Being a juez de paz opened up some economic opportunities for Reid. His friendship and business dealings with Governor Pío Pico allowed Reid and William Workman to purchase all the former lands of the San Gabriel Mission on June 8, 1846. The economic potential of this tract temporarily bolstered Reid's economic hopes, but like many of the rancheros, he had dangerously overextended himself.

With the outbreak of the California Gold Rush, Reid also entered the mines, which further weakened his already compromised health. Realizing that selling goods to miners brought in easier profits and having commercial ties with other tradesmen, he and Jim McKinley opened a store. They soon abandoned the enterprise, because of both McKinley's lack of business acumen and Reid's election as a representative to the California Congressional Convention of 1850.

The years 1850 to 1852 were not only the low mark in the Reids' economic situation, but in their marriage as well. Forced to sell most of their land, by 1852 the Reids owned a mere 188 acres.[77] Writing of Hugo to Stearns in May 1851, Victoria stated, "We have not heard from him, and we are very much surprised that he has not written a single letter since he left."[78] A strong possibility exists that Hugo had temporarily abandoned Victoria. Ironically, it was during this absence from home and possible estrangement from his wife, his supposed informant, that Hugo Reid wrote his collection of essays, *The Indians of Los Angeles County.* Published as letters in twenty-four weekly installments in the *Los Angeles Star* in 1852, this collection of essays described the history, habits, beliefs, and language of the California Indians prior to European contact. According to Robert F. Heizer, Reid's essays were his attempt to position himself as an authority and possibly to gain the next appointment as an Indian

agent.[79] Victoria was obviously not the sole informant for Reid's essays; his contact and association with the San Gabriel Mission and its inhabitants had exposed him to Native San Gabrieleño society and customs. However, since it was common knowledge that Reid was married to an Indian woman, his legitimacy was unquestioned.

Mirroring the economic ebbs and tides of the times, Hugo's affection for Victoria definitely cooled toward the end of his life, and he expressed a growing bitterness toward marriage—specifically, marriage to an Indian woman. In a revealing document, Hugo Reid's socioracial conflicts are exposed. In an undated note entitled "Anecdote of a Lawyer," Hugo copied and kept the following:

> In a justice of the Peace Court on one occasion two lawyers were engaged
> on one side, one of them had recently been married to an Indian girl, the
> other had an American wife. The opposite side was defended by a young
> lawyer who was not married but lived with one Indian girl. The client
> of the first had been proven by his own lawyer to have been going to the
> Ranchería to sleep!—The American wife's lawyer "feeling" his superiority
> over all others, to the total disregard of the "feelings" of others—Made the
> following remark—Any man who would cohabit with an Indian places
> himself on the level of the brutes![80]

Why did Hugo copy and keep this account? Was it a needed reminder of how Euro-Americans viewed the men who cohabited with "Indian" women? All the advantages and privileges of being married to Victoria were crumbling by the 1850s.

Before the establishment of American hegemony, Spanish-Mexican sensibilities excused and accommodated the union of a white man and a neophyte woman. In the emerging and transforming world of Euro-American dominance, as Hugo Reid's note indicates, interethnic alliances were a fact of life but hardly acceptable to the Euro-Americans' racialized, prejudiced mind-set. With only Spanish-Mexican neighbors, the Reids' marriage was understandable and supported by the community, but with new Euro-American neighbors, the history and social forces that supported this particular union were swept aside and interest in this exceptional union diminished.

However, in an ironic twist, the story of Victoria and Hugo Reid was later immortalized in one of the most important California novels, *Ramona* (see chapter 3). It is significant to note here, however, that Helen Hunt Jackson's story entirely erases Victoria from her cast of characters. Like Ramona's Indian

mother, Victoria lost her status and identity as history and the American invasion overtook her society and her people.

As the ranks of the gente de razón were overrun by Euro-Americans, social interaction between the Reids and the Bandinis declined, and the concessions previously granted to Victoria fell by the wayside. After Hugo's death Victoria was assigned a conservator, Benjamin Davis Wilson, to oversee her and her properties, but he soon proved untrustworthy. In 1854 he produced a deed to the Huerta del Cuati, claiming to have paid eight thousand dollars to Victoria, who had signed the deed with a cross.[81] Victoria's signing with a cross rather than with her name, which she was more than capable of writing, strongly suggests that the document was fraudulent. In 1855 a court appointed Agustín Olvera as administrator for Victoria, "because the court considered her incompetent to arrange her own property."[82]

According to Laura King, shortly before her death Victoria made a point of seeking King out for one last time. The "Doña" who once wore black satin and expensive lace shawls was now "robed in common cotton cloth wrapped in a quilt attended by a single Indian servant."[83] On December 23, 1868, Victoria, the former Señora Reid, died like so many other California Native Americans, ignored and destitute. But she was never just a "mere Indian woman."

In 1833 Thomas Oliver Larkin married Rachel Hobson Holmes, the first Anglo American woman to settle in Mexican California. Within the chronicles of California history, few men have been more lionized than Thomas Oliver Larkin, who as the first U.S. consul in California acted as purveyor and advance scout to the American conquest. Indeed, of all the foreigners residing in California at that time, none was more patriotic or nationalistic, and historians uniformly portray Larkin as a superpatriot. They point to his unwillingness to give up his American citizenship, his rejection of Roman Catholicism, and his marriage to Rachel Hobson Holmes rather than to a Californiana. Overall, he apparently lived in Mexican California on American terms.[84] Rachel's race and nationality did play a significant role in the Larkins' marriage, and although both individuals were American, this couple was also caught up in racial and cultural negotiations as they settled in California.

Larkin traveled to California in the spring of 1831, following a failed business venture in Wilmington, North Carolina, that left him three thousand dollars in debt. In order to overcome his financial setback, he contemplated marriage to a wealthy woman as a means of reestablishing himself, preferably to a female cousin in Boston: "and its also a fact that I want to marry and settle near

home. This I cannot do without the Lady is rich." Throughout his stay in the South, Larkin's affections for and enjoyment of female company were a source of pride and entertainment for the young Bostonian. Even though he contemplated marriage to a wealthy woman, Larkin was not totally mercenary. In the same letter to his cousin, he wrote: "All love and no capital will never do for me. I could not live on it. Give me some of each and I'll try the married life. . . . If I could make a fortune by marriage, I will do it providing I can find on being acquainted with the lady any Small love for her."[85] Unable to find an adequate balance of love and money, the now twenty-nine-year-old Larkin accepted his half-brother's offer of employment in California. Engaged in the Boston-California trade since 1823, John B. R. Cooper also raised cattle, hunted sea otters, and ran a trading house in Monterey. He had converted to Catholicism and become a naturalized Mexican citizen, and in 1827 he married Encarnación Vallejo, a member of the prominent northern California Vallejo family.[86]

Booking passage on the *Newcastle* in 1832, Larkin met and became friends with a fellow passenger, Rachel Hobson Holmes of Ipswich, Massachusetts. The twenty-four-year-old woman was sailing to join her husband, John A. C. Holmes, a captain and merchant trader in Monterey. When the *Newcastle* arrived in Monterey on April 13, 1832, Rachel discovered that her husband had sailed for the Sandwich Islands without arranging accommodations for his wife or making any other provisions for her. When John B. R. Cooper and his wife invited her to stay at their home, she accepted. Having traveled together and now sharing the same roof, Larkin and Rachel allowed their friendship to turn into a sexual relationship; on January 31, 1833, Rachel gave birth to Larkin's daughter, Isabel Ana, in Santa Barbara.[87] She was unaware that her husband had died on March 8 of the previous year and that she was a widow, so her pregnancy clearly placed her in a precarious position. Awaiting her husband and anticipating all the possible outcomes from physical violence to abandonment, Rachel was also isolated from her lover, as evidenced by her having the child in Santa Barbara. John Holmes's death made Rachel's infidelity a moot point, but it also made her relationship with Larkin more complex rather than simplifying the situation. According to historians Harlan Hague and David J. Langum, Rachel must have received news of her husband's death by October 1832, yet Larkin did not immediately propose marriage. Why?

Given Larkin's marital intentions and his need of a wife who could provide him with some economic advantages, his entrepreneurial desires could only be satisfied by a woman who could contribute at least three thousand dollars

to the marriage. Prior to his California venture, Larkin, voicing the prevalent racial prejudices of his compatriots, had "detested and despised" the Mexicans, but economic necessity forced him to reconcile these prejudices. He stated: "I am too old to stand on trifles that shall or should prevent my making myself independent. If I go to Monterey I shall do as the people do, if that will help me." [88] His beloved nationality and religion were cloaks that he would regret shedding, but potential wealth and stability were sufficient redress for his disappointment. The availability of eligible California women initially threatened Rachel's social status, not the other way around.

A few foreign merchants did transport their wives to California, but this did not necessarily assure them a more stable existence. In the early 1840s Captain Stevens, the New England master of the *Leonidas* and the *Bolivar,* brought his wife to California. Mrs. Stevens was visited and mentioned in several foreigners' accounts, indicating her initial acceptance into the foreigners' company. However, by January 18, 1846, she was wearing out her welcome. Larkin complained that "Mrs. Stevens has at last concluded again not to go home." [89] At the time her husband was building a canoe to hunt otters, and clearly Mrs. Stevens no longer wished to remain by her husband's side, nor did her husband make any effort to keep her in California. On January 26, 1846, John Coffin Jones wrote to Thomas Larkin, telling him "that Mrs. Stephens [*sic*] is now on board the *Admitence* [*sic*], and we sail this afternoon for Boston. She has assured me that you very generously offerd to pay half her passage money." [90] Neither man commented on why a man other than her husband paid her fare or why Mrs. Stevens was now considered a liability to her husband and the foreigners' community. Like Rachel Holmes, Mrs. Stevens's racial identity did not guarantee her economic and social stability.

Before committing himself to Rachel, Larkin weighed his marital options, because all around him were numerous examples of the advantages of marrying a daughter of the land. In fact his half-brother was a prime example of what allegiance to a Californiana could yield. By 1829 John Cooper and his wife, Encarnación Vallejo, owned two ranchos near Monterey, and Cooper was the most prominent trader in northern California. Moreover, Larkin's horizons were not limited to California. Prior to 1848, sexual competition for elite Californianas came not from Euro-American women but from South American women, because some traders and merchants opted to marry into wealthy and influential business families in Peru and Chile.

Rachel's racial identity was a consideration, but it did not assure her a superior sexual or social position. Larkin finally proposed marriage when

Holmes's financial affairs were settled and Rachel was named sole heir to a small fortune. While the exact amount is unclear, Hague and Langum estimate Rachel's inheritance at between three thousand and four thousand dollars. Marriage to Rachel now assured Larkin of a substantial sum—the stake necessary to carry out his dreams of economic entrepreneurship—without giving up his nationality or religion. It was Rachel's inheritance that funded the construction of Larkin House and enabled Larkin to open his own Monterey trading house.[91]

In the end one can only wonder what fate would have awaited Rachel Hobson Holmes and her child had Larkin found a wealthier Californiana to satisfy his economic needs. How would this "superpatriot" have fared in California history had Rachel remained married or not inherited a small fortune? Their first child's illegitimate birth failed to diminish the respectability of the Larkins, and they went on to raise eight children. Their firstborn, Isabel Ana, however, did not survive infancy and was buried in Monterey on July 9, 1833.[92]

By 1840 intermarriages along the California coast were an accepted feature of the social landscape for the communities' ethnic groups. Exchanging mercantile connections with the landholding rights of Californianas made marriage a viable social language in which Spanish-Mexican, Indian, and Euro-American parties successfully traded desired cultural capital. Had Bancroft truly understood the complex colonial policies that fostered these unions, he might have written that it was a happy day for the Californiana bride whose husband was American, just as it was a happy day for the Euro-American husband whose wife was Californiana.

The colonial policies that had attempted to forge social alliances and control over Native Americans were unwittingly providing an opening for another invading group to adhere itself and influence the local elites. After 1848 the Euro-Americans' need to justify these unions reified their persistent racial and sexual ideologies, projecting the idea that "Anglo-Saxon" males were "forced," because of the lack of "white" women, into accepting these marginal women. Accepting the racial delusions and self-defining racial categories that legitimized their control over the Native American population, Californios and Euro-Americans perpetuated the racial ideologies that elevated particular women over the lowest stratum of their society, the Native American women. However, as the union of Victoria Bartolomea Comicrabit and Hugo Reid indicates, important fissures in colonial policies allowed certain individuals to escape through the cultural cracks.

By the early 1840s the perception that Californianas preferred foreigners was becoming an integral part of Euro-American narratives. According to William Dane Phelps, Californianas preferred "having foreigners for husbands to their own countrymen, as they are treated with more kindness by the former, and are enabled to live easier. The Californians not only abuse their women . . . but compel them to do the hardest drudgery. But with the foreign husband, their labour is light, and they have much leisure time to waste in their beloved inaction, or in the amusements of the country."[93]

Comments such as these cemented the image of those Californianas married to Euro-Americans as leading carefree, indolent, luxurious lives at the side of their indulgent, all-loving Euro-American husbands. As this chapter has indicated, the lives of Californianas who married foreigners were hardly the carefree and laborless existence that the later popular imagination projected and that historians have uncritically accepted. The husbands' well-being was often predicated on the labor and interventions of their spouses, as the case of Teresa de la Guerra indicates.

While the unions of Teresa de la Guerra y Noriega and William E. P. Hartnell, Victoria Bartolomea Comicrabit and Hugo Reid, and Rachel Hobson Holmes and Thomas O. Larkin do not tell the complete story of the conflicts and contestations that were occurring as these groups joined, they do point to the need to reinterpret, or at least to be more sensitive to the ethnic, economic, and gendered issues involved in intermarriage. Marriage was perhaps the easiest method for foreigners to integrate themselves into Californio society, but there were stages and transforming conditions that influenced how the participants interpreted and gave meaning to the processes and experiences surrounding their intermarriages.

CHAPTER 3

⚛

Marriage and the
Myth of Romantic California

*I*N HIS PROVOCATIVE WORK *COLONIAL DESIRE,* Robert J. C. Young posits that in order to understand the heart of Victorian racial theory, and by extension those theories of the twentieth century, one has to understand that English racial theory ostensibly sought to keep races forever apart, transmuting into expressions of the clandestine, furtive forms of what can be called "colonial desire: a covert but persistent obsession with transgressive, inter-racial sex, hybridity and miscegenation."[1] Unions between "white" and "dark" peoples were universally categorized as unnatural, yet Young notes that a constant theme in late nineteenth-century English scientific and popular literature centered on miscegenation.[2] As the British and Anglo Americans encountered "the Other," they developed the colonial space where double in-scriptions define identity.[3] "The desire for the Other," according to Hommi Bhabha, "is doubled by the desire in language, which *splits the difference* between Self and Other so that both positions are partial; neither is sufficient unto itself."[4] This doubling of identity is part of being a colonized subject, and for none was this condition more paramount than for indigenous women married to colonizers.

One of the most interesting aspects of nineteenth-century intermarriage in California is the way in which Euro-American colonialism as a machine of desire did not produce "its own darkest fantasy" by categorizing all interethnic unions as "unnatural" and undesirable.[5] Indeed, California may be the only region of the Spanish Borderlands where Euro-Americans accommodated the explanation of these unions into what Bhabha calls "the metonymy of presence," whose core component rests on the nature of colonial desire and the figure of the double. He reminds us that it was Frantz Fanon in *Black Skin, White Masks*

who first dealt with "the doubling of identity" and with how identification in colonial settings is never "a finished product; it is only ever the problematic process of access to an image of totality."[6]

This chapter discusses how desire, both personal and collective, played a role in the colonizing discourse and the development of racialized processes within California society. It is largely through aspects of desire that Euro-Americans maintained an interest in these particular unions and subsequently developed the image of "romantic California." Californianas supposedly desired to marry "white" men, "white" men desired access to land, and the United States desired to portray the invasion of California as largely untraumatic for the invaded peoples. Intermarriage accommodated all these impulses and gave rise to a literature and to social attitudes that "mummified" the perception of Spanish-Mexican women as basically having only two dichotomous natures. In terms of gender, the interpretations basically broke down between "Mexican" and "Spanish" women. "Mexican" women were lower-class, racially mixed women of supposedly questionable morals and virtues whose perceived sexual availability made them an object of disdain for respectable Euro-Americans. "Spanish" women, on the other hand, were lighter skinned, thus perceived as racially superior, or in the words of Bhabha, they were "almost the same but not white," making their inscription more problematic but crucial in explaining the acceptability of certain interethnic unions. "Spanish" women as inherently "white" were everything that "Mexican" women supposedly were not: racially of pure Spanish decent, protected by a patriarchal family whose honor was beyond reproach, and endowed with personal virtue and sexual chastity beyond question. Even in the nineteenth century some Euro-Americans questioned this fiction, but throughout the Spanish Borderlands certain women were described in a form of colonial discourse that was "at the crossroads of what is known and permissible and that which though known must be kept concealed; a discourse uttered between the lines and as such must be kept concealed."[7] This chapter examines how two specific California episodes were culturally mined to create the stereotypical images of romantic interethnic unions so beloved in late nineteenth- and twentieth-century popular culture.

In California successful intermarriages became false symbols of peaceful invasion and control by the United States, because the conquerors chose to sublimate the desires of certain women who actively chose to marry foreigners. These women's actions reinforced white Euro-Americans' cultural fantasies that racially "inferior" peoples would accept and gravitate to the newcomers' "superior" presence and control. It is not surprising, therefore, that California

was the only region where a "romantic" tradition of storytelling and literature emerged. In other Borderland regions, such as New Mexico, no notable women were lionized for their roles in interethnic marriages as the Californianas were. Indeed, the most noted New Mexican woman, according to Euro-American accounts, was Gertrudis Barceló. These accounts, however, "fabricated some details, omitted others, and exaggerated local customs. They criticized Barceló and embellished images of her with portraits of other women to argue that Santa Fe's women were worthless."[8] Barceló, commonly referred to as "Las Tules" by the Euro-Americans, was many things, but foremost she was a businesswoman whose multifaceted establishment provided gambling and trade opportunities for Euro-Americans in the early nineteenth century. It is interesting that in both Texas and New Mexico the rate of intermarriage in the nineteenth century represented between 9 and 10 percent of the total marriages performed, so, as in California, the phenomenon of intermarriage was persistent. However, these regions never developed a "romantic tradition" to justify intermarriage.[9]

In 1806 Nikolai Petrovich Rezanov, the Russian ambassador and an official of the Russian-American Fur Company, arrived in Monterey to initiate trade with the Californios. He had sailed from Sitka, Alaska, where Russian colonists faced possible starvation if provisions were not secured.[10] Trade proved difficult, given the mercantilist and imperial concerns of the Spanish crown. Although individual mission fathers favored trade, the crown's prohibition of trade with foreigners forced the Californios to deny Rezanov's repeated requests for the needed goods.[11]

Rezanov begged for supplies from all segments of Californio society, but both secular and ecclesiastical subordinates reluctantly adhered to Governor José Joaquín de Arrillaga's stern refusal. Exhausting all possible avenues and facing the unimaginable possibility of returning to Sitka just to watch more of his people die, Rezanov grasped at the last possible solution to his problem: he proposed marriage to fifteen-year-old Concepción Argüello, daughter of Don José Argüello, commandant of the San Francisco presidio. The Argüellos had been gracious hosts to Rezanov throughout his extended stay, and Rezanov had noted the strong friendship between the governor and Don Argüello. Arriving with his wife in Alta California in 1781, Don Argüello had steadily risen from the rank of corporal to become the comandante of the San Francisco presidio. By 1797 Argüello had obtained the Pilar tract of land near San Francisco and was engaged in stock raising in order to provide for his growing family.[12]

Rezanov's bold proposal, coming from a foreigner and official of an imperial rival, opened up for him a social avenue beyond the exhausted diplomatic and economic avenues. By reverting to older social and cultural customs, a marriage alliance provided an acceptable conduit by which both parties could conveniently maintain that they had drawn closer together and diminished the potential economic and military rivalry. By positioning himself as a potential son-in-law, temporarily cloaking his "foreignness" or at least mitigating it, Rezanov calculated that Argüello's social and political influence could induce the Spanish authorities to acquiesce to his petitions.

Rezanov made it clear to his superiors that desperation rather than romance or personal affection had forced his decision. "My romance began not in hot passion," he wrote when he explained his course of action to the Russian court, "which has no place at my age, but from entirely different motives and perhaps also under the influence of remnants of feelings that in the past were the source of happiness in my life. Considering the circumstances, remoteness, and my duties I acted carefully and made the beginning subject to conditions."[13] Being thirty-five years older than his intended bride, Rezanov nevertheless felt that he had "sacrificed himself" in order to "bind in friendly alliance both Spain and Russia."[14]

Historical accounts have suggested that Concepción quickly and happily accepted marriage to Rezanov; after all, "[w]hat wonder that court life at St. Petersburg was fascinating, or that this child, weary of the sun-basking indolence of those about her, allowed her heart to follow her ambition."[15] Rezanov's personal account confirms the assertions that Concepción was highly anxious to escape the remote Spanish outpost. Obviously, Rezanov was spinning tales of St. Petersburg and not of Sitka, and by "courting every day the Spanish beauty, I noticed her venturesome disposition and the unlimited ambition which, at the age of fifteen, made her, alone among her family dissatisfied with the land of her birth . . . and finally I imperceptibly induced in her impatience to hear from me something more serious, to such a point that as soon as I offered her my hand I received consent."[16] Although Concepción was an active and determined participant in the courtship and betrothal, the proposal "shocked her parents, raised in fanaticism—the difference in religion and the future separation from their daughter were like a thunder clap to them. . . . Her parents took poor Concepción to church, made her confess, persuaded her to refuse me, but finally her determination calmed every one down."[17]

Faced with the couple's steadfastness and specifically with their daughter's determination to wed, the Argüello family reluctantly granted permission.

However, Rezanov's Russian Orthodoxy alarmed local Roman Catholic authorities, who promised to perform the ceremony only after Rezanov agreed to petition both the Vatican and his czar for permission to wed Concepción. Allowed to resupply his ship through mission trade, Rezanov promptly set sail for Sitka on May 21, 1806. Delayed there for a few months, he then returned to Russia via Mexico and Vera Cruz. But he never completed his journey, dying in Russia before he reached St. Petersburg and the Russian court.

Five years passed before news of Rezanov's death reached Concepción, who had patiently and faithfully awaited his return. According to both historical and romantic accounts, the mere memory of her first love kept Concepción from ever marrying; thereafter, she dedicated her life to charity work and ministering to the sick and infirm. Earning the nickname "La Beata" (the pious one), in 1852 she became the first nun initiated into the newly established Dominican convent in Monterey.[18] In 1899 Bret Harte immortalized her romance in his poem "Concepción de Argüello," but in this account she waited not a mere five years but forty. Furthermore, the climatic moment in the poem comes when Sir George Simpson visits California and at a banquet innocently asks if Rezanov's sweetheart, whom he assumes has since married, is still alive. The crowd goes silent, knowing that Concepción sits among them. Simpson asks the question again, and the physically fragile Concepción answers, "Señor, pardon, she died too!"[19] This romance became the first example of an elite Californiana selecting a "white" man as the perceived means to a better future for herself, and it lays the foundation for the popular vision of "romantic California."

Most scholars have focused on Rezanov's pragmatic objectives in promoting the betrothal, but what were Concepción's motivations and desires? Rather than being a mere object of mediation, Concepción actively sought a foreigner as a mate; therefore, she too was using marriage as a site of personal negotiation and mobility, literally both physical and social.[20] Concepción realized that for her, remaining in California meant marriage to a soldier, or at best to a low-ranking officer, thereby repeating her mother's fate of following her husband from military post to military post. According to Rezanov's account, Concepción initiated and pressured him into considering marriage; after all, he "finally" recognized her "impatience to hear from me something more serious." Marriage to Rezanov suited Concepción's personal desire to leave California.[21] Nor was she the only elite woman who manipulated her circumstances and contrived to escape the hardships of early Californio society.

While Concepción saw marriage as the means to a more comfortable life, Eulalia Callis made a tremendous effort to end her marriage and avoid

living in Alta California. Married to the governor of California, Pedro Fages, Eulalia Callis initiated divorce proceedings in Monterrey, Mexico, in 1783 but nevertheless joined her husband in San Francisco in January 1784. Within the year she gave birth to a daughter, but the marriage was still troubled. In February 1785 Eulalia accused her husband of infidelity with Indizuela, their eleven-year-old Yuma servant, and soon afterward she petitioned the local priests for a legal separation, making it public that she refused to share a bed with her husband. The public scandal escalated when she refused the counsel of the local priests to disavow her accusations and reconcile with her estranged husband. The priests then had her arrested and threatened to shackle, flog, and excommunicate her, but she still resisted reconciliation. Held incommunicado for several months in the San Carlos Mission, she finally agreed—or was pressured—into reconciliation. A month after reuniting with her husband, Eulalia Callis petitioned the *audiencia* (the royal tribunal in Mexico City) to transfer her husband back to Mexico. Fages still wished to remain in California, but in 1790 he requested to be relieved of his office. Eulalia left California after five years of sustained domestic and public struggles. As Antonia Castañeda points out, historians referred to Eulalia Callis as the "notorious *governadora*" and wrote about Fages's "domestic problems" with barely suppressed amusement at his inability to control this "fiery, tempestuous Catalan woman."[22]

Concepción's and Eulalia's actions demonstrate the lengths to which some Californianas were willing to go to escape the harsh conditions of nineteenth-century frontier society. As elite women, they both utilized whatever means were at their disposal to attain personal fulfillment.

Because Concepción ultimately chose to become a nun, scholars reinforced the impression that she refused to engage in any future romantic entanglements, choosing instead a sheltered and sequestered life. The reality is that throughout her life, Concepción exerted an individualism, agency, and self-awareness that were perhaps initiated by her failed romance, and her continued autonomy throughout her life indicates how thoroughly rebellious and subversive an existence she chose to lead.

Moreover, very pragmatic and unromantic factors kept Concepción from marrying another man. Under the Catholic rules that controlled proper marriage rituals and practices, Concepción was "forced" to remain single until informed of Rezanov's death; indeed, she was honor bound not to accept any other proposal. The strict religious orthodoxy governing the events and rituals of marriage throughout the Borderlands demanded that formal marriage procedures adhere to a prescribed sequence of events. First, a suitor had to

petition the intended's father, preferably in writing, for the privilege of courting his daughter. If the father and daughter found the man acceptable, the two families arranged the marriage. Once marriage was agreed upon, a *diligencia matrimonial* (matrimonial investigation) conducted by the parish priest was ordered to ensure "that no canonic impediments to the union existed."[23] The investigation mainly consisted of asking the couple six pertinent questions: Were they Christian, Catholic, Apostolic, Roman? Were they marrying of their own volition? What was their state—single, married, or widowed? Had they contracted matrimony or given promises to another suitor? Were they related to the betrothed? Did they know of any impediment to prohibit the celebration of this matrimony?[24] The couple was accompanied by three witnesses, preferably members of the parish and well known to the couple, the priest, and the community, who verified the couple's answers. Once the investigation ended satisfactorily, the priest read the banns in church for three consecutive Sundays and, if no impediments were discovered and no individual protested or challenged the validity of the marriage, the ceremony was performed. Even though the ideal and preferred sequence was not always strictly followed in the Borderlands, most of the inhabitants were familiar with the formal expectations and complied to the best of their abilities and means. Had Concepción accepted another marriage proposal before learning of Rezanov's death, her status as an already betrothed woman would have been revealed, ending the possibility of marriage.

Free to choose another mate after learning of Rezanov's death, and being then only twenty years old and thus young enough to bear children, why did Concepción refuse to marry at all? A potential union to a soldier or presidial officer should not have been difficult to arrange, and as a member of the military elite Concepción was favored by the marriage market. But five years had dramatically changed what she desired. Religion became increasingly important to her; indeed, her entire family was noted for its religiosity. Still, Concepción was not completely sheltered from society or from male companionship. By 1816 Captain James Smith Wilcox, a Bostonian, was openly courting her.[25] Neither declining nor accepting his offers, Concepción allowed the courtship to go on for two years, until Wilcox's incessant attentions became socially unacceptable to her. Concerned that "everywhere people believe something that isn't true, which disturbs me inexpressibly," Concepción wrote to José Comondú, governor of Baja California, to clear up any misconceptions. Wilcox had made public declarations of his willingness to convert to Catholicism in order to marry, a situation that finally forced her to refuse his proposal.[26]

Since marriage to Wilcox might have provided an escape from California, it seems that by 1818 Concepción no longer wished to leave the land of her birth. Displeased with her refusal, Wilcox solicited the governor of Alta California, Pablo Solá, for assistance. Concepción explained that she had entertained the possibility of marriage in order "to save his soul; but the Lord God freed [her] from this foolish scruple, and replied that she [Concepción] was not needed for the change of religion if his conversion was sincere." [27] Within ten years, Concepción had not only changed her mind about marriage; by 1816 she was also living the most independent existence imaginable for a single Californiana. In 1815 her father had been ordered to take command of a presidio in Baja California. Four of Concepción's siblings had already married and left Alta California, but Concepción chose both to remain single and to spend the rest of her life there.

After refusing Wilcox, Concepción's correspondence gives no evidence of her interest in marrying either a foreigner or a Californio; instead, she retreated further into her semireligious life and engaged in charity work. Clearly, Concepción's personal actions, convictions, desires, and downright willfulness in both courtships indicate that although social and patriarchal pressures were great, certain women could negotiate an escape from the prescribed sexual roles of wife and mother.

By the 1810s the gender ratio in California was still uneven, but the pressure to marry was easing, and children were exerting more autonomy in their selection of mates. Class heavily influenced their choices. For example, in 1800 the governor of New Spain shipped a number of families and twenty orphans—ten males and ten females—to California to aid in settling the new colony. Among them was four-year-old Apolinaria Lorenzana, accompanying her young widowed mother. The ten female orphans were explicitly sent as future brides for soldiers and were placed "like so many puppies" into Spanish-Mexican households throughout California. All the female orphans eventually married and remained in California except for Apolinaria, who was placed with the family of Raymundo Carrillo in San Diego after her mother married a soldier and followed him back to Mexico when he was restationed. [28] As a child and a teenager, Apolinaria was transferred between various families before eventually being recruited as a nurse by Frey José Sánchez of the San Diego Mission. For the rest of her life she labored within the mission in a variety of roles, much like Eulalia Pérez, and she never married, although she did receive a marriage proposal when she was a young woman. In her narración, Apolinaria remarked that "even though she understood the merits of such a

holy institution," she was never inclined to the call of matrimony and refused the offer.[29]

Apolinaria's decision not to marry raises some interesting gendered questions about women's autonomy. The lack of marriageable Spanish-Mexican women in California obviously meant that Apolinaria *chose* not to marry and, simultaneously, that no individual had sufficient influence to coerce her into such a union. This is in direct contrast to Eulalia Pérez, who contended that the determined Frey Sánchez of the San Gabriel Mission convinced her to marry Juan Mariné. She only assented to this marriage because "I didn't have the will to deny Father Sánchez who had been mother and father to me and my family."[30] The same Father Sánchez likely pressured one woman and not the other because Pérez already had biological children from her first marriage. Under Catholic and colonial marriage ideologies, this prescribed that she reestablish a household. Perhaps Apolinaria had religious predilections or else she used religion to justify her desire to remain single, but Pérez's sexual past and her ability to have children probably strengthened the father's position on proper gender relationships for widows. Even in the face of tremendous pressures to procreate and replicate European families, some women still negotiated more individualistic choices; indeed, some sexually uninitiated single women were able to opt out of marriage entirely by choosing to enter another "holy institution."

In choosing to remain unmarried, Concepción and Apolinaria accepted a life of labor and great economic uncertainty. Following the dominant pattern of unmarried and widowed women throughout the Southwest both in pre- and postconquest California, both women "lived and worked with relatives, sons or daughters, married or unmarried. Frequently, [they] adopted children or cared for children other than [their] own. These circumstances identify the extent of [their] incorporation and leadership in family and community life."[31] During most of her adult life, Concepción lived outside her parents' home, residing for long periods of time with the family of José de la Guerra and then in the home of Doña Josefa Boronda de Burke.[32] How Concepción fit into or contributed to these household economies remains uncertain, but her public labors of instructing Indians and Californios on religion, tending to the sick, leading choral instruction, and serving as a midwife to Indians and Californianas alike continued while—and perhaps only because—she was supported by these families.[33] Without this highly personal and supportive social network, her work within the community and, more important, her personal freedom would have ceased. When Concepción entered the Dominican order, the economic

burden for these families eased and Concepción was assured of adequate support through her old age.

This was not the case for Apolinaria Lorenzana. Like Concepción, Apolinaria spent her adult life laboring for others, and her livelihood was always dependent on her work and the social network she actively cultivated. Whenever her mission duties allowed it, she taught her various *ahijadas* (goddaughters) how to read, pray, and perform various household duties. Throughout her life at the mission, she "always cared for some little girls, many who were her own goddaughters. She had, in her charge, raising since she was two or three years old, a little girl, whose mother was [her] goddaughter from baptism and marriage."[34] In her testimonio, Apolinaria claimed to have served as comadre for between one and two hundred children, both Indian and gente de razón, both rich and poor.[35] Apolinaria's pride in being a valued and esteemed member of her community was evident in her pointing to the vast number of parents who wished to establish reciprocal relationships with her by inviting her to serve as a godmother to their children. The personal accomplishments of which she was proud also included the way in which she learned to write: "I taught myself to write, relying—in order to do so & on whatever books I saw. I copied the letters on whatever paper I was able to get a hold of such as empty packets of cigars or whatever blank piece of paper I found that had been thrown away." Her relationship to multiple generations of her neighbors, and specifically to females, indicates the length of service and high regard that Apolinaria managed to earn through her personal strength and character.

But unlike Concepción, who as a member of the elite maintained a relatively comfortable standard of living throughout her life, Apolinaria's social network declined as she aged, indicating the importance of class in Californio society. Thomas Savage describes her in 1878 as "a good old soul, cheerful and resigned to her sad fate, for in her old age and stone blind, she is a charge on the county and on her friends, having by some means or other lost all her property."[36]

In 1847 Apolinaria had owned three ranchos, having purchased Rancho Capistrano de Secuá from a compadre, Juan López, and receiving two others, Rancho Santa Clara de Jamachá and Rancho Buena Esperanza de los Coches, from the government in recognition of her many years of service to the community. After the Americans invaded and through the duplicity of John Forster, who was overseeing Rancho Jamachá, Apolinaria lost one rancho after the other. Radically contradicting Savage's implication and misinterpretation that she cheerfully accepted the loss of her lands and was resigned to her fate as a charge of the county, Apolinaria stated: "It's a long history, and I don't even

want to talk about it. They took away both ranchos from me one way or the other—That's why after so many years of working, after possessing goods, of which I never desired to be dispossessed of through sell [*sic*] or any other means, I find myself in great poverty, living on the favor of God and of those who give me a mouthful to eat."[37] Throughout her narrative, Apolinaria's definition of self was fundamentally based on the services she had performed for others and on how valuable she was to her various communities.[38]

Had Apolinaria married, her life might have resembled that of María de Jesús Valeriana Lorenzana, another of the Mexican *niñas de cuna* (foundlings). María married Deciderio Ibarra on September 20, 1807, in the San Diego presidio, and she ultimately gave birth to twelve children, three of whom died in childhood. In his will Deciderio named María and their three oldest sons as executors of his estate and itemized the family's wealth: a vineyard "consisting of 1800 vine stocks; a house in this city constructed of adobe, which has 8 living rooms and its respective furniture." The family did not, however, own a rancho. They apparently had access to some land, since Deciderio divided "four herds consisting of forty mares more or less" between his sons, along with a number of cows and oxen, but the family's principal livelihood must have been derived from some form of trade. Included in Deciderio's will was a list of fifty-four individuals who owed him money and goods.[39] Declaring that he owed no debts, Deciderio stated that the total of money and goods due to him consisted of four hundred and ninety-one pesos and fifty-seven and a half reales, which "upon receipt of such debts, they shall be added to my estate, and are to remain at my wife's disposal to be properly divided."[40] This amount of personal wealth may not have placed the Ibarras within the elite class, but marriage and children, particularly male children, did give María Valeriana greater social stability in her advanced years than Apolinaria Lorenzana had.

Joaquina Machado, who died on October 29, 1848, single and leaving behind an illegitimate daughter, had also chosen not to marry. Joaquina's sexual misconduct may have damaged her social standing, but it had little effect on her economic well-being. Her will listed numerous items of clothing and several pieces of gold jewelry, along with numerous household furniture items and a "house of four rooms and a hall, made of lumber, with doors and windows, and panes of windows." She also owned an orchard and declared herself to have an "interest and own one-half of the dwelling house of my mother, and to be the owner of a piece of land which my mother gave me and which has a vineyard thereon." Her will does not mention the child's father. Genealogical records indicate that Joaquina's background was stereotypical

of second-generation Californios. All her grandparents were born in northern Mexico, and both grandfathers were soldiers. Her mother was born in San Diego and her father in Santa Barbara. She was racially Spanish-Mexican. The abundance of material goods listed in her will indicates that Joaquina was of the middling class. In all likelihood she was able to maintain her independence and material comfort through the sale of distilled liquor, since her will included "a large still, a four-barrel vat and three empty barrels."[41]

While women like Apolinaria Lorenzana, María Valeriana Lorenzana, and Joaquina Machado labored in relative obscurity, Concepción Argüello's failed romance and its subsequent social notoriety gave her specific cultural capital in her own lifetime, as she became a celebrity of sorts, boosting her sense of self. By the time Sir George Simpson visited California in 1841–42, he had read Alexander Forbes's history of California, which described the Rezanov-Argüello romance.[42] He made a point of seeking out and meeting this "lady of some historical celebrity," but he was disappointed by the actual person. Concepción, on the other hand, was acutely conscious that she was the object of attention and interest for people beyond the borders of California.[43] Through Bancroft's and other travel narratives, certain Californianas became noted figures both in their own time and in later years.

Californio society emerged from its initial colonial setting a more racially, socially, and sexually stratified and hierarchical community. However, during the 1830s and 1840s the local patriarchies constantly confronted a series of social crises, sometimes because of the new Mexican national government's actions but often because of local conditions that threatened their political and patriarchal authority. In numerous historical narratives, Californios lament the noticeable decline in morals throughout their communities during these two decades. They cite the lack of honorable and talented leaders, the racially inferior quality of recent Mexican immigrants, the disrespectful behavior of U.S. travelers, and the loss of social cohesiveness. For Bancroft, one of the main causes of the moral decline in these decades "was owing to the more extended intercourse with foreigners, who were not all of good character; to the greater facility of acquiring means, and to political disturbances—these latter in particular opening the door to evil customs which were disseminated amongst the men."[44]

Californios after the Mexican-American War also spoke disapprovingly of their womenfolk's inappropriate public behavior. Male censure was particularly acute when women contested marriage as an institution. Because the political

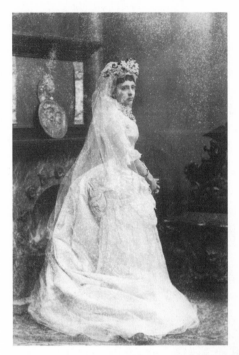

Josefa del Valle Forster. Josefa's husband, John Forster Jr., was the son of John Forster and María Isidora Ygnacia Pico. Reproduced by permission of The Huntington Library, San Marino, California.

Cave Johnson Couts and family. Note that Isidora Bandini Couts is obviously missing from the photo. Reproduced by permission of The Huntington Library, San Marino, California.

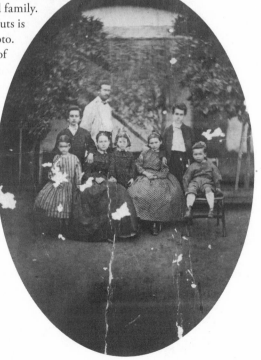

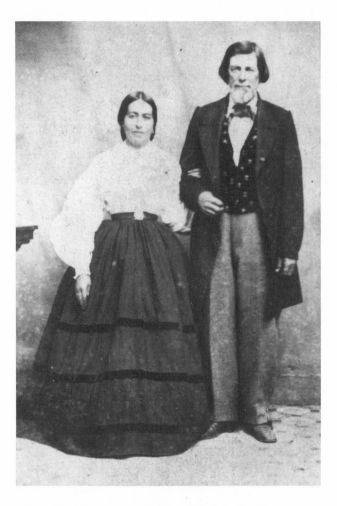

James Paul Thompson and Manuelita de la Osa Thompson.
The daughter of José Vicente de la Osa and María Rita
Guillen, Manuelita was also the granddaughter of Eulalia
Pérez. All the surviving de la Osa daughters married
foreigners. Reproduced by permission of The Huntington
Library, San Marino, California.

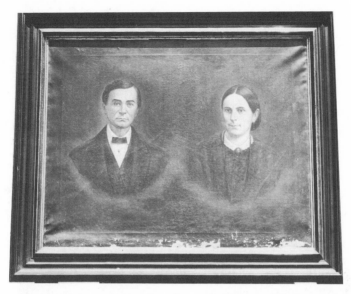

Portrait of Francis Pliny Fisk Temple and Antonia Margarita Workman. Antonia was the daughter of Julian William Workman and Nicolasa Urioste. Reproduced by permission of The Huntington Library, San Marino, California.

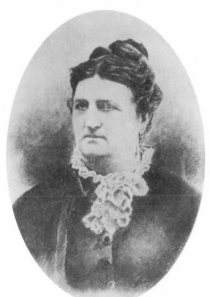

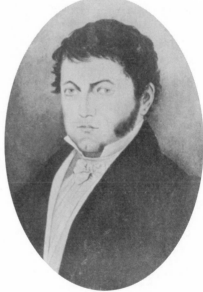

Josefa Carrillo Fitch (Mrs. Henry Delano Fitch). Reproduced by permission of The Huntington Library, San Marino, California.

Henry Delano Fitch. Reproduced by permission of The Huntington Library, San Marino, California.

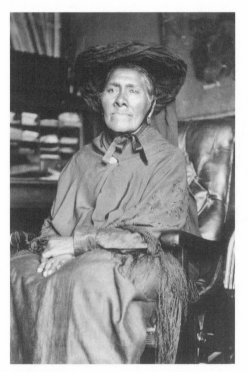

Martina Espinosa, "La Chola Martina." By the late nineteenth century, *chola* meant a laborer. This photo clearly shows the effects of a lifetime of labor on Spanish-Mexican women. Pierce Collection, Huntington Library. Reproduced by permission of The Huntington Library, San Marino, California.

Spirito, Indian wife of Miguel Leones, owner of a large ranch at Elizabeth Lake. Comparing this photo to that of "La Chola Martina" shows the importance of class in California. Pierce Collection, The Huntington Library. Reproduced by permission of The Huntington Library, San Marino, California.

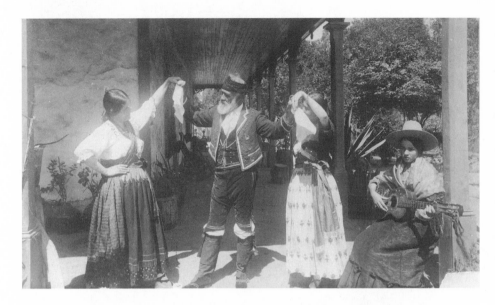

Don Antonio Coronel and three Spanish girls, Camulos Ranch, 1890. This is the image of Californio life before American conquest that Don Coronel worked so hard to promote and the image that Americans came to associate with "romantic California." Reproduced by permission of The Huntington Library, San Marino, California.

La Puente, home of John Rowland, 1870. Reproduced by permission of The Huntington Library, San Marino, California.

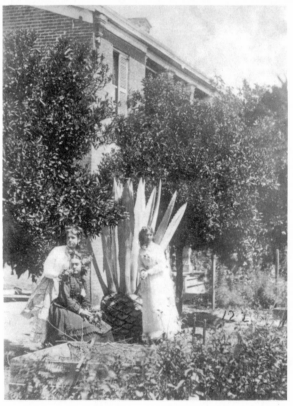

The young woman in the dark dress (*seated*) is Victoria Rowland, daughter of John Rowland, in front of La Puente. Victoria later married a Mr. Hudson; she and her husband eventually occupied the house. Reproduced by permission of The Huntington Library, San Marino, California.

"Ramona's Home," depicted on a "romantic" souvenir California postcard,
"On the Road of a Thousand Wonders." Author's collection.

Hemet, California, Ramona outdoor pageant, advertised as one of the greatest outdoor plays ever staged. Author's collection.

authorities had so quickly accepted the rule and republican rhetoric of the Mexican Revolution, their political language shifted with the new ideologies, but this language never displaced the older political language of colonialism. Contestation, whether manifest or subversive, whether between *abajeños* and *arrebeos* (northern Californios and southern Californios), parents and children, or males and females, was the social language of this community. Californios, male and female, worded their actions in the newer, more liberal political language, but their actions spoke of their continuing desire to inherit the colonial promises of land, honor, and power. No other incident so embodied the conflated issues involving women, foreigners, patriarchal authority, and marriage as the scandal surrounding the union of Josefa Carrillo and Henry Delano Fitch.

The chain of events leading to the Fitch-Carrillo scandal began on the night of April 15, 1829, when a small number of guests arrived at the home of Joaquín Carrillo, captain of the San Diego presidio, to witness the impending nuptials of his fifteen-year-old daughter, Josefa, to the American sea captain Henry Delano Fitch. The Carrillo family, by Californio standards, was influential and socially well connected, with relatives, through blood or marriage, scattered throughout the various presidios. Henry Fitch, on the other hand, had been raised in New England and, like his father, became a merchant seaman. Employed by the Danish merchant Henry Virmond in the lucrative hide and tallow trade, Henry came to California in 1826, and by 1827 he had completed the formality of presenting a written request to Josefa's parents asking for her hand in marriage. Joaquín and María Carrillo agreed to the marriage and to the larger social and business alliance that would derive from it.

According to Josefa's later testimonio, the Dominican friar Antonio Menéndez had just completed part of the marriage ceremony when, "by order of the Governor Echeandía, Domingo Carrillo, who was an assistant to the governor, gave the friar orders to desist from tying this nuptial knot under pain of incurring the anger of the civil, military and ecclesiastical authorities."[45] Domingo Carrillo was also Josefa's uncle and Henry Fitch's godfather.[46] Forty-five years after the event, Josefa still claimed to believe "that the governor's persecution of herself and her husband was . . . prompted by the hatred which possessed his soul when he realized that she preferred a rival whom he detested."[47] Over Fitch's protests, the priest refused to carry out the ceremony. According to Josefa's account, Fitch angrily left the Carrillo home, but not before conspiring with Pío Pico, her cousin, to assist him in abducting Josefa and delivering her to Henry's brig, the *Vulture,* that very night. When Pico

handed Josefa over to her future husband, he supposedly remarked, "Good-bye cousin and may God bless you, and you cousin Enrique be careful in giving Josefa any motive for regretting tying her fortune with yours." Fitch replied, "I promise before God and men that while I have life within me, my wife will be happy." Josefa swore it was a promise he kept loyally and faithfully for the twenty years she lived at his side.[48]

Pico's testimonio, on the other hand, narrates a slightly different sequence of events and causes for the disrupted marriage. According to Pico, the governor stopped the wedding because of Fitch's status as a foreigner and his not being a naturalized Mexican citizen rather than out of jealousy. Pico also had another version of the abduction: it was the following day during vespers that "Josefa arrived at my house and told me that she had agreed with Captain Fitch to go and get married in Valparaiso, and that she considered herself very unfortunate in not finding a person she could trust to take her to the appointed place to meet Fitch."[49] Pico volunteered his services and delivered the girl to Fitch, who awaited her arrival at the pier. Josefa and Fitch immediately set sail and were married in Chile. Within a year, business duties brought Henry, Josefa, and their newborn son, Eduardo, back to California; they arrived in San Diego in July 1830. Once in port, Josefa recounted that "all the resident ladies of the port came to visit her and within a few days her mother and sister came, they welcomed her and after so many greetings her mother told her that her father was very offended with her." Upset by this news, Josefa made her way to her father's home, declaring that "she preferred risking death rather than live in anger with the author of her days."[50]

Upon entering the house, Josefa found her father sitting close to a small writing desk with a musket at his side. She begged his forgiveness but received only silence. Falling on her knees, she began to plead and drag herself across the room, but her father remained silent, continuously staring at the musket. It was evident to Josefa that "a *verdadera borrasca,* a true storm, was agitating her father's soul."[51] Realizing that her pleading did not soften his heart, Josefa continued to crawl on her knees, reminding him that if she had disobeyed him, she did it only with the intention to "subvert the odious tyranny of our laws."[52] After she had dragged herself the length of the room, her father finally capitulated and embraced her. Joaquín and Josefa were reconciled.

Two days after this reconciliation, the Fitches sailed for Monterey, where Henry presented the governor, the same José María Echeandía, with their marriage certificate. To the couple's astonishment, the governor declared the certificate illegal and had Fitch imprisoned on August 29, 1830. Josefa was

simultaneously placed in *deposito*—the practice of separating a couple who had eloped in order to ascertain whether the woman had consented of her own volition to the union. Under church tradition, such a woman was placed in temporary custody with an unrelated family for three days in order to freely contemplate the step she was about to undertake and its consequences. By the time the ensuing ecclesiastical trial was over, Josefa had been twice placed in deposito, once by the governor and once by the church, and she spent not three days but nearly three months in a state of surveillance. However, Mariano Vallejo later claimed to have facilitated conjugal visits for the embattled couple.[53]

Had Fitch been devoid of economic resources or lacked acquaintances with means and influence, the couple might have remained under the governor's control. Instead, friends—who were predominately Euro-American—petitioned the ecclesiastical authorities to investigate the situation.[54] The authorities did begin an investigation of the governor's acts but unexpectedly, and to the couple's utter bewilderment, simultaneously initiated an annulment trial in October 1830. Josefa was removed from the state's control and placed in another house of deposito in San Gabriel, while Henry was sent to the prison in Monterey.

Josefa and Henry were not the only ones on trial; the governor's actions and motives were also scrutinized. The ecclesiastical trial was essentially a political struggle for power and authority between the church and the civil government, both in literal and symbolic terms. The church officials' antagonistic stance was quickly and strongly expressed when they charged Echeandía with "usurping, impeding and perturbing Church jurisdiction."[55] In a long tirade the *fiscal*, a lower church official, enumerated three specific points in which the governor was deficient in his duties: (1) he had failed to notify church officials that he had placed Josefa Carrillo in deposito; (2) the governor's secretary, "prodded by the Governor no doubt," had failed to authorize Josefa's removal into the church's hands; and (3) the governor had remained silent for over a month about the situation.[56] Unfortunately for the governor, all the charges were true.

The trial transcripts leave little doubt that Echeandía had failed in his official duties, but his inclusion in this ecclesiastical trial had to do more with the local manifestation of a broader power struggle between church and state concerning the secularization of the missions. In 1813 the liberal Spanish Cortes (courts) had "ordered the immediate conversion of all missions, ten years old or older, into parishes" and the distribution of mission lands among the Indians. King Ferdinand VII nullified these laws when he regained the throne, but a decade

later, when Mexico gained its national independence, "all acts of the liberal Cortes that did not affect Mexican sovereignty" were upheld. The Constitution of 1824 decreed "the equality of Mexicans," so enforcing the demise of the mission system was clearly in the federal government's political interest.[57]

However, enforcing secularization proved difficult throughout the northern frontier, especially in Alta California. Because California's strategic position, buffering Mexico from foreign powers, made its *pobladores* (settlers) vital to the colonizing effort, the conversion of public lands to private lands was the quickest means of attracting and retaining settlers. On the other hand, the military's dependence on the missions for food, sundry goods, loans, and, too often, their very salaries made forceful secularization impossible. Beginning in 1825, the Commission for the Development of the Californias spearheaded the secularization efforts but instructed the new territorial governors to "proceed 'slowly and prudently.'" José María Echeandía was the first governor to implement the new policies; by 1826 he proposed that Mission Indians be allowed "to petition to leave the mission," and in 1828 he proposed "to create Indian pueblos, with both Indian and non-Indian settlers," on mission sites.[58]

The church did not quietly submit to these political machinations designed to undermine its status and power. The Carrillo-Fitch elopement thus became an unexpected opportunity for the church to retain its authority in this emerging sociopolitical struggle. The church's position was made clear by José Palomares, the fiscal in the trial, who stated: "Never in California, nor in any other places which make up the Province of the Mexican Federation, has there been committed such an extreme, nor major violence against the Ecclesiastical and Spiritual Jurisdiction, as directed by Sr. de Echeandía towards Doña Josefa Carrillo. Because of this the Vice President, the legitimate judge, is senior in this privilege to judge and impose upon him the corresponding sentences."[59] To strengthen the church's position, Frey Sánchez turned to higher authorities, and by November 17, 1830, he had secured an epistle from the vice president of the Executive Government of Mexico, Anastasio Bustamante.

In this document Bustamente advised Frey Sánchez to use all means available to "reestablish public tranquility, that with all my sentiments, which finding it turbid, taking into consideration to gain the most perfect union and harmony between its habitants."[60] Bustamante's reassurances clearly emboldened church officials in their stance against the local civil authorities. Sánchez expediently used the situation to challenge Echeandía's fueros (the special privileges given to governmental officials), because the governor's transgressive political actions had resulted in social disorder and personal dishonor. The church considered

itself the only institution capable of reestablishing communal harmony. For a brief moment the church gained the upper hand, based on the social construction of honor, and claimed the proper moral authority. By publicly chastising the governor, the church symbolically reaffirmed itself as the supreme governing authority.

In December ecclesiastical authorities found the marriage valid but not legitimate under canon law, and they ordered the couple to present themselves in three days at the local church, the San Gabriel Mission. To show penance, the recalcitrant couple was required to hold lit candles as a sign of total devotion while attending High Mass. In addition they were ordered to pray the rosary for thirty days, concentrating on the Third Sorrowful Mystery, which calls on Catholics to remember that Christ received the Crown of Thorns for their sins.[61]

In Alta California, as throughout colonial Latin America, honor as a social construct was deeply embedded in the gender system. For Latin American societies:

> honor was first a value judgment concerning one's social personality, a reflection. It was not only the value of a person in his or her own eyes, but also the recognition of that worth in the eyes of others. It was a belief that the image of self, one's reputation, was the basis for pride, it had to be acknowledged by others. Honor materialized when deference was paid or when preferential access to scarce resources was gained because of it. Because public recognition of honor was essential to its value, the number of persons paying one honor depended on their familiarity with the claim and their willingness to pay it.[62]

The relevance of the public sociopolitical aspects of this trial, however, cannot overshadow the equally intense private drama that transpired as the trial quickly became what Sarah Maza describes as a "conflation of private stories with public issues."[63]

That the Carrillo-Fitch elopement became a question of public honor reflected the evolution and changes in nineteenth-century Catholic marriage ideology and practices. Societies have always used marriage to protect and/ or perpetuate honor; however, by the first quarter of the nineteenth century marriage throughout Mexico was "the most important ritual event in the life-course, and in it the honor of the family took precedence over all other considerations. The union of two properties, the joining of two households, the creation of a web of affinal relations, the perpetuation of a family's symbolic

patrimony—its name and reputation—were transactions too important to be made by minors. . . . Filial piety required the acceptance of any union one's parents deemed appropriate or advantageous."[64] This was not the case during the colonial period, as Patricia Seed convincingly argues in her account of the church's dramatic reversal concerning marriage ideology in Mexico.[65]

The major changes in marriage ideology basically concerned changes in the church's interpretation of free will. Beginning with the Council of Trent, the Catholic Church began to codify and organize its regulations in order to better distinguish a valid marriage from an invalid one.[66] Because marriage was regarded as a contractual agreement, the church placed great emphasis on the parties' "freely given consent to a marriage."[67] An important element of free will was the value placed on personal honor, since "individual consent was already well established in Catholic tradition as the essential condition for a valid marriage; the Council of Trent not only reiterated its importance, it also went further than had earlier Catholic tradition in defining the exercise of free will."[68]

Free will could only be exercised in the absence of coercion of either of the two parties. Coercion came predominately in the form of parental or familial pressure either to marry or not marry a specific individual. If coercion did take place, church officials were duty bound to examine the individuals and ascertain whether the promise of marriage was met. To ensure the integrity and truthfulness of the individuals, the examination was done in seclusion through the act of deposito, an oft-used tool of the colonial church.[69] After the Council of Trent, the promise of marriage made by a man to a woman validated a marriage. Once a promise of marriage was made, all parties—church, society, and individuals—were honor bound to carry out and fulfill the marriage rites.

However, the church distinguished how men and women possessed and were bound by honor along gender lines. According to Seed, "honor can be summed up in the equal concepts of honor = precedence (status, rank, superior birth) and honor = virtue (moral integrity). In the sixteenth and seventeenth centuries, honor was generally considered an attribute of the well-born, but its principal manifestation was through virtuous conduct."[70] Given the church's distinctive assumptions about the nature of men and women, the definition of honor proscribed different forms of behavior for the two. "Honor as virtue," according to Ramón Gutiérrez, "was an attribute of individuals and of corporate groups. When speaking of personal honor, it was considered a state of conscience that elevated the person's actions above reproach. If a person's

intentions were honorable, it was irrelevant what others might think."[71] Because *honor* was considered strictly a male attribute and *vergüenza* (shame) intrinsically a female attribute, men behaved honorably when they "esteemed honesty and loyalty and were concerned for their reputation and that of their family" and if they acted "with *hombría* [manliness] and exerted authority over their family."[72]

On the other hand, sexual abstinence prior to marriage and sexual control afterward was the prescribed behavior that embodied female honor. As Ann Twinan states, a "woman was to refrain permanently from intercourse if she remained single or was to maintain her virginity until she became a wife. Presumably, a woman was either 'in' sexual control, or 'out of' such control, and society did not recognize anything 'in between.' For that reason, single women who lost their virginity, or wives who strayed, lost any claim to respectability. They were 'out of control' and approximated the moral if not the actual, state of the prostitute."[73] If a woman lost her virginity after a promise of marriage was given, she was a seduced woman, and as such she had committed no religious transgression. The male, on the other hand, had greatly dishonored himself and his family. In such a situation, if the church found that a promise to marry had indeed been made, the couple was quickly and secretly married, restoring the woman's sexual and social honor. Although women were by and large in a more precarious position within this process, the church's emphasis on the individual did provide females some protection.

Adding to these complex issues were the various models of marriage that existed in the colonial Spanish Borderlands. "Whether one was a priest," according to Rámon Gutiérrez, "a marital candidate, or the parents of the bride and the groom largely dictated which model would be considered sacred and which profane."[74] Valuing spiritual salvation over property and the social interests that used marriage as a means to consolidate property and wealth, the church targeted and prohibited any marriage it considered incestuous. The church also "determined who were and were not appropriate marital partners," largely through its use of dire impediments "which prohibited marriage, required papal or Episcopal dispensation, and annulled a nuptial if discovered after it had occurred; and preventative impediments, which were less severe, could be dispensed by the lower clergy, and infrequently undermined the validity of the sacrament."[75] Priests were guided by canon law to protect individuals' freedom in selecting their mates, but throughout the Spanish empire "it was not uncommon for clerics charged with the interpretation and execution of Canon law to enforce it selectively or to bend its dictates to avoid misalliances

or subversion of the social order. If a friar believed an arranged marriage was a good match, he might uphold parental prerogatives, rationalizing that the natural authority of a father over his children was in full accord with the will of God."[76] California proved no exception to this rule.

With the church protecting individual rights and interests, women could resort to concepts of honor to protect themselves from seduction and therefore from social ruin. However, by the early nineteenth century this was no longer the case. Over time, societal changes in colonial Mexico linked honor less to the individual than to the family's patriarchal socioeconomic concerns. Marriage, and marriage alliances, increasingly became a means of advancing and strengthening a family's social position. The shift from individual to parental control was significant. Although there were various considerations, Seed posits that this shift derived largely from the change in the relationship between church and state.

As previously mentioned, the secularization of Mexican society brought about a breakdown in the relationship between church and state and caused rising animosity between the two. As secularization continued, the state progressively reduced the monetary and physical resources it gave to enforce the Catholic Church's decisions regarding marriage. Under the colonial administration, the government's soldiers and police force also served as the strong arm of the church, so if the church needed physical force to carry out its decisions, secular authorities provided the necessary men. As the authority of the church declined, parental authority and control increased, boosted by changing and expanding economic conditions. The growth in trade and wealth in Mexico and throughout Latin America transformed the importance of status and social standing, playing an increasing role in marriage selection.

Prior to the nineteenth century, church officials interpreted parental choices based on financial interest as coercion. However, by the eighteenth century, "some parents began to question the idea that interest was a malicious or unjust consideration. . . . Increasingly, 'interest' was regarded not as a demeaning passion but as a sensible motivation for everyone. The change was directly related to the increasing involvement of New Spain's merchants, miners, and bureaucrats in a world market, which aroused in them attitudes toward money and interest that were new to Hispanic culture."[77] The immediate danger that elopement posed for parents was the creation of a potentially inferior socioeconomic alliance. An improper choice in a marriage partner by a son or daughter undermined the entire family's social standing and status.

But if Joaquín Carrillo had agreed to his daughter's marriage, why did Josefa's elopement with Henry Delano Fitch escalate into public scandal? Private dramas and personal conflicts also influenced the events and outcome of this episode.

Although casting Echeandía as the spurned lover gives a romantic flavor to this drama, it is far more likely that the governor's actions were guided by his loyalty and attention to duty rather than by an affair of the heart. Echeandía's republican and nationalistic loyalties prompted him to punish Fitch as harshly as possible. Unlike his predecessors, Echeandía attempted to exert a viable federal presence in the colony, and for foreigners this meant the enforcement of trade laws and the proper collection of duty taxes. In all likelihood Fitch's smuggling activities were the cause of the governor's anger and resentment, rather than his marriage to a woman the governor fancied for himself. As various historians have pointed out, smuggling by both English and American ships was rampant along the California coast during this time.[78]

Foreign merchants quickly realized that although California revenue officers may have wished to enforce the tariffs, "they were really powerless to do so efficiently, for they had no detectives, no revenue cutters—none of those numerous aids and facilities for detecting the offenders against the law which prevail in these latter days."[79] William Davis Heath detailed the many ways in which merchants eluded paying the tariff: goods were concealed under false linings around the sides of ships; portions of cargoes were temporarily deposited on the Channel Islands—in some cases up to two-thirds of a cargo—to be picked up later and traded along the coast as usual; and if they were friends of the guard ordered to stand watch over the ship, a small bribe of "a bottle of Madeira, a bottle of aguardiente, cigars, and $20 in gold" was enough to have the guard look the other way as they unburdened the ship of most of its cargo.[80] Mexican laws for the punishment of smuggling were severe—in extreme cases prescribing death. In 1843 duties on imported foreign goods were averaging nearly 100 percent, along with numerous other costs, making smuggling a necessity for traders hoping to turn a profit. Even the rancheros "would hint to the merchants that they ought to smuggle all the goods they could, they knowing they would get what they purchased cheaper than if all the duties were paid."[81]

Not all Californios approved of the smuggling activities of foreigners. Antonio María Osio recalled that William A. Gale gave "express orders not to smuggle in so much as one ball of thread and to report all profits, whether large or small, to the customs employees." Because of this impeccable conduct, Gale,

"so different from that which normally is attributed to his national character, naturally earned the trust of all who came into contact with him."[82] In Don José Ramón Sánchez's opinion, David Spence, a Scotsman, John Bautista Rogers Cooper, an American, and Thomas Oliver Larkin, also an American, were "always ready to twist for the authorities their lack of respect for the laws, constitution, or governing acts; but when their personal interests were involved they trampled underfoot the laws since the great fortune which Spence accumulated was gathered by the means of smuggling and usury." As half-brothers, Larkin and Cooper were judged especially repulsive, because "they passed nights on end studying new ways to contraband, having no scruples they bought stolen hides from the Indians and conducted other equally odious operations."[83]

Ironically, Henry Fitch's smuggling activities ceased in 1845 when he was appointed Custom House officer for the port of San Diego. Referring to his current and past interest in smuggling, he wrote to Abel Stearns that "we have a French whaler here, full, bound home, and as I am Custom House Officer, am not able to smuggle anything as it would be against my conscious [*sic*], in fact she has very little to sell."[84] In time Fitch became a naturalized citizen and accommodated to Californio society by becoming Catholic and bilingual.

Although he was appointed a juez de paz in 1840, Fitch's actions in 1829 were too great an affront and a reminder of the government's impotence in controlling foreigners in the colony. Unlike some of the previous foreign immigrants who had actively incorporated themselves into Californio society, the more recent foreigners, particularly the fur traders from the United States, were not complying with the customs of the land. In 1830 Fitch was paying for the sins of his brothers. Echeandía's hostility and dislike of foreigners was understandable. From the time of his arrival in California, foreigners, particularly fur trappers, had constantly tried the governor's patience. The liberal commercial policies of the central government attracted a number of British and American hunting companies, which, along with persistent hunting by the Russians, had greatly reduced the sea-otter population.

Luis Antonio Argüello, as acting governor from 1822 to 1825, attempted to establish otter hunting as an industry. He negotiated a contract with the Russians that granted them sea-hunting rights for four months all along the California coast in exchange for an agreement that they would not establish a settlement or use Mission Indians in the hunts. The Russians were required to sell their skins only to the Mexican government at forty-five pesos per skin and to purchase wheat at three pesos per *fanega* (bushel).[85] Argüello's scheme

failed to turn a profit, but the idea of licensing as a form of social control and regulation appealed to the national authorities and particularly to the local authority, José María Echeandía.

Wishing "not to rebuff completely foreigners," Echeandía, nevertheless, greatly reduced the geographical area in which the Russians could hunt and simultaneously proposed to the central government a strict licensing system that would designate "a time limit, a specified place, the amount to be paid to the government."[86] By 1831 the new governor, Manuel Victoria, was granting licenses only to *hijos del país* (sons of the land) and to naturalized citizens such as John Bautista Rogers Cooper and William Goodwin Dana. As quickly as the policy was implemented, foreigners found ways to evade it. In October 1831 María Josefa Boronda, wife of James W. Burke, and Eduarda Osuña, wife of Englishman William Benjamin Foxen, applied for hunting licenses. Aware of the duplicity of these couples, Governor Victoria wrote, "Although the one who undertakes this will be your husband, a foreigner, nevertheless I grant the right to hunt otters for six months, he subjecting himself to the law."[87]

Because of these manipulations, Victoria attempted to restrict foreigners who abused the licensing privileges, but as the aforementioned case indicates, the activities of men married to Californianas made the term "in consideration of his being married to a daughter of the land" a key mechanism in the government's attempt to regulate the activities of foreigners. By the 1840s this phrase was the means of accepting foreign males into the Californio collectivity. Acceptance and legitimization of this phrase became so commonplace that nothing seems unusual in Juan (Jonathan T.) Warner's license petition of January 1843. As a resident of Los Angeles, he applied to the prefect of the district, Santiago Argüello, for a license to hunt for sealskins and goatskins on the islands of Santa Catalina and Santa Barbara, swearing "to act without malice and the necessary."[88] In consultation with the governor, the prefect decided that since "the petitioner is not naturalized, he cannot enjoy the benefits of our laws, which grant only to nationals the privilege of the proposed hunting. However if, in consideration of his being married to a native born daughter and having lived here for some time, his petition should be granted."[89]

Why the phrase is even included in the document is rather perplexing, since Juan Warner's wife, Anita Gale, was the daughter of William A. Gale, a Boston merchant who helped initiate the hide and tallow trade in 1822 as an agent for the Bryant and Sturgis firm. Indeed, there is a bit of mystery surrounding Anita's identity. Contemporaries acknowledge that she was William's daughter, but they fail to mention her mother. William married María Francisca Marcelina

Estudillo of San Diego on May 21, 1827, but in 1822 he left his five-year-old daughter with María Eustaquia Pico, the matriarch of the Pico clan of San Diego. Before 1822 Gale was a trader in the Hawaiian Islands, so it is possible that Anita was born of a Hawaiian, Californiana, or California Indian mother, since contemporaries would most certainly have mentioned the arrival of the first "white" child in California. Gale eventually became a naturalized citizen, but no record exists confirming Anita's naturalization or her conversion to Catholicism. Since she was named Anita and no Californio family claimed her, I suspect that her mother was a California Indian and that her acculturation through the Pico family continued the patina of Hispanicization. Indeed, when and by whom Anita and Warner were married is unknown, because Warner remained a Protestant all his life. However, the prefect's description of Anita Gale as an *hija del país* reveals the social value of the term and indicates how the continuance of colonial nomenclature still evoked individual female status and privilege. Regrettably, it also marks the socioeconomic erasure of Native American women, the original hijas del país. In using this particular term to link Spanish-Mexican women to the land, Native American women's colonial privileges and status were permanently revoked.

Although the power struggle between church and state played a considerable role in the Carrillo-Fitch trial, the broader conflicts inherent in the case should not be overlooked or minimized. On trial was a couple who had eloped, and more specifically, a man who may have forcefully seized and abducted a woman. The social and sexual implications of these actions were substantial. Indeed, one of the reasons for such great concern on the part of the church over this case—and all elopement cases—was their potential to distort normal societal and familial relationships. For the church, elopements were particularly disturbing because they "violated the trust, mutuality, and consent that the church regarded as indispensable conditions of acceptable sexuality. Furthermore, by side-stepping the regular canonical sequence in the rituals of marriage, abduction and elopement challenged the church itself."[90] An elopement did not concern only two individuals; it concerned all of society. Not only did it break familial and private conventions, but also public conventions. Elopements challenged the role and authority of parents, specifically those of the father, and of the friars in legitimizing such marriages. In the close-knit communities of early nineteenth-century California, news of these disobedient children shamed the authority figures.

After fully investigating the event and interrogating Josefa Carrillo, the

officials were sufficiently satisfied that no violence or rape had occurred: Josefa had gone off with Henry Fitch of her own free will. Although Fitch was found innocent on this count, the marriage was deemed illegitimate for several reasons, most of them dealing with marriage regulations and practices. For example, under Catholic marriage practices all couples had to wait until a priest had read the banns announcing the upcoming marriage of the prospective couple to the community. Any person who had legitimate grounds to challenge or impede the marriage could inform the priest at this time. Furthermore, Fitch and Carrillo did not have three witnesses swearing that there were no reasons why they should not marry. If these marriage regulations were not satisfied, the marriage could legally be prohibited by an impediment, as previously discussed.

In questioning Fitch and Josefa, officials found that the couple had met few of the required marriage regulations. Indeed, there were so many discrepancies and irregularities that the fiscal, José Palomares, stated with some exasperation that "Fitch need not have asked a man of letters, not even an official, but instead a *soldado qualquier* [any common soldier] would have told him what was needed" to get married.[91] In other words, any simpleton knew the correct sequence to a proper marriage. What the officials found most difficult to believe was that neither Josefa nor Fitch had remembered the regulation requiring a couple to marry in their own parish. Having been married in Valparaiso, Chile, they were not married in the correct parish—or even in the proper country. Since the couple had failed to meet so many of the marriage regulations, a preventative impediment effectively nullifying the marriage seemed to be in order. But a preventative impediment was not evoked. Why?

With the birth of the Carrillos's son, Enrique Eduardo Fitch, an annulment would have meant an illegitimate birth. This point was not lost on Henry Fitch. As he stated during the trial, since he really believed he had been married to Josefa in Valparaiso, "he consumed [i.e., consummated] his marriage, and God had blessed him by giving him a son, and if this marriage is declared null even though it is legitimate through virtue by law he [Enrique Eduardo] will never be legitimate, instead the one which is born after him, is the one who will be preferred by the same laws. And would this not be too painful a punishment? Especially when I know that the first son is the legitimate one?"[92] Maintaining the validity of the marriage protected Enrique Eduardo Fitch's social status and honor.[93] The importance of class cannot be underestimated.

Fiscal Palomares revealed the crux of the matter for many Californios during his interrogation of Fitch. Palomares pondered and was perplexed enough over

Josefa's motive for eloping to observe, "Well, it's incredible that a young noble girl of the best education should want to abandon her native soil, parents, and family to follow someone who was not her husband."[94] Palomares was asking not only why Josefa Carrillo chose to elope, but also why any woman of Josefa's social status would bring dishonor to herself and her family by eloping. Answering the question of why Josefa eloped is relevant, to be sure, but *how* she told her story reveals the conflicts and tensions that some women negotiated in the 1830s and 1840s.

A close reading of Josefa's 1875 narrative, "Dictation of Mrs. Captain Henry D. Fitch," subtly reveals why she took flight: her father, Joaquín Carrillo. Josefa was pointedly asked about her elopement, but the greater event that she described in her narrative was her reconciliation with her father. This moment, even after forty-five years, remained the most vivid and foremost in Josefa's memory. Her description of the scene seems hyperbolic and melodramatic, but Joaquín Carrillo was known to have a violent temper, and Josefa had probably fallen victim to his physical abuse as a child, hastening her decision to leave his household by whatever means possible—hence the elopement. Even after her marriage, she was not safe from her father. In a letter to Abel Stearns, Henry Fitch wrote that he refused to leave his very pregnant wife with Joaquín while he attended to business up north, "since I would be damned to leave her at the hands of her father."[95] Given her father's military experience and his access to and knowledge of weapons, Josefa was indeed pleading for her life as she dragged herself across the floor. Joaquín's reaction to the elopement also indicates his volatile nature. He had, after all, agreed to the marriage, but the harm done by the elopement to his personal honor and status was barely forgivable. That Josefa's individualistic act of patriarchal subversion came at the expense of Joaquín's authority was noted by numerous Californios who mentioned the incident.[96] The incident also indicates not only gendered, but also growing generational tensions. Pío Pico clearly sanctioned the elopement, even though it conflicted with Joaquín Carrillo's parental authority. Pico's speech appears, and reads, like a moral blessing on the anticipated spiritual and physical union of the couple. Pico seemingly had little concern for the potential physical and sexual danger this course of action could have on Josefa and on his own family's reputation. As Ramón Gutiérrez argues, romantic notions on the part of children of this Californio generation were undermining parental control of marriage choice.[97] Josefa's elopement was merely the most exaggerated example of children contesting their parents' authority.

In most cases foreigners willingly—or begrudgingly—accepted the social norms of courtship. Children were increasingly choosing their own mates, but the custom of a suitor's writing to a girl's father for permission to court her was still widely adhered to, as evidenced by Alfred Robinson's letter to José de la Guerra y Noriega. Because Don José had the "power to grant and to be the author of my felicity," and since Robinson claimed he could not "live or be happy in this world" without Anita, he requested her hand in marriage, ending his request with the obligatory "Your obedient servant who kisses your hand."[98] Californio patriarchs expected these attitudes and rituals of respect, and although some foreigners were unwilling to comply, most were willing. During the two years he courted María Estudillo, William Heath Davis did not remember "having spoken a hundred words to the young lady when we were alone, but I was permitted to converse with her in the presence of her parents, especially her mother." He, and the majority of other Euro-American suitors, strictly adhered to the Californio parents' sense of courting decorum.[99]

The reconciliation scene is important for another reason—Josefa's subversion of the ruling political language. Unwilling to reveal to her father that he was a contributing reason for her flight, she suggested that her flight was a response to public policies, that she had fled only to "subvert the odious tyranny of our laws." In other words, she claimed that the governor's actions and political repression had forced her to disobey her father. But, like her father, she too had forgiven those who persecuted her and had forgiven Echeandía, "for he had liberated my country from the yoke of the tyrant Victoria."[100] She also shifted attention away from her father, giving back his personal parental authority. In these statements Josefa cleverly manipulated political language in order to lessen her personal transgressions. Josefa questioned the moral authority of political authorities by portraying them as tyrannical and therefore dishonorable without having to name the true tyrant, her father.

The manner in which Josefa introduces the resident women's supposed acceptance of her actions also exposes a woman's consciousness at odds with patriarchal order. According to the Hispanic sexual code, Josefa's actions placed her beyond the pale. From the moment she left California to the time she arrived in Valparaiso, she was a woman sexually "out of control," or at the very least a seduced woman. By taking control of her own body and sexuality, she had broken societal norms and should have been treated as a social outcast; yet upon her return, it was the women who ostentatiously welcomed her back. Not only did the women in general welcome her, but within a few days her mother

and sister visited her. Were the women of San Diego consciously supporting Josefa's action by not ostracizing her upon her return? Were they sanctioning the means by which Josefa had contracted herself to Henry Fitch?

If revisionist historians such as Michael González and Douglas Monroy are correct, the republican ideology and rhetoric that circulated from the 1820s through the 1840s included ideas of republican motherhood and interpretations of proper female conduct benefiting the good of the country. After the overthrow of Spanish rule in 1821, the Mexican government drafted and passed the Constitution of 1824, which granted "greater regional autonomy and participation in national affairs" and eliminated racial and class distinctions, granted citizenship to Indians, and guaranteed freedom of speech. While liberalizing some political arenas, the constitution nevertheless "maintained special privileges or fueros for members of the clergy and the military" and "recognized only one religion, Roman Catholicism."[101] Attempting to remedy the inadequate judiciary, the Constitution of 1824 separated it from the legislative and executive branches. In the northernmost territories, this resulted in the establishment of district courts in New Mexico and Alta California, but more serious cases were appealed in the circuit courts in the nearest state. In extremely serious cases, appeals were to be taken to Mexico City.[102]

That women were cognizant of political shifts and openly expressed their points of view was often lost in their menfolks' account, but moments within the testimonials do contradict the men's dominating views, allowing for female political spaces. An example of how women engaged, interacted, and attempted to influence political actions occurred in 1836 when Juan Bautista Alvarado's decree of independence from Mexico was circulated throughout the territory. Read to all gente de razón, the decree included a call for private religious toleration. Opposition to the decree quickly arose, but the women in Santa Barbara were especially indignant. According to Antonio María Osio, when Don José Sepulveda, the *síndico* (public attorney or advocate/representative of a mission) of Santa Barbara tried to explain the decree of religious toleration, beginning with his mother and then to the rest of the Santa Barbara community, he claimed that Jews or Protestant clergymen would be free to marry and to officiate marriages without the permission of the bride's parents. "The girls who were present reacted very favorably," confirming the growing generational divisions in which the younger generation desired more individual choice in social arrangements, but their mothers did not.[103] Infuriated, the older women wondered "if men of character existed, men who would permit such a thing to happen to their daughters." Demanding the ouster of Alvarado "so that he

could take his decrees to hell," women of influence were summoned to hear the decrees for themselves. Once informed, the women declared "that men had lost faith in oral promises and needed to put agreements in writing. The women, however, would not need anything in writing to make them fulfill their promises. Each woman pledged to insure that her husband, children, and grandchildren, from seventeen to sixty years of age, would take up arms for the sake of their family honor."[104]

Beyond the female republican rhetoric, this moment also reveals the agency and social distinction that women were able to achieve, maintain, and control. We do not know who these individual women of influence were, but this specific community knew and regarded their opinions and actions highly. Men may have been able to ignore these women's declarations, but by questioning the men's manhood and their ability to protect their families, the women implied that they could not be deceived by mere words. They knew right from wrong and would do what they could, as mothers and women, to protect their daughters and their families.

If women, especially women of influence, could shame men into proper action, could they not also sanction and forgive female transgression if they knew the individuals and all the "considerations" involved in the episode? If Josefa's account is accurate, then there were obviously conflicting senses of "punishing" sociosexual transgressors based on gender and class. Were these women conscious of and did they sanction Josefa's declaration of autonomy over her body and sexuality? As the following chapter will indicate, there are strong arguments that this was exactly the case.

In spite of their early struggles, the rest of the Fitches' married life was not particularly eventful. After the trial the couple fulfilled the missing banns within the marriage process, both validating and legitimizing their marriage, and in time Josefa gave birth to seven sons and four daughters. Henry continued to engage in trade, and eventually the couple purchased four properties, the largest of which was Rancho Sotoyomi in Sonoma County, consisting of eight leagues. It was there that the Fitches eventually settled. On June 20, 1849, Henry Fitch died, leaving Josefa the supervision of the family's lands, most of which she managed to retain after the Mexican-American War. She never remarried, preferring to guard the memory of the man who had given her happiness "for the twenty years she lived at his side."[105]

In the 1880s Hubert Howe Bancroft and Helen Hunt Jackson published seminal works that left indelible images of early nineteenth-century California

on the American imagination. The motivation and intent of the two writers differed greatly, but the outcome and impact of their writings—Bancroft with his seven volumes of California history and Jackson with her novel *Ramona*—effectively created the image of Californios before the Mexican-American War as tragic, romantic figures following a pastoral lifestyle in a halcyon age. No other writers up to that time had recounted California history in such romantic terms. Bancroft interviewed and collected vital historical narratives from aging Californios, thereby preserving what he regarded as a vital record of the past. Jackson, however, was not interested in writing an accurate history.

Helen Hunt Jackson was an eastern reformer, Indian advocate, and muckraker who in 1881 published *A Century of Dishonor,* a scathing exposé of the outrages and wrongs committed by the U.S. government against Native Americans. To Jackson's disappointment, the book failed to capture the public's interest. She then determined to write a novel that would address the same issues from a fictional perspective, an *Uncle Tom's Cabin* about California's missionized Indians that would set forth "some Indian experiences in a way to move people's hearts."[106] In 1881 Jackson set off for California to conduct research for her novel. There she learned of the marriage of Victoria Comicrabit and Hugo Reid (see chapter 2) and used their experiences as the basis for her story.

Ramona, published in 1884, is basically a retelling of Shakespeare's *Romeo and Juliet,* centering on the tragic, doomed love and marriage of beautiful Ramona McPhail and a full-blooded Mission Indian, Alessandro. At the beginning of the story, the Scotsman Angus McPhail, "owner of the richest line of ships which traded along the coast at that time," is betrayed by his Californiana fiancée, Ramona Gonzaga, who instead marries an elite Californio. Shocked and demented, Angus slips not only into total dissipation but "after a time the news came up from Los Angeles that he was there, had gone out to the San Gabriel Mission, and was living with the Indians. Some years later came the still more surprising news that he had married a squaw—a squaw with several Indian children—had been legally married by the priest in the San Gabriel Mission Church." Then, twenty-five years after Doña Ramona's betrayal, Angus brings her his only child and begs her to bring up the little girl as her own, for, he says, "You sinned, and the Lord has punished you. He has denied you children. I also have done wrong; I have sinned and the Lord has punished me. He has given me a child." When asked of the child's mother, Angus responds, "That is nothing. She has other children, of her own blood. This is mine, my only one, my daughter."[107] It is interesting to note here that

Jackson made liberal use of dramatic license, recasting Hugo as a somewhat dubious character and completely erasing Victoria as an active participant in her husband's life or in that of her half-blooded daughter.

Soon orphaned, Ramona is raised by an aunt, the wealthy "Spanish" Doña Moreno, who never reveals to the child the circumstances of her birth—that her father was a wealthy Scottish merchant who married an Indian woman after being figuratively left at the altar by Doña Moreno's sister. No one ever questions that Ramona, as a half-European, is a true "Spanish" Californiana, so when she falls in love with the handsome and noble Alessandro, the relationship is deemed unacceptable. Eventually, Alessandro dies after being forced to flee the hard-hearted animosity and disapproval of Doña Moreno and failing to find work or to provide a home for Ramona. The novel ends with Ramona living in self-imposed exile in Mexico, unable to tolerate the economic and social injustices inflicted on California Indians by both the Spanish-Mexicans and the new settlers from the United States.

For all its fictional anguish, *Ramona* is an artifact of its time and is solidly grounded in the realities of nineteenth-century California society. Angus McPhail was drawn from Hugo Reid, the unnamed "squaw" was Victoria Comicrabit, and Ramona was based on Ygnacia Reid, Victoria's half-white daughter. The character of the mean-spirited, callous Doña Moreno was based on Ysidora Bandini de Couts, an associate of the Reid couple. It was a characterization that Ysidora did not appreciate, and she sued Jackson for defamation of character.[108]

Helen Hunt Jackson's intention "to move people's hearts" succeeded to a certain extent, but rather than moving the hearts of easterners to champion the cause of the California Mission Indians, *Ramona* sparked a popular interest in "romantic," "Spanish" Californio society. The novel failed to challenge American racist assumptions about Indians; instead, white audiences were introduced to, and thoroughly accepted, what Carey McWilliams has called the "Spanish fantasy" heritage of the Borderlands.

Had *Ramona* been the only literary publication based on Californio society, Anglo American interest would have eventually decreased. However, Jackson's work anticipated by only a few years the growing appetite of eastern tourists for California, an appetite fed by the Southern Pacific Railroad, which arrived in California in 1886 and in the late 1880s began an advertising campaign promoting California travel. By this time the railroad was eager to exploit its vast land holdings in southern California, and its publicity bureau encouraged "a flood of books, both fiction and nonfiction, and. . . . magazine articles

and stories [that] described California's charms and embellished its romantic heritage," a flood that culminated in the publication of "the phenomenally popular *Sunset,* a magazine of western travel and living."[109] As the flood of literary works about romantic California emerged, a simultaneous rate war began in 1885 between the Southern Pacific Railroad and the Santa Fe Railroad, lowering the price of railroad fares to the point that "for a brief time a ticket from Kansas City to Los Angeles could be bought for $1."[110]

As several Chicano and urban historians have pointed out, the growth of California tourism subsequently encouraged enthusiastic boosters to promote, maintain, and market the "Mexicanness" of southern California. Or, as William Deverell writes, "Los Angeles came of age amidst (and in part because of) specific responses to Mexican ethnicity and Mexican spaces. This 'ethnic stance,' one of the American Southwest's most important and troubling cultural markers, often attempted to isolate Mexicans in time and space," so that "understanding Los Angeles requires grappling with the complex and disturbing relationship between whites, especially those able to command various forms of power, and Mexican people, a Mexican past, and a Mexican landscape."[111] In the first three decades of the twentieth century, Euro-Americans actively remade the California landscape, both physically and culturally, through a variety of means but none more important than the Spanish Mission Revival movement. This effort to restore and preserve the decaying missions in turn launched an architectural movement in southern California that incorporated mission details, usually involving red tile roofs, wrought-iron balconies, and faux adobe finishes. Guided by boosters such as Charles Fletcher Lummis and Harry Chandler, Mexican institutions were redefined to fit Euro-American fantasies; thus, from the 1890s until the 1920s, many of the California missions were rebuilt and Olvera Street was reconstructed for the tourist market.

While most Chicano and urban historians have remarked on the economic and sociopolitical transformations at the turn of the century, we should not overlook how gender also facilitated the historical fantasies and erasure of a Mexican identity in southern California. The images of women and the gendered language at the turn of the century also influenced this growing trend (as will be discussed further in chapter 5).

Returning to the importance of *Ramona,* some eastern tourists in the late nineteenth and early twentieth century even attempted to find the real Ramona, and a small cottage industry emerged in southern California as local photographers sold postcards and photos of buildings that figured in the novel, such as the chapel where Ramona and Alessandro were married or the "real"

home of Ramona—Rancho Camulos. Souvenir photos of Indian women claiming to be the "real" Ramona, or else her daughter, were also hawked to the tourist trade. Nor was Ramona the only female image that tourists purchased.[112]

In 1893 the Merchants and Manufacturers Association of Los Angeles, which consisted of downtown merchants, boosters, and members of the chamber of commerce, came together in an effort to promote local commerce and to increase business in downtown Los Angeles. Their idea: a parade full of "pageantry and spectacle, with a healthy dollop of history tossed into the mix."[113] La Fiesta de Los Angeles only lasted from 1893 to 1902, but each year for one week, Los Angeles's history and its people—Indians, "Spanish Americans," African Americans, and Chinese—paraded through downtown Los Angeles. In all the parades, a "Fiesta Queen" and her court also appeared. This group was usually composed of leading society women "dressed in Spanish finery with *mantillas* draped across their faces."[114] As I discuss in the next chapter, copycat fiestas began to occur throughout California, specifically in San Francisco, Santa Barbara, and San Diego, and in all these festivals, the image of women helped to advertise a Euro-American fantasy and to erase the authentic Mexican history of California. But elite Californios, male and female, continued to contest this erasure, and their memories of specific events continued to challenge the Euro-American revisioning of Californio society and history.

In time the image of Ramona and romantic California was further ingrained into the Euro-American imagination with the introduction of another Californio character—Zorro. Written as a serialized novel by Johnston McCulley in 1919 for the pulp magazine *All Story Weekly,* the story proved so popular that by 1920 it was turned into a movie starring Douglas Fairbanks. McCulley would go on to write another sixty-four Zorro novels and to inspire a Walt Disney television series.[115]

In terms of history, two well-known incidents inspired Bancroft's and Jackson's versions of Californio society as an environment where romance and politics intertwined. The first was the romance between Concepción Argüello and the Russian Count Rezanov in 1806, the second the dramatic elopement in 1829 of Josefa Carrillo and the American Henry Fitch. Various historians and literary scholars have briefly mentioned these incidents but have discussed their significance solely in terms of male desires and agency. A closer examination of these particular unions reveals the changing strategies and social openings

that young women had at their disposal in contesting patriarchal authority and assuming control over their bodies and their choice of mates in the marriage market. Like women in other frontier societies, Californianas in the early nineteenth century were pressured to marry early and to reproduce frequently. Nevertheless, certain women either chose to remain single or went to extraordinary lengths to marry men of their own choosing.

Because one event occurred under Spanish royal rule and the other under Mexican authority, conclusions can be drawn concerning how and when issues of gender became more decisive. Both Concepción and Josefa lived in a society that valued the collectivity rather than the individual and in which concepts of social worth within these relationships and loyalty to the greater collectivities were well established. But the negotiation and spaces between these collectivities allowed for a degree of individual contestation.[116] As I discuss in chapter 2, social cohesion and public harmony were predominant concerns for both civilian government and ecclesiastical authorities. However, contestation also characterized social relations. These episodes serve as emblematic moments of how this community voiced, contested, and resolved various social, political, class, and sexual issues.

What conclusions can be drawn from this series of events? On a grand scale the Carrillo-Fitch trial exposed the societal tensions surrounding issues of marriage and honor. While these public issues were highly relevant, the importance of the private lives of the individuals involved cannot be overlooked, particularly that of Josefa Carrillo. In a society where women were relegated to the background and where historical tradition furthered this practice, Josefa Carrillo emerged from the backdrop of history onto center stage. Josefa's personal narrative to Thomas Savage reveals the individualistic concerns of a remarkable woman. Through a bold, independent act, Josefa came under the public's gaze, and neither while she was undergoing this ordeal nor later did she flinch from the scrutiny. One of the purposes of this book is to correct the rendering of nineteenth-century Spanish-Mexican women as powerless. In fact, many of them managed to find ways to manipulate social norms to their own benefit and to negotiate arrangements that gave them a degree of control over their lives.

CHAPTER 4

⅜

The Legal System and
"a Reckless Breed of Men"

HENRY FITCH WAS NOT THE ONLY AMERICAN incarcerated by Gover
nor José María Echeandía during his short administration. When Jedediah Smith and his fur-trapping party of seventeen men "accidentally" wandered into California in August 1826, they were "the first Americans to enter California's coastal settlements by an overland route."[1] California authorities quickly became suspicious of the party's activities, prompting Echeandía to order the trappers out of the territory—an order that Smith disregarded, resulting in the foreigners' being temporarily jailed. Smith eventually left California, but in the following years four other large parties of trappers, led by Sylvester Pattie in 1828, Ewing Young in 1830, William Wolfskill in 1831, and John Walker in 1833, followed the incursion pattern established by Smith.[2]

Unlike the earlier foreign merchants, this "reckless breed of men," consisting of a growing number of maritime deserters and of fur trappers, collectively cast an expanding shadow on interethnic relations in California.[3] These were the foreigners, according to Bancroft, who contributed to the Californios' moral decline; they were "not all of good character," and their activities began "opening the door to evil customs which were disseminated amongst the men."[4] Some of these hunters, thanks to their marksmanship and ownership of arms, were quickly incorporated into the sea-otter industry, others established trades, and still others settled on the outskirts of communities—far enough away to retain their independence yet close enough to aggravate Mexican authorities with their often disrespectful and arrogant behavior. Many of these newer strangers also married local women if the opportunity arose.

During the postindependence era, as Spanish-Mexican hegemony continued to solidify in the Southwest, more elite Spanish-Mexican women took

advantage of their legal status and privileges under Mexican law. Women as a social category were always legally defined in terms of being either wives or daughters. As a daughter, a woman lived under *patria potestas* (subject to her father's will) until the age of twenty-five and had few legal rights, but if she remained unmarried, she was given complete personal independence upon reaching the age of majority. As a wife, a woman was under the legal protection of her husband, but she could make legal transactions if her husband gave his consent. Once this license was given, a married woman could act with complete freedom in her legal dealings. More important, a married woman retained control of any property she had acquired prior to marriage, and a husband could not force or menace his wife into any legal transaction. As property owners—which made them very atypical compared to most European women—women throughout Latin America, including Californianas, could negotiate greater social space and, at times, could contest their prescribed sexual boundaries.[5]

This chapter examines these later marital alliances in terms of class and the ways in which they influenced political events during the 1830s and 1840s. The emergence of an elite ranchero class made property of any kind increasingly a mark of status and social standing. Because women along with men could own and control property, women were often actors in the legal dramas that unfolded in the late 1830s and early 1840s, adding to the oligarchy's anxieties over social control. A careful reading of legal and property cases involving women indicates that the Californios' lamentations and concerns about women's public behavior and moral decline were more than a nostalgic literary posture. By examining several incidents and concentrating on women's participation in the legal system, this chapter further explores women's social, political, and gender consciousness, elucidating how Californianas contested patriarchal rule through their use of the legal system and showing how their actions and social practices impacted their communities and their own understanding of their position in society.

Revisionist historians contend that a major factor in the dramatic changes in Californio society during the 1830s and 1840s was the introduction of a republican political ideology.[6] Pointing to the use of republican rhetoric by various factions, these historians note the broadening division between the elite oligarchy and the younger generation's sense of political organization and social hierarchy. This republican ideology and language certainly affected the social practices of the younger male generation, but women too were taking advantage of the "opening" created by efforts to liberalize local communities.

As the previous chapter reveals, Governor Echeandía was a strong proponent of the liberal policies of federalist Mexico, and he continued in his attempts to secularize mission lands throughout his tenure as governor of Alta California. Engaging the younger generation with the discourses of republicanism through the creation of study groups, Echeandía drew men such as Mariano Guadalupe Vallejo, Juan Bautista Alvarado, José Castro, and Salvador Vallejo into a discussion free of missionary influences. At the core of Echeandía's republican ideas was the declaration that Indians should be treated as equal citizens.[7] According to Mariano Vallejo, Echeandía criticized the missionaries' relegation of neophytes to a slavelike existence—it was, after all, the neophytes who produced the missions' wealth.

From Echeandía's liberal perspective, once the Indians were granted citizenship, they could demand their parajes from the mission fathers, and as new citizens they could be expected to support the political faction that had granted them their freedom. But in seeking to weaken the church's authority by uniting the neophytes and the rancheros, Echeandía failed to recognize the class and racial tensions that made such a union impossible. By the 1830s mission lands were the most agriculturally developed properties in the territory. Granting mission lands to the Indians—the very lands that most local elites desired to own—was not in the self-interest of second-generation Californios.

Rosaura Sánchez writes that Echeandía was the first authority to criticize the missions as a barrier to successful colonization. If the missions occupied the most fertile and desirable land, while "more than a thousand families of gente de razón did not possess more than what the missionaries were kindly willing to allow them," then why should pobladores settle in California?[8] These ideas, in Sánchez's words, "touched a chord, making it abundantly clear to the younger generation of Californios that property would, must, come from the mission lands."[9] Indeed, as secularization proceeded, the redistribution of mission lands became the means by which many of the younger generation acquired their ranchos.

The embattled Echeandía was finally removed from office in 1831, but his successors still had to contend with unruly foreigners whose actions were becoming alarmingly bold and aggressive and who, like the younger Californios, desired to own ranchos of their own. Adding to the succeeding governors' administrative troubles was the arrival of unwanted Mexican immigrants and a legal system inadequate for mitigating the rising tensions in this developing territory. The need to maintain domestic and social harmony

had been critical to the colonizing agenda of the Spanish crown; along with other colonial legacies, the Mexican government inherited this sensibility.

David J. Weber and David H. Langum point out that the Californios' attempts to stabilize the social order were often undermined by a structurally insufficient legal system.[10] The California legal system in the 1830s and 1840s contained elements of Spanish colonial and Mexican republican law, as well as restrictions inherent in the region's status as a territory subordinate to the authority of Mexico City and the nearest state, Sonora. After approximately ten years under a federalist constitution, Mexico enacted a centralist constitution in 1824. Despite this change, California experienced little change in its legal arrangements because of its continuing status as a territory.[11]

After Mexico achieved its independence in 1821, district courts were established in the northern territories of New Mexico and Alta California, but more serious cases were appealed in the circuit courts in the nearest states. In extremely serious cases, appeals were taken to Mexico City.[12] In local matters Californios turned to the court of first instance. According to Miroslava Chavez, "depending on the matter at issue, the tribunal convened a civil or criminal trial in the first court (juzgado primero), presided over by the alcalde, or a conciliation trial (juicio de concilio) in the second court (segundo juzgado), presided over by the justice of the peace, or juez de paz. In particularly violent and abusive relationships, the alcalde—with the consent of the individual issuing the complaint, usually the woman—would order a criminal trial, treating the physical violence in the home as a crime punishable by possible imprisonment or banishment."[13]

This court system was never fully implemented in the Borderlands because too few lawyers, or even men with a working knowledge of the law, ever immigrated to the remote territories. An *asesor* (legal counselor) was assigned to California in 1830 to advise local officials, but his participation failed to make the system perform adequately.[14] By the late 1830s Californio alcaldes functioned as mayors, justices of the peace, and councilmen, but their knowledge of the laws was often negligible. Centralists in Mexico City finally legislated the creation of appellate and superior courts in both New Mexico and California in 1836, thus granting judicial functions to governors and prefects. However, a decade later "California military officers continued to administer justice when civil courts failed to function."[15]

These halting steps toward a fully functioning court system resulted in a legal system "well calculated to advance its own ideals and jurisprudence of dispute resolution. These ideals included culturally based goals of conciliation

of the parties and, where that was impossible, the use of community pressures, rather than force, to compel adherence to a judicial resolution of a dispute."[16] Because the community's sense of law and order was based on an internalized assessment of local individuals and sensitivity to the way in which decisions would affect the community, the legal records have to be read carefully in order to evaluate what and how gender relationships and exchanges developed. Foreigners often criticized this community-based legal system as inadequate and arbitrary, but they nevertheless operated within its parameters. In Langum's assessment, "the expatriate community avoided the local legal system in some situations and used it for others."[17] The variation in their actions often reflected social and class divisions among the foreigners.[18]

After the Mexican-American War women's legal status changed, but under the Treaty of Guadalupe Hidalgo, property rights as defined by the Mexican government were upheld. Under the new American legal system, Californianas still maintained their rights to hold separate and community property; however, the laws no longer responded to communal interpretations, and women's ability to contest and defend themselves before the courts was shaped by their individual class and economic resources. Like Texas and Louisiana, where the Spanish once ruled, in California the Spanish community-property system was "spliced" with American common law in the 1840s.[19] Legal scholars clearly attribute the rise of women's property rights to this Hispanic tradition, along with frontier conditions, but for the first generation of postconquest Californianas, American property laws limited their legal status rather than advancing it.

Beyond Langum's work, few historical monographs have included or investigated women's legal activities, thereby suggesting that women were insignificant players in the legal arena. However, the Los Angeles County records and the Monterey County Archives from the 1840s reveal that women appeared before the courts for a variety of economic and domestic reasons. These legal documents give a more accurate picture of female socioeconomic agency than can be gleaned from autobiographical accounts alone. Inscribed in the documents are strategies and practices that reveal how women contested social and cultural boundaries. While Rosaura Sánchez and Genaro Padilla rightfully pointed to Californianas' autobiographical narratives as sites of contestation, legal records in which women voice their socioeconomic concerns and defend their actions, and themselves, also reveal female struggles.[20]

In the first systematic study of Californianas' legal participation, J. N. Bowman's article "Prominent Women of Provincial California," the author

correctly categorizes as exceptional women who managed to maintain their rights to land grants through the Mexican period into the American period. While only sixty-six women managed to accomplish this feat, in Bowman's opinion only twenty-six of the sixty-six truly "stand out as the prominent members of their sex during the provincial days," because they were literate. Furthermore, because there were "no fields of literature, theater, newspapers, education, or social work open to them, prominence was possible only in the field dominated by the men."[21]

While providing a brief biographical background for these twenty-two women, Bowman overlooks two important patterns. Most of the women who successfully held onto their land were widows, wives of foreigners, or both. Ten of the twenty-two (some 45 percent) were widows, and six (27 percent) were married to foreigners. Five of the twenty-two (23 percent) were either abandoned wives or spinsters. Thus the number of single women, or women on their own, increases to fifteen of the twenty-two (approximately 68 percent). The pattern of women living alone was the most significant, since widowhood conveyed a certain status on a woman that "often did not overlook her reliance on men or children, but told the community that she was a full-fledged member of the society. Not sequestered, rarely living alone, and often heading a family, the widow had to be so included."[22]

Widows, because of their legal status, had more cultural latitude in the strategies they used to protect their interests and contest the patriarchal order. Being associated with and under the protection of a male authority gave these women's actions greater legitimacy, but even without this "protection" women conducted business and legal transactions, making their needs and desires known. Bowman's statistics also allude to the developing familial pattern in California in which women headed an estimated 13 percent of all Californio households in the post–Mexican War era. It is also a powerful indication that widowed women, whether out of necessity or opportunity, were better able to navigate the changing economic and legal terrain under American domination.[23]

Contemporary accounts leave little doubt that few Californianas were literate, yet illiteracy did not necessarily limit women's knowledge and understanding of their legal rights. Because the laws were sensitive to the community's social and gender relations, and because legal authorities arbitrarily enforced their decisions based on the plaintiff's social standing and communal interests, community members were kept informed of legal developments through oral culture. If information about social, economic, local, and international events

was freely exchanged in these small, close-knit communities, as evidenced in the existing testimonios, women and illiterate persons were also cognizant of their legal rights.

The example of María Rosalía Villalobos, who went before the court on November 4, 1845, to reassert her guardianship over her grandson José de la Cruz Tapia, indicates the level of women's knowledge of their legal responsibilities and duties. María contested Inocente Valdes's "temerity" in requesting the guardianship of her grandson, since she had not waived her rights as guardian "but merely transferred them to Don Luis Bouchet, in whom I have great confidence, and because he is a cousin-in-law of the child and also godfather." This doubly close relationship, in María's opinion, made Bouchet a far better guardian than Valdes, who should have been "classified as a resident of depraved character."[24] She recounted to the court how Valdes "took undue advantage of the friendship he confessed to have with my late son, and during the latter's absence, he seduced his step-daughter, Presentación Duarte, and after having betrayed her, left her in a pregnant condition, as a reminder of his infamous conduct; this untoward incident caused the death of both Tomasa Valdes and of Tiburcio, my aforementioned son, because of the heartaches and disagreements they suffered on that account."[25] María Villalobos stated that she would comply with the decision of the court, but she first demanded that Presentación be questioned. Investigating the situation, the court exposed the plight of sixteen-year-old Presentación Duarte.[26]

Presentación testified that Inocente Valdes had taken advantage of her during her stepfather's absence, forcing himself on her while she was sound asleep, and "unable to drive him away, and desiring to avoid a scandal she consented; in this same manner he took advantage of her three consecutive nights which resulted in her now being pregnant." Upon discovering her pregnancy, an enraged Tiburcio Tapia severely "scolded her and finally he put her out of his house, [as] she lost [the] respect of the family [and] was covered with disgrace."[27] She was sent to live with an aunt, "with the understanding that she [the aunt] had to support her the rest of her life."[28]

The shame surrounding this situation greatly affected both Tiburcio and Tomasa Tapia. Presentación's brother, Ramón, testified that several days before Tomasa's death Tiburcio told him, "Ramón, we are in difficulty, Presentación is in trouble, do not go in to see Tomasa, nor speak to her because she is to blame for the conduct of her brother . . . I cannot see how I can go on, if this trouble does not kill me, I do not know what will."[29] Tiburcio died on August 25, 1845. Concluding that Valdes's acts were despicable enough to

literally shame the Tapias to death, the court found in favor of María Rosalía Villalobos. Presentación managed to survive her moment of disgrace, and she married Matías García on September 3, 1847.

Two years later, María Villalobos reasserted herself as José's guardian, removing Luis Bouchet, and assumed the duties of educating her grandson and equitably managing his property, paying his fair and legal debts, and working for his welfare and well-being.[30] To further ensure the well-being of the minor child and, equally important, to safeguard María's own property, three bondsmen were named: Andrés Duarte, Ignacio Palomares, and Ignacio María Palomares, who would answer all accountings, agreeing "that suit may be brought against them rather than against Señora Villalobos."[31] By acquiring these bondsmen, María Villalobos thoroughly protected her five ranchos— Topanga, Malibu, Sostomo, Simi, and Siguis.[32]

María Villalobos managed to use the law to fulfill both her familial and her communal obligations. She kept a watchful eye over the material and personal welfare of her grandson and still managed to protect her own material possessions. Why these men agreed to take on possible financial risks cannot be determined, but María's ability, despite her illiteracy, to assume the guardianship of her grandson and mitigate possible financial burdens exposes avenues opened to women before the law.

The final chapter in this guardianship case came when Mercedes Tapia, José's older sister, married Léon Victor Prudhomme. In December 1849 Prudhomme petitioned for guardianship and, like María Villalobos, assigned a "surety and guarantor in case of default"—in this instance, his own wife, Mercedes. As had the three bondsmen in the case of María Villalobos, Mercedes guaranteed "with her share of the estate, which her husband has in charge, the management of the property which rightfully belongs to her minor brother," and "that in the event that his interests are impaired through fault or carelessness of Prudhomme, she will pay with her own the entire amount of those of said minor."[33] Unlike the male guarantors, however, Mercedes waived "the laws which may favor her because of her sex and the general statutes applicable thereto."[34] Like her grandmother, Mercedes was illiterate.

In most cases where guardianship was assigned, immediate relatives and kin were the most likely candidates. For example, on June 28, 1849, the newly married Joaquín Machado and his wife, Lorenza Ortega, placed six-year-old Petronila Feliz Ortega, Lorenza's sister, in the custody of Machado's aunt, María Ignacia Verdugo, who was also Petronila and Lorenza's grandmother. Why the orphaned child was not immediately placed in her grandmother's

care is unknown, but since Lorenza was a grown, married woman and the most immediate relative, in all likelihood the authorities deemed her the most appropriate guardian. However, the young couple's decision to dissolve their responsibility for the child so quickly indicates that they saw this relationship as too heavy a burden and resorted to turning over their rights to another family member. In giving guardianship to María Ignacia Verdugo, the grandmother, the couple stipulated "that if during the life of Doña María Ignacio and while the child, Petronila, is under her care, Machado and his wife notice that the aforesaid Senora Verdugo gives her bad example, intentionally or unintentionally, or if she becomes neglectful, or inflicts unjust and cruel punishment that the child cannot endure, Machado and his wife shall likewise have the legal right to reclaim said child before competent authority, until she has been returned to their care. The aforesaid Señora Verdugo is specifically required to teach good habits to the said child, giving her in marriage, if she is in her care at that time, but not against her will."[35] The child's welfare and potential happiness were clearly a consideration, but the couple's apprehensions about their own ability to provide a stable home were justified. Joaquín Machado was stabbed to death on March 17, 1852.

There were exceptions to automatically selecting kin as guardians. Francisco Villa stated that his advanced age and feeble health left him unable to "continue the education of his daughters María, Petra, and María Ygnacia Villa."[36] Villa selected Léon Victor Prudhomme and Mercedes Tapia as guardians; although unrelated, Prudhomme pledged to treat the girls as his own daughters, to protect and keep them, and to give them "the necessary education, teaching them the Christian doctrine, and the duties they are able to perform, and in due time allowing them to marry according to their wishes."[37] Francisco may have made a point of including the need to teach Christian doctrine because of his eldest daughter's infamous act of killing her husband, discussed later in this chapter.

Returning to Bowman's premise that maintaining ownership into the American period distinguished exceptional women, it should be noted that he fails to examine the extent to which women were involved in land transactions during the Mexican period and before the American-imposed legal system was set in place. Women's ownership of land varied, depending on the means and needs of each individual woman. For example, Soledad Felix, widow of Francisco Serrano, and her twenty-one-year-old daughter, Luisa, decided to sell their portion of Rancho Temescal "because their sex prevented them from taking care of same, with the result that they did not derive any

benefit therefrom."[38] The purchasers, however, were Antonia Serrano, daughter of Soledad, and a Señora Felix, most likely a female relative, whose gender presumably would not prevent them from taking ownership and utilizing the land.

Other examples of land transactions exclusively between women include that of Andrea Avila, who sold her rights to Rancho Ana Yorba—rights she had inherited from her mother, Andrea Yorba—to Vicenta Sepulveda for one hundred pesos on March 23, 1847. On December 7, 1849, the aforementioned María Rosalía Villalobos and her daughter, Tomasa Tapia, sold their vineyard to Fernanda Tapia, María's daughter and Tomasa's sister.[39] These transactions not only reveal amounts of land and material goods exchanged between women, they also give us a cognitive map of the way in which individuals were socially connected and demonstrate how deep certain female relationships ran. When Rosalía Ochoa, a widow, entered into a sales contract with Juan Apablasa, the conditions of the contract stipulated that she would place in Apablasa's trust her orchard, "consisting of 643 vinestocks, 2 large fruit trees and 12 small trees with a half hedge, and growing on a tract adjacent to the properties of Don Encarnación Sepulveda, Don Juan Ramirez and Doña María Poyorena (Pollorena): which tract measures 83 varas in length and 72 varas in width."[40] If Rosalía Ochoa were to die before the year 1849, valuing her share of the orchard at two hundred and fifty pesos, Apablasa was to pay her funeral expenses and pay the rest to her neighbor, María Pollorena.[41] In another transaction, Luisa Domínguez sold a thirty-one by thirty-five vara lot located on Eternidad Street, which had been given to her before marriage, probably as her dowry, to Francisca Moreno.[42]

Women, particularly sisters and daughters, were frequently named as benefactors. Lacking immediate family, Rosalía Ochoa left her small inheritance to her nearest neighbor and seemingly closest friend, María Poyorena (Pollorena). When Manuela Villa died, she left her two sisters, Pilar Villa and Mercedes Leyva Villa, a city lot with a two-room adobe structure on it, as well as "nineteen joists, seven varas long, and nine, five varas long, all sawn pine lumber; two doors and two windows, and a note of Don Juan Pablo Peralta in the sum of one hundred pesos."[43] On February 19, 1850, the two sisters decided to sell this inheritance "of their own free will, and [it] has been the impelling motive of their desire that the contract be executed because its results will be beneficial to both."[44]

Just as land transactions reveal female networks, the few surviving wills of Californianas not only articulate and record the personal and social

activities of women but also open a window onto the material culture of these women's households and reflect their personal choices and decisions.[45] Similar to other Spanish-Mexican women throughout the colonial and Mexican periods, Californianas expressed emotional warmth—as well as bitterness and resentment—and made their desires known by the dispersal of their material goods after their deaths. In her study of New Mexican women, Deena González posits that after the Mexican-American War, "will-making became, among women, the primary means of preserving inheritances and of keeping property out of the prying hands of Euro-Americans."[46] For upper-class women especially, retaining their inheritance and property were acts of resistance against Euro-Americans "through the artful composition of final wishes carefully considered."[47] Important familial relationships were revealed when children, not necessarily the oldest, were made executors and administrators of wills and estates. For example, Josefa Ballesteros appointed her godson, Francisco Ballesteros, and María Gabriela Pollerena appointed her compadre, Hilario Machado, as executors of their respective wills.

Most important, wills also provided the historical evidence that Californianas were often small capitalists who engaged in commercial exchanges on their own behalf. The itemized business transactions described in Josefa Cota's will, along with other business records, indicate that she was a woman at ease in conducting transactions for herself. For example, on October 16, 1843, she proposed the purchase of her ranch to Abel Stearns, Juan Leandry, and Antonio María Lugo for five thousand pesos. In April 1845 she was listed as the second largest creditor, at six hundred pesos, among nine creditors to whom Rafael Gallardo owed money. Upon her death two years later, she left a house of "six rooms, a back-yard and a vineyard with one thousand and some odd grapevines and some fruit trees" to her nine surviving children. Like the majority of male Californios who left wills, Josefa Cota died in debt. She owed Vicente Guerrero two barrels of *aguardiente* (brandy, liquor), José Cot a piece of printed calico and two shawls, Apolinaria Lorenzana 6 pesos, Tomás Spark 112 pesos, and Julio Cretaine and Nepomuceno Alvarado 3 pesos each.[48]

In one of the most interesting wills of this era, Joaquina Machado left as her sole heir her illegitimate daughter, María del Rosario Angeles, naming her mother as the child's guardian. Comparing Joaquina Machado to Presentación Duarte reveals the varied responses to women bearing illegitimate children.[49] Whereas Presentación's rape brought shame on the Tapia family, Joaquina's material possessions speak of middling wealth, and her will makes no note of public shame. She listed her possessions as:

a suite of household furniture, composed of one dozen chairs; four large and four medium-size mirrors; an image of the Holy Christ; three trunks, two empty and one filled with clothing and jewelry, as follows: Two gold necklaces, two pairs earrings, one pair ear drops, four gold rings, one cape, four silk woman's head shawls, two silk cloaks, four silk dresses, four white lawn dresses, four striped dresses, four silk neckerchiefs, eight woolen dresses, and other trifles . . . two bedsteads, one common and one with turned legs and the respective curtains and mattresses. . . .

Six muslin dresses; three calico; one flannel and three lawn; one pair corsets; one embroidered anquera [round covering for the hind quarters of a horse]; three silk woman's head shawls; one shawl; three lace handkerchiefs, one black and two purple; two silk handkerchiefs; seven sets white linen underclothes; two silk sashes; one pair silver brooches; three used bedspreads and one new; one large kettle; one wool and cotton cape; two iron pots and one frying pan; two pair stockings, one silk and the other cotton; one pair satin shoes; four cushions, three silk and one woolen; seven pillow cases; two overgilt pitchers; one glass goblet; one drinking glass; one platter; one tin coffee pot; two cotton woman's head shawls; one silk dress.[50]

Joaquina also possessed an orchard, a large still, and half a share in her mother's house, which consisted of "four rooms and a hall, made of lumber, with doors and windows, and panes on the windows."[51]

At no point does Joaquina Machado indicate that her wealth was inherited, nor does she apologize or express shame for having sexually and morally transgressed by bearing an illegitimate child. Why Joaquina, twenty-five years old at the time of her death, never chose to marry remains a question, as well as why she never named the father of her child, but her ability to accumulate wealth through her own means indicates that illicit sex did not automatically mean one was ostracized and banished. Scattered listings of hijos naturales in baptismal records indicate that Joaquina was not alone in giving birth to an illegitimate child, but few single women had as much material wealth to bestow and to guarantee the welfare of their children.[52]

One of the reasons Joaquina may not have been ostracized was that she gave birth to an hijo natural, not an *hijo espurio*. The former designates a child whose parents were eligible to wed but did not do so; the latter was the term used for children conceived in adultery. This reinforces the question of why Joaquina and her lover did not marry.

If women appear throughout the Los Angeles County records and the Monterey County archives during the 1840s and 1850s, why then have historians failed to incorporate them into the larger social fabric of Californio society? There are two possible explanations. The first is the paternalistic nature of the legal system, in particular the conciliation process under which most court decisions were made. These decisions were determined collectively by "*hombres buenos*" (good men) and the alcaldes who acted as "'father-figures' to assert gentle pressures upon the disputants to reconcile themselves and accept a face-saving settlement."[53] Alcaldes, according to a contemporary legal theorist, were "'citizens chosen as fathers of the country,' and 'true fathers of the pueblos.'"[54]

Another possible reason for marginalizing women's participation was the frequency with which women gave their power of attorney to men. Documents dealing with power of attorney are the most numerous legal instruments in the extant public records from this period.[55] Men frequently acted on behalf of women, but under previous sexual and gender-biased interpretations this process was easily interpreted as women's needing the "protection" of men within the court system. Adding to these notions of female subordination was the customary inclusion of the legal phrase "with the prior consent of her husband," indicating that women's choices and decisions were dependent on the authority of their husbands. In all, men were seen as the principal actors, exerting male influence on female decisions. I argue that Californianas recognized this postwar legal shift and modified their actions accordingly. The fact that more women were giving their power of attorney to men after the Mexican-American War than before—a pattern that Deena González also found in New Mexico—highlights how women's actions exposed their personal and social concerns. This first generation of women who survived the American conquest met the legal challenges by more closely complying with American standards without totally sacrificing their authority over their own property.

Among the most important factors involving women's granting their power of attorney to men were the specificity and limitations they placed on this legal proviso. At times women did give their "attorneys" complete power over certain ventures; however, women also placed limits on the power of these "attorneys." For example, on November 30, 1848, Guadalupe Valencia had José María Deporto arrange the sale of her two-room home to José María Herrera for 150 pesos, with the condition that Herrera build on two more rooms in which she would live. In October 1847 Carmen Guirado, widow of Santiago Johnson, having "to attend to several matters in connection with her office and

personal matters," appointed Don Narciso Botillo as her general attorney in fact.[56] Within two years she revoked this power of attorney, "without impairing the good name and reputation of said Botello," and named her son, Francisco Johnson, as her representative.[57]

Some couples did experience conflict over issues of power of attorney. In 1849 Francisca Uribe, widow of Juan Bautista Leandry, revoked her power of attorney from Agustín Olvera, "whose absence from the city left her without representation before the Court."[58] When María Tosto, mother of the deceased Leandry, filed suit for half of Rancho de los Coyotes and the Cañada de la Habra land grant, as well as for half of the stock sold from these properties, her husband, Francisco Ocampo, was absent. María Tosto, through her attorney, Antonio José Cot, demanded a settlement of 16,000 pesos in silver in order to free the properties from any litigation—a necessary point considering that Francisca had sold the properties to Andrés Pico. Francisca Uribe attempted to resolve the dispute on her own, but on December 15, 1849, Francisco Ocampo filed a petition to nullify this action since it had taken place without his knowledge and during his prolonged absence.[59] Upholding his position, the two women reached an agreement on May 14, 1850, this time with Francisco Ocampo's full consent.

Women understood that they had legal recourse and that marital and familial alliances influenced but did not determine their choice of the right man to protect their economic interests. Rather than interpreting such transactions as reinforcements of stereotypical gender roles, we need to see how these transactions, like wills, pushed against patriarchal boundaries and helped to fulfill women's desires and needs.

Widows were given a considerable degree of social latitude in business transactions, but wives were also occasionally given power of attorney by their husbands and were sometimes allowed to conduct transactions for the benefit of the couple's well-being. For example, in 1841 José Abrego granted his wife, Josefa Abrego, the right to buy and sell their real property, and in 1849 Cayetana de la Serda paid off her husband's debt of 808 pesos, 1 real, and 6 grains from their property, of which she was in charge.[60] During the gold rush, John Temple, a Los Angeles merchant, loaned silver pesos to five women, two married, one a widow, and two single. Each woman promised to place personally in Temple's "own hands for her account and at her risk in one lump sum and not in other kind or species" various amounts of placer gold. Temple charged no interest on the loans, but all the women mortgaged a piece of property. Pascuala García de Aguila pledged to mortgage "a piece of land

she had purchased on May 5, 1845, from Manuel de Olivera, as is evidenced by the deed of sale," along with "everything that she has built on said land." Her husband, Lugardo Aguila, agreed with the "tenor of the instrument," since "the money is received for the maintenance of both and their family."[61] For her part, Antonia Pérez pledged "the share pertaining to her by inheritance from her late father in the ranch called Paso de Bartolo which has not yet been divided between the heirs."[62]

The legal system was emblematic of many aspects of Californio society. Prior to 1848, local conditions were often inadequate to implement the governmental policies meant to facilitate settlement. Liberal political and social ideas were introduced, but the local status quo still moderated their implementation. As tensions between the younger and older generations and between older and newer immigrants grew, women increasingly contested the patriarchal authority of their fathers. New immigrants increased the number of potential marital choices, and in the 1840s many Californianas paid the consequences of selecting badly from among the newcomers. Intermarriages continued to incorporate foreigners into the fold of the Californio elite, but as the population grew, the most desirable lands were already taken. Newcomers increasingly interpreted the protocol established during the initial stages of colonization as an obstacle to their efforts to establish their own homesteads and ranchos. For their part, the new wave of Euro-Americans resented the need to become naturalized citizens, convert to Catholicism, and marry a daughter of the land in order to become landowners. These growing social tensions concerning patriarchal, communal control over both women and newcomers came to a head in 1836 in an incident involving a wife murdering her husband. Along with this there was a growing resentment by Californios toward newer Mexican immigrants. This resentment and social anxiety needs to be understood before we discuss the 1836 incident.

Elite Californios had long been displeased with the inattentiveness that the Spanish and Mexican governments showed toward their demands for a better quality of settlers. Initially, it was the church and the government authorities who voiced the complaints, but by the 1830s the elite Californios themselves questioned the character of those who were sent to become their neighbors. With the growing solidification of a distinctive Californio identity and its subsequent social, cultural, and political investments, the elites' resentment toward the Mexican government's perceived irresponsible and half-hearted attempts at encouraging immigration increased. Californios were particularly

offended when the Mexican government, in their opinion, emptied the jails of Sinaloa and Sonora and encouraged the former prisoners to settle in the northern provinces. Between 1825 and 1830, approximately four hundred of these petty thieves and political prisoners arrived in California. The "convicts usually arrived in a state of wretchedness exceeded only by that of the Indians. Bands of these so-called cholos (scoundrels) would brawl drunkenly on the public streets and commit theft and other assorted misdeeds—even homicide— while the political prisoners among them organized rebellions."[63] In the 1830s California became the site of several colonization plans, all of which ended in failure and increased divisions within the Californio elite.

In their desire to populate and govern their territory, both Mexican and California authorities supported the most notable colonization scheme of the period, the Híjar-Padrés colony of 1834. Primarily motivated to discourage heightened British interest in the possible occupation and annexation of California, the Mexican government finally carried out the promises of the Constitution of 1824.[64] Under Valentín Gómez Farías, a longtime proponent of colonization of the northern territories who became vice president in 1833, the federal government was given special powers "to enable it to reestablish order and consolidate federal institutions; the special powers were to be used in the territories and frontier or coastal areas."[65] Loosely interpreting these special powers, Gómez Farías envisioned the successful secularization of mission lands, the division of civil and military commands, and the recruitment of several thousand artisans and their families as the means to bring the center and the periphery of the new Mexican nation into harmony. He selected José María Padrés as *comandante general* of the troops and José María Híjar as director of the colony, whose role was to recruit potential colonists from throughout Mexico. By January 1834 Padrés submitted to the minister of foreign relations a list of 210 colonists, many of them artisans.[66]

Californio resentment and hostility were quickly manifested and directed toward the leaders of the colonization company. In Antonio María Osio's opinion, Híjar and Padrés were merely "two excellent schemers" intent on lining their own pockets, who had duped not only the government but also the colonists. False promises included paid transportation for the colonists, as much land as they could cultivate, Indians to work the new farms, free licenses to hunt otters, and assurances that cows could be had at only one peso per head. If they succeeded, Padrés and Híjar stood to grow rich off the speculation in mission lands.[67]

More colonists joined the expedition as it traveled north; eventually, 239

colonists shipped out of San Blas to San Diego. The average age of the colonizers was twenty years; seventy-nine children were under the age of fourteen. Only fifty-five adult women, most of them married and traveling with their husbands and families, were in the group. While the enlistment rolls named teachers, lawyers, a doctor, a carpenter, a distiller, a tailor, and a shoemaker, the majority of the male colonists were farmers.[68]

From the moment the colonists arrived in California, they were met with public hostility. Coinciding with their arrival, Gómez Farías was overthrown and his replacement, Antonio López de Santa Anna, rescinded Híjar and Padrés's right to establish a colony. Despite their distrust of the newcomers, some Californios assisted the colonists, who had suffered great hardship in their journey. One of the colonists, seventeen-year-old Agustín Janssens, noted the generosity of the women, in particular María Ignacia Carrillo and her daughter Ramona, who "did everything possible for our comfort, giving us milk, green vegetables, fruit, and whatever else we wished, or which they saw we needed, without accepting a single centavo."[69] But human kindness extended only so far; these new colonists remained a political threat.

Into the political minefield that was Californio politics, Híjar and Padrés proceeded with their efforts to assume their federally commissioned political power. For their part many Californios, particularly those who supported the governor, accused the men of fomenting rebellion and usurpation. The colonists were "continually accused of plotting revolution[,] plots which I believed existed only in the fevered brains of their accusers," Janssens rightfully observed.[70] After several months of political maneuvering, José Figueroa had the two leaders arrested and repatriated to Mexico. Writing a pamphlet titled "Manifiesto a la República Mexicana," directed not only at Californios but also at the federal powers, Figueroa espoused the political language and metaphors of his colonial predecessors, justifying his actions as the only means of saving the "tranquility," "virtue," and "order" of the government.[71]

A number of the Híjar-Padrés colonists chose to remain and integrate, according to their talents and skills, into Californio society, but they had arrived at a particularly turbulent time. These new Mexican immigrants, similar to the Euro-Americans, were prone to question the motivations and control of the Californio oligarchy and were also interested in gaining land ownership—preferably from the missions' holdings. In 1836 the worries of the Californio oligarchy were borne out. In two separate incidents, Euro-Americans and members of the Híjar-Padrés colony openly contested the authority of the ruling oligarchy.

Known as the first vigilante action in California history, the Villa-Alipás episode signified more than the execution of two people for murder. The events leading to this dramatic event began in 1834 when María del Rosario Villa abandoned her home and husband, Domingo Felix, in favor of her vaquero lover, Gervasio Alipás. Although María has been vilified by most contemporary male accounts as a "bad" and "evil" woman easily governed by her immoral passions, Rosaura Sánchez credits Domingo's infidelity with causing María's loss of affection. For two years, the husband attempted to reconcile with and retrieve his wife.[72] Following the practice of the community, the husband petitioned the alcalde, Manuel Requena, to assist him in restoring peace to his troubled household. Confronting the couple at a public fiesta at the San Gabriel Mission in late March 1836, members of the *ayuntamiento* (town council), symbolizing and representing the community's moral authority, convinced María del Rosario to return to her husband.[73] On March 26, 1836, the body of Domingo Felix was found near the San Gabriel Mission. The authorities quickly suspected the two lovers and soon apprehended the fugitives, jailed them, and prepared for a criminal trial.[74]

Popular opinion condemned the lovers. Fearing legal delays and possible leniency by the governor who would decide the case, a group of men organized themselves into the Junta Defensora de la Seguridad Pública (Public Safety Defense Council).[75] Two leaders emerged, Víctor Prudón, a member of the Híjar-Padrés colony, and John Temple, an in-law of the murder victim. Fifty-five men joined this junta: thirteen were Euro-Americans, the rest were mostly members of the Híjar-Padrés colony, and a small number were native-born Californios. Arming themselves, the vigilante committee removed the couple from the jail, questioned, tried, and sentenced them. Each party accused the other of the murder, deepening the committee's thirst for retribution. Found guilty, the two were publicly executed. The townspeople were "especially enraged that Villa's infidelity should have led first to the fragmentation of the family and then to murder, so much so that at first they wanted her to die contemplating the corpse of her lover so that she would suffer more."[76] At the last moment, Villa was spared that indignity and quickly executed.

The extremity of the punishment speaks to the local tensions in Los Angeles. As Michael González points out, one must read the Villa-Alipás incident in a broader political context. In 1836 Alta California was seemingly on the edge of revolt. The new centralist Mexican legislature had just enacted the

Constitution of 1836, following the loss of Texas to the Americans, and the northern frontier was again politically reorganized. States and territories were converted to *departamentos,* and in order to unify the nation, all state and territorial governmental authority was to reside in the office of the newly named governors, who exercised this authority through district prefects and subprefects. The representative government of the ayuntamientos was allowed only "in the capitals of departments, in inland towns over 8,000 and coastal towns over 4,000, or in places where an Ayuntamiento had existed prior to 1808."[77] Los Angeles remained an ayuntamiento, but the governor's and prefects' newly acquired political power could effectively oppose and block the economic and political interests of the newcomers as well as those of the older settlers. After the executions an investigation was quickly ordered, prompting Víctor Prudón to write a fifteen-page defense of the vigilante committee. Casting the vigilantes as "virtuous citizens" who feared that the city council would thwart "the justice of their demands," Prudón ended by submitting to the power of the authorities.[78]

The similarities between the Villa-Alipás and the Carillo incidents are striking, because both exposed larger social frustrations with political power and authority. In both incidents the male authorities defended their actions as protecting the morality of the republic, reestablishing social order, and upholding the recalcitrant couples as examples of aberrant and punishable behavior. In the Villa-Alipás affair, however, other factors were in play. For example, in the same year in Monterey a corporal and his female confederate murdered a man and were tried in a civil court. The man was sentenced to ten years in a Mexican prison, and the woman was confined to a mission for two years.[79] Because other murder cases involving women did not provoke a public response as did the Villa-Alipás affair, Rosaura Sánchez posits that this incident "provides a good indication of the people's intolerance for what was perceived as the ultimate transgression on the part of the woman."[80] But clearly it was not just the exceptional act of a wife killing her husband, but the added participation of the Euro-Americans' sense of frontier justice that motivated this particular response. For example, other women abandoned their husbands and chose to live alone. María Josefa Boronda married James Walter Burke on January 9, 1829, in Monterey, but she soon relocated to Santa Barbara, where Burke was engaged in trade. By the late 1830s Burke had abandoned Josefa and was living in concubinage with María Pegui, a single woman who, according to Padre Durán, "followed her Irishman around wherever he went." Calling on

the local prefect to uphold the morals of the parish, the priest requested that María Pegui be expelled from Santa Barbara. The prefect complied, expelling the young woman on July 1, 1840.[81]

It is not known whether María Josefa had instigated the banishment by requesting assistance from the priest, but the removal of her rival did not alleviate her domestic situation, and she was totally abandoned by October 1842. Dictating a letter to Thomas B. Park, Josefa solicited Abel Stearns's assistance in collecting four accounts:

> I take the liberty of inclosing a list of those persons that have accounts with Mr. James Burke, my husband. The sums have been long due, and it is high time they were paid. Please take my situation into view, without my husband here to attend to business, & with a large family to support, which if they will reflect upon I think they will hardly refuse to settle with you. I should like that you would take some trouble in procuring a settlement, at present what I have said, you must be convinced that I much require these attentions for the sake of my family.[82]

The couple continued to live in Santa Barbara, but not under the same roof, and Burke remained a resident of the port until his death in 1878 or 1879.[83]

In 1842 Teodora Soto, widow of Guadalupe Barcenas, was granted rights to Rancho Cañada del Hambre. She attempted to build an adobe house to establish permanent residence, but heavy rains ruined her efforts. Though she married Disiderio Briones in the late 1840s, domestic tranquility apparently eluded her—officials recorded that she alone built a *palizada* house on the junta's land grant. By 1853 she was known as the "widow Soto" and was living on the west side of the valley in a house of poles and skins, even though her husband was still living in Marin County. Teodora did not divorce her estranged husband; she merely killed him off metaphorically and conducted herself in the manner of a widow. Although she was unfortunate in her married life, in December 1866 she was granted a land patent for 13,353.95 acres.[84]

Unhappy marriages seemed to have run in the Briones family. Disiderio's sister, Juana Briones, married Apolinario Miranda, a soldier at the San Francisco presidio, and together they were granted land rights to Rancho Ojo de Agua de Figueroa in 1838. Sometime after 1840, Juana's domestic relationship deteriorated to the point that she petitioned the bishop of San Francisco for separation from her husband. Alone, she purchased Rancho Purísima Concepción, built an adobe house, cultivated fields, and raised stock. Following the pattern of widowhood in the Southwest, she provided social

services to her community: "assistance to deserting seamen, providing milk, vegetables, and yerba buena tea to callers, serving her neighbors in sickness and childbirth, giving testimony in the collection of data for the beatification of Padre Catalá." In 1871 she received a patent for Rancho Purísima Concepción consisting of 4,439 acres; her husband won a patent for Rancho Ojo de Agua de Figueroa, consisting of 1¾ acres of land.[85]

Another woman who skillfully managed a rancho and escaped the intimate confines of marriage was Catarina Manzaneli de Munras, wife of Estévan Munras, who resided in Monterey by the early 1830s. She may have left her husband in Mexico, as no California source notes his ever living in California. A woman of some wealth, in 1832 she purchased Rancho Laguna Seca, where she raised her children and several orphans. Spending five hundred dollars on improvements and having the financial means to build a wooden house, she alone managed the property and household.[86]

María Rita de Valdez de Villa, a resident of Los Angeles, entered into a common-law marriage with Luciano Valdez soon after her husband's death. Although they were jointly granted rights to Rancho Rodeo de las Aguas, it was she who stocked the rancho with cattle and horses, built two houses, registered a cattle brand, and maintained the acequias (irrigation ditches). The arrangement was not harmonious, and María Rita finally petitioned the alcalde, who removed Valdez from the property, having judged him a "bad" character. Luciano Valdez continued to aggravate María Rita by building "a house back of hers then built one in front, had to use the water from her well, had no stock of his own and borrowed her cows for milk, and opposed her planting grapevines."[87]

In such small communities, how did the examples of these women living independent lives affect the overall female consciousness toward patriarchal order? Did it encourage women to seek more flexible arrangements or to remove themselves from their specific patriarchal arrangements if they were living in unhappy situations? The factor that distinguishes María del Rosario Villa, executed for an alleged murder, from these other women "living on their own" was the other women's compliance with the communal and legal system's structures of reconciliation. As Langum shows, the 1840s were marked by an increase in cases of separation, abandonment, and divorce, signifying that domestic relations were as troubled as social and political relations. Filing for separation, by either a wife or a husband, was the most common type of case dealing with domestic issues, while divorce proceedings were the most unusual. Langum argues that couples often filed for separation not to end

their marriages but "to put the other party in a position of public exposure and disgrace."[88]

By exposing displeasure with a spouse, a husband or wife enlisted public censure to "air grievances, obtain counseling, and modify spousal behavior."[89] Langum notes the high success rate of reconciliation, which he places at 85 percent, as evidence of the viability of this communal legal system, particularly for women. On the other hand, this meant that 15 percent of the cases did end in divorce or permanent separation, which forced the community to accept these "women living on their own." In the small, insular communities, such women were regarded as constant symbols of social and domestic disturbances and as women capable of slipping out of direct patriarchal control.[90]

The persistence and importance of this legal custom can be seen even after the American conquest. For example, during the late 1840s and early 1850s, Pedro C. Carrillo and his wife, María Josefa Bandini Carrillo, were continuously at odds. Pedro's "disposition" was the main cause of the lack of "peace, tranquility, happiness, and general welfare of [his] wife and family." When María Josefa adamantly declined to continue to live with him and sought protection under her father's roof, Pedro pledged to "change my hitherto disposition; never by words or gesture to do anything that may cause, or be calculated to cause her pain or disquietude." Pedro enlisted his brother-in-law, Cave J. Couts, as his witness, and the Carrillos remained married.

Airing out grievances reconciled many couples, but a noticeable pattern among the women's complaints involved physical abuse and extramarital sexual relations. Ending an abusive relationship too often meant ending the union. For example, on March 18, 1842, María Guadalupe Castillo sued for separation from her husband, Edward Watson, on grounds of frequent ill treatment. Watson finally agreed to a legal separation and was ordered to pay twelve dollars a month in support.[91] In another case, María Dolores Valenzuela had lived for several years out of wedlock with Justo Morillo, but on May 25, 1848, she filed for separation after Morillo threatened and maltreated her. Deciding to "withdraw from her unhappy life with him and to be freed from his control and authority," she desired to regain her status as a free woman, as "the said Morillo has threatened to kill her." Being a free woman would leave "her legally free to prosecute the aforesaid Morillo, when permitted in justice for assault upon her person, in case the aforesaid Morillo again threatens or maltreats her."[92]

The number of interethnic marriages that ended in separation or divorce was also significant. On November 10, 1842, María Francisca Butrón sued

William Robert Garner for divorce. The latter's sexual involvement with María Ignacia Amador instigated the proceedings, but the couple had repeatedly separated prior to the divorce settlement.[93] In 1837 María de la Luz Valencia left her common-law husband, William Wolfskill, to follow her lover, Francisco Araujo, to Mexico.[94] As previously mentioned, Jacob P. Leese abandoned his wife, Rosalía Vallejo, and Angustias Noriega de la Guerra sued for divorce from her husband, James L. Ord, in 1856, on grounds of adultery. During the 1840s marriages between Californianas and the second wave of Euro-Americans were far less stable than previous ones.

Because extant marriage records from this period are incomplete, a thorough statistical analysis of interethnic marriages has yet to be completed. Several scholars place the percentage of interethnic marriages between Californianas and Euro-Americans at roughly 15 percent of the total Californio population.[95] In his study of Rocky Mountain trappers and traders, William R. Swagerty notes that only half of the trappers who entered California married Californianas, but as a group, 10.2 percent of all trappers and traders eventually separated from their wives.[96] Combining these two studies with my preliminary inquiry, the numbers reinforce the pattern of an important shift in interethnic marriage patterns during the late 1830s and 1840s. Euro-Americans who settled in California after 1836 were less likely to abide by the customary social mores.

The Villa-Alipás affair was actually the second incident in which the potential violence of foreigners threatened the authorities' peace of mind. In 1832 a band of fifty Euro-Americans formed the Compañía Estranjera (the Foreign Company) and begun to drill, patrol, and support the rule of Governor Agustín Zamorano. In response, a southern political faction headed by the Carrillo and Pico families threatened arms against the governor. Eventually, peace was negotiated and the Compañía Estranjera voluntarily disbanded. Members of the Compañía included William E. P. Hartnell and several leading foreign Monterey merchants, but southern Euro-American traders and merchants such as Abel Stearns also supported the company. Personal and business interests prompted the men's support of Governor Zamorano.[97]

This action alarmed the authorities. A band of fifty well-armed men could easily tip the balance of power in California, and many members of the Compañía Estranjera were married to Californianas or had close business ties to elite Californios. The foreigners defended their actions as an effort to protect their private property—a legitimate action in the eyes of the authorities—but the foreigners' actions also pointed to the limits of official power. The authorities

could not disband the foreigners, just as they could not force a woman to continue living with her husband if the arrangement no longer suited her. Women and foreigners were not behaving, as male Californios constantly complained in their testimonios.

The actions of the Compañía Estranjera motivated authorities to monitor foreigners and Californios who owned weapons more closely. Beginning in 1833, the Los Angeles ayuntamiento passed several ordinances banning *paisanos* from carrying weapons.[98] Routinely disregarding these ordinances, many individuals doubted the ability of civil and military authorities to provide sufficient protection from the increasing banditry and revolts. For example, after arresting the Spaniard Antonio Apalátegui and the Mexican Francisco Torres in 1835 as leaders of a Sonoran-based plot to invade California, Juan Bautista Alvarado informed the Los Angeles town council that he was unable to "comply with your request for an armed citizenry, which you make in your official communication of today, and I have made every effort possible to provide and arm 20 or 30 men."[99]

Various officials had attempted to organize a civilian militia, but lack of adequate arms resulted in continuing failures. As Francisco J. Alvarado described the situation, "the residents have made it known that most of them have no arms; the foreigners may have some, but they refuse to lend them, because they state that under the present circumstances they need them for the defense of their persons and property against any outrage which the *Sonorenses* (Sonorans), who are still in town may attempt."[100] With the help of the foreigners, the threat was put down and the Compañía Estranjera quietly disbanded, but the political arena was still troublesome for the authorities.

In 1836 another band of foreigners armed themselves and entered the political fray. This group consisted of "twenty-five to thirty English, Irish, and American adventurers" siding with the northern forces of Juan Bautista Alvarado.[101] Naming themselves the Rifleros Americanos and led by Isaac Graham, a Tennessee fur trapper who was also a grog-shop owner and distiller, these armed foreigners soon demonstrated their disruptive potential. Unlike the earlier Compañía Estranjera, the Rifleros Americanos did not disband once their candidate won political office. By 1840 their belligerent presence and bellicose language directly threatened Juan Bautista Alvarado himself. Demanding land and money from the governor, these men, some of whom were married to Californianas, indicated the growing reluctance of this "reckless breed of men" to acculturate and accept the cultural norms of Californio society.[102]

For four years, the Rifleros Americanos posed a potential social and political threat. As they had done in 1833 and 1836, officials in 1840 surveyed the citizens capable of bearing arms; as before, Euro-Americans were heavily represented on the list.[103] Perhaps the desire to assess the extent of gun ownership happened to coincide with these disturbances mounted by foreigners, but more likely it was an effort to determine the potential threat to the social order posed by newcomers, both Mexican immigrants and Euro-Americans. Unable to disassociate himself from the foreigners who had supported him, Juan Bautista Alvarado was relieved from his political dilemma on April 3, 1840, when the pastor of the San Carlos Mission in Monterey informed the authorities of a planned insurrection by the Rifleros Americanos against the government. While receiving the last rites, an American trapper named Tomlinson, husband of María de Jesús Bernal, implicated Isaac Graham and his company in a plan to seize Monterey. A secretly called special junta meeting produced orders for the arrest of "all foreigners who did not have permission to reside in California—all, that is, except those married to hijas del país, or engaged in well-known and honorable occupations."[104] Sixty-five foreigners, among them Isaac Graham, were arrested, and forty-five were deported to Tepic, Mexico.[105] After five months of imprisonment, through the intercession of Eustace Barron, the British consul in Tepic, the charges were dropped. Eventually, twenty of the exiles returned to California, but the mostly unwanted and unattached faction had been successfully removed.[106]

Californios and Euro-Americans alike championed the removal of this group. John Chamberlain, a blacksmith who made fetters for the prisoners, remembered that when placing the irons on the prisoners he had commented to Thomas O. Larkin that he hoped they would soon return, to which "Mr. Larkin said he hoped not." David Spence went even further and called them "a pack of damned rascals" deserving their punishment.[107] Conducting business in California made many foreigners immediate friends and allies; however, intimate contact often brought out personal hostilities. Accusations of underhandedness, deceitfulness, and outright thievery plagued some of the business transactions in this insulated business community. On March 25, 1834, William Day accused Abel Stearns of knowingly selling him sour wine and demanded a refund. Stearns refused, claiming that Day should have examined the wine more thoroughly before he purchased it. Day pulled out a knife and repeatedly stabbed Stearns, who survived the near-fatal attack but was left with a speech impediment and facial scars.[108] For the most part, Euro-Americans preferred legal battles to fisticuffs, but Hugo Reid's business dealings were so

exasperating that he declared in 1834, "St Paul says— 'For we trust we have a good conscious' [*sic*]—St Paul however spoke for the Corinthians and not for the Bostonians.—Lord! Lord! Seeing is believing—Gracias a Dios I am hand-carted and wheel borrowed."[109] National ties reinforced some associations, but successful business deals proved more lasting and fundamental.

The junta's exemption from the arrest order of men married to Californianas deepened the context of women's influence in the political arena in the 1830s and 1840s. Evidence indicates that men married to hijas del país also conspired with Graham. For example, William Robert Garner, the British deserter married to María Francisca Butrón, had been a Riflero Americano in 1836; when Garner was not arrested with the others, Graham suspected him of being an informer. After Graham returned to California from his Mexican deportation, he filed a libel suit against Garner, but he eventually lost.[110] The irony of the situation should not be overlooked: the very proviso that gave Juan Bautista Alvarado the excuse to remove the troublemakers also limited his actions. Since men married to daughters of the land were heads of households, deporting these men would have passed the limits of legitimacy by local norms. Patriarchal privilege protected these troublemakers from political retribution, because the family still had to be maintained as the fundamental social unit.

While women were not the central actors in the incidents involving the Compañía Estranjera and the Rifleros Americanos, these incidents, especially the latter, reflect the final failures of the colonial policy of using women and marriage to control the foreigners in their midst. For both women and foreigners, property ownership transformed social relations during the 1830s and 1840s. Being rancheras and property owners within their local communities supported these women's sense of themselves and their self-worth, making them more willing to contest the patriarchal boundaries that bound them. Regrettably, after the Mexican-American War this new consciousness was largely undermined by the shift in the newly imposed American legal system, a situation that harmed many Californianas—María Merced Williams in particular.

María Merced Williams was the daughter of Isaac Williams, a man who had arrived in California in 1832 as a member of the Ewing Young trapper party. Deciding to stay, he married María de Jesús Lugo in 1837, and in 1841 he and his father-in-law, Antonio María Lugo, were granted rights to Rancho Santa Ana del Chino, a 22,000-acre land grant. In the next five years María de Jesús bore four children, of whom only two girls survived, María Merced and Francisca. The mother died soon after delivering her fourth child. Isaac

Williams never remarried, but he maintained two Indian mistresses, María Antonia Apis and María Jesús Apis, along with one Californiana mistress, referred to as Doña Jesús Villanueva.[111] Adopting the lifestyle of a landed ranchero, Williams employed numerous Indians as household servants, cowboys, field hands, blacksmiths, and carpenters.[112] He continued to prosper throughout the turbulent 1840s, unlike some of his compatriots, and his daughters were indulged and pampered. By the standards of their day, both girls lived in affluence. Upon his death Isaac bequeathed the majority of his wealth to his two legitimate daughters, including the guardianship of their five half-sisters and one half-brother. As full-blooded Indians, the mothers were denied custody of their own children and were placed under the guardianship of the two girls they had helped raise.[113]

On September 15, 1856, three days after the death of her father, sixteen-year-old María Merced Williams married twenty-seven-year-old John Rains. Little is known of Rains's background except that he was a southerner, probably from Alabama, and had served both as a Texas Ranger in the early 1840s and as a private during the Mexican-American War. After the war he herded sheep from Mexico and Texas to California, where he finally settled in 1849. In 1851 he attempted, unsuccessfully, to enter local politics by running for Los Angeles County sheriff. Failing to win the position, Rains continued to herd sheep and, in partnership with Andrew Gibson, purchased the Bella Union Hotel in Los Angeles. He continually ran for local office in the pursuit of wealth and respectability. In 1854 Isaac Williams contracted Rains to oversee his cattle on Rancho Temecula, where the young María Merced Williams fell in love with him.[114]

Contemporaries quickly suspected Rains's economic motivation in marrying so quickly after Isaac Williams's death, and their suspicions were well founded. Rains was financially strapped on the day he married. Soon after the marriage ceremony, he borrowed five hundred dollars from John Reed, who stated, "He came to me and said he had no money—no means to raise money . . . and I loaned him $500 which he paid back to me two or three months after he was married."[115] According to Judge Benjamin Hayes, Rains had luckily married a "rich heiress." In 1858 Isaac Williams's estate was finally settled; its estimated value was $124,000.

Enjoying his new landed status, Rains attempted to safeguard and even expand his newly acquired wealth. A supporter of the Democratic Party, he involved himself in local and state politics and was appointed the Indian subagent in Temecula and justice of the peace for Chino Township.[116] In

March 1858 Rains purchased six five-acre lots in San Bernardino for seven hundred dollars each from Mormon immigrants.[117] Two months later, he began the process of purchasing the 13,000-acre Rancho Cucamonga; however, purchasing this property necessitated the sale of his wife's share of Rancho Santa Ana del Chino. According to Jonathan Scott:

> Early in 1858, I think, in May, he consulted with me as to the costs of
> vineyard stock. He was going to sell his wife's interest in the Chino rancho
> for $25,000, and asked my opinion about the property. I advised him that
> I thought it would be a good investment to make with the money. I then
> proposed to Rains that I would go in with him to take half of it. The first
> talk was to put the deed in his own name, agreeing to let me go in with
> him for one-half of the vineyard. On the 11th of August, 1858, the day he
> had finished paying for the Rancho, he and his wife had an argument.[118]

Scott was unable to join Rains in this venture, and Rains had the papers and deeds drawn up in his name alone, even though it was María Merced's inheritance that paid for the new rancho.

María Merced Williams's inheritance made John Rains one of the largest landholders in the San Bernardino area. Using the land as collateral, Rains made a series of mortgage loans to various individuals and also purchased several mortgage loans in an effort to increase his land holdings.[119] In 1861 he purchased land in San Diego County—the 26,688-acre Rancho San José del Valle for $2,776, and the 17,634-acre Rancho Valle de San José for $3,450.[120]

Rains's primary reason for purchasing Rancho Cucamonga was to develop a vineyard. Building a house and a brick wine house and cellar, he hoped to benefit from the growing profitability of wine and grapes. The money to erect these structures came from the sale of approximately three thousand of María Merced's cattle, but despite this infusion of cash, by 1861 Rains was deeply in debt.[121] Unfortunately for María Merced, Rains carried out these land and business transactions without including her name in the property titles. After 1858 Rancho Cucamonga belonged solely to Rains, a point that made the marriage highly volatile. Many business associates later testified that Rains and his wife were constantly battling over this financial issue. For example, on August 11, 1858, Rains had just finished paying off Rancho Cucamonga when he stepped in to see his lawyer, Jonathan Scott. Scott recalled that "John had called at his office and reported a recent argument with Merced. On the occasion he was not feeling kindly toward her, and did not insist her name be included on the deed from Prudhomme."[122]

While María Merced had been raised with little responsibility, she was still cognizant of her legal and property rights under the Treaty of Guadalupe Hidalgo. Nonetheless, she had surrendered authority over her material property to a man she hoped would abide by the laws that made them partners in life. When Rains undermined their relationship, she feared she was being victimized. She made efforts to rectify the situation and asked several men to look into the matter. Robert Carlisle, her brother-in-law and Rains's business associate, was several times asked to investigate but repeatedly declined, fearing that his intervention might "cause a blowup."[123] Stephen C. Foster declared, "I think she would not forgive anyone who created a disturbance between her and Rains, although it might be for her benefit. I think she would act from the information, but would not forgive the person who gave it."[124]

John Rains may have attempted to remedy the matter, having once stated to Jonathan Scott that he wanted "to make conveyance of his interest from himself to his wife of the Rancho Cucamonga, the Bella Union property, the San Diego County rancho, and the brand that he used on Merced's cattle. . . . They were all bought with her money, as you know very well, and she ought to have it[.] I do not want to have any hard feelings about it."[125] When debt finally forced Rains to mortgage Rancho Cucamonga, María Merced's signature was needed on the mortgage and, as Jonathan Scott explained, "I went and saw Mrs. Rains and said things before her, and explained about the indebtedness. She consented and signed the mortgage. There was nothing said about the title of the property, whose name was on it. She relied upon me in all her transactions as her attorney. I had always intended to fix the matter, but it was one of great delicacy."[126] At one point Scott intimated that María Merced was at the mercy of her husband in the matter of the couple's business transactions, but clearly others were also responsible for continuing to keep her from knowing the truth and legally protecting herself.

In the end the mortgage only paid the most pressing debts. Neither Rains nor María Merced attempted to be frugal, and merchants were too generous with their credit. Had Rains survived, Rancho Cucamonga might have turned a profit. However, on November 17, 1862, Rains was murdered—waylaid en route to Los Angeles, he was dragged from his wagon and shot to death. He left no will. A tribunal headed by Judge Benjamin Hayes was quickly installed, but no one was ever brought to trial for the murder.[127] María Merced sought solace with her sister and brother-in-law, but within two weeks several of Rains's associates, among them Jonathan Scott, Stephen C. Foster—the executor of her father's will and the man who had consented to Rains's marrying María

Merced—and her brother-in-law, Robert Carlisle, "told Merced that John had owed so much money that they did not know what to do. They then reminded her that if she paid every debt left by John she would be out on the street—but not quite on the street, because her brother-in-law would look after her. They told her that 'because she was a woman' she could not manage her own affairs."[128]

María Merced's predicament marks the shift in Californianas' legal standing. The California Congressional Convention of 1850 had recognized women's rights to community property, but the underlying legal structures and social relationships that had protected women were no longer in place. María Merced was not just at the mercy of the husband in whom she had placed unconditional trust, but of his male associates who had refused, or willingly failed, to inform her of her husband's legal improprieties. Gone were the communal sensibilities that would have motivated some men to ensure that María Merced and her children were safeguarded, or at least to forewarn her so that she could take measures to protect herself. Throughout the aftermath of her husband's death, María Merced was caught up in the shift between the legal systems and social mores.

After recovering from the shock of her husband's death, María Merced quickly petitioned the court to recognize her legal rights to properties, as "she believed that up until the time of his death that deeds were all executed in her favor . . . that she was deceived by said Rains, and that by his actings and doing he fraudulently contrived and intended to deprive her of her separate property and convert it to his own use."[129] The presiding judge was Benjamin Hayes, a sympathetic friend to María Merced and her orphaned children. On March 13, 1863, he ordered that new deeds be drawn up naming María Merced as owner and proprietor. The next morning, six men—Jonathan Scott, Stephen C. Foster, James H. Lander, E. K. Dunlap, Alden A. M. Jackson, and Robert Carlisle—descended on María Merced and from breakfast to nightfall badgered her to give Carlisle her power of attorney, to which she finally acceded. Carlisle had anticipated being named receiver of the Rains estate, and with power of attorney he would make all financial decisions pertaining to Rancho Cucamonga.[130] Realizing her mistake in signing such a document, María Merced retained Benjamin Hayes as her lawyer to contest Carlisle's authority. Hayes rightfully suspected that Carlisle and his associates "were attempting to involve the rancho so deeply into debt that they would eventually not only control it, but possibly own it."[131] Proof of this suspicion was provided when Carlisle placed Rancho Valle de San José for sale and subsequently purchased

a half-interest in the ranch for a mere three hundred dollars.[132] María Merced was in the legal battle of her life, a battle she was ill equipped to fight. She could no longer appear before the alcalde with her hombres buenos and be satisfied that the decision would be based on a local sense of justice that respected her personal social standing.

For the next two years, Robert Carlisle and Benjamin Hayes maneuvered through the courts, the former attempting to gain possession of as much of the Rains estate as possible, the latter attempting to maintain the estate intact. Meanwhile, María Merced contemplated another means of protecting herself— a second marriage. The correspondence of the undersheriff of San Bernardino County, Henry Wilkes, with Benjamin Hayes spoke of a great concern for the young widow. Wilkes believed that marriage to him would give her added protection and succor, but María Merced instead chose José Clemente Carrillo, constable of Los Angeles Township. Ethnicity was undoubtedly a factor in her choice, as her battles with "Anglos" heightened the appeal of her Californio heritage and connections. In Benjamin Hayes's opinion, "I wish heartily that she had married the Captain [Wilkes]. It would have been better for her pecuniary interests."[133]

Fluent in English and Spanish, José Clemente Carrillo had held various minor offices. For the eleven years following the marriage, the family lived at Rancho Cucamonga under constant threat of foreclosure. María Merced kept mortgaging the rancho in an attempt to stave off the inevitable. In 1876 the Carrillos moved to Los Angeles, and by 1880 they were no longer living together in the same residence. In the 1880 census, María Merced declared her occupation as laborer; she was living with her oldest daughter, Cornelia Rains Foley, along with her seven other children.[134]

While through her lifetime María Merced descended the socioeconomic ladder, her sisters, both legitimate and illegitimate, successfully maintained their social status through marriages with Euro-Americans. After being widowed, her sister Francisca married Dr. F. A. MacDougall, mayor of Los Angeles, in 1877, and she continued to maintain a lifestyle that included servants and respectable social status. In his will Isaac Williams had left each illegitimate daughter a small bond to go toward her education and upkeep. With this modest income, some education, and their partial Euro-American heritage, María Merced's half-sisters were considered acceptable mates. In 1865 Victoria Apis married Joseph Bridger, a native of Louisiana, and settled on a 640-acre farm near Chino; in 1874 Manuela Villanueva married William Rowland, sheriff of Los Angeles County and son of John Rowland and María Leonor

Yorba; also in 1874, Concepción Apis married Sidney E. Lacey, an Englishman whose occupation was listed as notary public and real-estate dealer. There is no marriage record for the last half-sister, Francisca Apis.[135]

The 1830s and 1840s in California were a time of dramatic political and socio-economic shifts. As more foreigners, both Euro-American and Mexican, made their way to this remote territory, the authority and control of the ruling oligarchy continued to slip. This sense of loss and decline marked many of the testimonios that voiced the consciousness of the male Californio collectivity. But as this chapter has argued, there were other divisions, factions, and con-testations within this collectivity, and women played a significant role in both heightening and resolving the social tensions in the emerging bicultural society. Like their older sisters who had married Euro-Americans, younger sisters and daughters continued to intermarry. However, the second wave of potential Euro-American mates was less economically stable and less willing to fully incorporate themselves into Californio society. Divorce and separation became more commonplace, and if the women chose unwisely, their economic, social, and personal happiness was at stake.

As historical texts the Californio testimonios are invaluable, but social practices also reflect the historical realities of this community. Our examination of how women contested patriarchal rule through the legal system completes the problematic testimonio texts and sharpens our vision of how women participated in and influenced these greater social changes and transformations. Marriage and family were still the cornerstones of social harmony in Mexican California, but women were now more willing to use the social structures, par-ticularly the legal system, to protect their and their children's well-being. Their ability to own property and the legal system's sensitivity to the community's social relationships and to individuals' social status opened social spaces for women. Women, for the most part, complied with the social order but used their knowledge of it to ensure that their desires and wishes were met. Their actions and practices dispel the notion of Californianas as frivolous, vapid, and submissive women.

These women's desires and wishes at times contested their fathers' and brothers' authority, but when unhappy and physically abusive relations developed, women opted for socially sanctioned separation or even divorce. Although only a small number of women lived "on their own," they were a constant reminder to the community around them that an alternate female space removed from the constraints of marriage was possible. Women were

more vulnerable and more likely to be punished for this transgressive behavior, as the case of María del Rosario Villa demonstrates, but this was an extreme case that involved more general social and political factors. More reflective of the situation are the numerous and largely ignored business and personal transactions of women buying and selling lands to their female and male neighbors. Women, on the whole, faced limitations based on their gender, but they fully negotiated the social spaces open to them.

As the case of María Merced Williams de Rains shows, however, the new legal system closed many of the social spaces that had been opened during the 1830s and 1840s. When María Merced faced the loss of her property under the new American legal system, she was unable to resort to the previous legal customs and community support that would have protected her. The shift in legal systems inflicted considerable harm on the entire class of Californio rancheros, men and women alike, and initiated broad changes in the economy, society, and politics of California.

CHAPTER 5

𝒵

Interethnic Marriages in the
Post–Mexican-American War Era

A S THE LAST BUILDING OF THE ARCADIA BLOCK was being demolished
on May 15, 1927, a reporter for the *Los Angeles Times* wrote how "an old
timer," with a tear in his eye remarked, "there goes about the last reminder of
the Los Angeles of the good old days. If that old block could only speak, what
tales it could relate!"[1] In a nostalgia-filled, abbreviated version of "the good old
days," the reporter went on to describe the important role that Abel Stearns had
played in the development of this Los Angeles business center. The reporter also
unconsciously reflected the romantic fascination with interethnic marriages.
Asked why the area was named the Arcadia Block, the reporter exclaimed,
"There's the touch of romance! There was a woman in this case—beautiful,
bewitching, captivating—whose hand was sought far and wide among the
good-looking young rancheros and townsmen of Los Angeles and Los Angeles
County."[2] Competing against handsome Californios, homely Abel Stearns,
whose Spanish nickname was "Cara de Caballo" (Horse Face), nevertheless
charmed lovely fourteen-year-old Arcadia Bandini, and they married on June
22, 1841.[3] Abel Stearns had literally watched Arcadia Bandini grow up, because
he was both a friend and a business associate of her father, Juan Bandini. Stearns
so adored his young bride that he not only imported, at considerable expense,
"the first carriage ever seen in Los Angeles just to please Doña Arcadia," but
built her a house so large that it was commonly referred to as "El Palacio de
Don Abel."[4] From the 1840s to the 1860s, El Palacio was the social center of Los
Angeles society, and Arcadia the reigning "queen" over the activities.

This chapter examines several marriages and shows how both resistance
and selective accommodation were emblematic of Californianas married to
Euro-Americans in the postwar era. Like their menfolk, Californianas engaged

147

in the shifts of recreating a Californio identity. Although their marriages to Euro-Americans may have compromised their identities, the Californianas' personal actions and agency reveal that cultural resistance and contestation, as well as accommodation, were still in play. These women occupied what Bhabha describes as "the Third Space of enunciation which makes the structure of meaning and reference an ambivalent process," and the outcome was a state of hybridity "which constitutes the discursive conditions of enunciation that ensure that the meaning and symbols of culture have no primordial unity or fixity; that even the same signs can be appropriated, translated, rehistoricized and read anew."[5] Although their social positions were now more ambiguous, these Californianas still retained a particular cultural capital that, according to Pierre Bourdieu, consisted not only of material things with symbolic value, but also of culturally significant attributes such as prestige, status, authority, culturally valued taste, and consumption patterns that reflected their shifting Californio identity.[6] As I have argued in the previous chapters, women were cognizant of their collective power and defended their homeland to the best of their ability. In the postwar era this collective power and corporate identity were diminished, but individually women's actions and social practices still articulated their Californio identities and sensibilities.

Californios as a whole became a deposed social group during this period, but charting how and why certain individuals declined more precipitously than others helps to explain the ensuing transformation and reinterpretation of race, class, and nationalism in the former Spanish Borderlands. As Nira Yuval-Davis and Floya Anthis write, since "women get constituted in relation to the nation in terms of the functions they fill as reproducers of ethnicities, cultural transmitters, and participants in nationalist struggles," they become "markers of collective boundaries and differences."[7] It is as reproducers of ethnicity and as cultural transmitters that the identity and voices of these Californianas can be found. Californianas were aware of the "middle ground" on which they stood. The new Euro-American society around them was redefining the categories of "white" and "nonwhite," as well as all the privileges associated with these constructions, but the Californianas nevertheless still actively negotiated, protected, and maintained their social, cultural, and racial privileges for themselves and for their children. This chapter will examine the depth of these women's compromised cultural identity and how they envisioned California's future and their role in its production.

For women who married Euro-Americans in the postwar era, the colonial racial impulses that favored light over dark skin supported postwar interpre-

tations that these women desired and willingly assimilated and accommodated into the now-dominant Euro-American culture. Lisbeth Haas, however, points out that the bipolarity of assimilation and accommodation models allows for only two options: one either remains in one's primary ethnic identity or "becomes" American.[8] Haas also attempts to delineate precisely *when* race becomes the most important cultural marker; rather than during the decades following 1848, Haas places the time closer to 1900. "Ethnic identities do not remain static," she writes, "nor are [they] dominated by one biological or cultural marker." Instead, identities "are grounded in the particular relationships formed through histories of race, gender, class, and place. One identity does not displace another."[9] It is in this light that we should consider Californianas married to Euro-Americans in the postwar era. The actions and options available to these women are represented in the marriages of Arcadia Bandini, who married two American husbands, Abel Stearns and Colonel Robert S. Baker; of her sister, Ysidora Bandini, who married Cave J. Couts; and finally of María Amparo Ruíz, who married Colonel Henry S. Burton.

For Euro-Americans, Abel Stearns's marriage to Arcadia Bandini was an especially compelling union because they symbolized not only a harmonious couple, but also the way in which the Californio past was smoothly giving way to a prosperous American future. Born in Massachusetts in 1798, Stearns became an orphan at the age of twelve, forcing him to go to sea to earn a living. Engaged in the expanding Boston trade, Stearns moved to Mexico in 1826 and became a naturalized Mexican citizen. By 1829 he had settled in Los Angeles and unsuccessfully attempted to obtain a land grant. Opening a store where he sold groceries, sundry goods, and liquor in exchange for hides and tallow, Stearns subsequently became an integral figure in the commercial life of Los Angeles when he built a warehouse where the missions and rancheros could store their hides and tallow to await foreign trading ships. Acting as the middleman, Stearns became the buying and selling agent for rancheros who no longer had to travel to Los Angeles to negotiate personally for the purchase and sale of their goods. He was highly respected by many of the rancheros and was commonly referred to as "Don Abel," indicating his high level of acculturation and acceptance by this particular community. Still, not all Californios or Americans admired him. He actively opposed Governor Victoria, who ordered Stearns out of California in 1831. Later that same year, after Stearns had returned to California, a drunken, knife-wielding American trapper attacked him, permanently disfiguring his face and damaging his tongue to the point that Stearns talked with a lisp for the rest of his life. In 1836 Stearns held

political office as a síndico, and he supported the embattled Governor Alvarado in the 1840s, an association that culminated in Stearns's finally becoming a landowner.[10] Even though Stearns had lived in California since 1829, it was only after he married that he began to purchase land and establish land rights. His first purchase was Rancho Los Alamitos, a 26,000-acre land grant; at the height of his business career, Stearns owned roughly 200,000 acres of land in southern California.[11]

Arcadia Bandini was the daughter of a Peruvian, Juan Bandini. Born in 1800, Bandini came from a trading family; along with his father, he first traveled to California in the early 1820s and decided to settle there. In 1822 he married María de los Dolores Estudillo; after her death, he married María del Refugio Arguëllo in 1835—both women were members of the Californio elite, which facilitated Bandini's trading activities. In time he purchased land in both Alta and Baja California, was named customs officer for San Diego, and became a political leader of the southern Californian faction. In 1833 he was also elected to the Mexican Congress, an indication of his prominence and elite status. Although a "foreigner" by Mexican standards, Bandini also distinguished himself by constantly advocating the economic development of California and its possibly becoming a protectorate of the United States or of England. It was Bandini who encouraged and supported the failed Híjar-Padrés colonization scheme. Its subsequent failure only strengthened his resolve that the fortunes of California might best be served if the Mexican flag no longer flew over the territory.[12]

Once married, Arcadia Bandini preferred living in the city rather than establishing a household on one of Stearns's ranchos, and she was seemingly content in her role as a child bride. Abel Stearns, however, was acutely self-conscious of the couple's age discrepancy; he requested that the priest dispense with proclaiming the marriage banns in order "to avoid the ridicule which the differences in ages might arouse among thoughtless young people, she being fourteen and I being forty."[13]

Arcadia was not the only Californiana encased in the image of a pampered child bride. The image of Californianas underwent a subtle but significant transformation in the postwar era. The need to continue the fiction of the Spanish-Mexican people as innately childlike and unable to fend off stronger, more masculine forces was further cemented by accounts asserting that child brides were a common phenomenon in California. For example, a year after thirty-year-old Alfred Robinson married fourteen-year-old Anita de la Guerra, the couple traveled to Robinson's native Lowell, Massachusetts, for a prolonged

visit. Anita's arrival caused a sensation among Robinson's neighbors not only because she was "foreign" and "Spanish," but also because the women were so surprised "that one so young should be a wife and mother."[14] In New England sixteen-year-old girls were still in school, whereas Anita had given birth to her first child, Elena, within a year of marriage and would deliver her second child in November 1837.

Returning to Antonia Castañeda's argument that Americans distinguished between "Spanish" women and "Mexican" women in terms of race and virtue, another tendency occurred. In the postwar era, detailed accounts of how well, how showily, and how richly elite Californianas dressed, especially the women married to Euro-Americans, became commonplace. Before 1848 Euro-American visitors were perplexed as to why the elite spent so much of their time and money grooming themselves and presenting themselves to the public or why, in such a poor community, the elite, and those who wished to associate themselves with the elite, spent so much for clothing. Euro-Americans were unable to understand that precisely because the community was so poor, the elite maintained their prestige and standing simply by appearing in public in costly dress. What to Euro-Americans seemed an obvious waste of money was to Californios an obvious means of maintaining social and class norms. The difference after 1848 in what to Euro-Americans seemed the Californios' almost obsessive behavior with regard to dress was that now Euro-Americans could place an exact dollar value on what the Californios spent. In the postwar era, detailed accounts of how well and how richly these interethnic brides were provided for by their Euro-American husbands became commonplace. It would appear that well-to-do Euro-Americans were adopting local traditions by demonstrating their own worth through the lavish provisions they made for their Spanish-Mexican wives.

Newspapers, magazines, and visitors described in elaborate detail the amount and costliness of these women's clothing, jewels, and household furnishings. One Euro-American reminiscing about bygone days described María Guadalupe Zamorano, who in 1847, at the age of fourteen, married a forty-four-year-old Englishman, Henry Dalton, in the following terms: "At the ball, where the beauty and chivalry of California vied with each other, she shone resplendent in a magnificent satin gown, glittering with jewels. Wonderful pearls and rubies were pinned and fastened in every conceivable manner over that gown, radiant as a midnight sky whose stars wink rapturous eyes. In all, the jewels flashing upon that splendid young matron represented the amazing sum of $52,000."[15] Dollar amounts were always given in these accounts, and

the women's love of luxury items and frivolous activities was accentuated. Of course, the accounts also described the impoverished state, squalor, and inferior living conditions of the majority of Californios, thus imposing a tragic-comic, almost mannequinlike image onto the elite Californianas.

Popular accounts fail to mention that María Guadalupe Zamorano's parents had recently died, leaving the family near destitution. María Guadalupe chose her husband well. Soon after their wedding, Henry Dalton ordered $626 worth of silks and fine clothing for his bride, along with a harp from Tepic, Mexico, and furniture from England. He also acquired two Indian girls to do the housework.[16] According to Dalton's biographer, María Guadalupe's love of city life hastened Henry Dalton's decision to move from their Rancho Azusa to Los Angeles in 1850, where the "newly rich displayed their wealth by laying expensive imported rugs on floors and decking themselves out in silk gowns, lace rebozos and expensive ornamental clothing. . . . Guadalupe Dalton reveled in all the excitement."[17] Engaged in the cattle trade and supplying the goldfields, Dalton saw his fortune grow; as a doting husband, he spent it on his most-prized possession, his beautiful child bride. The Daltons eventually lost their wealth in the drought of 1863, which devastated the California cattle industry.[18]

In Arcadia Stearns's case, city life greatly reduced her burdens and responsibilities in comparison with the duties involved in supervising a rancho household, and because the Stearnses were unable to conceive children, Arcadia never had to assume the kind of parental and household responsibilities that were the lot of most other wives of her time. Not that Arcadia was ever taxed or burdened by running a household. Soon after the Stearnses' wedding, Ysidora Bandini, Arcadia's younger sister, came to live with them; she supervised the Stearns household until she married Cave J. Couts in 1851. Abel Stearns's fortunes continued to increase in the 1850s from both livestock raising and money lending; many Californios would eventually sign over their mortgages to "Don Abel." The relative lack of household burdens allowed Arcadia's life to revolve around entertaining and socializing among the old and new Los Angeles elite.[19]

Throughout the Sternses' marriage, Arcadia's material needs were met, but the couple could not escape the drought of 1863–64, which diminished their fortune and forced Abel to sell most of his land. Stearns was beginning to recover from his financial setbacks when he died in 1871. Arcadia inherited 20,000 acres of land, what were left of her husband's commercial interests, and the Arcadia Block.[20] Although the amount of land was greatly diminished,

rising real-estate prices and the location of her landholdings made Arcadia Bandini de Stearns one of the wealthiest women in the state. Her subsequent marriage to the oilman Colonel Robert S. Baker on April 20, 1875, ensured that her wealth would be maintained, if not increased, through Baker's business acumen and her land. Indicative of her personality, the pampered Arcadia left few written documents to gauge her personal views on the changes that she and her community had undergone, but if one closely examines where and how she chose to live, her entire adult life reflected her self-awareness of having remained a Californiana on her own terms.

It is significant that when Colonel Baker finally demolished "El Palacio de Don Abel" in 1878 and began construction of the Baker Block, Arcadia insisted on remaining on the premises. Rather than taking up residence in another part of the city among American society, the couple made their home in an eight-room apartment on the second floor of their business building, literally over the site of her old home. Arcadia's identity was formed when Californios were the dominant cultural group. Her first marriage was to a man who had accommodated himself to Californio culture, and in her second marriage she insisted that fundamental change could be, and was, avoided.

In both marriages Arcadia was surrounded by luxury, and at the time of her death on September 15, 1912, several newspaper accounts described how this heir of "romantic California" had lived. A former maid recalled the apartment's "crystal chandeliers and Aubusson carpets" and the fourteen long windows, "6 overlooking Main Street and 8 overlooking Arcadia Street," which were covered with "Alencon lace curtains costing $75 a pair."[21] Over the windows, "an artist brought here from Italy" had drawn "cupids and garlands of flowers in pinks and pastel shades." Fine furniture, a mahogany grand piano, silver and fine linen, and a solid rosewood bedroom set shipped from Spain typified Arcadia Bandini de Baker's physical surroundings. Although she had twice married Americans, "Mrs. de Baker lived much among her own family," and on "Wednesdays family members would gather at her home where an especially elaborate dinner was served."[22]

Although Arcadia's example cannot be ignored, it should not be seen as the sole representation of the experiences and agency of all intermarried Californianas. Ysidora Bandini's life also demonstrates how women negotiated the postwar period to their own benefit and how, based on their cultural and class identity, they survived the economic and sociocultural transformation of California. Ysidora Bandini was born two years after Arcadia, and from an early age she exhibited intelligence and an outgoing personality.[23] During the

Mexican-American War, she was declared a beauty, and her wit charmed many American officers in San Diego. A contemporary described Arcadia as "white" and Ysidora as "trigeña," meaning wheat colored or olive skinned, a fact that may explain why Ysidora refused to be photographed throughout her lifetime. As a member of the elite, and being fully consciousness of the hierarchy of phenotype, she may have felt that drawing attention to her "darker" appearance was unnecessary and unwanted.[24]

Ysidora's husband, Cave J. Couts, was born in Springfield, Tennessee, on November 11, 1821. Educated in various Tennessee schools, he received an appointment to West Point in May 1838 largely because of the influence of Cave Johnson, Cave J. Couts's namesake and uncle, who served in President James K. Polk's administration. Graduating in the bottom third of his class, Couts was commissioned a brevet second lieutenant in the Regiment of Mounted Rifles and participated in the Mexican-American War. Never rising above the rank of second lieutenant during the war, Couts was ordered to California in 1849 to help reinforce the troops occupying the province. During this expedition, he kept a journal in which he clearly shared his fellow countrymen's nationalistic and jingoistic prejudices against Mexicans. Like other Euro-Americans, Cave J. Couts's impressions were highly influenced by gender stereotypes. In his opinion Mexican men were "diminutive," "weak," "feeble," and "utterly worthless for anything on earth."[25] Incessant sexual intercourse made them "entirely destitute of all principles and feeling, and without as much spirit as will be found among Negroes in the States."[26] The women he found beautiful but without virtue and "ready to follow an American any time, any where, and to any place."[27]

Couts's views on Euro-American racial superiority were assuredly informed by his family's background as a slave-owning family, and he continued to invest in and purchase slaves while living in California. In 1852 John F. Couts purchased on Cave's behalf a "boy, worth $600 or $700" and in 1853 a "young Negro woman 21 years old, with two children for $1,500." The woman was pregnant with her third child, and John assured Cave that "she will be a little fortune to your children if she lives."[28] Given Cave's racial prejudices, the question arises how a slave owner could marry an "olive-skinned" "Mexican" woman, especially as other "white" women were now available as mates. Was the enticement of gaining land through Ysidora's inheritance enough to overrule Couts's obvious racial prejudices?

Both Euro-American and Chicano historians have asserted that Euro-American husbands quickly assumed control of their wives' property, but was

this necessarily the case? If the Gómez family was indicative of the relations between Californio fathers-in-law and Euro-American sons-in-law, then we must pay close attention to exactly when the men inherited or took control of their wife's property. For example, on July 5, 1852, María Ysabel Gómez married the Bostonian Charles Johnson. Attending the wedding was María Amparo Ruíz de Burton, who wrote: "As you know the beautiful Ysabel married the elegant Johnson, I was at the wedding and everything went well, the old man Spence did his usual clowning and everyone *seemed* content. Now everyone is at odds with each other, they threw the happy couple out on the street, the elegant one got mad and demanded the inheritance, the old man denied it, and etc., etc. I was at Monterey this past August, Ysabel was too skinny and Johnson was as usual with the only difference that he had lost his curls because he could not dedicate as much time in curling his hair, an illusion 'gone.'" [29]

In the Bandini family, Euro-American sons-in-law were often at odds with Juan Bandini. Conducting himself as the patriarch, Bandini assumed that his American sons-in-law would defer to his patriarchal authority as well as respecting and supporting his business decisions. The personal narratives of various Californios mention how children were expected to obey their father's wishes throughout their lives. José de la Guerra was such an autocrat that "long after the sons had grown to be men, and some of them married, obedience to the father did not lessen. It was an established rule with the old man that every one of his sons should be at home by 9 o'clock at night, or give a satisfactory account to where they had been and this rule applied as strictly to married as to the single son." [30] According to José Arnaz, he was present several times when "an aged father whipped his son, who was married and had children, and the son received the blows on his knees, with bowed head." [31] In short, Californio patriarchs believed their foreign sons-in-law should act like sons, so angry disputes and confrontations between patriarchs, sons, and sons-in-law were common. On June 7, 1853, Juan Bandini's financial affairs were in crisis, according to Charles Johnson, the husband of María de los Dolores Bandini. Juan's business schemes, the Bandini sons' proclivity for gambling, and Doña Refugia Bandini's extravagant entertaining all led Johnson to implore Abel Stearns to "assist the old gent out of this scrape; for it had nearly killed him [Bandini] thinking of it." [32]

In 1853 Juan Bandini finally granted his power of attorney to Charles Johnson, who, along with Bandini's other American sons-in-law, attempted to save his property and make the family lands more productive, but by 1859 Bandini's failed schemes and overwhelming debts forced him to sell the

rancho's livestock. Sale of the land soon followed. In 1859, in payment for the $24,000 that Abel Stearns had loaned him, Juan Bandini signed over his rights to Rancho Jurupa. As this transaction shows, Euro-Americans often acquired lands from their Californio in-laws. It is significant that these acquisitions came more often through business transactions with their fathers-in-law or brothers-in-law than directly through their wives. The Mexican-American War affected the fortunes of the Bandinis as a whole, but Ysidora's married life was a continuation of the lifestyle of the ranchero class of the 1830s and 1840s. Establishing herself as the mistress of a large rancho household, she became Cave J. Couts's consummate helpmate.

Land was the easiest route to wealth in postwar California, and as early as 1850 Couts began to purchase property. According to that year's tax list, he owned property in La Playa, Old Town (San Diego), and Soledad, its worth totaling $11,470. In partnership with Juan Bandini, Couts began to invest in livestock, hastening his decision to resign from the U.S. Army in 1851. The fact that he could purchase land on his own made his decision to marry a Californiana who had no land an intriguing move. On April 5, 1851, he wed Ysidora Bandini. As a wedding gift, Abel Stearns gave the bride the rights to Rancho Guajome, consisting of 2,219.4 acres located near the San Luis Rey Mission. In time Cave and Ysidora turned Rancho Guajome into one of the premier ranchos in southern California. Originally only a five-room adobe, the house was eventually expanded into "the traditional Spanish-Mexican one-story adobe hacienda with an inner and outer courtyard plan," and the outer buildings included a store, school, and chapel, all built by Indian labor.[33] Couts "hired" three hundred Luiseños, as the Native Americans living in the rancherías near the mission were called, to finish the expansion. Facilitating Couts's access to Indian labor was his appointment in 1853 as subagent for the Indians of San Diego County—a position he subsequently abused. In 1855 he was twice indicted and acquitted for whipping Indians with rawhide; one victim died from his wounds. Nor was Couts's violence directed solely toward Native Americans; in 1865 he was indicted for shooting Juan Mendoza in the back. Couts argued that it was self-defense, and since Mendoza had a reputation as a robber and troublemaker, Couts was acquitted.[34] Couts was a heavy drinker, and his alcoholism undoubtedly aggravated his propensity for violence. Whether Ysidora was ever the victim of her husband's drunken rages is not known.

Like her husband, Ysidora utilized Native American labor. A nephew remembered that ten to fifteen Native American servants regularly followed

Ysidora as she assigned the various tasks essential to maintaining the household. Several of these Native American servants were acquired as children when the Coutses, like other Euro-Americans and Californios, took advantage of indenture laws that allowed the placement of Native American children in "white" households. As early as 1850, the newly established state legislature passed a bill that mandated the heavy regulation and supervision of Native Americans. This act allowed for the indenture of Native American orphans or of children whose parents had given their consent to the arrangement. Adults could also be forced into labor for up to four months if they were found "loitering or strolling about." Any white citizen—a category that included the Californios—could arrest a "loitering" Native American; within twenty-four hours, the court would have hired out the detainee.[35] An 1850 legislative act established a coercive labor system that "bound and put-out" Indians into Christian households, facilitating Couts's access to indentured Native Americans. On January 10, 1861, Couts wrote to the county judge of San Diego listing the vagrant Indians living in his home and requesting that the judge indenture these individuals to him "for such length of time as is permitted by law." Assuring the judge that the males were apprenticed to husbandry and the women to housewifery, the Coutses were granted rights over José, Juan, and Juan Chino, all thirteen years old; Albino, twenty-six years old; Augustine, thirty years old; Tomasa, sixty years old; Josefa, twenty-five years old; and Felicita, twenty-five years old.[36] This arrangement was familiar to the Californios, as they too had coerced and colluded with the missions for Native American labor. The institutions and players had changed, but the outcome insofar as the Native Americans were concerned remained the same.

The compadrazgo system continued to provide another way to obtain Indian servants. In 1858 Couts petitioned the San Diego court to return "the Indian boy by the name of Francisco a minor under the age of eighteen years" to his control, because his wife had stood as godmother to the boy "according to the customs of the country at that time."[37] The court found in Couts's favor. Through legal mechanisms and traditional labor practices, the Coutses continuously availed themselves of Indian labor. In the Couts household, however, Ysidora was the one who personally acquired most of the indentured Native American children. In 1851 six-year-old Sasaria was bound by Jesús Delgado and his wife, Paula, to "Doña Ysidora Bandini de Couts, to serve her as a servant until she arrives at the age of 18 or 21 years." This arrangement was "intended for the benefit of the [orphan] Child"; after paying the couple fifty dollars, Ysidora was assured of a servant for twelve to fifteen years. In the

rancho's daybook, Couts entered Sasaria as a purchase.[38] On August 13, 1866, a Pala Indian woman named Jacinto bound her son, twelve-year-old, fatherless José Antonio, to Doña Ysidora Couts for three years. In exchange for her son's upkeep, Jacinto was to receive thirty dollars a year. Included in the document was the clause that "she, Jacinto, further requests that no Indian agent, or Indian Captain or Alcalde, interferes with the boy during the time named."[39] Whether through compadrazgo relationships or through indenture, Ysidora continued to benefit from the privileges to which she was accustomed.

Several rancho account books record the wages and debts of servants while in service to the Coutses, demonstrating how labor relations had scarcely altered in form or substance since the prewar era. Servants bought their goods at inflated prices from the rancho's store, wages were low, constant debt legally tied them to the rancho, and workers often ran away as a means of resistance, as evidenced by Francisco.[40] How the servants interpreted their status within the household cannot be determined, but their continued presence provided another bridge that linked the past to the present.

Relationships to land and race were critical, having long supported California society, and these relationships continued into postwar California. But as the Californios continued their decline into poverty and dispossession, Ysidora and her children reaped the racial and economic privileges of Couts's "whiteness." Following the pattern of prewar Californio society, the Coutses often entertained their numerous friends and acquaintances, and prolonged visits by Arcadia and other family members were common.[41] Still, Ysidora's hospitality had its limits. While conducting research for *Ramona,* Helen Hunt Jackson visited Rancho Guajome, but Ysidora soon asked her to leave. According to relatives, differences in the women's ethnic backgrounds caused the dispute. In the mid-1880s Ysidora filed a suit against Jackson in Los Angeles County for defamation of character, believing that Jackson had based the character of Señora Moreno in *Ramona* on her.[42]

Community property laws extended ownership over Rancho Guajome to Cave J. Couts, but the brand and earmark of the herds were registered in Ysidora's name. In the 1860s Couts purchased other tracts of land, most notably Rancho San Marcos, consisting of 8,975 acres, and Rancho Buena Vista, consisting of 2,288 acres. The rancho daybook recorded Ysidora's presence in the rancho's economic activity: she bought and sold livestock, helped supervise the yearly butchering, and attended to the rancho's needs whenever her husband was away.

The greatest testament to Ysidora's capabilities was her continued and skillful

management of the family's property after Couts's death on June 10, 1874.[43] As executor of his estate, Ysidora maintained control of the properties. Their daughter María Antonia Couts alone inherited Rancho Buena Vista, while the other children received equal interests in the remaining properties. During his childhood, Cave Couts Jr. had been his father's favorite child, but this early affection lessened as he developed into an irresponsible, impetuous young man who greatly displeased his father and mother. Writing to his sister Carolina, he stated that he was "well aware of my presence always causing mother more displeasure" and that members of the family had "extremely bitter hatred towards him."[44] To make matters worse, Cave Jr. repeatedly questioned his mother's ability to handle the complex details of business, thereby making their relationship even more acrimonious. In 1883 Tomás Alvarado sued Ysidora Bandini over Rancho San Marcos, and Cave Jr. tried to be of assistance. Rancho San Marcos was an especially troublesome piece of property, so much so that Cave Jr. advised his mother to leave the dealings in the hands of Colonel Baker or of the firm of Christy and Wise, since "it is impossible 'mamacita' that a woman tend these types of business, this business is for competent men not dummies [dumb lawyers]."[45] Cave's pessimistic assessment of his mother's intelligence and ability to protect their property was unfounded, since Ysidora successfully maintained the rancho, remained head of the household, chose not to remarry, and judiciously selected her legal representation.

Like Arcadia, Ysidora left no detailed accounts expressing her cultural worldview, but María Amparo Ruíz de Burton did. One of the most intriguing and accomplished nineteenth-century Californianas, Ruíz de Burton gave voice to the cultural and social dilemmas faced by Californianas who married Euro-Americans. Born on July 3, 1831, María Amparo Ruíz was the daughter of Jesús Maitorena, a soldier, and Isabel Ruíz, the daughter and granddaughter of soldiers. While her mother and brother used Ruíz and Maitorena interchangeably, throughout her adult life María Amparo used her maternal surname, because Ruíz was a more prestigious and influential family name in Baja California than Maitorena.[46] For example, her maternal grandfather was at one time the governor of Baja California and received a land grant to the Ensenada de Todos Santos, though the lands provided merely subsistence rather than profits. María Amparo also favored her maternal line because of its kinship ties to a number of important Alta California families, particularly the Carrillos of San Diego.

Sixteen-year-old María Amparo was with her family in La Paz, the capital of Baja California, when the American forces invaded. Among the forces

was twenty-eight-year-old Lieutenant Colonel Henry Stanton Burton, who, after a few months of occupation, was ordered to evacuate the women and children from Baja California to Monterey, in Alta California, for the duration of the war.[47] Records do not indicate when Burton proposed marriage to María Amparo, but unlike so many other interethnic marriages in California, the couple decided on a Protestant ceremony, causing great consternation within both ethnic groups. Both the bishop of Alta and Baja California and the American military governor refused to sanction any marriage between a Catholic and a Protestant; furthermore, the Californio community, especially the ladies of Monterey, were outraged, and they ostracized María Amparo, who "received no better than a chere amie by her countrywomen."[48] A more timid woman might have taken this social ostracism to heart and changed her mind; María Amparo, however, went through the Protestant ceremony on July 9, 1849, doing so after the Catholic authorities had agreed to remove all impediments under the conditions that Burton never prevent María Amparo from practicing her religion, that all children be educated as Catholics, and that María Amparo pray wholeheartedly that her husband convert to Catholicism.[49]

In her literary biography of María Amparo Ruíz de Burton, Rosaura Sánchez discusses this interethnic marriage in terms of treason. "The question," according to Sánchez, "then is whether marriages such as MARB's [María Amparo Ruíz de Burton's] can be constructed as cementing treason or, on the other hand, as opening doors, as some Chicana critics have suggested in analyzing and rethinking the position of Malintzin. Could sleeping with the enemy be viewed in other terms?"[50] María Amparo proved exactly why we should view intermarriages in other terms. Sánchez carefully describes the various identities, positions, and social strategies that María Amparo employed throughout her life and how she "masterfully maneuvered" being both an insider and an outsider, colonizer and colonized. Personal treason was not the real issue in her decision to marry an American; it was instead the immediate advantages that this union provided. María Amparo affords the most sophisticated example of how a Californiana's marriage to a Euro-American did not destroy or erase the woman's personal Californio identity. Although her individual attitudes and justification do not translate totally to the other women, I believe that, like María Amparo, these other Californianas had an innate sense of self and that they refashioned themselves to better negotiate the greater social and cultural processes that were transforming their national, social, cultural, and gendered landscapes.

After the war the Burtons were stationed in San Diego and set up a household.

Like her mother and grandmother, María Amparo adjusted to being an officer's wife. Unlike her foremothers, however, she also spent time writing, directing, and coordinating plays and amateur entertainments staged in the old San Diego Mission in an effort to enliven the frightfully dull, dry, dusty town. When the two married, Henry was a widower with a young daughter but with little money; by March 1854 the Burtons were able to pay one thousand dollars for the purchase of Rancho Jamul, totaling 8,926 acres, with the promise of paying another one thousand dollars at a later date. Gracious and congenial hosts, the couple entertained and enjoyed the social life of San Diego. They soon had two children, Nellie, born in 1850, and Henry Halleck Burton, born in 1852. Another sign of María Amparo's contradictory accommodation was her consistent use of the Burton surname. Just as she abandoned her original surname in favor of Ruíz, she later abandoned her maiden name in favor of Burton due to largely the same class motivations. In terms of class, the name of Burton advanced and protected her interactions with American society; therefore, she made a relatively quick and easy accommodation. Yet she raised her children in a bilingual, bicultural household.

In the case of María Amparo, it is difficult to ascertain when class considerations trumped ethnic issues. This makes her one of the most provocative and engaging historical figures. She vented vitriolic diatribes against the Americans but lived most of her adult life among them and demanded to be treated by them as an equal. Her presence and existence constituted what Bhabha calls mimicry, which within colonial discourse allows certain colonial subjects to sustain a position of being "almost the same but not white." This state of colonial discourse, Bhaba believes, was produced at the site of interdiction, which is "a discourse at the crossroads of what is known and permissible and that which though known must be concealed; a discourse uttered between the lines and as such both against the rules and within them."[51] By remaining within this state of interdiction, María Amparo was able to rail against and critique the injustices under which she and other Californios suffered. In symbolic and real terms, her entire life within American society was one of existing between the lines, and she constantly manipulated the rules to her own advantage. Overall, however, she was more successful in areas of gender and ethnicity than in economic ones.

During her stay in Monterey, María Amparo had met and initiated a correspondence with her distant cousin, Don Mariano Guadalupe Vallejo of Sonoma. Although Vallejo was twenty-four years her senior, a noted and admired political leader and a well-read scholar, María Amparo found him

a kindred spirit, possessed of an intelligence equal to her own and sharing her love of scholarly knowledge. After leaving Monterey, she continued the correspondence, which from all accounts she initiated, for the next twenty-five years.[52] Indeed, María Amparo Ruíz de Burton's sense of her own intelligence bordered on arrogance, as in her writing to Vallejo in November 1851:

> But isn't it true that between ourselves it is a very difficult thing for a married woman to write a letter to a gentleman? Yes, and you know that the difficulties grow if the married woman has to remind the gentleman that he promised to lend her all the books that she desired. This in now the case, . . . I realize how good and useful it is to have a good understanding between two compatriots; what a pity that there aren't more like we two! Isn't that what we agreed upon in the conversation we had in the home of Mr. Kane? Yes, it seems to me we were in agreement that we were a pair of prodigies. . . . I am persuaded that we were born to do something more than simply live . . . to do more than the *rest* of our poor *countrymen*; I have spoken frankly and I hope it proves my sincerity, and in this way you can count on me, in whatever enterprise which for the well-being of our homeland or for whatever other glorious work . . . which is our mission on this earth. . . . Between two superior beings all should be in agreement.[53]

Vallejo patronized and indulged the young woman, but in time a deep friendship emerged, and he described her as "an erudite and cultured lady, passionate for the honor and traditions of her homeland, a worthy wife, a loving mother, and a loyal friend."[54]

In 1859 Henry Burton was ordered to Virginia, and for the next decade the Burtons lived on the East Coast. María Amparo joined her husband whenever possible as he was transferred to various military posts. When unable to join him, she spent most of the time in Washington D.C. An astute observer of the capital's social and political activities, she kept Vallejo abreast of events with her pointed commentary. As she was an ambitious and outgoing woman, she met "a number of diplomats, military officers and their wives, congressmen, and other officials," including President James Buchanan and later President Abraham Lincoln and Mary Todd Lincoln, with whom she sporadically corresponded. After the Civil War, Burton was given command of Fortress Monroe in Virginia, where Jefferson Davis was held prisoner, and María Amparo befriended Davis's wife.[55]

After Burton's death in 1869, María Amparo returned to the rancho near San Diego and was soon enmeshed in the economic, legal, and social turmoil faced

by all landowners who held Mexican land grants. She was also the sole means of support for her two young children. Having already exhibited her literary skills (she had written a play and published several magazine articles), in 1872 she published *Who Would Have Thought It?* the first English-language novel written by a Latina in the United States. Drawing from the author's personal experience in Washington D.C., the novel is clearly autobiographical in terms of race and gender and expresses what Beatrice Pita and Rosaura Sánchez term "negative identification" with the United States. The novel captures Maria Amparo's acute awareness of being a cultural outsider throughout her stay in the East.

Published under the pseudonym H. S. Burton, the novel's far-fetched plot takes place in Springfield, Massachusetts, and primarily critiques the racist sentiments and moral hypocrisy of the Euro-Americans. The novel revolves around the fate of Lola, a young California girl brought to New England by an explorer, Doctor Norval. During a geological expedition, Norval encounters an "Indian" woman who beseeches him to return her daughter to civilization. The woman turns out to be Doña Teresa Almenara de Media, a daughter and wife of Spanish noblemen who settled in Baja California; indeed, her husband is blond and blue-eyed, but he is Mexican in national sentiment. Tragically, soon after the wedding Doña Teresa is kidnapped by Apache Indians and sold to Mojave Indians. Although pregnant, she is forced to become the wife of an Indian chief. Throughout her ordeal, she has opportunities to escape but realizes that returning to her family would bring shame and dishonor to them, so she chooses instead to accept her debased condition. Furthermore, to avoid detection, the Mojaves dye the mother and child's white skin so they will pass for Indians. The color of her skin is not Doña Teresa's only "hidden" asset. She has also managed to find and keep hidden a pile of rocks she intuitively knows are diamonds and emeralds. After surviving ten long years of misery, and knowing she is dying, Doña Teresa's only wish is "to help her daughter escape, to be baptized and brought up as a Roman Catholic."[56] She gives Lola's inheritance to Doctor Norval, and he promises to save the girl. When Norval arrives in Massachusetts with ten-year-old Lola, his wife believes the child to be a "Negro" and immediately detests her for her dark skin color and inferior race.[57]

Lola is raised in the household that includes two daughters, who share their mother's dislike of her dark skin, and a son, Julian. The dye eventually wears off, and Lola's white skin slowly reemerges—indeed, she is fairer than the daughters—but Mrs. Norval and her daughters still consider Lola racially

and culturally inferior, constantly referring to her as a "Negro." The affection of Dr. Norval and Julian, who innately recognize Lola's natural intelligence, kindness, and superior morality, provides Lola some happiness; after prolonged exposure to her many virtues, Julian's affection turns into love. Lola's beauty and virtue also attract the attention of the family's minister, who attempts to kidnap and marry Lola. Mrs. Norval opposes any possible marriage between Julian and Lola until Doctor Norval reveals that Doña Teresa had collected precious gems and that Lola is now a fabulously rich heiress. The novel ends with Lola's father finding her and reconnecting her to her California heritage. Lola finally marries Julian as a social, economic, and racial equal.

More interesting than the novels, she wrote, was María Amparo's ability to be an "astute fashioner of self."[58] Throughout her life she articulated a variety of positions and ideas, often contradicting herself, but her self-identification as a *baja californiana* demonstrated how being from a specific region shaped women's identity. For example, María Amparo had harsh words for both the United States and Mexico, which in her opinion had victimized and betrayed the Californios. The relentless desire of the United States to steal land gained her contempt, as did Mexico's failure to protect the Californios against this violence. At one point she stated, "If it weren't for the Republic's unhappy condition I would have already arranged my property in such a way as to save it forever from suits."[59] Interpreting political and historical events from a decidedly personal position, María Amparo favored Emperor Maximilian's reign over Mexico. Writing from Columbia, South Carolina, in 1867 to Mariano Vallejo about the overthrow of Maximilian and the U.S. government system, she declared, "Let us continue being friends just as we are. You with your admiration for republics and for the Americans, and I with my convictions that republics are still and for years will be 'impossible chimera' and that the Americans are and will always be the mortal enemies of my people, of my Mexico."[60] Her personal sufferings so colored her attitudes that she came to sympathize with the post–Civil War South, not necessarily for its proslavery stance but because of its similarity to California as a conquered territory.

María Amparo's prolonged contact with Washington politics during the Civil War and Reconstruction eras were encapsulated in *Who Would Have Thought It?* Beyond the fantastic nature of the novel, if we assume that Lola symbolized in part the author's own ideas about race, then we must conclude that she saw herself as a racial and social equal of the Euro-Americans. However, the Americans' inability to recognize this equality resulted in her alienation from Euro-American society.

Just as *Who Would Have Thought It?* articulated María Amparo's racial and gender awareness, her experiences defending her property encouraged her in 1885 to write another novel, *The Squatter and the Don,* under the pseudonym C. Loyal. Voicing the grievances of the dispossessed Californios, this novel brought the plight of the elite Californios to a larger and what the author hoped was a more sympathetic audience. Reflecting what was actually happening, she accused a variety of villains of colluding in the theft of Californio lands. State laws allowed settler-farmers (called squatters by the Californios) to homestead contested land while title to the land was being confirmed. Furthermore, corrupt Euro-American politicians turned a deaf ear to the plight of the Californios; railroad companies schemed with elected officials to steal land from the rightful owners; and squatters killed cattle randomly without making payment to the owners. Even when land titles were confirmed, the squatters often had to be forcibly removed.[61] In Ruíz de Burton's case, American squatters had steadily whittled away at Rancho Jamul, and various men questioned the legality of her land-grant rights to both of her ranchos. Henry S. Burton had died intestate, leaving his widow to deal personally with the legal battles over land rights, which she did for the next twenty-three years. At one point even her own mother accused Ruíz de Burton of defrauding her, claiming that she had signed a legal document written in English—a language she neither spoke nor read—that she believed gave her power of attorney to her daughter; only later did the mother discover that the document transferred her claim to Rancho Ensenada to María Amparo.[62]

While ideas of race were central to *Who Would Have Thought It?* in *The Squatter and the Don* class and race are the main topics and points of conflict. Ruíz de Burton was sympathetic only to the landholding elite, erasing from her tale the trials of the mestizo working-class segment of Californio society.[63] One of the author's most transparent intents was that "in the course of her indictment of the status of things, negative stereotypes are subverted and partially inverted: the Mexicans and Californios are presented as superior in both intellect and culture, in contrast to the Anglos, who fall far short of their much-heralded moral and social superiority, but are economically and politically stronger."[64]

In the novel the Alamar family symbolizes the elite Californios who were forced to survive racial and social insults along with the economic and political degradation that accompanied the loss of their power, honor, and social status. In order to stress this precipitous decline, Ruíz de Burton idealizes the Alamars, whose manners and demeanor gain the respect and admiration of

some of the conquering Euro-Americans. In terms of ethnic identity, Ruíz de Burton's Californios are identified as "Spanish people," of "Spanish descent," and "Spano Americans," and the Alamars are as European as any of their new "white" neighbors. The men are all noble and honorable to the point that some commit suicide rather than continue to endure the unacceptable conditions that challenge and diminish their Californio manhood. The women, like their menfolk, are well cultured and decorous, and they never engage in physical labor. The daughters are obedient, virtuous, chaste, and carefully chaperoned, as befits their social status. The novel's final resolution of its various social and cultural clashes and its vision for the future is through interethnic marriage. In the novel a Californio brother and sister, Gabriel and Elmira Alamar, marry two Euro-American siblings, George and Lizzie Mechlin, implying that better understanding between the two cultures could be achieved if Euro-Americans accepted Californios as equals.[65] The marriage of George and Elmira is prosperous, but Gabriel and Lizzie's union steadily declines, because Gabriel is unable to find a suitable occupation. This decline is especially cruel for Lizzie, who "years before, when she was Lizzie Mechlin . . . had moved in what was called San Francisco's best society." After Gabriel loses his job at a bank and "her fashionable friends disappeared," Lizzie comes to realize "that Gabriel was a native Spaniard, she saw plainly, militated against them. If he had been rich, his nationality could have been forgiven, but no one will willingly tolerate a poor native Californian." By the end of the novel, Gabriel has been reduced to wage labor and by "carrying his hod full of bricks up a steep ladder, was a symbolical representation of his race."[66]

Both novels reflect Ruíz de Burton's strong nationalistic, racial, and class identity as a Californio. Marriage and prolonged contact with Euro-Americans had neither diminished her ties to her homeland nor her ethnic identity. In the 1870s both Mariano Vallejo and María Amparo Ruíz de Burton were harassed by squatters and involved in legal battles to protect and control their lands. These battles gave Ruíz de Burton the platform on which to rant against her tormentors and make racial determinations. But her racial terms sometimes confused Vallejo, who finally asked, "A thousand times you have said to me, 'our race' and 'the Anglo-Saxon race' and I confess to you candidly that even now my attention has been aroused to such a degree that I take the liberty of asking you, 'What do you mean in those two distinct phrases.'"[67]

Being a racial and cultural outsider on the East Coast had heightened Ruíz de Burton's sense of race, but she never considered that her marriage to an Anglo American made her one. Her support of interethnic marriage went

beyond literary contrivance; on being informed by Vallejo that a mutual friend was marrying a Belgian woman, she wrote, "It is true that the Yankee and Mexican race is pretty, and prettier still is that of a Belgian and a Mexican, but the most attractive is between a protestant and a Catholic . . . apostolic . . . Californio." In her opinion people of mixed race were more attractive, and she declared that mixed marriages should continue so that "our nationalities are not stepped upon by the heel of the Saxon."[68] Furthermore, when her daughter, Nellie, reached marriageable age, Ruíz de Burton encouraged the girl to marry a Euro-American.

María Amparo Ruíz de Burton's English proficiency stood her in good stead in defending her legal rights and property, but she clearly understood how being a widow, a woman, and a Californio placed her at a disadvantage. In a moment of anger, she declared: "What a miserable thing a woman! Decidedly, providence should compensate me in some way for making me a woman! . . . and ugly . . . and poor! . . . Neither my race nor my sex will do me any good."[69] Despite her race and sex, Ruíz de Burton continued to improve her lands and attempted to create wealth. Whether running cattle, investing in mines, starting a cement business, or even hiring a geologist to investigate the idea of creating a reservoir to supply fresh water to San Diego from her Rancho Jumal, she found that all her enterprises failed to reestablish her family's finances.[70] Eventually, Ruíz de Burton lost most of her land, but she continued her legal struggles until her death in Chicago on August 12, 1895.[71]

The family's financial woes also affected the two Burton children. María Amparo was convinced that their impoverished state hindered her children's social and economic opportunities. Henry, like the Alamar men in *The Squatter and the Don,* was forced to drop out of college and work as a laborer to help support the family. Nellie failed to attract a Euro-American husband and eventually married a Californio widower, Miguel de Pedrorena, in 1875.[72]

It was in the next generation that the cultural legacies of these biethnic marriages came to fruition. Resistance and female agency in the postwar era were clearly evident in terms of culture, language, religion, social customs, and social practices; indeed, Euro-American husbands continued to accommodate even after the war. As was the case in the Bandini family, all the weddings were Catholic ceremonies, and the children were raised in bilingual, bicultural households. Many women who married Euro-Americans never learned to speak or write English fluently. Furthermore, by examining the marriage patterns of biethnic, bicultural children, one can ascertain how concepts of

race and gender were being transmitted and adapted. In terms of race, there was a significant marriage pattern based on gender. Biethnic females were four times more likely to marry Euro-Americans than were their brothers, whose dominant marriage choice was Californianas. Like most of their parents, few of these biethnic children left behind substantial autobiographical accounts making their actions and practices more reflective of their personal identities. What follows is a short collective biography of the experiences of these biethnic children.

When the biethnic children lived in California, their identities were more cohesive and unchallenged. However, some interethnic couples could afford to send their male children to eastern schools. The experience of these children varied, with some of them confronting discrimination and hostility from their Euro-American relatives. For example, when Alpheus Basil Thompson and Francisca Carrillo sent their son Francis to Bridgeton, Massachusetts, for an education, things did not go well between the young man and his paternal aunt. What exactly occurred is unclear, but rather than remaining with his relatives, Francis preferred to reside with Timothy Wolcott. Writing to Wolcott, Alpheus Thompson agreed to pay all necessary expenses for Francis's stay, although Francis had "omitted to tell me his circumstances, which has been wrong, but still, he is young and of foreign stock, which with the mixed up affairs betwixt himself, his Aunt Mary, and the Revd. Mr. Pendleton etc, etc, I do not think him much in the fault, not enough to give him the blues, although I blush for my Sister's treatment to him."[73] Alpheus did not expand on what occurred, but if a Protestant minister was involved, one can assume that issues of religion arose and that Francis's Catholicism proved troublesome, if not totally unacceptable, to his aunt.

Unlike Francis Thompson's experience, when Cave J. Couts and Ysidora Bandini sent their two oldest sons, Cave Jr. (nicknamed Cuevas or Cuevitas, meaning "caves" or "little caves" in Spanish) and William Bandini Couts, to Clarksville, Tennessee, in the fall of 1871, the two young men had less conflicted experiences. Attending Stewart College, a Catholic institution, along with their cousin Miguel Aguirre, the Coutses' experiences with their Euro-American kinfolk were affectionate and welcoming. The boys were included in family gatherings such as weddings and holiday meals, and their ability to speak Spanish was a source of distinction and pride: as Cave Jr. informed his father, "no one else knows how to speak Spanish except us three."[74]

All three boys experienced bouts of homesickness and missed news of California, leading William to ask his father to send him the *Weekly Union*

and *Examiner* newspapers, "for that will be the only way we have to hear the California news."[75] The Coutses' correspondence indicated no social hostility or discrimination based on their mixed ethnic background. Both boys became interested in romance, even though Cave thought "the girls are very ugly here and there is only one pretty one in all of Clarksville and she is old and very short but is still very pretty."[76] In a rather curious turn of events, Cave's friendship with one young woman in particular led to her conversion to Catholicism. He wrote to his mother concerning the matter: "A Protestant girl is going to become a Catholic in four or five days . . . I am going to be the godfather of the lovely young girl who for the last four months has been, or was a great friend of your son Billy, who is the cause for the said young girl to find her fortune or misery; but she has been in Catholic schools, and is very grateful in belonging to the Church and also one of the family" (my translation).[77] It would seem the young woman converted to Catholicism in the hope of marrying Billy Couts, but Billy eventually married his cousin María Christina Estudillo.

Another important cultural trait the Couts brothers strove to maintain was their Spanish writing skills. They wrote to their father in English, but they addressed their mother in Spanish. By their second year at school, Billy expressed his difficulty writing in Spanish: "I greatly fear that I might forget it; because every time I speak Spanish some English gets mixed in."[78] Billy was not the only one to mix languages. In a highly reflective example of their bilingual, bicultural household, when Cave J. Couts Sr., who constantly referred to himself as "Papa Grande" in his letters, was informed of the boys' poor grades, he wrote and admonished them to concentrate on their studies and not on sweethearts, novels, or love stories. "For little bits of boys," he pointed out, "this may do very well to allow them to run to their mama's [*sic*] for a little Chichi, but young men of your age, talking about Sweethearts, should study as much during vacation as any other time—particularly reading."[79] Using the Spanish slang for breast-feeding indicates the maternal influence and the manner in which the Couts children were raised. In another letter informing them about the ranch's activities, Cave Sr. wrote: "Tonia, with Felipe Manon, are keeping house during our absence. Dicen que Toñita esta ganando fama de housekeeper" (They say that Toñita is gaining fame as a housekeeper).[80]

Language is, according to the theories of Pierre Bourdieu, a multifaceted system that can be defined as "part of the way of life of a social group and serves essentially practical ends." But language is also an instrument of domination, particularly when "one language dominates the market, it becomes the norm against which the prices of the other modes of expression, and with them the

values of the various competencies, are defined."[81] It is in the choice of the family's language that the continuation and presence of women persists and bridges the postwar era. While the majority of Californios were forced to undergo "barrioization," as described in the work of Albert Camarillo, women married to Euro-Americans escaped or at least mitigated this marginalization.[82] Their use of language and close kinship ties to their Spanish-speaking relatives, their being raised Catholic, and their residual identity as Californianas indicates that individual women's personal identity had undergone little reformulation or reconfiguration. In the case of Ysidora Bandini, even after three decades of living with a Euro-American and being surrounded by American cultural forces, her strong sense of cultural identity assured that her Californio past influenced their children. Nevertheless, the children were products of their new environment, and their identities had been reformulated in comparison to those of their parents.

For some of the children of interethnic marriages, language was a clear indicator of their cultural association. For example, in April 1874 Enrique Cerruti interviewed Guillermo Fitch, the son of Henry and Josefa Fitch. The entire interview was in Spanish. Mentioning only that his father came from Massachusetts, Guillermo mainly discussed his mother's family and their place in California's history. The episode of his parents' elopement was repeated, but the only personal information he volunteered was that he owned "a vineyard and fruit trees that produce enough to permit me to live with decency."[83] Californio sensibilities and means of articulating social position were still relevant for the children of these interethnic couples.

After graduating from college, Cave Couts Jr. became an engineer and was employed by various firms in South America. For the next two decades, he managed to earn a living but never became wealthy, which he found disturbing.[84] He married Lily B. Clemens in 1887, but this marriage ended in a bitter divorce. In the 1920s Couts fathered two children with his housekeeper, Ida Richardson.[85] His relationship with his mother never improved, but upon her death Cave Jr. inherited equally with his siblings. Throughout his adult life, Cave Jr.'s interest in Rancho Guajome never wavered. As his siblings married and left the rancho, Cave Jr. bought out their interests; by the 1890s he controlled the 1,800 acres to which the rancho had been reduced. As the new owner, Cave Jr. hoped to make Rancho Guajome profitable through a variety of development schemes. He began to market the rancho to groups such as the Guajome Fruit Colony and to the U.S. government for use as an Indian reservation. Finally he considered converting the property into the Guajome Health Club.[86]

In order to entice the last group, Couts commissioned architects William Hebbard and Irving Gill, two pioneers in the Mission Revival movement, who sketched a proposed remodeling of the original Guajome adobe. The architects envisioned a twenty-four-room hotel, which would include a spa and a sanatorium, housed in a "pseudo Spanish-Colonial structure of some grandeur, replete with arches, anachronistic Indian corner bell towers and Mission predominate facades." However, Cave Jr.'s lack of finances never allowed him to initiate this grandiose project.[87]

Luckily for Cave Jr., when his aunt, Arcadia Bandini Stearns de Baker, died in 1916, he inherited enough money to settle his considerable personal debts. Using this inheritance, Cave began a more modest remodeling of Rancho Guajome, cheaply covering the original adobe with "a superficial frame and stucco arches," tailored to entice Hollywood and the tourist industry, and in the early 1920s he opened the rancho to guests. But despite all his efforts, Rancho Guajome never became a financial success as a tourist site.[88] By the 1920s many Californio descendants were mining their personal histories to maintain a financial and social place in California society, but now romantic images were substituted for historical realities.

In 1932 author Virginia Kassler visited Rancho Guajome while preparing to write yet another novel set in romantic California. Kassler interviewed Cave Couts Jr., who by the late 1910s had begun to call himself "the last of the Dons." She described the physical environment but also commented that back at the ranch, "Mr. Couts was interviewing a villainous-looking half-breed who stood cowed and humble answering in meek monosyllables to Mr. Couts' voluble Spanish." The fact that Couts Jr. was also a "half-breed" failed to register. Kassler instead points out how Couts was the last remnant and proud defender of his cultural legacy.[89]

Cave J. Couts was hardly the only upholder of the nineteenth-century Californio past. Carmen and Francisca Dibblee, granddaughters of Andrés de la Guerra, continued to maintain the de la Guerra household in Santa Barbara well into the twentieth century. Beginning in the 1890s, the city began to reconstruct itself to represent and uphold its "Spanish" past. Through architecture and "Spanish"-themed festivals and by "prettifying" the legend of conquest and settlement—to use Cary McWilliams's terms—Santa Barbara helped to create and maintain the "Spanish heritage fantasy." But one person's fantasy was another person's historical heritage. As late as 1919, Delfina and Herminia de la Guerra, the daughters of Andrés de la Guerra, along with their nieces Carmen and Francisca, actively participated in—indeed, gave

authenticity to—the annual Santa Barbara Spanish festival. Delfina chaired the Spanish pageant committee, and Herminia organized both the parade and the dancers for the pageant.[90] Moreover, both the aunts and the nieces maintained the de la Guerra household as the jewel and center of the Spanish festivities. As heirs to an illustrious past, these women became valued civic volunteers in numerous social agencies that serviced both the immigrant and the native Santa Barbara population.

Returning to the issue of marriage and identity, it is in terms of marriage patterns that the largest difference exists between the sexes of biethnic children. Because the children had Euro-American surnames and were positioned as "white" persons, there should have been little distinction between the men and women whom they chose to marry, but this was not the case. In a sample of sixteen families and the surviving children who married, I found sixty marriages recorded. In terms of gender, the family members involved in these marriages consisted of thirty-five females and twenty-five males. In terms of marriage choices, only ten of these biethnic females married Spanish-surnamed men; the majority, twenty-four of them, married Euro-American-surnamed men. Thus, it appears that biethnic Californianas were twice as likely to marry Euro-Americans as were Californios. For the men, the pattern is reversed: of the twenty-five biethnic men, fifteen married Spanish-surnamed women, while only eleven married Euro-American-surnamed women. However, of these eleven wives, three were biethnic women. Therefore, we may conclude that biethnic men were only 32 percent more likely to marry Euro-American women. Clearly, race and gender were intrinsically intertwined and influenced how children aligned themselves. A biethnic woman with a Euro-American surname was able to continue and deepen her association with Euro-American culture through her marriage choice, but a biethnic male with a Euro-American surname was either less acceptable to potential Euro-American brides or less inclined to marry into the Euro-American culture. But it is precisely in this generation that the ideas and complexities of nationalism and cultural identity continued in play. If we accept the traditional definition of nationalism and place all the children under the protection and identity of the father, then the majority of the children should have married Euro-Americans. They did not. In terms of nationality, the majority of children, thirty-two out of sixty, chose to marry and remain within their mothers' Californio community. But as the experiences of the de la Guerra women indicate, the Californio community of the twentieth century was not the same as that of their foremothers.

Eighty-four years after the Mexican-American War, the children of interethnic couples still retained valued remnants of their mothers' culture. These women's cultural legacy of selective accommodation and compromise indicated that women married to Euro-Americans during the nineteenth century never totally surrendered in the battle of cultural conquest. As this chapter has argued, interethnic marriages occurring after the Mexican-American War shared some similarities with those that took place prior to the war. However, while the practice remained the same, the shifting sociopolitical and economic terrains demanded a reinterpretation of what exactly was being exchanged. Supposedly, the Californianas' ethnic identity was subsumed within their husbands' national identity, making them the first Californios to purposely accept assimilation and accommodation into the dominant Euro-American culture and nationalism. But this was not the case. The previous decades had fostered a sense of self within elite Californianas, based on their gender and class affiliation, that was not easily erased by the U.S. invasion or by their willingness to align themselves through marriage with the conquerors. The bicultural households they established proved that their vision of California's future was one in which their past identities were being refashioned and transformed but never totally erased.

Epilogue

MARRIED TO A DAUGHTER OF THE LAND. Marriage. Daughters. Land.
In every society and culture around the world, these words and their meaning can be clearly discussed and their relevance to each specific society can be examined. But when societies combine and mix, the various components and relationships developed among all three of these ideas become intertwined, conflicted, troublesome, confusing—in a word, messy. The way in which societies live on the land has tremendous implications for these societies and the cultures they develop. Human settlement and the growth of societies, through peaceful or violent means, have always been predicated on the participation and involvement of women, but how women function and participate in their native, and at times nonnative, societies varies over time and space. As this study shows, examining specific women involved in specific cultural practices can further our understanding of how varied and multidimensional some women's lives can be. It is not enough to examine any one particular role that women occupy in their societies, because the way their social, cultural, economic, and legal relationships intertwine and develop over time also sheds light on their lives. Gender identity, kinship ties, social status, economic privilege—or lack of economic privilege—and legal rights all come together to ground women's lives. However, the exceptions to the rules are often as telling as traditional, normative definitions of women's roles. Trying to find and narrate the important ties and connections within these complex relationships has been daunting, but by putting "new wine into old bottles" we discover that the image and history of Californianas in the nineteenth century is more connected and intertwined with American western history than we previously believed.

In its grandest terms this study is a revisionist work, but not just revisionist in terms of historiography. Although I hope that readers and students of his-

tory will begin to reexamine and be more critical of how nineteenth-century California history and the colonial history of the Southwest in general is written, I also hope this book will help them reimagine the ways women traditionally participated in helping societies develop from colonial outposts to permanent settlements, as well as what it meant to these women, both collectively and individually. Stereotypes and static assumptions of the past, particularly as they apply to women, must be systematically challenged in order to give voice to historical subjects who seemed to whisper, but who were actually speaking in firm tones, laughing, crying, and at times shouting about their lives to any who would take the time and effort to listen. Because Californianas married to foreigners were some of the most silenced subjects, I hope this study will encourage younger scholars to examine intermarriages in other places and times and expand our knowledge of all women's experience in the American West.

While this book is primarily about how marriage and race impacted specific historical subjects and helped to create a bicultural world in California's past, it is also about California's future; indeed, it touches on the future of America's racial and ethnic relations in the twenty-first century. In our attempts to create clear-cut historical periods where a dominant narrative takes place, abstract periods in terms of race make no historical sense. Here the continuous ebb and flow, the persistent state of flux that intermixing both introduces and maintains, will be part of future historical discussions of race and ethnicity in America. In other words, periodization makes sense for studying public lives and public institutions, but it fails to help us understand the private lives of certain historical subjects, especially women. The continuity and familiarity of frontier societies is a critical component of understanding American western history. I hope this book will guide future students to be critical of older frameworks and return to neglected regions where intermarriage expressed the contestation and negations that two—and in some places, more than two—societies worked out over time. Indeed, I dare any historian of the West to find a time when societies were not in contact and conflict with each other. Studying the bicultural, multicultural nature of the West opens up grand new vistas for scholarship in several disciplines.

Beyond challenging the traditional historiographical assumptions and periods, American students of the West need to move beyond viewing Mexicans solely as an immigrant population. The roots of colonial southwestern societies still have important historical legacies through the twentieth century and now into the twenty-first. Rather than persisting as foreigners and immigrants, Mexicans in the twentieth and twenty-first centuries became Americans and

in a way also became "children of the land," just as Euro-American immigrants became "native" Americans. Like the original Native Americans, the Spanish-Mexicans have given the continuation of their people and their culture as their legacy to American history. Mexico and the United States will continue to be neighbors, and as Mark Twain commented, "Familiarity breeds contempt, and children." But rather than contempt, further studies of just how familiar some Euro-Americans and Spanish-Mexicans have been may help to lessen the contempt and fear often associated with these relationships and instead lead to embracing the origins and continuous instances of these fascinating unions, both in the past and in what will become an increasingly multiethnic, multiracial American society in the twenty-first century.

It is time to get away from "romantic" ideas about California's past and to focus instead on the histories of *real* lovers, families, kinship alliances, and cultural exchanges, which tell us far more interesting stories of "old California" than the swashbuckling caballeros and bare-shouldered, flirting señoritas of novels and movies ever did. The physical and architectural legacy of Spanish-Mexican California—the missions and adobes—should be visited and preserved to remind us of America's richly diverse cultural past. But the people of Spanish-Mexican California also need to be remembered. As some Americans in the United States continue to fear the "porous" border between Mexico and the United States, and as they debate how Latinos will impact the country's society, this study points to a specific experience and outcome that no closing of a border can stop. In the future as in the past, individuals will look beyond racial and ethnic borders and choose to marry and love outside their own ethnic and cultural groups. They will raise their hybrid, interethnic American children as well and as lovingly as they can, and they will steadily change the face of America. But the nation and its people will endure these changes, and maybe one day the United States will wake up and say, "But we were doing this all along, in America." Maybe then we can all just consider ourselves children of the land.

APPENDIX

De la Guerra y Noriega Family Genealogy

For a more complete geneological record see Helen Louise Pubols,
"The De La Guerra Family: Patriarchy and the Political Economy of
California, 1800–1850," diss., University of Wisconsin Madison, 2000, 602–9.

José Antonio Julián de la Guerra y Noriega, b. 6 Mar 1779, d. 22 Feb 1858
m. **María Antonia Carrillo y Lugo,** b. 15 Mar 1786, d. 25 Dec 1843

Children
1 **José Antonio de la Guerra y Noriega,** b. 1805, d. ca. 1878
 m. María Concepción Manuela Ortega y Lopez, b. 12 Sept 1808,
 d. 28 Aug 1885; m. 23 Nov 1824

 Children
 José Antonio Jugardo Jr., b. 23 Sept 1825, d. ?
 María Dolores de Alta Gracia, b. 8 Apr 1927, d. ?
 m. José Antonio Estrada; m. 24 Jan 1854
 Juan de Deos, b. 22 Feb 1929, d. 5 Mar 1829
 María Soledad de la Gracia, b. 25 Apr 1830, d. 2 Feb 1838
 Catarina Felicia Ramona, b. 1 Apr 1832, d. 16 May 1887; never married
 José Antonio, b. 16 Oct 1834, d. 13 Jan 1885; never married
 José Ramón, b. 24 Mar 1836, d. ?
 Guillermo Eduardo, b. 26 Nov 1837, d. 1874
 m. Francisca Foxen; m. 7 Jan 1863
 Juana, b. ca. 1838, d. 4 Jan 1885
 m. José Antonio Feliz; m. 16 July 1854
 Alejandro, b. 4 July 1840, d. 29 Jan 1895
 m. Juana Ayala; m. 14 Dec 1873
 José Joaquín Gaspar, b. 5 Sept 1841, d. 26 June 1844
 José Federico de Alta Gracia, b. 5 May 1844, d.?

2 **Rita de Jesús,** b. 25 Apr 1807, d. ca. 1810

3 **María Teresa Isidora de Jesús,** b. 18 May 1809, d. ca. 1885
 1.m. William Edward Petty Hartnell, b. 24 Apr 1798, d. 2 Feb 1854;
 m. 30 Apr 1825

 Children
 Guillermo Antonio, b. 31 Mar 1826, d. ?
 m. María del Refugio y Morena; m. 16 Nov 1850
 Nathaniel Mariano de la Natividad, b. 8 Sept 1827, d. ? Dec 1833
 Jorge Albano Manuel, b. 16 June 1829, d. 9 Aug 1829
 Juan Eadbert, b. 6 May 1830, d. ?
 m. María de las Angustias Jimeno y de la Guerra; m. 21 May 1857
 Adelberto Pedro, b. 25 June 1831, d. ?
 María Teresa Gregoria, b. 17 Nov 1832, d. ?
 m. Miguel Smith; m. 6 June 1851
 José Gonzalo, b. 15 Apr 1834, d. 28 Dec 1902
 m. María Ignacia Watson; m. 1 Aug 1861
 María Matilde, b. 25 Apr 1835, d. ?
 Urbano Pablo, b. 6 May 1836, d. 18 Aug 1836
 Ysabel Ana Prudenciana, b. 19 May 1837, d. ?
 m. Pedro Zabala; m. 24 Apr 1859
 María Magdalena del Refugio, b. 22 July 1838, d. ?
 Natanieles Finiano, b. 10 Sept 1840, d. 20 Nov 1847
 Pablo Eduardo, b. 8 Feb 1842, d. ?
 m. Juliana de la Torre; m. 7 Jan 1866
 Vidarico, b. 20 Feb 1843, d. ?
 Francisco Gumesindo, b. 13 Jan 1845, d. 17 Nov 1845
 Silvestre Albano, b. 31 Dec 1845, d. ?
 Margarita Amelia, b. 22 Feb 1847, d. ?
 Arnulfo Benjamin, b. 18 July 1849, d. 17 May 1852
 María, b. Nov 1851, d. ?

 2. m. Maturano, b. ?, d. ?, mar. ?

4 **Raymundo,** b. 1813, d. ?

5 **Juan José,** b. ca. 1814, d. Sept 1833

(continued on next page)

6 María de las Angustias Josefa Antonia Bernabe, b. 11 June 1815,
d. 21 June 1890

1.m. Manuel Jimeno y Casarin, b. ?, d. 23 Dec 1853;
m. 12 Jan 1833

Children
Manuela, b. 1834, d. 4 ? 1851
 m. Col. Alfred Sully; m. ca. 1850
María Angustias, b. 1835, d. ?
 m. Juan Eadberto Hartnell; m. 21 May 1857
María Antonia Josefa Borraba, b. June 1837, d. ?
 m. Juan Arata
José Antonio Sebastián, b. 25 Feb 1839, d. ca. Jan 1866
 (engaged to Francisca, daughter of Pablo de la Guerra)
unidentified, boy, b. 14 Aug 1840, d. ?
Porfirio, b. 1841, d. 9 Nov 1870
Carolina (1), b. 1843, d. ?
Belisario, b. 1844, d. ?
Carolina (2), b. 1846, d. ca. 1924
 m. Kahn
Santiago, b. 1848, d. ?
 m. Paula de la Cortina Gomez (in Mexico)
Juan, b. 1850, d. ca. 1852
Alfredo Justo and Enrique Pastor (twin), b. ca. Jan 1853, d. ?
Enrique Pastor (twin), b. ca. Jan 1853, d. ?

2.m. Dr. James L. Ord; m. 31 Oct 1856, divorced 1875

Child
Rebecca María, b. ca. 1857, d. ?
 m. Maj. John Henry Hobart Peshine, b. 1847; m. 5 May 1887

7 **Francisco Antonio María de Alta Gracia,** b. 25 June 1817, d. 8 Jan 1878
Mistress, María del Rosario Lorenzana, b 13 May 1816, d. ca. 1857

Child
(2 *hijos naturales,** adopted after their mother's death)
Felipe Santiago, b. 5 May 1837, d. 31 May 1918

Mistress, María Ysabel Davis

Children
María de Los Angeles de la Guerra, b. 2 July 1861, d. 13 July 1913
Rodolfo de la Guerra, b. 10 Sept 1863, d. ?
Alberto José de la Guerra, b. 3 Dec 1864, d. ?
Estella de la Guerra, b. 16 Apr 1864, d. ?
Clotilda Inez Soledad, b. 9 May 1839, d. ?
 m. Andronico Encarnación Sepulveda, b. 30 Mar 1840,
 d. 31 May 1914; m. ca. 1866

1.m. María Ascención Sepulveda y Serrano, b. ca. 1821,
d. 2 Aug 1844; m. 16 Feb 1839

Children
Francisco Jr., b. 30 Apr 1840, d. ?
María Antonia, b. Nov 1841, d. ?
 m. Ulpiano Undart

2.m. Concepción Sepulveda y Serrano (sister of first wife),
b. ca. 1823, d. ?; m. 5 Jan 1864

Children
Juan José, b. 23 May 1847, d. ca. 1940
Concepción, b. ca. 1849, d. pre-1860
Anita, b. ca. 1850, d. post-1878
 m. Franciso Alphaeus Thompson; m. pre-1867
Osbaldo, b. ca. 1853, d. post-1878
José, b. ca. 1854, d. pre-1878
Erlinda, b. ca. 1858, d. post-1878
 m. Antonio Ygnacio Sepulveda, b. ca. 1 July 1842, d. ca. 1916;
 m. ca. Feb 1873
Rosa, b. ca. 1861, d. post-1878
Hercules, b. ca. 1863, d. post-1878
Victoria Adriana Elvira, b. ca. Mar 1867, d. pre-1878
Pablo Eduardo Ramon, b. ca. 2 Sept 1868, d. post-1878
Diana, b. ca. 1868, d. post-1878
Anibal Absalom, b. 16 Oct 1869, d. post-1878
Victor Alfredo, b. 24 Oct 1870, d. ?
Joaquin Cipio Genardo, b. 27 Feb 1872, d. ?

**hijo natural:* illegitimate birth

(continued on next page)

8 Pablo Andres Antonio María Saturnini, b. 29 Nov 1819, d. 5 Feb 1874
 m. Josefa Moreno y Castro, b. ca. 1829, d. 9 ? Mar 1904;
 m. 7 Mar 1847

Children
María Francisca, b. 21 Sept 1849, d. 17 Aug 1931
 m. Thomas Bloodgood Dibblee, b. 3 Apr 1823, d. Dec 1895;
 m. 8 Dec 1868

 Children
 Teresa Andrea, b. 3 Oct 1869, d. Aug 1896
 Francisca Josefa, b. 29 Dec 1870, d. ?
 Ynez Leanor, b. 22 Nov 1873, d. 25 Apr 1963
 Pablo, b. 18 Oct 1875, d. 5 Oct 1876
 Ysabel Mercedes, b. 17 Nov 1877, d. 4 Aug 1969
 Thomas Wilson de La Guerra, b. 22 Mar 1879, d. 18 Dec 1951
 Hermina Elvira, b. 11 Nov 1880, d. 27 June 1881
 William Charles Henry, b. 30 June 1884, d. 13 July 1956
 Carmelita, b. 19 Feb 1886, d. 2 Apr 1964
 m, Francis T. Underhill
 Helena Delfina, b. 8 Dec 1887, d. Sept 1968

Carlos Pablo, b. 10 July 1852, d. 18 June 1912; never married
 Mistress Garcia [Indian] b. ca. 1856, d. 1875?

 Child
 José María (*hijo natural*), b. 20 Nov 1873, d. ?

María Paulina, b. 25 Mar 1855, d. 23 Aug 1861
Ana María Elena, b. 6 May 1857, d. post-Apr 1866
Delfina, b. 21 Feb 1861, d. 25 Apr 1953 (twin brother stillborn)
Hermina Andrea, b. 30 Nov 1862, d. 12 May 1927
 m. Lewis E. Lee
Ynez, b. ? d. ?

9 Ana María de Alta Gracia Leonarda Severa, b. 6 Nov 1821, d. 24 Nov 1855

 m. Alfred Robinson, b. 1806, d. 1895; m. 24 Jan 1836

 Children

 Ana María Elena, b. ca. 1837, d. 10 Feb 1860
 James, b. ca. Nov 1838, d. ca. 1855 at West Point
 Angustias, b. 184?, d. pre-1855
 Alfredo, b. 184?, d. pre-1855
 Francisco Miguel, b. 29 Feb 1853, d. pre-1855
 María Antonia, b. ?, d. post-1882
 m. Gustav Ohnesorg; m. pre-1877
 Antonia, b. ?, d. pre-1855
 Paulina, b. ?, d. pre-1855
 José A. A.?
 James Alexander, b. 3 Nov 1855, d. post-1882
 m. Caroline Hawes

10 José Joaquín Francisco, b. 16 Oct 1822, d. 5 Mar 1870

 Mistress, Ramona Lisaldi, b. ? d. ?

 Child

 José Timateu (*hijo natural*), b. ca. 25 Jan 1853, d. ?

 Mistress, Rafaela Olivera, b. ca. 1832, d. ?

 Children

 María Olimpia, b. 21 Sept 1862, d. ?
 José de los Santos, (*hijo natural*), b. 30 Feb 1864, d. ?
 Paulina, b. 25 June 1866, d. ?
 Amalfo, b. 15 July 1868, d. ?

(continued on next page)

11 Miguel Carlos Francisco María de Alta Gracia, b. 3 Nov 1823,
d. 25 Apr 1878

m. María de la Trinidad Serafina Ortega y Pico, b. 28 Aug 1832,
d. 19 Sept 1903

Children

Andrés, b. Oct 1854, d. 12 Sept 1855
Gaspar, b. ca. 1856, d. 1906
María, b. 19 Dec 1858, d. 30 Apr 1942
 m. Alexander S. Taylor; m. 8 May 1881
Josefa, f. ca. 1860, d. 27 Dec 1946
 m. Alejandro Savin
Ydelviges Carolina Olimpia, b. 18 Oct 1862, d. 1937
 m. Edward M. Arrellanes
Da Gloria Joaquina, b. 16 Jan 1866, d. 1929
 m. Thomas Soguio
Ulpiano, b. ca. 1867, d. ?
León, b. ca. 1869, d. 21 Dec 1954
Paulina, b. 2 July 1872, d. 9 Oct 1941
 m. Manuel Castañeda; m. 21 Jan 1917

12 Antonio Maria de Alta Gracia Francisco Remigio, b. 1 Oct 1825,
d. 28 Nov 1881

13 María Antonia de Alta Garcia Gerónima, b. 30 Sept 1827,
d. 25 Nov 1916
 m.1. Cesario Armand Latillado, b. ?, d. 12 Apr 1849;
 m. 23 June 1845

 Children
 María Antonia, b. 5 July 1846, d. ?
 Carlos, b. ? d. 1849
 Cesario Eugene Jr., b. 2 Dec 1849, d. ?

 m.2. Gaspar Oreña, b. 10 May 1824, d. ?; m. 5 Jan 1854?

 Children
 Acasia Teresa, b. ?, d. 24 Feb 1958
 m. James B. Rickard, b. 3 Oct 1878
 Orestes, b. 1857, d. 1930
 m. Berta Oprecht
 Dario, b. ?, d. ?
 m. Herminia Ortiz
 Leopoldo, b. ?, d. ?
 Anna Juana, b. ca. 29 May 1864, d. ?
 Arturo Gaspar, b. 21 Aug 1865, d. 10 Sept 1908
 m. Caroline Redmond, d. ?; m. 10 Sept 1908
 Serena Rosa, b. 11 Nov 1867, d. ?
 m. Guillermo I. Koch
 Teresa Acasia María Oreña, b. 28 July 1872, d. ?
 Rosa, b. ?, d. ?

NOTES

INTRODUCTION

1. Rosalía Vallejo de Leese, "History of the Bear Flag Party," Bancroft Library, University of California, Berkeley, California. See also Genaro Padilla, *My History, Not Yours: The Formation of Mexican American Autobiography* (Madison: University of Wisconsin Press, 1993), 148–49.

2. Rosaura Sánchez, *Telling Identities: The Californio Testimonios* (Minneapolis: University of Minnesota Press, 1995), 216.

3. The use of *Californio* refers to the self-identifying term that second- and third-generation Spanish-Mexicans were using by the 1830s, when they first began to articulate a territorial identity that distinguished them from the deposed Indians and that emerged during the political debates between the territory and the Mexican federal government. See Lisbeth Haas, *Conquests and Historical Identities in California, 1769–1936* (Berkeley: University of California Press), 3–4. Throughout this study, I use the terms *Californio, gente de razón,* and *Spanish-Mexican.* Although all these terms basically refer to the same group of people, mainly those of Spanish-Mexican ancestry, in terms of chronology the way in which these people referred to themselves helps to situate the changes this society was undergoing. For example, when I use *Spanish-Mexican*, it is to describe the racially mixed population who spread out from New Spain, Mexico, into the northern frontiers. During the first stage of conquest, the terms *gente de razón* and *españoles* were commonly used to distinguish the conquerors from their Amerindian subjects. After Mexican independence, these people referred to themselves as *Mexicanos* and *Californios.* Some native-born Californios, however, were antagonistic toward many Mexicano immigrants, so readers need to be cautious about the names applied to Spanish Borderland populations. For clarity, this study strives for consistency in use of terms, but the multiple terms of identification can prove confusing.

4. Alan Rosenus, *General M. G. Vallejo and the Advent of the Americans: A Biography* (Albuquerque: University of New Mexico Press, 1995), 144.

5. Leese to Abel Stearns, San Francisco, May 8, 1837, FAC 217, Abel Stearns Collection, Huntington Library, San Marino, California. Jacob Primer Leese was born in 1809 in

Ohio. In the early 1830s he was trading along the Santa Fe Trail, and by 1834 he was trading in Alta California, when he and two other Anglo Americans opened a store in Los Angeles.

6. William Heath Davis Jr., *Seventy-Five Years in California: Recollections and Remarks by One Who Visited These Shores in 1831 and Again in 1833, and Except When Absent on Business Was a Resident from 1838 until the End of a Long Life in 1909* (1929; reprint, San Francisco: John Howell Books, 1967.), 22. William Heath Davis Jr. was a second-generation trader in California. His father, William Heath Davis, was born in Boston and was involved in the China and Hawaii trade during the 1810s and 1820s. He died in Honolulu in 1823. During the gold rush, Davis Jr. became a prominent merchant in San Francisco.

7. During the 1870s the historian and bookseller Hubert Howe Bancroft, along with Cerruti and Savage, interviewed approximately sixty-two old Californios with the intent of recording first-person accounts of what California was like before the American invasion. Of varying lengths, these narratives, or testimonios, provide important insights into Californio society in general. However, Bancroft was especially concerned about gathering the personal accounts of elite males, so collectively these testimonios are decidedly male centered and elitist.

8. By the term *Euro-American,* I am referring to all "white" ethnic males of European origin who traveled to California, mostly from the United States. Technically, this should include Spanish-born males like the original de la Guerras, but so few Spanish-born men moved to California during the period I am discussing that I feel comfortable using *Euro-American* to refer specifically to non-Californio outsiders of "white" ethnic identity. I use the term *American* to refer to the United States, its population, and its culture. The term is somewhat arbitrary, given that Spanish-Mexicans had and have an equal right to refer to themselves as Americans, but for the purposes of this study, the term *American* serves as a concise reference to the political, economic, and cultural realities embodied by the United States and its conquest and development of the formerly Spanish-Mexican Southwest, including California.

9. More than just the feminine form of *Californio,* in this study I use the term *Californiana* to refer to a collective feminine, political, and class identity. Like their male counterparts, these women also formed and defined their individual and collective social positions based on their understanding of local conditions.

10. James F. Brooks, *Captives and Cousins: Slavery, Kinship, and Community in the Southwest Borderlands* (Chapel Hill: University of North Carolina Press, 2002), 37.

11. Ibid., 34; Deena J. González, *Refusing the Favor: The Spanish-Mexican Women of Santa Fe, 1820–1880* (London: Oxford University Press, 1999), 114.

12. By *Amerindians,* I refer to indigenous peoples of North America as differentiated from Mesoamericans. In this study I use this term when referring to Amerindians in general. When I use the term *Indian,* I am referring to the way Americans have constructed the stereotypical image of indigenous peoples.

13. Brooks, *Captives and Cousins,* 40, 31.

14. Hubert Howe Bancroft, *California Pastoral, 1769–1848* (San Francisco: History Co., 1888), 289, 305, 312.

15. Sandra L. Myres, *Westering Women and the Frontier Experience, 1800–1915* (Albuquerque: University of New Mexico Press, 1982), 84–85; Rebecca McDowell

Carver, *The Impact of Intimacy: Mexican-Anglo Intermarriage in New Mexico, 1821–1846,* Southwestern Studies Monograph, no. 66 (El Paso: Texas-Western Press, 1982), 17. Examples of uncritical discussions of intermarriage include Darlis A. Miller, "Cross-Cultural Marriages in the Southwest: The New Mexico Experience, 1846–1900," *New Mexico Historical Review* 57 (October 1982): 352; and Jane Dysart, "Mexican Women in San Antonio, 1830–1860: The Assimilation Process," *Western Historical Quarterly* 7 (October 1976): 372.

16. For a discussion of Mexican attitudes toward miscegenation, see Octavio Paz's classic essay "The Sons of La Malinche" in *The Labyrinth of Solitude: Life and Thought in Mexico,* trans. Lysander Kemp (New York: Grove Press, 1961), 65–88. Tomás Almaguer, *Racial Fault Lines: The Historical Origins of White Supremacy in California* (Berkeley: University of California Press, 1994), 50–65.

17. Rosaura Sánchez, *Telling Identities,* 216.

18. Deena J. González, *Refusing the Favor,* 73–74.

19. Ibid., 113–14.

20. Ibid., 114–15.

21. Nancy F. Cott, *Public Vows: A History of Marriage and the Nation* (Cambridge: Harvard University Press, 2000), 1.

22. See Hendrik Hartog, *Man and Wife in America: A History* (Cambridge: Harvard University Press, 2000), chaps. 1 and 2.

23. For African American intermarriage rates, see Paul R. Spickard, *Mixed Blood: Intermarriage and Ethnic Identity in Twentieth-Century America* (Madison: University of Wisconsin Press, 1989), 280. For Chicano intermarriage rates, see Susan E. Keefe and Amado M. Padilla, *Chicano Ethnicity* (Albuquerque: University of New Mexico Press, 1987), 173–74.

24. Gary B. Nash, "The Hidden History of Mestizo America," in Martha Hodes, ed. *Sex, Love, Race: Crossing Boundaries in North American History* (New York: New York University Press, 1999), 10–32.

25. Audrey Smedley, *Race in North America: Origin and Evolution of a Worldview,* 2nd ed. (Boulder, Colorado: Westview Press, 1999), 25.

26. *Gente de razón* literally means "people of reason." According to Douglas Monroy, this term "encapsulates the wholeness of the Spanish vision for the Indians of California. Of course to a Spaniard to be *de razón* meant to be Catholic, Castilian-speaking, settled into tax-paying towns, working in agriculture, and loyal to the majesty, the king of Spain." But the term *gente de razón* also had ethnic implications. Ramón Gutiérrez points out that this term basically differentiated Spaniards from Indians before the 1600s throughout the Spanish Borderlands, but as Indians were Christianized and through miscegenation the legal definitions of racial classification changed, a new caste system developed to maintain some social order over the fluid racial communities throughout New Spain. Douglas Monroy, *Thrown Amongst Strangers: The Making of Mexican Culture in Frontier California* (Berkeley: University of California Press, 1990), 22; Ramón Gutiérrez, *When Jesus Came, the Corn Mothers Went Away: Marriage, Sexuality, and Power in New Mexico, 1500–1846* (Stanford: Stanford University Press, 1991), 195–96.

27. Vicki L. Ruiz, *From Out of the Shadows: Mexican Women in Twentieth-Century America* (New York: Oxford University Press, 1998), 50.

CHAPTER 1. SPANISH WOMEN AS CULTURAL AGENTS FROM MEDIEVAL SPAIN TO THE NEW WORLD FRONTIER

1. Pierre Bourdieu, *In Other Words: Essays Towards a Reflexive Society* (Stanford: Stanford University Press, 1990), 64.

2. Hommi K. Bhabha, *The Location of Culture* (London: Routledge, 1994), 37.

3. Robert J. C. Young, *Colonial Desire: Hybridity in Theory, Culture and Race* (London: Routledge, 1995), 181–82.

4. Gayatri Chakravorty Spivak, *In Other Worlds: Essays in Cultural Politics* (New York: Methuen, 1987), 79.

5. See Cott, *Public Vows,* 11–13; Hartog, *Man and Wife in America,* 118–20, 139–40, 232–33.

6. Cott, *Public Vows,* 3.

7. Ibid., 2.

8. Nancy Wollach, *Women and the American Experience* (New York: Alfred A. Knopf, 1984), 19–20.

9. Karin Wulf, *Not All Wives: Women of Colonial Philadelphia* (Ithaca: Cornell University Press, 2000), 5.

10. See Frederick Jackson Turner, "Significance of the Frontier in American History," in *Major Problems in the History of the American West: Documents and Essays,* ed. Clyde A. Milner II, 2–34 (Lexington: D. C. Heath, 1989); Howard Lamar and Leonard Thompson, eds., *The Frontier in History: North America and Southern Africa Compared* (New Haven: Yale University Press, 1981).

11. Dee Alexander Brown, *The Gentle Tamers: Women of the Old West* (New York: Putnam, 1958), 190, 290.

12. David J. Weber, *The Spanish Frontier in North America* (New Haven: Yale University Press, 1992), 11.

13. For the complexity of Spanish colonial identity, see Ramón Gutiérrez, *When Jesus Came,* 193–206, 285–92, 338–40; David J. Weber, *The Spanish Frontier,* 326–28, 330; Brooks, *Captives and Cousins*; and Omar Valerio Jiménez, "Indios Bárbaros, Divorcées, and Flocks of Vampires: Identity and Nation on the Rio Grande, 1749–1894" (Ph.D. diss., University of California, Los Angeles, 2000).

14. Ann L. Stoler, "Sexual Affronts and Racial Frontiers: European Identities and the Cultural Politics of Exclusion in Colonial Southeast Asia," *Comparative Studies in Society and History* 34 (July 1992): 224.

15. María Rosa Menocal, *The Ornament of the World: How Muslims, Jews, and Christians Created a Culture of Tolerance in Medieval Spain* (Boston: Little Brown, 2002). See also Vivian B. Mann, Thomas F. Glick, and Jerrilynn D. Dodds, eds., *Convivencia: Jew, Muslims, and Christians in Medieval Spain* (New York: G. Braziller; Jewish Museum, 1992).

16. Heath Dillard, *Daughters of the Reconquest: Women in Castilian Town Society, 1100–1300* (Cambridge: Cambridge University Press, 1984), 12–35. Given the large number of individuals of Basque origin or descent present in the Spanish Empire, a significant number of them serving in the colonial military, civil administration, and church, and including a number of Californio elite families with Basque surnames (Echeandía, Guerra, Ibarra, Noriega, Uribe, and others), it is interesting to speculate

that the exceptional degree of self-determination traditionally accorded to Basque women in their homeland may have translated itself to the Spanish colonies in a way that supported other conditions encouraging women's independence. The Basque homeland was for centuries both a frontier bastion against Muslim expansion and a center of Iberian Christianity, and Basque women historically played a significant role as cultural and religious defenders of their homeland and, by extension, of Christian Europe. While it is not the purpose of this book to explore the Basque influence in colonial California, the presence of Basque-descended families may indicate some degree of non-Castilian tradition at work in the shaping of Californio and borderlands society.

17. Ibid.

18. Ibid., 68–95.

19. Ann Twinam, *Public Lives, Private Secrets: Gender, Honor, Sexuality, and Illegitimacy in Colonial Spanish America* (Stanford: Stanford University Press, 1999), introduction.

20. Dillard, *Daughters of the Reconquest,* 215.

21. See Ann Twinam, "Honor, Sexuality, and Illegitimacy in Colonial Spanish America," in *Sexuality and Marriage in Colonial Latin America,* ed. Asunción Lavrín (Lincoln: University of Nebraska Press, 1989); Twinam, *Public Lives,* 59–88.

22. Twinam, *Public Lives,* 37, 107.

23. Ibid., 35–55.

24. Michael E. Smith and Frances F. Berdan, eds., *The Postclassic Mesoamerican World* (Salt Lake City: University of Utah Press, 2003), 6.

25. José María Ots y Capedequí, *Instituciones,* vol. 14 of *História de América* (Barcelona: Salvat, 1959), 367–68, quoted in Juan Francisco Maura, *Women in the Conquest of the Americas,* trans. John F. Deredita (New York: Peter Lang, 1997), 14.

26. Maura, *Women in the Conquest of the Americas,* 18–30. See also Amanda Angel, "Spanish Women in the New World: The Transmission of a Model Polity to New Spain, 1521–1570" (Ph.D. diss., University of California, Davis, 1997).

27. José Luis Martínez, *Pasajeros de Indias* (Madrid: Alianza, 1983), 168.

28. Martha Menchaca, *Recovering History, Constructing Race: The Indian, Black, and White Roots of Mexican Americans* (Austin: University of Texas Press, 2001), 53.

29. David J. Weber, *The Spanish Frontier,* 124, 126.

30. Menchaca, *Recovering History,* 134–35; Antonia I. Castañeda, "Presidarias y Pobladores: Spanish-Mexican Women in Frontier Monterey, Alta California, 1770–1821" (Ph.D. diss., Stanford University, 1990), 132–33.

31. Ots y Capedequí, *Instituciones,* 361, quoted in Maura, *Women in the Conquest of the Americas,* 21.

32. Menchaca, *Recovering History,* 59–66.

33. For a discussion of African slavery in Latin America, see James Lockhart and Stuart Schwartz, *Early Latin America: A History of Colonial Spanish America and Brazil* (Cambridge: Cambridge University Press, 1983); Stuart Schwartz, *Slaves, Peasants, and Rebels: Reconsidering Brazilian Slavery* (Urbana: University of Illinois Press, 1992).

34. Magali Marie Carrera, *Imagining Identity in New Spain: Race, Lineage, and the Colonial Body in Portraiture and Casta Paintings* (Austin: University of Texas Press, 2003).

35. Menchaca, *Recovering History*, 81; Cheryl English Martin, *Governance and Society in Colonial Mexico: Chihuahua in the Eighteenth Century* (Stanford: Stanford University Press, 1996), 210.

36. Ramón Gutiérrez, *When Jesus Came*, 198.

37. Twinam, *Public Lives*, 32–33.

38. David J. Weber, *The Spanish Frontier*, 88–91.

39. Ibid., 133–41; Andrew L. Knaut, *The Pueblo Revolt of 1680: Conquest and Resistance in Seventeenth-Century New Mexico* (Norman: University of Oklahoma Press, 1995).

40. Max L. Moorhead, *The Presidio: Bastion of the Spanish Borderlands* (Norman: University of Oklahoma Press, 1975), 3–4.

41. Castañeda, "Presidarias y Pobladoras," 120.

42. David J. Weber, *The Spanish Frontier*, 215–20.

43. Patricia Seed, "The Church and the Patriarchal Family: Marriage Conflicts in Sixteenth- and Seventeenth-Century New Spain," *Journal of Family History* 10 (Fall 1985): 285. See also Silvia Marina Arrom, *Women and the Family in Mexico City: 1800–1857* (Ann Arbor, Mich.: University Microfilms, 1977); David A. Brading, *Miners and Merchants in Bourbon Mexico* (Cambridge: Cambridge University Press, 1971); John Kicza, *Colonial Entrepreneurs: Families and Business in Bourbon Mexico City* (Albuquerque: University of New Mexico Press, 1983); Asunción Lavrín, "In Search of the Colonial Woman in Mexico: The Seventeenth and Eighteenth Centuries," in Asunción Lavrín, ed., *Latin American Women: Historical Perspectives* (Westport, Conn.: Greenwood Press, 1978); Asuncíon Lavrín, *Sexuality and Marriage in Colonial Latin America* (Lincoln: University of Nebraska Press, 1989); Asuncíon Lavrín and Edith Couturier, "Dowries and Wills: A View of Women's Socioeconomic Role in Colonial Guadalajara and Puebla, 1640–1790," *Hispanic American Historical Review* 59, no. 2 (May 1979): 280–304; Ramón A. Gutiérrez, "Honor Ideology, Marriage Negotiation, and Class-Gender Domination in New Mexico, 1690–1846," *Latin American Perspectives* 12 (Winter 1985): 81–104; Edith Couturier, "Women and the Family in Eighteenth-Century Mexico: Law and Practice," *Journal of Family History* 10 (Fall 1985): 294–304; Elizabeth Kuznesof and Robert Oppenheimer, "The Family and Society in Nineteenth-Century Latin America: An Historiographical Introduction," *Journal of Family History* 10 (Fall 1985): 215–34; Ann Twinam, "Honor, Sexuality, and Illegitimacy in Colonial Spanish America."

44. Lavrín, *Sexuality and Marriage*, 18.

45. Castañeda, "Presidarias y Pobladoras," 132–33; Luis Martin, *Daughters of the Conquistadores: Women of the Viceroyalty Peru* (Albuquerque: University of New Mexico Press, 1983), 105–12.

46. Castañeda, "Presidarias y Pobladoras," 63–92; Monroy, *Thrown Amongst Strangers*, 51–96; Virginia Marie Bouvier, *Women and the Conquest of California, 1542–1821: Codes of Silence* (Tucson: University of Arizona Press, 2001).

47. Castañada, "Presidarias y Polbldoras," 137. Castañeda effectively contextualizes the dilemma faced by the early Christian fathers in recruiting and maintaining social and sexual control over the female and male members of these nascent communities. By examining the presidial forces' sexual violence on Amerindian women, this chapter centers the impact of sexual hierarchies in colonial settlement and its formation on this northern frontier.

48. Ibid., 250–62.

49. Ibid., 256.

50. Ibid.

CHAPTER 2. CLASS AND MARRIAGE CHOICES

1. Sylvia Van Kirk, *Many Tender Ties: Women in Fur-Trade Society, 1670–1870* (Norman: University of Oklahoma Press, 1983), 2–3.

2. Ibid., 201–30.

3. Anne C. Rose, *Beloved Strangers: Interfaith Families in Nineteenth-Century America* (Cambridge: Harvard University Press, 2001), 62.

4. Paul A. Gilje, *The Road to Mobocracy: Popular Disorder in New York City, 1763–1834* (Chapel Hill: University of North Carolina Press, 1987), 205. See also Mary P. Ryan, *Cradle of the Middle Class: The Family in Oneida County, New York, 1790–1865* (Cambridge: Cambridge University Press, 1981); Stuart M. Blumin, *The Emergence of the Middle Class: Social Experience in the American City, 1760–1900* (Cambridge: Cambridge University Press, 1989); Sean Wilentz, *Chants Democratic: New York City and the Rise of the American Working Class, 1788–1850* (Oxford: Oxford University Press, 1984); G. J. Barker-Benfield, *The Horrors of the Half-Known Life: Male Attitudes Toward Women and Sexuality in Nineteenth-Century America* (New York: Harper Colophon, 1976); Charles E. Rosenberg, "Sexuality, Class and Role in Nineteenth Century America," *American Quarterly* 35 (May 1973): 131–53.

5. Gail Bederman, *Manliness and Civilization: A Cultural History of Gender and Race in the United States, 1880–1917* (Chicago: University of Chicago Press, 1995), 7.

6. Ibid., 11. See also Warren I. Susman, *Culture as History* (New York: Pantheon, 1984); J. A. Mangan and James Walvin, *Manliness and Morality: Middle-Class Masculinity in Britain and America, 1800–1940* (New York: St. Martin's Press, 1987).

7. Bederman, *Manliness and Civilization*, 20–30.

8. Matthew Basso, Laura McCall, and Dee Garceau, *Across the Great Divide: Cultures of Manhood in the American West* (New York: Routledge, 2001), 6–7. See also Susan Johnson, *Roaring Camp: The Social World of the California Gold Rush* (New York: W. W. Norton, 2000).

9. María Tomás Ygnacia Lugo married the captain of the San Diego presidio, Raimundo Carrillo, in 1781, and their daughter, Antonia Carrillo, married the second lieutenant of Monterey, José de la Guerra y Noriega, in 1806. See Marie E. Northrop, *Spanish-Mexican Families of Early California, 1769–1850*, 2 vols. (Burbank: Southern California Genealogical Society, 1984–87), for this marriage pattern.

10. "Plan of the Royal Presidio of Santa Barbara," in Joseph A. Thompson, O.F.M., *El Gran Capitán: José de la Guerra* (Los Angeles: Franciscan Fathers of California, Cabrera and Sons, 1961), 176; Susanna Bryant Dakin, *The Lives of William Hartnell* (Stanford: Stanford University Press, 1949), 60–64.

11. Thompson, *El Gran Capitán*, 1–40; Alfred Robinson, *Life in California: During a Residence of Several Years in That Territory and Chinigchinich: An Historical Account of the Origin, Customs, and Traditions of the Indians of Alta California* (Santa Barbara and Salt Lake City: Peregrine Publishers, 1970), 169. See also William Henry Phillips, "Don José Antonio Julian de la Guerra y de Noriega, of California" (Master's thesis, University of Southern California, 1950), 4–20.

12. William Dane Phelps, *Alta California, 1840–1842: The Journal and Observations of William Dane Phelps, Master of the Ship "Alert,"* int. and ed. Briton Cooper Busch (Glendale, Calif.: Arthur H. Clark, 1983), 178.

13. Dakin, *The Lives of William Hartnell,* 133. Mission and nonmission Indians usually ate three meals a day. More variety in foodstuffs may have existed on the ranchos compared to what was available to Mission Indians, whose two main meals consisted of pozole.

14. Bancroft, *California Pastoral,* 312.

15. Haas, *Conquests and Historical Identities,* 52.

16. José del Carmen Lugo, "Life of a Rancher," *Historical Society of Southern California Quarterly* 32 (September 1950): 225.

17. D. Mackenzie Brown, ed., *China Trade Days in California: Selected Letters from the Thompson Papers, 1832–1863* (Berkeley: University of California Press, 1947), 2.

18. "*Memorias* de doña Apolinaria lorenzana 'La Beata' dictadas por ella en Santa Barbara en marzo de 1878 a Tomas Savage, Bancroft Library 1878," in Rosaura Sánchez, Beatrice Pita, and Bárbara Reyes, *Crítica: A Journal of Critical Essays,* Crítica Monograph Series No. 68 (San Diego: University of California, 1994), 6.

19. David J. Weber, *The Mexican Frontier, 1821–1846: The American Southwest under Mexico* (Albuquerque: University of New Mexico Press, 1982), 138.

20. Dakin, *The Lives of William Hartnell,* 60–62.

21. William Hartnell to Hannah, Santiago, Chile, October 22, 1819, in William Hartnell Letterbook, c-b 665, Bancroft Library.

22. William Hartnell to Nathaniel, in ibid.

23. Ibid.

24. Doyce B. Nunis Jr., ed., *The California Diary of Faxon Dean Atherton, 1836–1839* (San Francisco: California Historical Society, 1964), 46. Atherton would eventually marry Dominga Goñi, a member of an elite Chilean family.

25. Ibid.

26. William Atherton to William E. P. Hartnell, January 20, 1823, quoted in Dakin, *The Lives of William Hartnell,* 45–46.

27. Dakin, *The Lives of William Hartnell,* 28.

28. David Spence to William Hartnell, quoted in ibid., 59.

29. Castañeda, "Presidarias y Pobladores," 238–39. Some historical accounts contend that Vallejo literally helped deliver María Antonia. See Alan Rosenus, *General M. G. Vallejo and the Advent of the Americans,* 3–5.

30. Northrop, *Spanish-Mexican Families,* 2: "lo que ya tenian clebrado esponsales y estaban en vigilias de contraer Matrimonio." María Francisca died at the age of twenty.

31. Gloria E. Miranda, "Gente de Razón Marriage Patterns in Spanish and Mexican California: A Case Study of Santa Barbara and Los Angeles," *Southern California Historical Quarterly* 63 (1981): 6–7. Although Miranda systematically analyzes only the 1790 California census, she does extrapolate this information into the early nineteenth century, particularly in denoting the difference between the presidial and pueblo communities. In regard to age, William and Teresa were within the norm of age disparity between husband and wife, as well as of the average age when couples first married.

32. Northrop, *Spanish-Mexican Families,* 2:120–21. Several foreign visitors anecdotally relate how even Teresa forgot the number of children to whom she had given birth, "as it was a seemingly annual occurrence." In her narración she claimed to have given birth to twenty males and five females, but this was probably an exaggeration. I believe that by claiming so many children Teresa is also claiming greater legitimacy within Californio society—after all, a woman capable of producing this many children can easily produce an accurate account of the past. Teresa de la Guerra de Hartnell, "Narración de la distinguida matron Californiana," MS C-E 67, p. 20, Bancroft Library.

33. Ibid., 16–17.

34. Dakin, *The Lives of William Hartnell,* 34; Robert Huish, comp., *A Narrative of the Voyages and Travels of Captain F. W. Beechey R.N. to the Pacific and Behring's Straits, Performed in the Years 1825, 26, 27, and 28* (London: W. Wright, 1836), 448. Tivy left California in 1839.

35. William Hartnell to José de la Guerra Noriega, May 4, 1831, Item 534, De la Guerra Collection, Huntington Library; William Edward Petty to María Antonia (Carrillo) de la Guerra, November 15, 1842, Patrocinio Hartnell [Rancho del Alisal], Item 667 (494), in ibid.

36. Northrop, *Spanish-Mexican Families,* 1:34.

37. Apolinaria Lorenzana, "Memorias de doña Apolinaria Lorenzana 'La Beata' dictadeas por ella en Santa Bárbara en Marzo de 1878 a Thomas Savage, Bancroft Library 1878," in Rosaura Sánchez, Pita, and Reyes, *Crítica,* 13.

38. María Inocenta Pico de Ávila, "Cosas de California, contadas a Thomas Savage en Ávila y San Luis Obispo por Doña María Inocenta Pico, viuda de Don Miguel Ávila," in ibid., 63.

39. "Census of 1834," John Temple Collection, Huntington Library.

40. De la Guerra de Hartnell, "Narración," 17.

41. Ibid. 17–18.

42. Dakin, *The Lives of William Hartnell,* 213–42, 286–89.

43. Thompson, *El Gran Capitán,* 155.

44. Ibid.

45. See John McHenry Hollingsworth, "The Journal of John McHenry Hollingsworth, 1846–1849," *Historical Society of Southern California Quarterly* 1, no. 3 (January 1923): 207–70.

46. Hubert Howe Bancroft, *Pioneer Register and Index,* vol. 7 of *History of California,* 7 vols. (San Francisco: History Co., 1884–89), 742.

47. De la Guerra de Hartnell, "Narración," 21.

48. Ibid., 24.

49. Ibid., 23.

50. Dakin, *The Lives of William Hartnell,* 291.

51. See Sheriff of Santa Barbara to Charles E. Hase, February 25, 1856; Sheriff of Santa Barbara to Teresa Hartnell, December 21, 1857; Teresa Hartnell to Miguel Smith and Wife, May 28, 1859; Teresa de la Guerra to Juan E. Hartnell, August 29, 1859; Sheriff of Santa Barbara to Samuel A. Pollard, May 24, 1862, all in Charles Fernald Collection, Box 7, Folder Misc. Legal Papers, Huntington Library.

52. Monroy, *Thrown Amongst Strangers,* 59–61; Haas, *Conquests and Historical Identities,* 24, 26.

53. Eulalia Perez, "Una Vieja y Sus Recuerdos," in Rosaura Sánchez, Pita, and Reyes, *Critica,* 36–37.

54. The Rancho el Rincón de San Pascual (present-day Pasadena) was a 3 ½-square-league land grant to which Eulalia eventually lost her grantee rights, having failed to record her deed. At some point after beginning her employment at the mission, Eulalia married Juan Mariné. At the time Eulalia lost her grantee rights, Mariné recorded the deed in his own name, although he was by then separated from Eulalia. Eulalia's subsequent efforts to regain the rancho proved useless. Ibid., 37.

55. See Ramón Gutiérrez, *When Jesus Came,* 176–206; Norbert Elias, *The Civilizing Process: The History of Manners and State Formation and Civilization,* trans. Edmund Jephcott (New York: Pantheon Books, 1982), 492–513.

56. According to J. N. Bowman and Lisbeth Haas, over sixty-six women were granted ranchos after 1821, the majority of them single or widowed. Of the sixty-six, only two were Native American women, Victoria Reid and the Luiseño Indian María Juana de los Angeles. Gloria Ricci Lothrop raises some speculation as to Victoria's ownership of Rancho Santa Anita. Haas, *Conquests and Historical Identities,* 82–85; J. N. Bowman, "Prominent Women of Provincial California," *Southern California Historical Quarterly* 39, no. 2 (1957): 149–66; Gloria Ricci Lothrop, "Rancheras and the Land: Women and Property Rights in Hispanic California," *Southern California Historical Quarterly* 76, no. 1 (1994): 82, fn. 19. For a general overview of rancho ownership prior to American conquest, see Robert G. Cowan, *Ranchos of California: A List of Spanish Concessions, 1775–1822, and Mexican Grants, 1822–1846* (Los Angeles: Historical Society of Southern California, 1977); and Manuel Jimeno Casarín and William E. P. Hartnell, *Indexes to Land Concessions from 1830 to 1846, Including Toma de Razon or Registry of Titles for 1844–45* (San Francisco: Kenny and Alexander, 1861).

57. According to Robert F. Heizer, ed., *The Indians of Los Angeles County: Hugo Reid's Letters of 1852* (Los Angeles: Southwest Museum, 1968), Reid was born in Cardross, Scotland, in 1811. I will accept Dakin's biographical dates and locations until other sources clear up the matter. Susanna Bryant Dakin, ed., *A Scotch Paisano: Hugo Reid's Life in California, 1832–1852* (Berkeley: University of California Press, 1939), 42–43.

58. David J. Weber, *The Mexican Frontier,* 107–46. The Californio elite were always fearful of emigrants, desiring a greater population but unwilling to give newcomers equality or to undermine their own social positions of power.

59. Dakin, *A Scotch Paisano,* 21–36.

60. Hugo Reid to Abel Stearns, San Gabriel, March 24, 1843, in Box 52, Stearns Collection.

61. Hugo Reid to Abel Stearns, June 29, 1841, in ibid., Box 52. See also Perfecto Hugo Reid to Abel Stearns, January 1840; Perfecto Hugo Reid to Abel Stearns, Rancho de los Coyotes, October 18, 1840; Perfecto Hugo Reid to William Davis Merry Howard, 1840, all in ibid., Box 52.

62. The vineyard contained 20,500 *uba prieta,* 2,070 *uba blanca,* and 160 *uba cimarrona* vines, totaling 22,730 grapevines, with space to expand to 40,000. Along with the vines, the Reids cultivated a variegated orchard consisting of 21 fig, 7 plum, 25 pear, 5 apple, 32 orange, 40 pomegranate, 2 honey mesquite, 240 peach, 8 blood

orange, 3 walnut, 7 olive, and 40 lemon trees, totaling 430 trees. Dakin, *A Scotch Paisano,* 113–14.

63. Hugo Reid to Abel Stearns, August 25, 1839, Box 52, Stearns Collection.

64. Victoria Bartolomea Comicrabit Reid to Abel Stearns, San Gabriel, July 16, 1842, Box 51, Stearns Collection.

65. Hugo Reid to Abel Stearns, July 16, 1842, Box 52, Stearns Collection.

66. Davis, *Seventy-Five Years in California,* 109.

67. Ibid.

68. Laura Evertson King, "Hugo Reid and His Indian Wife," *Historical Society of Southern California and Pioneer Register* 4 (Los Angeles: Historical Society of Southern California, 1899): 111.

69. Ibid.

70. Ibid., 112.

71. Davis, *Seventy-Five Years,* 109.

72. For the interactions of American soldiers and their opinions of the Bandini women, see Hollingsworth, "Journal of John McHenry Hollingsworth"; William Rich Hutton, *Glances at California, 1847–1853* (San Marino, Calif.: Huntington Library, 1942); William Ryan, *Personal Recollections in Upper and Lower California* (London: W. Shoberl, 1850); M. A. DeWolfe Howe, ed., *Home Letters of General Sherman* (New York: Charles Scribner's Son, 1909).

73. Victoria Bartolomea Comicrabit to Abel Stearns, May 30, 1849, Box 51, Stearns Collection.

74. Virginia L. Carpenter, *The Ranchos of Don Pacífico Ontiveros* (Santa Ana, Calif.: Friis Pioneer Press, 1982), 56–78.

75. Three children were born to Felipe and María de la Resurección, two daughters and a son. During the early 1850s the entire family, except for one daughter, Sara, died in a smallpox epidemic. Sara was raised by her maternal grandparents, but when she married at age sixteen her surname was given as Alvarado—her maternal grandmother's surname—and no reference was made to the ethnicity of her father, Felipe. See Carpenter, *The Ranchos of Don Pacífico Ontiveros,* 87.

76. Perfecto Hugo Reid to Abel Stearns, Rancho Uva Espina, June 1, 1844, Box 52, Stearns Collection.

77. Dakin, *A Scotch Paisano,* 190.

78. Victoria Bartolomea Comicrabit to Abel Stearns, May 30, 1851, Box 51, Stearns Collection.

79. Heizer, *The Indians of Los Angeles County,* 2, 3.

80. "Anecdote of a Lawyer," undated, in Hugo Reid Collection, Seaver Center for Western History Research, Los Angeles County Museum of Natural History, Los Angeles, California.

81. María Victoria Bartolomea Reid (Comicrabit) to Benjamin Davis Wilson, Deed to Rancho Huerta del Cuati, February 6, 1854, WN 1528, Benjamin Davis Wilson Collection, Huntington Library.

82. U.S. Courts, District Court, California, *Proceedings of California Land Cases,* Southern District Case 171 (Rancho Huerta del Cuati or Quati), María Victoria Bartolomeo (Comicrabit) Reid, claimant, 1852–1857, FAC 700 (455), Huntington Library.

83. King, "Hugo Reid and His Indian Wife," 113.

84. Harlan Hague and David J. Langum, *Thomas O. Larkin: A Life of Patriotism and Profit in Old California* (Norman: University of Oklahoma Press, 1990), 229–31.

85. Ibid., 31–33.

86. Northrop, *Spanish-Mexican Families,* 1:351.

87. Ibid., 37–40.

88. Ibid., 34.

89. Thomas Oliver Larkin, *The Larkin Papers: Personal, Business, and Official Correspondence of Thomas Oliver Larkin, Merchant and United States Consul in California,* ed. George P. Hammond, 10 vols. (Berkeley: University of California Press, 1953), 4:167.

90. Ibid., 185.

91. Ibid., 42–43.

92. Ibid., 44.

93. Phelps, *Alta California,* 178.

CHAPTER 3. MARRIAGE AND THE MYTH OF ROMANTIC CALIFORNIA

1. Young, *Colonial Desire,* xii.

2. Ibid., chap. 1.

3. For discussion of "the Other," see Edward Said, *Orientalism* (London: Routledge and Kegan Paul, 1978); Bhabha, *The Location of Culture.*

4. Bhabha, *The Location of Culture,* 50.

5. Young, *Colonial Desire,* 98.

6. Bhabha, *The Location of Culture,* 51.

7. Ibid., 89.

8. Deena J. González, *Refusing the Favor,* 39.

9. For New Mexican intermarriage patterns, see ibid., 113–14, and for Texas, see Mark M. Carroll, *Homesteads Ungovernable: Families, Sex, Race, and the Law in Frontier Texas, 1823–1860* (Austin: University of Texas Press, 2001).

10. Castañeda, "Presidarias y Pobladoras," 11–12; James J. Rawls and Walton Bean, *California: An Interpretive History,* 7th ed. (Boston: McGraw Hill, 1998), 49–50.

11. Thomas C. Russell, trans., *Langsdorff's Narrative of the Rezanov Voyage to California in 1806* (San Francisco: Private Press of Thomas C. Russell, 1927), 76. Although trade with foreigners was prohibited, one friar from the Monterey area did present the Russians with forty fanegas of wheat for humanitarian reasons.

12. The Argüellos had thirteen children, but only nine survived. Concepción was the sixth child and one of seven girls. Three sons survived into adulthood and were pushed into presidial service, but the eldest chose the priesthood instead, and the other two were indifferent soldiers. Bancroft notes that the Argüellos "took great pains with the home education of their sons," which further emphasizes that Concepción's religious studies were taken up on her own. See Hubert Howe Bancroft, vol. 19 of *The Works of Hubert Howe Bancroft,* 39 vols. (San Francisco: History Co., 1883–90), 358–60.

13. Richard A. Pierce, ed., *Rezanov Reconnoiters California: A New Translation of Rezanov's Letters, Parts of Lieutenant Khvostov's Log of the Ship Juno, and Dr. Georg von Langsdorff's Observations* (San Francisco: Book Club of California, 1972), 33.

14. Russell, *Langsdorff's Narrative*, 86.

15. Bancroft, *History of California*, 2:72. As Castañeda points out, it is this particular episode that begins Bancroft's romanticized stereotypes of Californianas. For the most complete literary work on the Rezanov and Argüello romance, see Eve Ivesen, *The Romance of Nikolai Rezanov and Concepción Argüello: A Literary Legend and Its Effect on California History* (Kingston, Ontario: Limestone Press, 1998). Only one other woman, Eulalia Callis, wife of Governor Pedro Fages, received individual attention from Bancroft; however, it was Callis's "deviant" sexual behavior that merited her being mentioned. This "infamous *gobernadora*" refused her husband sexual rights until he promised to remove himself as governor of Alta California and return the family to Mexico. For more details, see Castañeda, "Presidarias y Pobladoras," chaps. 1 and 5.

16. Petr. A. Tikhmenev, *The Historical Review of [the] Formation of the Russian-American Company and Its Activity up to the Present Time*, vol. 1, cited in Susanna Bryant Dakin, *Rose or Rose Thorn? Three Women of Spanish California* (Berkeley: Friends of the Bancroft Library, 1963), 38.

17. Dakin, *Rose or Rose Thorn?* 39.

18. Castañeda, "Presidarias y Pobladoras," 12; Rawls and Bean, *California*, 50.

19. See "Concepción de Argüello" in Bret Harte, *Complete Poetical Works* (New York: P. R. Collier and Son, 1899), 76–82.

20. Rosaura Sánchez, *Telling Identities*, 209.

21. Russell, *Langsdorff's Narrative*, 85–86.

22. Castañeda, "Presidarias y Pobladoras," 262–64.

23. Ramón Gutiérrez, *When Jesus Came*, 265.

24. For an example of a California *diligencia matrimonial*, see "Anthony Forster" in Uncatalogued Collection Huntington Library. For the most intensive study of these marriage investigations along the northern frontier, see chap. 8, "Marriage and the Church," in Ramón Gutiérrez, *When Jesus Came*. Throughout this work, Gutiérrez notes how the need of the church and the state to regulate marriage alliances was an important sociopolitical, racial, and cultural factor in New Mexican society. An investigation of the depth and number of New Mexican marriage investigations in relation to those in other Borderlands regions could possibly provide important comparative elements to determine key differences in the development of Borderlands communities, especially in terms of gender. A study of how a rapidly developing versus a more slowly developing commercial base affected women's social and personal participation in marital ideologies and practices has yet to be done, but it might provide useful insights into the changes of women's lives depending on geographic location.

25. Dakin, *Rose or Rose Thorn?* 43–44.

26. Ibid., 53–56.

27. Ibid., 57.

28. In her narrative Apolinaria Lorenzana reveals that she had traveled to California with her mother, who soon married a soldier. When fresh recruits arrived to relieve the San Diego forces, her new stepfather returned to Mexico, taking Apolinaria's mother with him. Californios would progressively complain about the class and *cualidad* (quality) of the people whom governmental authorities sent to California, and this group of immigrants indicates why the Californios were concerned. Many of the adults

who came quickly returned to Mexico; California held few enticements for career soldiers, making the stepfather's decision to return to Mexico fairly understandable, and the orphans were foundlings. Apolinaria was given the surname Lorenzana after the bishop of Mexico, whose patronage had made their journey to California possible. But if Apolinaria's mother still survived, why was Apolinaria named Lorenzana and thereafter categorized as a foundling? In all likelihood she was born out of wedlock, and California provided an opportunity for her mother to reestablish some respectability in a place where a woman's past sexual indiscretions were not as damaging or as much an impediment to a possible legitimate marriage alliance as they would have been in Mexico. In the end Apolinaria's mother made the agonizing choice of leaving her illegitimate daughter behind when she returned to Mexico and a new, respectable life as a married woman.

29. Apolinaria Lorenzana, "Memorias de Doña Apolinaria Lorenzana 'La Beata' dictadas por ella en Santa Bárbara," in Rosaura Sánchez, Pita, and Reyes, *Critica,* 14.

30. Eulalia Pérez, "Una Vieja y Sus Recuerdos Dictados . . . a la Edad Avanzada de 139 años," in *Critica,* 37.

31. Deena J. González, "The Widowed Women of Santa Fe: Assessments of the Lives of an Unmarried Population, 1850–1880," in *Unequal Sisters: A Multicultural Reader in U.S. Women's History,* ed. Ellen Carol DuBois and Vicki L. Ruiz (New York: Routledge, 1990), 40.

32. Josépha Boronda de Burke was the widow and second wife of Manuel Antonio Cota. Her marriage to James Walter Burke was not a tranquil one, and she finally sued for separation from her husband. See Josefa (Boronda) de Burke to Abel Stearns, Santa Barbara, October 6, 1842, in Stearns Collection, Box 12, item 19. For other details, see Northrop, *Spanish-Mexican Families,* 1:116.

33. Sister Mary Jane Mast, quoted in Dakin, *Rose or Rose Thorn?* 53.

34. Lorenzana, "Memorias," 13.

35. Ibid.

36. Ibid., 3.

37. "Es una historia larga, y no quiero ni hablar de ella. Los dos ranchos me los quitaron de algún modo—Así es que después de trabajar tantos años, de haber poseído bienes, de que yo no me desposeí por venta ni de otro modo, me encuentro en la mayor pobreza, viviendo del favor de Dios y de los que me dan un bocado de comer." My translation. Ibid., 10.

38. Castañeda, "Presidarias y Pobladoras," 217–25.

39. Will of Deciderio Ibarra, Los Angeles, November 11, 1840, in MS Film 00382, Los Angeles Prefect Records (hereafter cited as LAPR), Vol. A, 144–47 (translated into English), Bancroft Library, University of California, Berkeley, California. Since many of the LAPR entries do not have formal titles, for clarity the first sentence of the entry will be cited along with the page number in the translated documents.

40. Ibid.

41. Will of Joaquina Machado, LAPR, Vol. A, 396, Bancroft Library.

42. Alexander Forbes, *California: A History of Upper and Lower California from Their First Discovery to the Present Time, Comprising an Account of the Climate, Soil, Natural Productions, Agriculture, Commerce, &c. A Full View of the Missionary Establishments*

and Condition of the Free and Domesticated Indians (London: Smith, Elder, and Co., 1839).

43. Sir George Simpson, *Narrative of a Journey Round the World, During the Years 1841 and 1842,* 2 vols. (London: Henry Colburn, 1847), 2:116–18.

44. Hubert Howe Bancroft, *California Pastoral,* 327.

45. Carrillo de Fitch, "Dictation of Mrs. Captain Henry D. Fitch," 7–8, in Hubert Howe Bancroft Collection, Fitch Documents, Bancroft Library.

46. Domingo Antonio Ignacio Carrillo was born in San Diego in 1791. Trained as a soldier, he moved to Santa Barbara in 1830, where he served in a number of minor capacities and temporarily took command of the Californio forces during the Chico affair of 1836. In Juan Bautista Alvarado's account, it is Domingo who resented Enrique's foreignness and who petitioned Echeandía to stop the marriage. In 1810 Carrillo married Pío Pico's sister, Concepción, and on March 1, 1837, he died suddenly when thrown from his carriage.

47. Carrillo de Fitch, "Dictation," 8. However, Alfred Robinson intimates that the reason for the governor's interference was Fitch's failure to secure a special license from the governor. In Robinson's account, Fitch "prevail[ed] upon the chaplain of the Presidio to perform the ceremony without the necessary form of becoming a Catholic." The "old friar in his heart wished them married, yet he dared not disobey the injunctions of a superior." Robinson's account seems suspect, because Fitch had clearly become a Catholic prior to the interrupted marriage ceremony. See Robinson, *Life in California,* 14.

48. Carrillo de Fitch, "Dictation," 3.

49. Pío Pico, *Don Pío Pico's Historical Narrative,* trans. Arthur P. Botello, ed. and int. Martin Cole and Henry Welcome (Glendale, Calif.: Arthur H. Clark Co., 1970), 38–39.

50. Carrillo de Fitch, "Dictation," 9.

51. Ibid.

52. Ibid., 4.

53. Ecclesiastical Trial of Enrique Fitch, December 22, 1830, notarized by Pablo de la Ossa, Document 1118, Calendar of Documents Collection, Santa Barbara Mission Archive, Santa Barbara, California. The ecclesiastical trial transcripts consist of forty-odd documents totaling ninety-two pages of actual depositions and correspondence between the ecclesiastical and secular authorities. Hereafter cited as Trial Transcripts. For clarity, I shall use the date to distinguish between documents rather than referring to the entire transcript.

54. Trial Transcripts, August 21, 1830. John Bautista Rogers Cooper led the Euro-American contingency in petitioning church officials to investigate the matter, and Josefa was placed in *deposito* in his home during the trial.

55. Ibid., November 17, 1830, notarized by José Palomares.

56. Ibid.

57. David J. Weber, *The Mexican Frontier,* 47.

58. Ibid, 60–63; Rosaura Sánchez, *Telling Identities,* 113.

59. "Que ni [en] California, ni en lugar alguno de todos los que componen las Provincia del Federacion Megicana, se há cometido jamas extremo, ni mayor violencia

contra la Jurisdiccion Eclesiastica, y Espiritual, . . . que ha dictado el Sr. de Echeandía en favor de D_ Josefa Carrillo. Tal és que por ella há hecho su Señoria de este fuera, y V.P. su Juez legitmo, para juzgarlo é imponerle las correspiondientes penas." My translation. Trial Transcripts, November 17, 1830, notarized by Francisco Morales.

60. Ibid.

61. Ibid., Fr. José Sanchez, San Gabriel, December 22, 1830.

62. Ramón Gutiérrez, *When Jesus Came*, 177.

63. Sarah Maza, "Domestic Melodrama as Political Ideology: The Case of the Comte de Sanois," *American Historical Review* 94, no. 5 (December 1989): 1263.

64. Ramón A. Gutiérrez, "Honor, Ideology, Marriage Negotiation, and Class-Gender Domination in New Mexico, 1690–1846." *Latin American Perspectives* 12 (1985): 88.

65. Patricia Seed, *To Love, Honor, and Obey in Colonial Mexico: Conflicts Over Marriage Choice, 1574–1821* (Stanford: Stanford University Press, 1988); Seed, "The Church and the Patriarchal Family," 284–93; Twinam, "Honor, Sexuality, and Illegitimacy," 118–55; Kuznesof and Oppenheimer, "The Family and Society," 215–34; Couturier, "Women and the Family in Eighteenth-Century Mexico," 94–304.

66. For a better understanding of the issues involved in the dissolution of Catholic marriage, see John T. Noonan Jr., *The Power to Dissolve: Lawyers and Marriage in the Courts of the Roman Curia* (Cambridge: Belknap Press of Harvard University Press, 1972).

67. Seed, *To Love, Honor, and Obey*, 33.

68. Ibid.

69. Seed defines *deposito* as temporary custody, or *depósiton* (from the Latin word *depositus*, meaning a trust or a bond). It originally signified the temporary placement of property in trust (as a deposit). In medieval ecclesiastical writing, the term was used to refer to temporary guardianship of people, as in the practice of separating a young couple who had eloped in order to ascertain whether the young woman had run away on her own volition. By church tradition, a woman who had eloped was placed in temporary custody with an unrelated family for three days so that she could freely contemplate the step she was about to undertake. Seed, *To Love, Honor, and Obey*, 78.

70. Ibid., 62.

71. Ramón Gutiérrez, *When Jesus Came*, 209.

72. Ibid.

73. Twinam, "Honor, Sexuality, and Illegitimacy," 120.

74. Ramón Gutiérrez, *When Jesus Came*, 241.

75. Ibid., 243.

76. Ibid., 253.

77. Seed, *To Love, Honor, and Obey*, 122.

78. David J. Weber, *The Mexican Frontier*, 125, 149–50; Monroy, *Thrown Amongst Strangers*, 72–73, 171–73; Adele Ogden, *The California Sea Otter Trade, 1784–1848* (Berkeley: University of California Press, 1941), 120–39; Magdalen Coughlin, C.S.J., "Boston Smugglers on the Coast (1797–1821): An Insight into the American Acquisition of California," *California Historical Society Quarterly* 46, no. 2 (1967): 94–120. See also Michael González, "Searching for the Feathered Serpent: Exploring the Origins of

Mexican Culture in Los Angeles, 1830–1850" (Ph.D. diss., University of California, Berkeley, 1993), which discusses the generational divisions between the Californio elders and their increasingly disobedient children.

79. Davis, *Seventy-Five Years in California,* 81.

80. Ibid., 79–81.

81. Ibid., 81–82.

82. Antonio María Osio, *The History of Alta California: A Memoir of Mexican California,* trans., ed., and annotated by Rose Marie Beebe and Robert M. Senkewicz (Madison: University of Wisconsin Press, 1996), 70. The bespeckled Gale, known as *cuatro ojos* throughout the territory, was a widower who in 1822 brought with him his five-year-old daughter, Anita, whom he placed in the care of Doña Eustaquia Pico. He married María Francisca Marcelina Domínguez in 1827, and he died suddenly the following year. Anita remained in Doña Pico's care.

83. José Ramón Sánchez, "Narration," 169, 175, in Hubert Howe Bancroft Collection.

84. Henry Delano Fitch to Abel Sterns, San Diego, September 12, 1845, in Stearns Collection, Box 26.

85. Ogden, *The California Sea Otter Trade,* 96.

86. Ibid., 104.

87. Governor Manuel Victoria to Eduarda Osuña, Monterey, October 30, 1831, quoted in Ogden, *The California Sea Otter Trade,* 114. See also Jonathan Trumball Warner, "Reminiscences of Early California," 65, in Hubert Howe Bancroft Collection.

88. Honorable Prefect of This District, in LAPR, Vol. A, 143, Bancroft Library; and Hubert Howe Bancroft, *California Pioneer Register 1542–1848* (Baltimore: Regional Publishing Co., 1964), 5:767.

89. To His Excellency, the Governor, in LAPR, Vol. A, 148, Bancroft Library.

90. Asunción Lavrín, "Sexuality in Colonial Mexico: A Church Dilemma," in *Sexuality and Marriage in Colonial Latin America,* ed. Asunción Lavrín (Lincoln: University of Nebraska Press, 1989), 65.

91. Vista al Pasmoto Fiscal Fr. José Sanchez Morales Notario, Septiembre de 1830, Mision de San Gabriel, in Trial Transcripts.

92. Don Enrique D. Fitch Natural de Nueva Bedford de Estado Mansachusas de la America del Norte, Marido de Dñ Josefa Carrillo Natural del Presidio de Sn Diego; y actuamente berenido, y arrestado en esta Mision, con todo mi respeto. My translation. In Trial Transcripts, December 21, 1830, notarized by Pablo de la Ossa.

93. H.R.P. Pres. y Vicario Foranco. El Promotor Fiscal de este Fingado Eclesiastico, Respondiendo ála vista, que V.PR. le ha dado de un Memorial remitido de Monterrey en 31 de Agosto pp_ Enrique Domingo Fitch Dice: Que qualquiera que lea esta fueza conocerá en el momento que en produccion propis del mismo suplicante, y no de otro alguno, in Trial Transcripts, September 17, 1830, notarized by José Palomares.

94. Confeción de D. Enrique D. Fitch, En la Mision de San Gabriel, a once de Diciembre de mil ochocientos y treinta el M.R.P. Fr. José Sanchez Predicador Apost Foraneo del Obispado de Sonora en esta Provincia, Presidente de sus Misiones, y Ministro de la ya nominada, in Trial Transcripts, December 11, 1830, notarized by Pablo de la Ossa.

95. Ronald J. Miller, "A California Romance in Perspective: The Elopement,

Marriage, and Ecclesiastical Trial of Henry D. Fitch and Josefa Carrillo," *Journal of San Diego History* 19, no. 2 (1973): 12–13, n. 45.

96. Juana Machado de Ridington, "Los Tiempos Pasados de la Alta California," 22; Eulalia Pérez, "Una Vieja y sus Recuerdos," 39, both in Rosaura Sánchez, Pita, and Reyes, *Crítica*.

97. Ramón Gutiérrez, *When Jesus Came*, 298–336.

98. Maynard Geiger, trans., *Letters of Alfred Robinson to the De la Guerra Family of Santa Barbara, 1834–1873* (Los Angeles: Zamorano Club, 1972), 12.

99. Davis, *Seventy-Five Years in California*, 55.

100. Carrillo de Fitch, "Dictation," 15.

101. David J. Weber, *The Mexican Frontier*, 22.

102. Ibid., 37–42.

103. Osio, *The History of Alta California*, 160.

104. Ibid.

105. Carrillo de Fitch, "Dictation," 7.

106. Helen Hunt Jackson, to the Coronels, November 8, 1883, in George Wharton James, *Through Ramona's Country* (Boston: Little, Brown, 1910).

107. Helen Hunt Jackson, *Ramona* (1884; reprint, New York: Grosset and Dunlap, 1912), 31–32. The popularity of this story transcends literary representation; numerous plays and three movies have been based on the novel. Currently, several editions exist, and *Ramona* has undergone more than three hundred reprintings, along with numerous stage presentations, the most important of which is the annual Ramona Pageant in Hemet, California. Prior to 1933 three movie versions, one with Dolores del Rio and another featuring Don Ameche, were filmed. Hunt intended her novel as an exposé of the treatment of the Californian Mission Indians, but it was *Ramona*'s popularity as a love story that made it a persistent bestseller. According to Kevin Starr, the novel's popularity lies not in the fact "not that it translates fact into fiction, but that it translates fact into romantic myth." Because of the novel's popularity, eastern tourists attempted to "find" the real Ramona and to retrace Alesandro and Ramona's escape route. See Valerie Sherer Mathes, *Helen Hunt Jackson and Her Indian Reform Legacy* (Austin: University of Texas Press, 1990), 76–94; Mathes's essay, "Helen Hunt Jackson as Power Broker," in Margaret Connell Szasz, ed., *Between Indian and White Worlds: The Cultural Broker* (Norman: University of Oklahoma Press, 1994), 141–57; Kevin Starr, *Inventing the Dream: California Through the Progressive Era* (New York: Oxford University Press, 1985), 60–61.

108. Iris H. W. Engstrand and Mary F. Ward, "Rancho Guajome: An Architectural Legacy Preserved," *Journal of San Diego History* 41 (Fall 1995): n. 47.

109. Rawls and Bean, *California*, 192.

110. Ibid.

111. William Deverall, *Whitewashed Adobe: The Rise of Los Angeles and the Remaking of Its Mexican Past* (Berkeley: University of California Press, 2004), 6.

112. There are currently several editions in print, and *Ramona* has undergone more than three hundred reprintings along with numerous stage presentations, the most important of the latter being the annual Ramona Pageant in Hemet, California. Prior to 1933 three movie versions, one with Dolores del Rio and another featuring Don Ameche, had been filmed. *Ramona*'s popularity as a love story made it a persistent

best-seller. After visiting California and interviewing a number of elite Californios, Hunt Jackson drew on a true person for the character Angus Phail. Had Hunt Jackson been a better historian, she would have realized that the really dramatic history did not solely lie with Hugo Reid but with his Indian wife, Victoria Bartolomea Camicrabit. See chapter 2.

113. Deverell, *Whitewashed Adobe,* 53.

114. Ibid., 64.

115. Johnston McCulley, "The Curse of Capistrano," *All Story Weekly* 100, no. 2–101, no. 2 (August 9, 1919–September 6, 1919).

116. Rosaura Sánchez, *Telling Identities,* 203.

CHAPTER 4. THE LEGAL SYSTEM AND
"A RECKLESS BREED OF MEN"

1. After a brief detention and inquiry, Echeandía ordered Smith to leave the country immediately by the same route by which he had illegally entered. Disobeying these orders, Smith traveled north through the San Joaquin Valley, hoping to reach the rendezvous at the Colombian River basin. Crossing the Sierra Nevada, he traveled through Nevada and Utah before returning to California via the very route he had traveled a year earlier. Within months, Echeandía was aware of Smith's deception and sent him written orders to leave the country. When Smith appeared again at San Gabriel, he was detained a second time, and authorities threatened to send him to Mexico in chains. However, John Rogers Cooper and three other foreign captains posted bond for him. Smith was again ordered to leave by a designated route, and again he traveled to the San Joaquin Valley. Before leaving California, he sent a letter via John Rogers Cooper to the American consul in Mexico, Joel Poinsett, to report his abuse at the hands of California authorities, making his California adventure for a brief moment an international incident.

2. David J. Weber, *The Mexican Frontier,* 132–34; Robert Glass Cleland, *The Cattle on a Thousand Hills: Southern California, 1850–1880.* 2nd ed. (San Marino, Calif.: Huntington Library, 1951), 185–86.

3. Robert Glass Cleland, *This Reckless Breed of Men: The Trappers and the Fur Traders of the Southwest* (New York: Knopf, 1950). See also Leonard Pitt, *The Decline of the Californios: A Social History of Spanish-Speaking Californians, 1846–1890* (Berkeley: University of California Press, 1971), 17; Rodolfo Acuña, *Occupied America: A History of Chicanos* (New York: Harper Collins, 1988), 5–18; Doyce B. Nunis Jr., "Alta California's Trojan Horse: Foreign Immigration," in *Contested Eden: California Before the Gold Rush,* ed. Ramón Gutiérrez and Richard J. Orsi (Berkeley: University of California Press, 1998), 299–330.

4. Hubert Howe Bancroft, *California Pastoral,* 327.

5. Lavrín, "In Search of the Colonial Woman in Mexico," 30. For a more thorough explanation of Latin American women's legal rights, see Marcelo Martínez Alcubilla, *Códigos antiguos de España,* 2 vols. (Madrid: López Camacho, 1885); José María Manresa y Navarro, *Comentarios al código civil español,* 9 vols. (Madrid: Imprenta de la Revista de Legislación, 1908), 9:23–61; Rafael Cibert y Sánchez de la Vega, *El consentimiento familiar en el matrimonio seún el derecho medieval español* (Madrid: Instituto Nacional de Estudios Jurídicos, 1947); José María Ots y Capdequí, "Bosquejo histórico de

los derechos de la mujer en la legislación de Indias," *Revista general de legislación y jurisprudencia* 132 (March–April 1918): 161–82; Woodrow W. Borah, "Marriage and Legitimacy in Mexican Culture: Mexico and California," *California Law Review* 54 (May 1966): 946–1008.

6. See Michael González, "Searching for the Feathered Serpent"; Monroy, *Thrown Amongst Strangers*; Haas, *Conquests and Historical Identities*.

7. Rosaura Sánchez, *Telling Identities,* 110–12. As early as 1826 and again in 1828, Echeandía called for Indian emancipation; by 1830 and 1831, he attempted the secularization of mission lands, to considerable Californio resistance.

8. Mariano Vallejo, "Recuerdos históricos y personales tocante a la Alta California," 2:107, quoted in Rosaura Sánchez, *Telling Identities,* 112.

9. Rosaura Sánchez, *Telling Identities,* 112.

10. Bancroft, *History of California,* 3:188; David J. Langum, *Law and Community on the Mexican California Frontier: Anglo-American Expatriates and the Clash of Legal Traditions, 1821–1846* (Norman: University of Oklahoma Press, 1987), chaps. 1 and 2; David J. Weber, *The Mexican Frontier,* 28.

11. David J. Weber, *The Mexican Frontier,* 17–18.

12. Ibid., 37–42.

13. Miroslava Chavez, "Pongo Mi Demanda: Challenging Patriarchy in Mexican Los Angeles, 1830–1850," in Valerie J. Matsumoto, ed., *Over the Edge: Remapping the American West* (Berkeley: University of California Press, 1999), 275.

14. Langum, *Law and Community,* 45–46. In 1830 Rafael Gómez was appointed California's first *asesor,* but he was replaced by Cosme Peña in 1834. Also in 1834, Luis del Castillo Negrete, a trained lawyer, was appointed district judge of California, but his activities in local politics forced his departure after two years of service. Anglo Americans constantly complained about the lack of lawyers in California, but there was a shortage of trained lawyers throughout Mexico during the nineteenth century.

15. David J. Weber, *The Mexican Frontier,* 39. See also Woodrow James Hansen, *The Search for Authority in California* (Oakland: Biobooks, 1960), 34, 46–50.

16. Langum, *Law and Community,* 5.

17. Ibid., 94.

18. Ibid., 109.

19. See Carroll's discussion of matrimonial property law in *Homesteads Ungovernable,* 228–33.

20. The following analysis has been informed by my readings of Michel de Certeau, *Heterologies: Discourse on the Other,* trans. Brian Massumi (Minneapolis: University of Minnesota Press, 1986); Michel de Certeau, *The Practice of Everyday Life,* trans. Seven Rendall (Berkeley: University of California Press, 1984); Michel Foucault, *Critique and Power: Recasting the Foucault/Habermas Debate,* ed. Michael Kelly (Cambridge: MIT Press, 1994); Michel Foucault, *Discipline and Punish: The Birth of the Prison,* trans. Alan Sheridan (New York: Vintage Books, 1979); Pierre Bourdieu, *The Field of Cultural Production: Essays on Art and Literature* (New York: Columbia University Press, 1993); Pierre Bourdieu, *The Logic of Practice* (Stanford: Stanford University Press, 1990); and Nicholas B. Dirks, Geoff Eley, and Sherry B. Ortner, eds., *Culture/Power/History: A Reader in Contemporary Social Theory* (Princeton: Princeton University Press, 1994).

21. Bowman, "Prominent Women of Provincial California," 165.

22. Deena González, "The Widowed Women of Santa Fe," 45. See also "Introduction," in Arlene Scadron, *On Their Own: Widows and Widowhood in the American Southwest, 1848–1939* (Urbana: University of Illinois Press, 1988), 1–21.

23. Richard Griswold del Castillo, *The Los Angeles Barrio, 1850–1890: A Social History* (Berkeley: University of California Press, 1979), 65; Lothrop, "Rancheras and the Land," 59–84; Bowman, "Prominent Women of Provincial California."

24. "Investigation of Inocente Valdes, 1845," in LAPR, Vol. A, 221, Bancroft Library.

25. Ibid., 223.

26. Presentación was only two years old when her father, Juan María Duarte, married fifteen-year-old Tomasa Valdes. Widowed after eleven years of marriage, Tomasa retained custody of Duarte's children and eventually married Tiburcio Tapia. Presentación was Inocente's stepniece and not related by blood.

27. "Statement of Judge of First Instance, Vicente Sanchez," Los Angeles, November 7, 1845, LAPR, 225–26, Bancroft Library.

28. "On this date I went to my home with my assisting witnesses and I summoned to appear before me the resident Ramón Duarte," LAPR, 227, Bancroft Library.

29. Ibid., 228.

30. "In the City of Los Angeles, Alta California, on the sixth day of August, one thousand eight hundred and forty-seven, before me, José Salazar, First Alcalde and Judge of First Instance of said City," LAPR, 362, Bancroft Library.

31. Ibid.

32. "In the City of Los Angeles, Alta California, on the twenty-fourth day of January, 1848, before me, Estevan C. Foster, First Alcalde and Judge of First Instance," LAPR, 441, Bancroft Library.

33. "In the City of Los Angeles, of Alta California, on the twenty-fourth day of the month of December, one thousand eight hundred and forty nine, before me, José del Carmen Lugo, Judge of First Instance of said City," LAPR, 837, Bancroft Library.

34. Ibid., 838.

35. "In the City of Los Angeles, Alta California, on the twenty-eighth day of the month of June, one thousand eight hundred and forty-nine, before me, José Lopez, Senior Regidor and functioning as Justice of the Peace," LAPR, 663, Bancroft Library.

36. "In the City of Los Angeles, on the thirtieth day of the month of May, one thousand eight hundred and forty-nine, before me, José del Carmen Lugo, First Alcalde and Judge of First Instance, of this City, appeared Don Francisco Villa, also of this City," LAPR, 663, Bancroft Library.

37. Ibid.

38. "In the City of Los Angeles, Alta California, on the tenth day of May, eighteen hundred and fifty, before me, Agustín Olvera, Civil Judge of first Instance of said City and District," LAPR, 927, Bancroft Library.

39. "In the city of Los Angeles, Alta California, on the seventh day of December, eighteen hundred and forty-nine, before me, José del Carmen Lugo, Judge of First Instance of the said City," LAPR, 804–6, Bancroft Library.

40. "In the city of Los Angeles, on the tenth day of December one thousand eight hundred and forty-seven, before me, José Salazar, First Alcalde and Judge of First Instance of the aforesaid City," LAPR, 423–24, Bancroft Library.

41. Ibid.

42. "In the City of Los Angeles, of Alta California, on the twenty-fifth day of February, eighteen hundred and fifty, before me, Agustín Olvera, Civil Judge of First Instance of this District," LAPR, 867, Bancroft Library.

43. "In the City of Los Angeles, of Alta California, on the nineteenth day of February, of the year eighteen hundred and fifty, before me, Agustín Olvera, Civil Judge of the Division Court of First Instance of this District," LAPR, 853–55, Bancroft Library.

44. "In the City of Los Angeles, of Alta California, on the nineteenth day of February, of the year eighteen hundred and fifty, before me, Agustín Olvera, Civil Judge of the Division Court of First Instance of this District," LAPR, 853, Bancroft Library.

45. Lavrín and Couturier, "Dowries and Wills," 280–304.

46. Deena González, *Refusing the Favor,* 95.

47. Ibid., 96.

48. "Will of Josefa Cota," date unknown, LAPR, 376, Bancroft Library.

49. According to Langum, banishment was the typical punishment for adulterers, male or female, but as Antonia I. Castañeda and other Latin American historians point out, "women were prosecuted more vigorously." Illegitimate children were not uncommon in Californio communities, as is indicated by baptismal records. See Langum, *Law and Community,* 75–77; Antonia I. Castañeda, "Engendering the History of Alta California, 1769–1848," in Gutiérrez and Orsi, *Contested Eden,* 250; Lavrín, "In Search of the Colonial Woman." See also Richard Boyer, *The Life of the Bigamists: Marriage, Family, and Community in Colonial Mexico* (Albuquerque: University of New Mexico Press, 2001).

50. "Will of Joaquina Machado," date unknown, LAPR, 398–99, 403, Bancroft Library.

51. Ibid., 399.

52. For scattered references of *hijos naturales,* see Northrop, *Spanish-Mexican Families.* Although this is the most thorough printed publication involving Californio genealogies, the records are incomplete, as the category of hijos naturales indicates. Illegitimate children fathered by Spanish-Mexican men with Native American women were not included in the records. Also missing are unions that were not sanctioned by marriage and the children resulting from those unions.

53. Langum, *Law and Community,* 133.

54. Ibid., 133.

55. Ibid., 163–86.

56. "In the City of Los Angeles, on the fifth day of the month of April, one thousand eight hundred and fifty, before me, Ignacio del Valle, First Protem Alcalde," LAPR, 992, Bancroft Library.

57. Ibid., 993.

58. "Señor Alcalde Primero, Francisca Uribe, widow Juan Bautista Leandy, with due respect before you, states," LAPR, 605, Bancroft Library.

59. "In the City of Los Angeles of Alta California, on the 15th day of the month of December 1849, before me, José del Carmen Lugo, Judge of 1st. Instance of this City, appeared Francisco Ocampo," LAPR, 625, Bancroft Library.

60. José Abrego to Josefa Abrego, Monterey Archives, Monterey, California, 15: 645 (1841); "In the City of Los Angeles, Alta California, on the sixteenth day of August, eighteen hundred and forty-nine, before me, José del Carmen Lugo," LAPR, 705, Bancroft Library. See also Castro to Castro, Monterey Archives, 11: 571 (1844).

61. "In the city of Los Angeles of Alta California, on the 24th day of March 1849, before me, Stephen C. Foster, First Alcalde," LAPR, 635, Bancroft Library.

62. "In the city of Los Angeles, of Alta California, on the thirty-first day of the month of March, one thousand eight hundred and forty-nine, before me, Estevan C. Foster," LAPR, 647, Bancroft Library.

63. Pitt, *The Decline of the Californios,* 6.

64. David J. Weber, *The Mexican Frontier,* 185.

65. C. Alan Hutchinson, *Frontier Settlement in Mexican California: The Híjar-Padrés Colony, and Its Origins, 1769–1835* (New Haven: Yale University Press, 1969), 181. Although written in 1969, this book remains the most complete study of the Híjar-Padrés colonization effort. As scholarly interest in nineteenth-century California increases, this colonization effort is proving to be a pivotal moment in the socioeconomic and political shifts in California society.

66. Ibid., 181–215.

67. Osio, *The History of Alta California,* 126–35.

68. David J. Weber, *The Mexican Frontier,* 185.

69. Victor Eugene August Janssens, *The Life and Adventures in California of Don Agustín Janssens, 1834–1856,* trans. Francis Price, ed. William H. Ellison and Francis Price (San Marino, Calif.: Huntington Library, 1953), 21.

70. Ibid.

71. José Figueroa, *Manifiesto a la República Mexicana,* trans. and ed. C. Alan Hutchinson (Berkeley: University of California Press, 1978). See also Hutchinson, *Frontier Settlement,* 216–66.

72. Juan Bautista Alvarado, "History of California," 5 vols., trans. Earl R. Hewitt, Bancroft Library, 1876, 3:60. See also Rosaura Sánchez, *Telling Identities,* 221.

73. Rosaura Sánchez, *Telling Identities,* 222; Michael González, "Searching for the Feathered Serpent," 140–43.

74. Michael Gonzales, "Searching for the Feathered Serpent." For other primary and secondary accounts of the Villa-Alipás affair, see Los Angeles County Archives, MS, II, 134–41, Huntington Library; Nicolás Gutiérrez to Mariano G. Vallejo, Monterey, 22 April 1836, in "Vallejo Documents," III, 197, Bancroft Library; Alvarado, "History of California," 3:60–71; Charles C. Baker, "The Dispensing of Justice Under the Mexican Regime," *Annual Publications of the Historical Society of Southern California* 10, pt. 3 (1917): 38–39; George Tays, "California's First Vigilantes," *Touring Topics* 25 (May 1933): 18–19; Bancroft, *History of California,* 3:417–19, 430–33, 5:703.

75. "Junta Defensora de la Seguridad Pública," April 7, 1836, Los Angeles Archives, I, 87, Bancroft Library; Michael González, "Searching for the Feathered Serpent," 143.

76. Rosaura Sánchez, *Telling Identities,* 223; Alvarado, "History of California," 3:66–67.

77. David J. Weber, *The Mexican Frontier,* 33.

78. Victor Prudón, "Vigilantes of 1836," trans. Earl Hewitt, in Bancroft Library,

printed in Bancroft, *Works,* 36:318, 675; Michael González, "Searching for the Feathered Serpent," 144–46.

79. Langum, *Law and Community,* 80; Bancroft, *Works,* 36:675.

80. Rosaura Sánchez, *Telling Identities,* 223.

81. LAPR, Vol. A 451–52 (1840) and Vol. A447B (1840), Bancroft Library.

82. Josefa (Boronda) de Burke to Abel Stearns, Santa Barbara, October 6, 1842, Stearns Collection, Box 12, Folder 19. The accounts were as follows: José Alvarado, $3.4; Pedro Lopez, vaquero de McKinley, $8.6; Ramona Sepulbida $26-; José Sepulbida, $44-.

83. Dakin, *Rose or Rose Thorn?* 52.

84. Bowman, "Prominent Women of Provincial California," 156–57.

85. Ibid., 163–64; Lothrop, "Rancheras and the Land," 70.

86. Bowman, "Prominent Women of Provincial California," 160–61.

87. Ibid., 159–60.

88. Langum, *Law and Community,* 237.

89. Ibid., 238.

90. Carrillo, Pedro C[atarino], Reconciliation agreement with his wife, María Josefa (Bandini) Carrillo, December 27, 1851, Item 169, Cave Johnson Couts Collection, Huntington Library.

91. Langum, *Law and Community,* 236. According to Bancroft, María Guadalupe Castillo asked for a legal separation, but Edward Watson reluctantly agreed to a divorce. Bancroft, *California Pastoral,* 314–15.

92. "On this date, Dona María Dolores Valenzuela appeared before me, and in my presence made the following statement," Los Angeles, May 25, 1848, LAPR, 481, Bancroft Library.

93. William Robert Garner, *Letters from California, 1846–1847,* ed. Donald Munro Craig (Berkeley: University of California Press, 1970), 29–30.

94. Iris Higbie Wilson, *William Wolfskill 1798–1866: Frontier Trapper to California Ranchero* (Glendale: Arthur H. Clark, 1965), 95–96.

95. Castañeda, "Engendering History," 240; Gloria E. Miranda, "Hispano-Mexicano Childbearing Practices in Pre-American Santa Barbara," *Southern California Historical Quarterly* 65, no. 4 (Winter 1983): 307–20.

96. William R. Swagerty, "Marriage and Settlement Patterns of Rocky Mountain Trappers and Traders," *Western Historical Quarterly* 11, no. 2 (April 1980): 164.

97. Garner, *Letters from California,* 21–22. Thomas J. Farnham was the first to write about the "Graham Affair," casting it in terms of the oppressive and bigoted Californio legal system. For other accounts about this episode, see Dorothy Allen Gertzog, "Isaac Graham: California Pioneer" (master's thesis, University of California, Berkeley, 1941); Doyce Blackman Nunis Jr., *The Trials of Isaac Graham* (Los Angeles: Dawson's Book Shop, 1967); Leon Rowland, "Isaac Graham, "Swashbuckling Soldier of Fortune," *Santa Cruz News* 58 (August 1, 1936), 7.

98. Los Angeles Ayuntamiento Archives, January 4, 1833, IV, 81–84, BANC MSS C-A 72, Bancroft Library.

99. "Francisco J. Alvarado to the City Council," March 7, 1835, LAPR, 29, Bancroft Library.

100. Ibid.

101. Garner, *Letters from California,* 22.

102. Bancroft, *History of California,* 4: chap. 1.

103. "List of the Individuals who shall form the Guard of this City," prepared by Abel Stearns and Bacilio Valdez, February 17, 1836, in Receipts of the Ayuntamiento, 1836–1844, Los Angeles Ayuntamiento Archives, Translations, III, 151, BANC MSS C-A 72, Bancroft Library.

104. Provincial State Papers, 1767–1822, VIII, 139–40, BANC MSS C-A, Bancroft Library.

105. Garner, *Letters from California,* 25–27.

106. Ibid., 27.

107. John Chamberlain, "Memoirs of California Since 1840," 1877, BANC MSS C-D 57, Bancroft Library. See also Larkin, *Larkin Papers* [Larkin to Buchanan], 7:73.

108. Cleland, *Cattle on a Thousand Hills,* 187–88; Langum, *Law and Community,* 79. For the most complete account of Abel Stearns's activities prior to the Mexican-American War, see Doris M. Wright, *A Yankee in Mexican California: Abel Stearns, 1798–1848* (Santa Barbara: Wallace Hebberd, 1977).

109. Reid, Perfecto Hugo to Abel Stearns, March 31, 1843, Stearns Collection, Box 52.

110. Garner, *Letters from California, 1846–1847,* 214–36.

111. Esther Boulton Black, *Rancho Cucamonga and Doña Merced* (Redlands, Calif.: San Bernardino County Museum Association, 1975), 145.

112. Ibid., 2.

113. Ibid., 145.

114. Ibid., 3–12.

115. Benjamin Hayes, *Pioneer Notes from the Diaries of Judge Benjamin Hayes, 1849–1875,* ed. Marjorie Tisdale Wolcott (1929; New York: Arno Press, 1976), 147.

116. "Testimony of John Reed," Case .0138, *Rains v. Dunlap* (1867), First Judicial District Court, San Bernardino County.

117. Black, *Rancho Cucamonga,* 12–18.

118. "Testimony of Jonathan Scott," *Rains v. Dunlap.*

119. Black, *Rancho Cucamonga,* 30–31.

120. Ibid., 33.

121. Ibid., 62–63.

122. Ibid., 63.

123. "Testimony of Robert Carlisle," *Rains v. Dunlap.*

124. "Testimony of Stephen Foster," *Rains v. Dunlap.*

125. "Testimony of Jonathan Scott," *Rains v. Dunlap.*

126. Ibid.

127. For contemporary accounts of the Rains murder, see the newspaper articles in the *Los Angeles Star,* November 29, 1862. While no one was ever officially found guilty of the murder, Manuel Cerradel was arrested, tried, and sentenced to a ten-year prison term for complicity in the crime. Several Euro-Americans believed that Ramón Carrillo had murdered John Rains, and some even suspected María Merced of having an affair with the older Carrillo. Even Cerradel's conviction did not satisfy their outrage. When Cerradel was being ferried to the ship that would take him to prison, a vigilante group of Euro-Americans lynched him from the mast of the ship

and afterward weighted his body with stones and threw it into the bay. See Cleland, *Cattle on a Thousand Hills,* 99, for this account and how it figured into the overall violence between the Californio and Euro-American communities.

128. "Memorandum, February, 1864," Benjamin Hayes, "Scraps," BANC MSS C-B 82, vol. 14, Benjamin Hayes Papers, Bancroft Library.

129. "Testimony of María Merced Williams de Rains," *Rains v. Dunlap.*

130. Black, *Rancho Cucamonga,* 84–85.

131. Ibid., 87.

132. Ibid., 88.

133. "Hayes to Brown, June 20, 1864," Benjamin Hayes, "Scraps," Manuscript, vol. 14, Bancroft Library.

134. Black, *Rancho Cucamonga,* 124.

135. Ibid., 176–83.

CHAPTER 5. INTERETHNIC MARRIAGES IN THE POST–MEXICAN-AMERICAN WAR ERA

1. "Historic Building Is Razed," *Los Angeles Times,* Features Section, May 15, 1927. See also Cave Johnson Couts Collection, Folder 89, Newspaper Clippings.

2. "Historic Building Is Razed."

3. Ibid. See also Northrop, *Spanish-Mexican Families,* 2:23.

4. "Historic Building Is Razed."

5. Homi Bhabha, *The Location of Culture,* 37.

6. Richard Harker, Cheleen Mahar, and Chris Wilkes, eds., *An Introduction to the Work of Pierre Bourdieu* (New York: St. Martin's Press, 1990), 140–43.

7. Nira Yuval-Davis and Floya Anthias, *Woman-Nation-State* (New York: St. Martin's Press, 1989), 7.

8. Haas, *Conquests and Historical Identities,* 9.

9. Ibid.

10. See Bancroft, *History of California,* 5:732–33; Monroy, *Thrown Amongst Strangers,* 156–57.

11. Cleland, *Cattle on a Thousand Hills,* 190–93.

12. Bancroft, *History of California,* 5:709–10.

13. Cleland, *Cattle on a Thousand Hills,* 189. See also "April 29, 1841, Stearns Marriage Papers," Stearns Collection.

14. Elizabeth White Fairley, quoted in Helen Louise Pubols, "The de la Guerra Family: Patriarchy and the Political Economy of California, 1800–1850" (Ph.D. diss., University of Wisconsin–Madison, 2000), 468.

15. "Noted Early Day Beauty Passes," *Grizzly Bear* 16 (November 1914): 7.

16. Sheldon G. Jackson, *A British Ranchero in Old California: The Life and Times of Henry Dalton and the Rancho Azusa* (Glendale, Calif.: Arthur H. Clark, 1977), 123–24.

17. Ibid., 141.

18. The drought of 1863 has been extensively chronicled. See James M. Guinn, *A History of California and an Extended History of Los Angeles and Environs,* 3 vols. (Los Angeles: Historic Record Co., 1915), 1:290; Cleland, *Cattle on a Thousand Hills,* 125–37.

19. Monroy, *Thrown Amongst Strangers,* 160–62.

20. Cleland, *Cattle on a Thousand Hills,* 203–207.

21. "A Lady's Maid to Senora de Baker Tells Golden, Glamorous Days of Baker Block, Now Doomed to Perish," *San Diego Union,* April 23, 1936. See also Cave Johnson Couts Collection, Folder 89, Newspaper Clippings.

22. "A Lady's Maid to Senora de Baker Tells Golden, Glamorous Days of Baker Block."

23. Hollingsworth, "Journal of John McHenry Hollingsworth."

24. Ibid.

25. Henry F. Dobyns, ed., *Hepah California! The Journal of Cave Johnson Couts from Monterey, Nuevo León, Mexico, to Los Angeles, California, During the Years 1848–1849* (Tucson: Arizona Pioneers' Historical Society, 1961), 31.

26. Ibid.

27. Ibid., 18.

28. John F. Couts to Cave J. Couts, Springfield, November 22, 1853, Cave Johnson Couts Collection, Item 389.

29. María Amparo Ruíz de Burton to William Rich Hutton, November 20, 1853, San Diego (HM 13216), Huntington Library.

30. William A. Streeter, "Recollections of Historical Events in California, 1843–1878, of William A. Streeter," ed. William H. Ellison, *California Historical Society Quarterly* 18 (1939): 170.

31. Quoted in José Arnaz, "Memoirs of a Merchant: Being the Recollections of Life and Customs in Pastoral California by José Arnaz, Trader and Ranchero," trans. and ed. Nellie Van De Grift Sánchez, *Touring Topics* 20 (September 1928), 18.

32. Charles Johnson to Abel Stearns, quoted in Pitt, *The Decline of the Californios,* 112.

33. Engstrand and Ward, "Rancho Guajome," 259.

34. Ibid., 255. See also Report of Coroner's Jury on the Body of Juan Mendoza, February 6, 1865, Coroner's Inquest Collection, No. 152–4, San Diego Historical Society Research Archives, San Diego, California; "The State of California vs. Cave Johnson Couts, charged with assault and battery on Waldemar Müller with intent to commit murder," Cave Johnson Couts Collection, Item 293 (1–2); and Cave Johnson Couts to Benjamin Ignatius Hayes, "COLONEL CAVE J. COUTS TO JUDGE HAYES CONCERNING THE BURIAL OF DON YSIDRO ALVARADO OF RANCHO MONTSERRATE," Cave Johnson Couts Collection, Item 307.

35. See Albert L. Hurtado, *Intimate Frontiers: Sex, Gender, and Culture in Old California* (Albuquerque: University of New Mexico Press, 1999), 130.

36. Cave Johnson Couts to Don A. Hollister, January 10, 1861, "Petition for binding out several Indian servants," Cave Johnson Couts Collection, Item 309.

37. "Judgement rendered by William Caswell Ferrell, Justice of the Peace, in case of Cave Johnson Couts vs. Francisco, an Indian boy, May 6th, 1858," Justice of the Peace, San Diego County, California, in Cave Johnson Couts Collection, Item 204.

38. "Indenture wherein Jesús Delgado and Paula bind an Indian child Sasaria to Isidora (Bandini) de Couts, January 25, 1854," Cave Johnson Couts Collection, Item 2615; Cave Johnson Couts, Rancho Guajome Account Book and Journal, Cave Johnson Couts Collection, Item 2543 (15).

39. CT 207 California, San Diego County, Justice of the Peace. (Indenture wherein Indian woman, Jacinto, binds over her son to Isidora [Bandini] Couts), Cave Johnson Couts Collection.

40. Ibid.

41. See Cave Johnson Couts Collection, boxes 18 and 19, for miscellaneous letters from visitors to Rancho Guajome.

42. Engstrand and Ward, "Rancho Guajome," 258, 280, n. 47.

43. Ibid., 268–70.

44. Letter from Cave J. Couts to Maria Carolina Couts, Winston, February 28, 1884," Cave Johnson Couts Collection, Item 344.

45. Cave Johnson Couts, Jr. to Isidora Bandini Couts, June 25, 1877, Cave Johnson Couts Collection, Item 330 (1–2).

46. Rosaura Sánchez, ed., *Conflicts of Interest: The Letters of María Amparo Ruíz de Burton* (Houston: Arte Público Press, 2001), 5.

47. Kathleen Crawford, "María Amparo Ruíz de Burton: The General's Lady," *Journal of San Diego History* 30 (Summer 1984): 200.

48. Lina Fergusson Browne, ed., *J. Ross Browne, His Letters, Journals and Writings* (Albuquerque: University of New Mexico Press, 1969), 129–30. See also Rosaura Sánchez, *Conflicts of Interest,* 11.

49. Rosaura Sánchez, *Conflicts of Interest,* 14.

50. Ibid., 14–15.

51. Bhabha, *The Location of Culture,* 88–89. In some ways these intermarriages anticipate the debate over whiteness in the twentieth century. See Neil Foley, "Becoming Hispanic: Mexican Americans and the Faustian Pact with Whiteness," in *Reflexiones 1997: New Directions in Mexican American Studies,* ed. Neil Foley (Austin: Center for Mexican American Studies Books, 1998), 53–70.

52. The Huntington Library has an extensive collection of María Amparo Ruíz de Burton's personal and business correspondence. One folder, (FAC 667 [1135]), holds eighty-one letters to Mariano Guadalupe Vallejo. See also María Amparo Ruíz de Burton to William Rich Hutton, November 20, 1853, San Diego (HM 13216); and the papers of Samuel L. M. Barlow, MSS BW, Box 156 (55), Huntington Library.

53. María Amparo Ruíz de Burton to Mariano Guadalupe Vallejo, Monterey, November 23 [?], 1851. My translation. FAC 667 (1135), De la Guerra Family Collection, Huntington Library.

54. Mariano Guadalupe Vallejo, cited in Harold Augenbraum and Margarite Fernández Olmos, eds., *The Latino Reader: An American Literary Tradition from 1542 to the Present* (Boston and New York: Houghton Mifflin, 1997), 80.

55. Rosaura Sánchez, *Conflicts of Interest,* 188–89.

56. María Amparo Ruíz de Burton, *Who Would Have Thought It?* ed. Rosaura Sánchez and Beatrice Pita (Houston: Arte Público Press, 1995), 35–37.

57. Ibid., 17.

58. Rosaura Sánchez, *Conflicts of Interest,* 18.

59. María Amparo Ruíz de Burton to Matías Moreno, September 2, 1863, Pittsburg, Pennsylvania. My translation. Ibid., 263. This is a Spanish letter transcribed by Sánchez in this book.

60. "Asi pues, sigamos siendo buenos amigos tal como somos. V. con su admiracion

por las republicas y pos los Americanos, y yo con mi conviccion q. republicas son todavia y seran por años 'impossibilidades quimerieas,' y q. los Americanos son y seran siempre los enemigos MORTALES de mi raza, de me Méjico." My translation. María Amparo Ruíz de Burton to Mariano Guadalupe Vallejo, August 23, 1867, FAC 667 (1135), De la Guerra Family Collection, Huntington Library.

61. Rosaura Sánchez, *Conflicts of Interest*, 373–81.

62. Ibid., 413–14.

63. María Amparo Ruíz de Burton, *The Squatter and the Don*, ed. Rosaura Sánchez and Beatrice Pita (Houston: Arte Público Press, 1997), introduction.

64. Ibid., 7.

65. Ibid., 258.

66. Ibid., 351–52.

67. Mariano Guadalupe Vallejo, cited in *Who Would Have Thought It?* lvii.

68. María Amparo Ruíz de Burton to Mariano Guadeloupe Vallejo, August 26, 1867, Columbia, South Carolina. My translation. Quoted in Rosaura Sánchez, *Conflicts of Interest*, 270–71.

69. María Amparo Ruíz de Burton to Mariano Guadeloupe Vallejo, New York, February 15, 1869, quoted in ibid., 280.

70. Crawford, "María Amparo Ruíz de Burton," 207.

71. Rosaura Sánchez, *Conflicts of Interest*, 414.

72. Ibid., 206.

73. Alpheus Basil Thompson to Timothy Wolcott, September 6, 1856, Santa Barbara, in California Files (HM 18997), Huntington Library.

74. Cave Johnson Couts (son) to Isidora Bandini Couts, Colegio de Stewart, February 28, 1872, Couts Collection, Item 328.

75. William Bandini Couts to Cave Johnson Couts, December 5, 1871, Stewart College, Clarksville, Tennessee, Couts Collection, Item 472 (1–7).

76. Cave Johnson Couts (son) to Isidora Bandini Couts, Colegio de Stewart, February 28, 1872, Couts Collection, Item 328.

77. William Bandini Couts to Isidora (Bandini) Couts, Clarksville, Tennessee, February 24, 1873. My translation. Couts Collection, Item 482A.

78. William Bandini Couts to Cave Johnson Couts, Clarksville, Tennessee, January 20, 1872. My translation. Couts Collection, Item 472 (1–3).

79. Cave Johnson Couts to William Bandini Couts and Cave Johnson Couts (Jr.), Guajome, January 16, 1874, Couts Collection, Item 302 (1–7).

80. Cave Johnson Couts to William Bandini Couts and Cave Johnson Couts Jr., San Fran., May 16, 1874.

81. Pierre Bourdieu, "The Economy of Linguistic Exchanges," *Social Science Information* 16, no. 6 (1977): 652.

82. See Albert M. Camarillo, *Chicanos in a Changing Society: From Mexican Pueblos to American Barrios in Santa Barbara and Southern California, 1848–1930* (Cambridge: Harvard University Press, 1979).

83. Guillermo Fitch, *The Narrative of Guillermo Fitch and Blas Piña: Taken on Board of Steamer M.S. Latham on Her Voyage from San Francisco to Donahue. April 16th, 1874*, translated by Members of Los Hispanistas (Sacramento: Nugget Press, 1941).

84. See esp. Letter from Cave J. Couts to Maria Carolina Winston, February 28,

1884, Cave Johnson Couts Collection, Item 344, and Letter from Cave Johnson Couts to Isidora Bandini Couts, Escuintla, Guatemala, June 5, 1884, Cave Johnson Couts Collection, Item 331.

85. See Diary of Cave Johnson Couts (b), Cave Johnson Couts Collection, Item 2546 (16); Sharon Loughlin Bollinger, "Cave Johnson Couts, Jr.: Last of the Dons" (master's thesis, University of San Diego, 1976), 74–106; Engstrand and Ward, "Rancho Guajome," 251–283.

86. Engstrand and Ward, "Rancho Guajome," 269.

87. Ibid., 270.

88. Ibid., 274.

89. See Cave Johnson Couts Collection, Box 89, Box 90 (16), (49); and Bollinger, "Cave Johnson Couts," 160–63.

90. See Helen Luise Pubols, "The De La Guerra Family," 599.

BIBLIOGRAPHY

PRIMARY SOURCES
Manuscript Collections
Bancroft Library, University of California, Berkeley, California

Alvarado, Juan Bautista. "History of California." 5 vols. Translated by Earl R. Hewitt. 1876. MS C-D 1–5.

Provincial State Papers. 1767–1822. 14 vols. BANC MSS C-A 1–14.

Bancroft, Hubert Howe. Collection.

Chamberlain, John. "Memoirs of California Since 1840." 1877. BANC MSS C-D 57.

De la Guerra de Hartnell, Doña Teresa. "Narrativa de la distinguida matron Californiana." March 12, 1875. MS C-E 67.

Hartnell, William. "Letterbook." C-B 665.

Hayes, Benjamin. Papers. 1849–64.

Leese, Rosalía Vallejo de, "History of the Bear Flag Party."

Lorenzano, Apolinaria. "Memorias de la Beata." 1878. MS C-D 116.

Los Angeles Prefect Records. MS Film 00382.

Machado Alipás de Ridington, Juana de Dios. "Los tempos pasados de la Alta California." 1878. MS C-D 119.

Myron, Felipa Osuña de. "Recuerdos del pasado." 1878. MS C-D 120.

Pérez, Eulalia. "Una vieja y sus recuerdos." 1878. MS C-D 139.

Pico de Avila, María Inocenta. "Cosas de California." 1878. MS C-D 34.

Vallejo, Mariano Guadalupe. "Historical and Personal Memoirs Relating to California." 5 vols. Translated by Earl Hewitt. 1875. MS C-D 169.

Huntington Library, San Marino, California

Barlow, Samuel L. M. Papers.

California Files.

Couts, Cave Johnson. Collection.

Dalton, Henry. Collection.

De la Guerra Family Collection. 1752–1955.

Fernald, Charles. Collection.
Leidesdorff, William A. Collection.
Monterey Collection, 1824–54. MSS MR 1–407.
Stearns, Abel. Collection.
Temple, John. Collection.
Uncatalogued Collection.
Wilson, Benjamin Davis. Collection.

LOS ANGELES COUNTY MUSEUM, LOS ANGELES, CALIFORNIA

Coronel Collection.
Del Valle Family Collection.
Fitch, Henry D. Collection.

SAN DIEGO HISTORICAL SOCIETY RESEARCH ARCHIVES, SAN DIEGO, CALIFORNIA

Coroner's Inquest Collection.

SANTA BARBARA MISSION ARCHIVE, SANTA BARBARA, CALIFORNIA

Trial Transcripts.

SEAVER CENTER FOR WESTERN HISTORY RESEARCH, LOS ANGELES COUNTY
MUSEUM OF NATURAL HISTORY, LOS ANGELES, CALIFORNIA

Hugo Reid Collection.

Miscellaneous Papers

U.S. Courts. District Court, California. *Proceedings of California Land Cases,* Southern
District Case 171 (Rancho Huerta de Cuati or Quati), María Victoria Bartolomeo
(Comicrabit) Reid, claimant. 1852–1857. FAC 700 (455).
U.S. Department of the Interior. Census Office. *The Seventh Census of the United
States: 1850.* Washington, D.C.: Robert Armstrong, Public Printer, 1853.

SECONDARY SOURCES

Acuña, Rudolfo. *Occupied America: A History of Chicanos.* New York: Harper Collins,
1988.
Agarwal, Bina. *Structures of Patriarchy: The State, the Community, and the Household.*
London: Zed Books, 1990.
Almaguer, Tomás. "Ideological Distortions in Recent Chicano Historiography: The
Internal Model and Chicano Historical Interpretation." *Aztlán: A Journal of
Chicano Research* 18 (1987): 7–28.
———. "Interpreting Chicano History: The World-System Approach to Nineteenth-
Century California." *Review* 4 (Winter 1981): 459–501.
———. *Racial Fault Lines: The Historical Origins of White Supremacy in California.*
Berkeley: University of California Press, 1994.
Alonzo, Armando C. *Tejano Legacy: Rancheros and Settlers in South Texas, 1734–1900.*
Albuquerque: University of New Mexico Press, 1998.
Alvarez, Roberto, Jr. *Familia: Migration and Adaptation in Baja and Alta California,
1800–1975.* Berkeley: University of California Press, 1987.

Anderson, Benedict. *Imagined Communities: Reflections on the Origin and Spread of Nationalism.* London: Verso, 1993.

Angel, Amanda. "Spanish Women in the New World: The Transmission of a Model Polity to New Spain, 1521–1570." Ph.D. diss., University of California, Davis, 1997.

Anzaldúa, Gloria. *Borderlands/La Frontera: The New Mextiza.* San Francisco: Spinsters/ Aunt Lute, 1987.

Apodaca, María Linda. "The Chicana Woman: An Historical Materialist Perspective." In *Women in Latin America: An Anthology from Latin American Perspectives,* edited by Eleanor B. Leacock et al. Riverside, Calif.: Latin American Perspectives, 1979.

Archibald, Robert. "Acculturation and Assimilation in Colonial New Mexico." *New Mexico Historical Review* 53, no. 2 (July 1978): 205–17.

——. *The Economic Aspects of the California Missions.* Washington, D.C.: Academy of American Franciscan History, 1978.

Armitage, Susan. "Through Women's Eyes: A New View of the West." In *The Women's West,* edited by Susan Armitage and Elizabeth Jameson, 9–18. Norman: University of Oklahoma Press, 1987.

——. "Women and Men in Western History: A Stereotypical Vision." *Western Historical Quarterly* 16 (October 1985): 381–95.

Armitage, Susan, and Elizabeth Jameson, eds. *The Women's West.* Norman: University of Oklahoma Press, 1987.

Arnaz, José. "Memoirs of a Merchant: Being the Recollections of Life and Customs in Pastoral California," translated and edited by Nellie Van De Grift Sánchez. *Touring Topics* 20 (September 1928): 14–19, 47–48.

Arrom, Silvia Marina. *Women and the Family in Mexico City: 1800–1857.* Ann Arbor, Mich.: University Microfilms, 1977.

——. *The Women of Mexico City, 1790–1857.* Stanford: Stanford University Press, 1985.

Augenbraum, Harold, and Margarite Fernández Olmos, eds. *The Latino Reader: An American Literary Tradition from 1542 to the Present.* Boston and New York: Houghton Mifflin, 1997.

Bancroft, Hubert Howe. *California Pastoral, 1769–1848.* San Francisco: History Co., 1888.

——. *California Pioneer Register 1541–1848.* Baltimore: Regional Publishing, 1964.

——. *History of California.* 7 vols. In *The Works of H. H. Bancroft.* San Francisco: History Co., 1884–89.

——. *The Works of H. H. Bancroft.* 39 vols. San Francisco: History Co., 1883–90.

Bandini, José. *A Description of California in 1828.* Berkeley: University of California Press, 1951.

Bannon, John Francis. *The Spanish Borderlands Frontier, 1512–1821.* New York: Holt, Rinehart and Winston, 1970.

Barker-Benfield, G. J. *The Horrors of the Half-Known Life: Male Attitudes Toward Women and Sexuality in Nineteenth-Century America.* New York: Harper Colophon, 1976.

Barrera, Mario. *Race and Class in the Southwest: A Theory of Racial Inequality.* Notre Dame: University of Indiana Press, 1984.

Barrows, H. D. "Don Ygnacio del Valle." *Annual Publications of the Historical Society of Southern California* 4 (1899): 213–15.

———. "Pio Pico: A Biographical and Character Sketch of the Last Mexican Governor of Alta California." *Annual Publications of the Historical Society of Southern California* 5 (1903): 25–30.

Basso, Matthew, Laura McCall, and Dee Garceau. *Across the Great Divide: Cultures of Manhood in the American West.* New York: Routledge, 2001.

Bean, Walton. *California: An Interpretive History.* 7th ed. New York: McGraw-Hill, 1973.

Bederman, Gail. *Manliness and Civilization: A Cultural History of Gender and Race in the United States, 1880–1917.* Chicago: University of Chicago Press, 1995.

Beechy, Frederick W. *Narrative of a Voyage to the Pacific and Bearing's Strait in the Years 1825, 26, 27, 28.* 2 vols. New York: Da Capo Press, 1968.

Belcher, Sir Edward. *Narrative of a Voyage Round the World, Performed in Her Majesty's Ship Sulphur, During the Years 1836–1842.* London: H. Colburn, 1843.

Belden, Josiah. *Josiah Belden, 1841 California Overland Pioneer: His Memoir and Early Letters,* edited by Doyce B. Nunis Jr. Georgetown, Calif.: Talisman Press, 1962.

Bell, Horace. *Reminiscences of a Ranger, or Early Times in Southern California.* Los Angeles: Yarnell, Caystile and Mathes, 1881.

Bhabha, Hommi. *The Location of Culture.* London: Routledge, 1994.

Black, Esther Boulton. *Rancho Cucamonga and Doña Merced.* Redlands, Calif.: San Bernardino County Museum Association, 1975.

Blumin, Stuart M. *The Emergence of the Middle Class: Social Experience in the American City, 1760–1900.* Cambridge: Cambridge University Press, 1989.

Bollinger, Sharon Loughlin. "Cave Johnson Couts, Jr.: Last of the Dons." Master's thesis, University of San Diego, 1976.

Bolton, Herbert Eugene. "Defensive Spanish Expansion and the Significance of the Spanish Borderlands." In *Bolton and the Spanish Borderlands,* edited by John Francis Bannon, 32–64. Norman: University of Oklahoma Press, 1964.

———. "The Epic of Greater America." *American Historical Review* 38 (1933): 448–74.

———. "The Mission as a Frontier Institution in the Spanish American Colonies." *American Historical Review* 23, no. 1 (October 1917): 42–61. Reprint in *Bolton and the Spanish Borderlands,* edited by John Francis Bannon, 187–211. Norman: University of Oklahoma Press, 1964.

———. The Northward Movement in New Spain." In *Bolton and the Spanish Borderlands,* edited by John Francis Bannon, 67–85. Norman: University of Oklahoma Press, 1964.

———. *Outpost of Empire.* New York: A. A. Knopf, 1931.

———. *The Spanish Borderlands Frontier: A Chronicle of Old Florida and the Southwest.* New Haven: Yale University Press, 1921.

———. *Spanish Exploration in the Southwest, 1542–1706.* New York: Charles Scribner's Sons, 1916.

Borah, Woodrow W. "Marriage and Legitimacy in Mexican Culture: Mexico and California." *California Law Review* 54 (May 1966): 946–1008.

Borah, Woodrow, and Sherburne F. Cook. *Marriage and Legitimacy in Mexican Culture: Mexico and California.* Reprint No. 290. Berkeley: Center for Latin American Studies, University of California, 1968.

Boulding, Elise. *The Underside of History: A View of Women Through Time.* Boulder, Colo.: Westview Press, 1976.

Bourdieu, Pierre. "The Economy of Linguistic Exchanges." *Social Science Information* 16, no. 6 (1977): 652.

——. *The Field of Cultural Production: Essays on Art and Literature.* New York: Columbia University Press, 1993.

——. *The Logic of Practice.* Stanford: Stanford University Press, 1990.

——. *In Other Words: Essays Towards a Reflexive Society.* Stanford: Stanford University Press, 1990.

Bouvier, Virginia Marie. *Women and the Conquest of California, 1542–1821: Codes of Silence.* Tucson: University of Arizona Press, 2001.

Bowman, J. N. "Prominent Women of Provincial California." *Southern California Quarterly* 39, no. 2 (1957): 149–66.

Boyer, Richard. *Lives of the Bigamists: Marriage, Family, and Community in Colonial Mexico.* Albuquerque: University of New Mexico Press, 2001.

Boyle, Susan Calafate. *Los Capitalistas: Hispano Merchants and the Santa Fe Trade.* Albuquerque: University of New Mexico Press, 1997.

Brading, David A. *Miners and Merchants in Bourbon Mexico.* Cambridge: Cambridge University Press, 1971.

Brent, Joseph Lancaster. *The Lugo Case: A Personal Reminiscence.* New Orleans: Searcy and Pfaff, 1926.

Brewer, William Henry. *Up and Down California in 1860–1864: The Journal of William H. Brewer.* Berkeley: University of California Press, 1966.

Brooks, James F. *Captives and Cousins: Slavery, Kinship, and Community in the Southwest Borderlands.* Chapel Hill: University of North Carolina Press, 2002.

Brothwick, J. D. *Three Years in California.* Edinburgh and London: W. Blackwood and Sons, 1857.

Brown, Dee Alexander. *The Gentle Tamers: Women of the Old West.* New York: Putnam, 1958.

Brown, D. Mackenzie, ed. *China Trade Days in California: Selected Letters from the Thompson Papers, 1832–1863.* Berkeley: University of California Press, 1947.

Brown, Jennifer S. H. *Strangers in Blood: Fur Trade Company Families in Indian Country.* Norman: University of Oklahoma Press, 1980.

Browne, Lina Fergusson, ed. *J. Ross Browne, His Letters, Journals, and Writings.* Albuquerque: University of New Mexico Press, 1969.

Bruner, Edward M. "Ethnography as Narrative." In *The Anthropology of Experience,* edited by Victor W. Turner and Edward M. Bruner, 139–55. Urbana: University of Illinois Press, 1986.

Bryant, Edwin. *What I Saw in California: Being the Journal of a Tour in the Years 1846–1847.* New York: D. Appleton and Co., 1848.

Calhoun, Craig, Edward LiPuma, and Moishe Postone, eds. *Bourdieu: Critical Perspectives.* Chicago: University of Chicago Press, 1993.

Camarillo, Albert M. *Chicanos in a Changing Society: From Mexican Pueblos to American Barrios in Santa Barbara and Southern California, 1848–1930.* Cambridge: Harvard University Press, 1979.

———. *Chicanos in California: A History of Mexican Americans in California.* San Francisco: Boyd and Fraser, 1984.

Camp, Charles L., ed. "The Chronicles of George C. Yount, California Pioneer of 1826." *California Historical Society Quarterly* 2 (1923): 38–44.

Campbell, Leon G. "The First Californios: Presidial Society in Spanish California, 1769–1822." In *The Spanish Borderlands: A First Reader,* edited by Oakah L. Jones Jr., 106–18. Los Angeles: Lorrin L. Morrison, 1974.

———. "The Spanish Presidio in Alta California During the Mission Period, 1769–1784." *Journal of the West* 16 (1977): 63–77.

Carpenter, Virginia L. *The Ranchos of Don Pacífico Ontiveros.* Santa Ana, Calif.: Friis Pioneer Press, 1982.

Carrera, Magali Marie. *Imagining Identity in New Spain: Race, Lineage, and the Colonial Body in Portraiture and Casta Paintings.* Austin: University of Texas Press, 2003.

Carroll, Mark M. *Homesteads Ungovernable: Families, Sex, Race, and the Law in Frontier Texas, 1823–1860.* Austin: University of Texas Press, 2001.

Carter, Charles Franklin, ed. and trans. "Duhaut-Cilly's Account of California in the Years 1827." *California Historical Society Quarterly* 8, nos. 2–4 (June–December 1929): 131–66, 214–50, 306–36.

Carver, Rebecca McDowell. *The Impact of Intimacy: Mexican-Anglo Intermarriage in New Mexico, 1821–1846.* Southwestern Studies Monograph, no. 66. El Paso: Texas-Western Press, 1982.

Casarín, Manuel Jimeno, and William E. P. Hartnell, *Indexes to Land Concessions from 1830 to 1846, Including Toma de Razon or Registry of Titles for 1844–45.* San Francisco: Kenny and Alexander, 1861.

Castañeda, Antonia I. "Gender, Race, and Culture: Spanish-Mexican Women in the Historiography of Frontier California." *Frontiers: A Journal of Women's Studies* 11 (1990): 189–211.

———. "The Political Economy of Nineteenth-Century Stereotypes of Californianas." In *Between Borders: Essays on Mexican/Chicana History,* edited by Adelaida R. Del Castillo, 213–38. Encino, Calif.: Floricanto Press, 1990.

———. "Presidarias y Pobladores: Spanish-Mexican Women in Frontier Monterey, Alta California, 1770–1821." Ph.D. diss., Stanford University, 1990.

———. "Sexual Violence in the Political and Policies of Conquest: Amerindian Women and the Spanish Conquest of Alta California." In *Building with Our Hands: New Directions in Chicana Studies,* edited by Adela de la Torre and Beatríz Pesquera, 15–33. Berkeley: University of California Press, 1993.

Certeau, Michel de. *Heterologies: Discourse on the Other,* translated by Brian Massumi. Berkeley, University of Minnesota Press, 1986.

———. *The Practice of Everyday Life,* translated by Seven Rendall. Berkeley: University of California Press, 1984.

Chatterjee, Partha. *Nationalist Thought and the Colonial World: A Derivative Discourse.* Minneapolis: University of Minnesota Press, 1993.

Chavez, Miroslava. "Pongo Mi Demanda: Challenging Patriarchy in Mexican Los Angeles, 1830–1850." In *Over the Edge: Remapping the American West,* edited by Valerie J. Matsumoto, 272–90. Berkeley: University of California Press, 1999.

Chiles, Joseph B. *A Visit to California in 1831, as Recorded for Hubert Howe Bancroft.* Berkeley: Friends of the Bancroft Library, 1970.

Churchill, Charles B. *Adventurers and Prophets: American Autobiographers in Mexican California, 1828–1847.* Spokane: Arthur H. Clark, 1995.

Cibert y Sánchez de la Vega. *El consentimiento familiar en el matrimonio seún el derecho medieval español.* Madrid: Instituto Nacional de Estudios Jurídicos, 1947.

Cipriani, Count Leonetto. *California and Overland Diaries of Count Leonetto Cipriani from 1853 Through 1871.* Translated by Ernest Falbo. Portland: Champoeg Press, 1962.

Cleland, Robert Glass. *The Cattle on a Thousand Hills: Southern California, 1850–1880.* 2d ed. San Marino, Calif.: Huntington Library, 1951.

——. *This Reckless Breed of Men: The Trappers and the Fur Traders of the Southwest.* New York: Knopf, 1950.

Clendinnen, Inga. *Ambivalent Conquests: Maya and Spaniard in Yucatan, 1517–1570.* Cambridge: Cambridge University Press, 1989.

Colton, Walter. *Three Years in California.* Stanford: Stanford University Press, 1949.

Comaroff, Jean. *Body of Power Spirit of Resistance: The Culture and History of South African People.* Chicago: University of Chicago Press, 1985.

Connolly, Mark. "My House Used to Be Your House: The Changing Household Unit in Nineteenth-Century Santa Barbara, California, 1850–1870." *Southern California Quarterly* 71 (1989): 1–12.

Cook, Sherburne. *The Population of California Indians, 1769–1970.* Berkeley: University of California Press, 1976.

——, ed. *The Conflict Between the California Indian and White Civilization.* Berkeley: University of California Press, 1976.

Cook, Sherburne, and Woodrow Borah, eds. *Essays in Population History: Mexico and the Caribbean.* 3 vols. Berkeley: University of California Press, 1971–79.

Cott, Nancy F. *The Bonds of Womanhood: "Women's Sphere" in New England, 1780–1835.* New Haven: Yale University Press, 1977.

——. *Public Vows: A History of Marriage and the Nation.* Cambridge: Harvard University Press, 2000.

Coughlin, Magdalen, C.S.J. "Boston Smugglers on the Coast (1797–1821): An Insight into the American Acquisition of California." *California Historical Society Quarterly* 46, no. 2 (1967): 99–120.

Couturier, Edith. "Women and the Family in Eighteenth-Century Mexico: Law and Practice." *Journal of Family History* 10 (Fall 1985): 294–304.

Cowan, Robert G. *Ranchos of California: A List of Spanish Concessions, 1775–1822, and Mexican Grants, 1822–1846.* Los Angeles: Historical Society of Southern California, 1977.

Crawford, Kathleen. "María Amparo Ruíz de Burton: The General's Lady." *Journal of San Diego History* 30 (Summer 1984): 198–211.

Culleton, James. *Indians and Pioneers of Old Monterey.* Fresno: Academy of California Church History, 1950.

Cutter, Donald C. *California in 1792: A Spanish Naval Visit.* Norman: University of Oklahoma Press, 1990.

———. *Malaspina in California.* San Francisco: John Howell Books, 1960.

Cypess, Sandra Messinger. *La Malinche in Mexican Literature: From History to Myth.* Austin: University of Texas Press, 1991.

Dakin, Susanna Bryant. *The Lives of William Hartnell.* Stanford: Stanford University Press, 1949.

———. *Rose or Rose Thorn? Three Women of Spanish California.* Berkeley: Friends of the Bancroft Library, 1963.

———, ed. *A Scotch Paisano: Hugo Reid's Life in California, 1832–1852.* Berkeley: University of California Press, 1939.

Dana, Richard Henry. *Two Years Before the Mast and Twenty-Four Years After.* New York: P. F. Collier and Son, 1909.

Davis, William Heath, Jr. *Seventy-Five Years in California: Recollections and Remarks by One Who Visited These Shores in 1831 and Again in 1833, and Except When Absent on Business Was a Resident from 1838 until the End of a Long Life in 1909.* 1929. Reprint, San Francisco: John Howell Books, 1967.

Day, Mrs. F. H. "Sketches of Early Californian Settlers: Capt. John Paty." *The Hesperian* 3 (September 1859): 289–300.

———. "Sketches of Early Californian Settlers: George C. Yount." *The Hesperian* 2 (March 1859): 1–6.

———. "Sketches of Early Californian Settlers: Jacob P. Leese." *The Hesperian* 2 (June 1859): 145–56.

———. "Sketches of Early Californian Settlers: Thomas O. Larkin." *The Hesperian* 2 (April 1859): 97–100.

———. "Sketches of Early Californian Settlers: William D. M. Howard." *The Hesperian* 3 (December 1859): 432–37.

de la Torre, Adela, and Beatríz M. Pesquera, eds. *Building with Our Hands: New Directions in Chicana Studies.* Berkeley: University of California Press, 1993.

de Lauretis, Teresa, ed. *Feminist Studies, Critical Studies.* Bloomington: Indiana University Press, 1986.

Del Castillo, Adelaida R., ed. *Between Borders: Essays on Mexicana/Chicana History.* Encino, Calif.: Floricanto Press, 1990.

De León, Arnoldo. *The Tejano Community, 1836–1900.* Albuquerque: University of New Mexico Press, 1982.

———. *They Called Them Greasers: Anglo Attitudes Toward Mexicans in Texas, 1821–1900.* Austin: University of Texas Press, 1983.

Deutsch, Sarah. *No Separate Refuge: Culture, Class, and Gender on an Anglo-Hispanic Frontier in the American Southwest, 1880–1940.* New York: Oxford University Press, 1987.

Deverall, William. *Whitewashed Adobe: The Rise of Los Angeles and the Remaking of Its Mexican Past.* Berkeley: University of California Press, 2004.

DeWolfe Howe, M. A., ed. *Home Letters of General Sherman.* New York: Charles Scribner's Son, 1909.

di Leonardo, Micaela, ed. *Gender at the Crossroads of Knowledge: Feminist Anthropology in the Postmodern Era.* Berkeley: University of California Press, 1991.

Dillard, Heath. *Daughters of the Reconquest: Women in Castillian Town Society, 1100–1300.* Cambridge: Cambridge University Press, 1984.

Dirks, Nicholas B., ed. *Colonialism and Culture.* Ann Arbor: University of Michigan Press, 1992.

Dirks, Nicholas B., Geoff Eley, and Sherry B. Ortner, eds. *Culture/Power/History: A Reader in Contemporary Social Theory.* Princeton: Princeton University Press, 1994.

Dobyns, Henry F. *Hepah California! The Journal of Cave Johnson Couts from Monterey, Nuevo León, Mexico, to Los Angeles, California, During the Years 1848–1849.* Tucson: Arizona Pioneers' Historical Society, 1961.

Drake, Eugene B., comp. *Jimeno's and Hartnell's Indexes of Land Concessions, from 1830 to 1846; Also, Toma de Razón, or Registry of Titles for 1844–45.* San Francisco: Kenny and Alexander, 1861.

DuBois, Ellen Carol, and Vicki L. Ruiz, eds. *Unequal Sisters: A Multicultural Reader in U.S. Women's History.* New York: Routledge, 1990.

Dysart, Jane. "Mexican Women in San Antonio, 1830–1860: The Assimilation Process." *Western Historical Quarterly* 7 (October 1976): 365–75.

Edwards, Philip L. *California in 1837.* Sacramento: A. J. Johnson and Co., 1890.

Elias, Norbert. *The Civilizing Process: The History of Manners and State Formation and Civilization.* Translated by Edmund Jephcott. New York: Pantheon Books, 1982.

Emparan, Madie Brown. *The Vallejos of California.* San Francisco: Gleeson Library Association, 1968.

Engelhart, Zephyrin, Fr. *Mission San Carlos Borromeo (Carmelo): The Father of the Missions,* edited by Fr. Felix Pudlowski. Santa Barbara: Mission Santa Barbara, 1934.

——. *The Missions and Missionaries of California.* 4 vols. San Francisco: James H. Barry Co., 1908–15.

——. *San Diego Mission.* San Francisco: James H. Barry Co., 1920.

——. *San Francisco or Mission Dolores.* Chicago: Franciscan Herald Press, 1924.

——. *San Gabriel Mission and the Beginnings of Los Angeles.* San Gabriel, Calif.: Mission San Gabriel, 1927.

——. *Santa Bárbara Mission.* San Francisco: James H. Barry Co., 1921.

Engels, Frederick. *The Origin of the Family, Private Property and the State.* London: Pathfinder Press, 1972.

Engstrand, Iris H. W. "The Legal Heritage of Spanish California." *Southern California Quarterly* 75, nos. 3–4 (1993): 205–36.

——. "Rancho Guajome: An Architectural Legacy Preserved." *Journal of San Diego History* 41 (Winter 1994): 251–83.

Engstrand, Iris H. W., and Mary F. Ward. "An Enduring Legacy: California Ranchos in Historical Perspectives." *Journal of the West* 27 (1988): 36–47.

Etienne, Mona, and Eleanor Leacock. "Introduction." In *Women and Colonization: Anthropological Perspectives,* edited by Mona Etienne and Eleanor Leacock, 1–24. New York: J. F. Bergin, 1980.

——, eds. *Women and Colonization: Anthropological Perspectives.* New York: J. F. Bergin, 1980.

Faragher, John Mack. "Americans, Mexicans, Métis: A Community Approach to the Comparative Study of North American Frontiers." In *Under an Open Sky: Rethinking America's Western Past,* edited by William Cronon, George Miles, and Jay Gitlin, 90–109. New York: W. W. Norton, 1992.

Farnham, T. J. *Travels in the Californias, and the Scenes in the Pacific Ocean.* 1844. Reprint, Oakland: Biobooks, 1947.

Faulk, Odie B. "The Presidio: Fortress or Farce." In *The Spanish Borderlands: A First Reader,* edited by Oakah L. Jones Jr., 67–78. Los Angeles: Lorrin L. Morrison, 1974.

Figueroa, José. *Manifiesto a la República Mexicana.* Translated and edited by C. Alan Hutchinson. Berkeley: University of California Press, 1978.

Fitch, Guillermo. *Narrative of Guillermo Fitch and Blas Piña: Taken on Board of Steamer M.S. Latham on Her Voyage from San Francisco to Donahue. April 16th, 1874.* Translated by Members of Los Hispanistas. Sacramento: Nugget Press, 1941.

Foley, Neil. "Becoming Hispanic: Mexican Americans and the Faustian Pact with Whiteness." In *Reflexiones 1997: New Directions in Mexican American Studies,* edited by Neil Foley, 53–70. Austin: Center for Mexican American Studies Books, 1998.

Forbes, Alexander. *California: A History of Upper and Lower California from Their First Discovery to the Present Time, Comprising an Account of the Climate, Soil, Natural Productions, Agriculture, Commerce, &c. A Full View of the Missionary Establishments and Condition of the Free and Domesticated Indians.* London: Smith, Elder and Co., 1839.

Foucault, Michel. *Critique and Power: Recasting the Foucault/Habermas Debate.* Edited by Michael Kelly. Cambridge: MIT Press, 1994.

———. *Discipline and Punish: The Birth of the Prison.* Translated by Alan Sheridan. New York: Vintage, 1979.

———. *The History of Sexuality.* Vol. 1, *An Introduction.* New York: Vintage, 1990.

———. *The History of Sexuality.* Vol. 2, *The Use of Pleasure.* New York: Vintage, 1990.

Fowler, Bridget. *Pierre Bourdieu and Cultural Theory: Critical Investigations.* London: Sage Publications, 1997.

Freedman, Estelle B., and D'Emilio, John. *Intimate Matters: A History of Sexuality in America.* New York: Harper and Row, 1988.

García, Mario T. "The Californios of San Diego and the Politics of Accommodation, 1846–1860." *Aztlán: Journal of Chicano Research* 6 (1975): 69–85.

———. "The Chicana in American History: The Mexican Women of El Paso, 1880–1920: A Case Study." *Pacific Historical Review* 49 (1980): 315–37.

———. *Desert Immigrants: The Mexicans of El Paso, 1880–1920.* New Haven: Yale University Press, 1981.

———. "Merchants and Dons: San Diego's Attempt at Modernization, 1850–1860." *Journal of San Diego History* 21 (1975): 52–80.

Garner, William Robert. *Letters from California, 1846–1847.* Edited by Donald Munro Craig. Berkeley: University of California Press, 1970.

Gates, Paul W. "Adjudication of Spanish-Mexican Land Claims in California." *Huntington Library Quarterly* 21 (1958): 213–36.

———. "The California Land Act of 1851." *California Historical Quarterly* 50 (1971): 99–130.

Geertz, Clifford. *The Interpretation of Cultures: Selected Essays.* New York: Basic Books, 1973.

Geiger, Maynard, O.F.M. "The Building of Mission San Gabriel: 1771–1828." *Southern California Quarterly* 50 (1968): 33–42.

——. "Pedro Fages: A Description of California's Principal Presidio, Monterey, in 1773." *Southern California Quarterly* 49 (1967): 327–36.

——. trans. *Letters of Alfred Robinson to the De la Guerra Family of Santa Barbara, 1834–1873.* Los Angeles: Zamorano Club, 1972.

——, trans. and ed. "Fray Antonio Ripoll's Description of the Chumash Revolt at Santa Barbara in 1824." *Southern California Quarterly* 52 (1970): 109–24.

Gertzog, Dorothy Allen. "Isaac Graham: California Pioneer." Master's thesis, University of California, Berkeley, 1941.

Gibson, James R. *Otter Skins, Boston Ships, and China Goods: The Maritime Fur Trade of the Northwest Coast, 1785–1841.* Seattle: University of Washington Press, 1992.

Giffen, Guy J. *California Expedition: Stevenson's Regiment of First New York Volunteers.* Oakland: Biobooks, 1951.

Giffen, Helen S. "The Adopted Californian: The Life and Letters of William Goodwin Dana." *Quarterly of the Historical Society of Southern California* 19 (1937): 49–62.

Gilje, Paul A. *The Road to Mobocracy: Popular Disorder in New York City, 1763–1834.* Chapel Hill: University of North Carolina Press, 1987.

Gillingham, Robert Cameron. *The Rancho San Pedro: The Story of a Famous Rancho in Los Angeles County and of Its Owners, the Dominguez Family.* Los Angeles: Cole-Holmquist Press, 1961.

González, Deena J. *Refusing the Favor: The Spanish-Mexican Women of Santa Fe, 1820–1880.* London: Oxford University Press, 1999.

——. "The Widowed Women of Santa Fe: Assessments of the Lives of an Unmarried Population, 1850–1880." In *Unequal Sisters: A Multicultural Reader in U.S. Women's History,* edited by Ellen Carol Dubois and Vicki L Ruiz, 34–50. New York: Routledge, 1990.

González, Michael J. "Searching for the Feathered Serpent: Exploring the Origins of Mexican Culture in Los Angeles, 1830–1850." Ph.D. diss., University of California, Berkeley, 1993.

Green, Mrs. Edward C., ed. "Journal of Captain John Paty, 1807–1868." *California Historical Society Quarterly* 14 (1935): 291–346.

Green, Rayna. "The Pocahontas Perplex: The Image of Indian Women in American Culture." In *Unequal Sisters: A Multicultural Reader in U.S. Women's History,* edited by Ellen Carol DuBois and Vicki L. Ruiz, 15–21. New York: Routledge, 1990.

Griswold, Robert L. *Family and Divorce in California, 1850–1890.* Albany: State University of New York Press, 1982.

Griswold del Castillo, Richard. "The Del Valle Family and the Fantasy Heritage." *California History* 59 (1980): 2–15.

——. *La Familia: Chicano Families in the Urban Southwest, 1848 to the Present.* Norte Dame: University of Notre Dame Press, 1984.

——. *The Los Angeles Barrio, 1850–1890: A Social History.* Berkeley: University of California Press, 1979.

——. "Neither Activists Nor Victims: Mexican Women's Historical Discourse; The Case of San Diego, 1820–1850." *California History* (1995): 230–43.

——. *The Treaty of Guadalupe Hidalgo: A Legacy of California*. Norman: University of Oklahoma Press, 1990.

Grivas, Theodore. "Alcalde Rule: The Nature of Local Government in Spanish and Mexican California." *California Historical Society Quarterly* 40 (1961): 11–32.

Guinn, James M. *A History of California and an Extended History of Los Angeles and Environs*. 3 vols. Los Angeles: Historic Record Co., 1915.

Gutiérrez, David G. "Significant to Whom? Mexican Americans and the History of the American West." *Western Historical Quarterly* 24 (1993): 519–40.

——. "Honor and Marriage in New Mexico." In *Major Problems in the History of the American West*, edited by Clyde A. Milner II, 102–15. Lexington, Mass.: D. C. Heath, 1989.

——. "Honor, Ideology, Marriage Negotiation, and Class-Gender Domination in New Mexico, 1690–1846." *Latin American Perspectives* 44 (1985): 81–104.

——. *When Jesus Came, the Corn Mothers Went Away: Marriage, Sexuality, and Power in New Mexico, 1500–1846*. Stanford: Stanford University Press, 1991.

Gutiérrez, Ramón, and Richard J. Orsi, eds. *Contested Eden: California Before the Gold Rush*. Berkeley: University of California Press, 1998.

Haas, Lisbeth. *Conquests and Historical Identities in California, 1769–1936*. Berkeley: University of California Press, 1995.

Hague, Harlan, and David J. Langum. *Thomas O. Larkin: A Life of Patriotism and Profit in Old California*. Norman: University of Oklahoma Press, 1990.

Hagwood, John A. "The Pattern of Yankee Infiltration in Mexican Alto California, 1821–1846." *Pacific Historical Review* 27 (1958): 27–37.

Hansen, Woodrow James. *The Search for Authority in California*. Oakland: Biobooks, 1960.

Harding, George L. *Don Agustín Zamorano*. New York: Arno Press, 1976.

Harker, Richard, Cheleen Mahar, and Chris Wilkes, eds. *An Introduction to the Work of Pierre Bourdieu*. New York: St. Martin's Press, 1990.

Harris, Barbara J., and JoAnn K. McNamara, eds. *Women and the Structure of Society: Selected Research from the Fifth Berkshire Conference on the History of Women*. Durham, N.C.: Duke University Press, 1984.

Harte, Bret. *Complete Poetical Works*. New York: P. R. Collier and Son, 1899.

Hartog, Hendrik. *Man and Wife in America: A History*. Cambridge: Harvard University Press, 2000.

Hayes, Benjamin E. *Pioneer Notes from the Diaries of Judge Benjamin Hayes, 1849–1875*. Edited by Marjorie Tisdale Wolcott. 1929. Reprint, Los Angeles: Marjorie Tisdale Wolcott, 1976.

Heizer, Robert F., ed. *Handbook of North American Indians*. Vol. 8, *California*. Washington, D.C.: Smithsonian Institute Press, 1978.

——. *The Indians of Los Angeles County: Hugo Reid's Letters of 1852*. Los Angeles: Southwest Museum, 1968.

Hernández, Salome. "No Settlement Without Women: Three Spanish California Settlement Schemes, 1790–1800." *Southern California Quarterly* 72 (1990): 203–33.

Hess, Beth B., and Myra Marx Ferree, eds. *Analyzing Gender: A Handbook of Social Science Research*. Newbury Park, Calif.: Sage Publications, 1987.

Hill, Joseph J. *The History of Warner's Ranch and Its Environs*. Los Angeles, 1927.

Hinojosa, Gilberto Miguel. *A Borderlands Town in Transition: Laredo, 1755–1870.* College Station: Texas A&M University Press, 1983.

"Historic Building Is Razed." *Los Angeles Times,* May 15, 1927. Features Section.

Hittel, Theodore S. *History of California,* 4 vols. San Francisco: N. J. Stone, 1897–98.

Hodes, Martha, ed. *Sex, Love, Race: Crossing Boundaries in North American History.* New York: New York University Press, 1999.

Hollingsworth, John McHenry. "The Journal of John McHenry Hollingsworth, 1846–1849." *Historical Society of Southern California* 14 (1923): 207–70.

Horsman, Reginald. *Race and Manifest Destiny: The Origins of American Racial Anglo-Saxonism.* Cambridge: Harvard University Press, 1981.

Huish, Robert, comp. *A Narrative of the Voyages and Travels of Captain F. W. Beechey R.N. to the Pacific and Behring's Straits, Performed in the Years 1825, 26, 27, and 28.* London: W. Wright, 1836.

Hurtado, Albert L. *Indian Survival on the California Frontier.* New Haven: Yale University Press, 1988.

——. *Intimate Frontiers: Sex, Gender, and Culture in Old California.* Albuquerque: University of New Mexico Press, 1999.

Hutchinson, C. Alan. *Frontier Settlement in Mexican California: The Híjar-Padrés Colony and Its Origins, 1769–1835.* New Haven: Yale University Press, 1969.

——. "An Official List of the Members of the Híjar-[Padrés] Colony for Mexican California, 1834." *Pacific Historical Review* 42 (1973): 407–18.

——, ed. *A Manifesto to the Mexican Republic.* Berkeley: University of California Press, 1978.

Hutton, William Rich. *Glances at California, 1847–1853.* San Marino, Calif.: Huntington Library, 1942.

Ivesen, Eve. *The Romance of Nikolai Rezanov and Concepción Argüello: A Literary Legend and Its Effect on California History.* Kingston, Ontario: Limestone Press, 1998.

Jackson, Helen Hunt. *Ramona.* 1884. Reprint, New York: Grosset and Dunlap, 1912.

Jackson, Robert H., and Edward Castillo. *Indians, Franciscans, and Spanish Colonization: The Impact of the Mission System on California Indians.* Albuquerque: University of New Mexico Press, 1995.

Jackson, Sheldon G. *A British Ranchero in Old California: The Life and Times of Henry Dalton and the Rancho Azusa.* Glendale, Calif.: Arthur H. Clark, 1977.

——. "Henry Dalton, Southern California Ranchero." Ph.D. diss., University of Southern California, 1970.

James, George Wharton. *Through Ramona's Country.* Boston: Little, Brown, 1910.

Jameson, Elizabeth, and Susan Armitage, eds. *Writing the Range: Race, Class, and Culture in the Women's West.* Norman: University of Oklahoma Press, 1997.

Janssens, Victor Eugene August. *The Life and Adventures in California of Don Agustín Janssens, 1834–1856.* Translated by Francis Price. Edited by William H. Ellison and Francis Price. San Marino, Calif.: Huntington Library, 1953.

Jeffrey, Julie Roy. *Frontier Women: The Trans-Mississippi West, 1840–1880.* New York: Hill and Wang, 1979.

Jensen, James M. "John Forster: A California Ranchero." *California Historical Society Quarterly* 48 (1969): 37–44.

Jensen, Joan M., and Darlis A. Miller. "The Gentle Tamers Revisited: New Approaches to Women in the American West." *Pacific Historical Review* 49 (1980): 173–213.

Jensen, Joan M., and Gloria Ricci Lothrop. *California Women: A History.* San Francisco: Boyd and Fraser, 1987.

Jiménez, Omar Valerio. "Indios Bárbaros, Divorcées, and Flocks of Vampires: Identity and Nation on the Rio Grande, 1749–1894." Ph.D. diss., University of California, Los Angeles, 2000.

John, Elizabeth. *Storms Brewed in Other Men's Worlds.* College Station: Texas A&M University Press, 1975.

Johnson, Susan Lee. *Roaring Camp: The Social World of the California Gold Rush.* New York: W. W. Norton, 2000.

——. "Sharing Bed and Board: Cohabitation and Cultural Difference in Central Arizona Mining Towns, 1863–1873." In *The Women's West,* edited by Susan Armitage and Elizabeth Jameson, 77–91. Norman: University of Oklahoma Press, 1987.

Jones, Howard, and David A. Rakestraw. *Prologue to Manifest Destiny: Anglo-American Relations in the 1840s.* Wilmington, Del.: Scholarly Resources, Inc., 1997.

Jones, Oakah L., Jr. *Nueva Vizcaya: Heartland of the Spanish Frontier.* Albuquerque: University of New Mexico Press, 1988.

——. *Los Paisanos: Spanish Settlers on the Northern Frontier of New Spain.* Norman: University of Oklahoma Press, 1979.

——. *The Spanish Borderlands: A First Reader.* Los Angeles: Lorrin L. Morrison, 1974.

Keefe, Susan E., and Amado M. Padilla. *Chicano Ethnicity.* Albuquerque: University of New Mexico Press, 1987.

Kicza, John. *Colonial Entrepreneurs: Families and Business in Bourbon Mexico City.* Albuquerque: University of New Mexico Press, 1983.

King, Laura Evertson. "Hugo Reid and His Indian Wife." *Historical Society of Southern California and Pioneer Register* 4 (Los Angeles: Historical Society of Southern California, 1899): 111–13.

Klein, Kerwin Lee. "In Search of Narrative Mastery: Postmodernism and the People Without History." *History and Theory: Studies in the Philosophy of History* 34 (1995): 226–98.

Klor de Alva, J. Jorge. "Chicana History and Historical Significance: Some Theoretical Considerations." In *Between Borders: Essays on Mexicana/Chicana History,* edited by Adelaida del Castillo, 61–85. Los Angeles: Floricanto Press, 1990.

Knaut, Andrew L. *The Pueblo Revolt of 1680: Conquest and Resistance in Seventeenth-Century New Mexico.* Norman: University of Oklahoma Press, 1995.

Kuznesof, Elizabeth, and Robert Oppenheimer. "The Family and Society in Nineteenth-Century Latin America: An Historiographical Introduction." *Journal of Family History* 10 (1985): 215–34.

Lacy, James H. "New Mexico Women in Early American Writings." *New Mexico Historical Review* 34 (1959): 41–51.

"A Lady's Maid to Senora de Baker Tells Golden, Glamorous Days of Baker Block, Now Doomed to Perish." *San Diego Union,* April 23, 1936.

Lamar, Howard, and Leonard Thompson, eds. *The Frontier in History: North America and Southern Africa Compared.* New York: Yale University Press, 1981.

Langellier, John Phillip, and Katherine Meyers Peterson. "Lancers and Leatherjackets:

Presidial Forces in Spanish Alta California, 1769–1821." *Journal of the West* 20 (1981): 3–11.

Langum, David J. "Californios and the Image of Indolence." *Western Historical Quarterly* 9 (1978): 181–96.

———. "Californio Women and the Image of Virtue." *Southern California Quarterly* 59 (1977): 245–50.

———. *Law and Community on the Mexican California Frontier: Anglo-American Expatriates and the Clash of Legal Traditions, 1821–1846.* Norman: University of Oklahoma Press, 1987.

———. "Sin, Sex, and Separation in Mexican California: Her Domestic Relations Law." *Californians* 5 (1987): 41–66.

La Pérouse, Jean François de la. *Monterey in 1786: The Journals of Jean François de la Pérouse.* Edited by Malcolm Margolin. Berkeley: Heyday Books, 1989.

———. *A Voyage Round the World in the Years 1785, 1786, 1787, and 1788.* Edited by M. L. A. Milet-Mureau. 3 vols. London: J. Johnson, 1798.

Larkin, Thomas Oliver. *First and Last Consul: Thomas Oliver Larkin and the Americanization of California.* Edited by John A. Hawgood. 2nd ed. Palo Alto: Pacific Books, 1970.

———. *The Larkin Papers: Personal, Business, and Official Correspondence of Thomas Oliver Larkin, Merchant and United States Consul in California.* 10 vols. Edited by George P. Hammond. Berkeley: University of California Press, 1951–68.

Lavrín, Asunción. "Introduction: The Scenario, the Actors, and the Issues." In *Sexuality and Marriage in Colonial Latin America,* edited by Asunción Lavrín, 1–46. Lincoln: University of Nebraska Press, 1989.

———. "Sexuality in Colonial Mexico: A Church Dilemma." In *Sexuality and Marriage in Colonial Latin America,* edited by Asunción Lavrín, 47–95. Lincoln: University of Nebraska Press, 1989.

———, ed. *Latin American Women: Historical Perspectives.* Westport, Conn.: Greenwood Press, 1978.

———, ed. *Sexuality and Marriage in Colonial Latin America.* Lincoln: University of Nebraska Press, 1989.

Lavrín, Asunción, and Edith Couturier. "Dowries and Wills: A View of Women's Socioeconomic Role in Colonial Guadalajara and Puebla, 1640–1790." *Hispanic American Historical Review* 59, no. 2 (1979): 280–304.

Layne, Gregg. *Annals of Los Angeles, 1769–1861.* San Francisco: California Historical Society, 1935.

———. "The First Census of the Los Angeles District: Padrón de la Ciudad de Los Angeles y su jurisdicción año 1836." *Southern California Quarterly* 18 (1936): 81–99.

Lecompte, Janet. "The Independent Women of Hispanic New Mexico, 1821–1846." *Western Historical Quarterly* 12 (1981): 17–35.

Lederer, Lillian Charlotte. "A Study of Anglo-American Settlers in Los Angeles County Previous to the Admission of California to the Union." Master's thesis, University of Southern California, 1927.

"The Leese Scrap Book." *Society of California Pioneers Quarterly* 8 (March 1931): 9–37.

Lerner, Gerda. *The Creation of Patriarchy.* New York: Oxford University Press, 1986.

Lévi-Strauss, Claude. *The Elementary Structure of Kinship.* Boston: Beacon Press, 1969.

——. *Tristes Tropiques.* Translated by John Weightman and Doreen Weightman. New York: Penguin Books, 1984.

Limerick, Patricia Nelson. *The Legacy of Conquest: The Unbroken Past of the American West.* New York: W. W. Norton, 1987.

Lockhart, James, and Stuart Schwartz. *Early Latin America: A History of Colonial Spanish Amrica and Brazil.* Cambridge: Cambridge University Press, 1983.

Lomnitz, Larissa Adlerm, and Marisol Perez-Lizaur. *A Mexican Elite Family, 1820–1980: Kinship, Class, and Culture.* Princeton: Princeton University Press, 1987.

Lothrop, Gloria Ricci. "Rancheras and the Land: Women and Property Rights in Hispanic California." *Southern California Historical Quarterly* 76, no. 1 (1994): 59–84.

Lugo, José del Carmen. "The Days of a Ranchero in Spanish California." Translated by Nellie Van de Grift Sánchez. *Touring Topics* 22 (April 1930): 22–29.

——. "Life of a Rancher." *Historical Society of Southern California Quarterly* 32 (September 1950): 185–236.

Lyman, Chester S. *Around the Horn to the Sandwich Islands and California, 1845–1850.* Edited by Frederick J. Teggart. New Haven: Yale University Press, 1924.

McAlister, Lyle N. "The Reorganization of the Army of New Spain, 1763–1766." *Hispanic American Historical Review* 33 (1953): 1–31.

McCulley, Johnston. "The Curse of Capistrano." *All Story Weekly* 100, no. 2–101, no. 2 (August 9–September 6, 1919).

McWilliams, Carey. *North from Mexico: The Spanish-Speaking People of the United States.* 1948. Reprint, New York: Greenwood Press, 1968.

Machado de Ridington, Juana. "Times Gone by in Alta California: Recollections of Doña Juana Machado Alipaz de Ridington." Translated and annotated by Raymond S. Brandes. *Historical Society of Southern California* 41 (1959): 195–240.

Mangan, J. A., and James Walvin. *Manliness and Morality: Middle-Class Masculinity in Britain and America, 1800–1940.* New York: St. Martin's Press, 1987.

Mann, Vivian B., Thomas F. Glick, and Jerrilynn D. Dodd, eds. *Convivencia: Jews, Muslims, and Christians in Medieval Spain.* New York: G. Braziller; Jewish Museum, 1992.

Manresa y Navarro, José María. *Comentarios al código civil español.* 9 vols. Madrid: Imprenta de la Revista de Legislación, 1908.

Martin, Cheryl English. *Governance and Society in Colonial Mexico: Chihuahua in the Eighteenth Century.* Stanford: Stanford University Press, 1996.

Martin, Luis. *Daughters of the Conquistadores: Women of the Viceroyalty of Peru.* Albuquerque: University of New Mexico Press, 1983.

Martinez, José Longinos. *California in 1792: The Expedition of José Longinos Martinez.* Translated by Lesley Byrd Simpson. San Marino, Calif.: Huntington Library, 1938.

Martínez, José Luis. *Pasajeros de Indias.* Madrid: Alianza, 1983.

Martínez Alcubilla, Marcelo. *Códigos antiguos de España.* 2 vols. Madrid: López Camacho, 1885.

Martinez-Alier, Verena. *Marriage, Class and Colour in Nineteenth-Century Cuba.* Ann Arbor: University of Michigan Press, 1989.

Mathes, Valerie Sherer. *Helen Hunt Jackson and her Indian Reform Legacy.* Austin: University of Texas Press, 1990.

——. *The Indian Reform Letters of Helen Hunt Jackson, 1879–1885.* Norman: University of Oklahoma Press, 1998.

Matsumoto, Valerie J. *Over the Edge: Remapping the American West.* Berkeley: University of California Press, 1999.

Maura, Juan Francisco. *Women in the Conquest of the Americas.* Translated by John F. Deredita. New York: Peter Lang, 1997.

Maxwell, R. T. *Visit to Monterey in 1842.* Edited by John Haskell Kemble. Los Angeles: Glen Dawson, 1955.

Maynes, Mary Jo, Ann Waltner, Birgitte Soland, and Ulrike Strasser, eds. *Gender, Kinship, and Power: A Comparative and Interdisciplinary History.* New York: Routledge, 1996.

Maza, Sarah. "Domestic Melodrama as Political Ideology: The Case of the Comte de Sanois." *American Historical Review* 94, no. 5 (December 1989): 1249–64.

Meinig, D. W. *Southwest: Three Peoples in Geographical Change, 1600–1970.* New York: Oxford University Press, 1971.

Memmi, Albert. *The Colonizer and the Colonized.* Boston: Beacon Press, 1965.

Menchaca, Martha. *Recovering History, Constructing Race: The Indian, Black, and White Roots of Mexican Americans.* Austin: University of Texas Press, 2001.

Menocal, María Rosa. *The Ornament of the World: How Muslims, Jews, and Christians Created a Culture of Tolerance in Medieval Spain.* Boston: Little Brown, 2002.

Meyer, Doris L. "Early Mexican American Responses to Negative Stereotyping." *New Mexico Historical Review* 53 (1978): 75–91.

Miller, Darlis A. "Cross-Cultural Marriages in the Southwest: The New Mexico Experience, 1846–1900." *New Mexico Historical Review* 57 (1982): 335–59.

Miller, Ronald J. "A California Romance in Perspective: The Elopement, Marriage, and Ecclesiastical Trial of Henry D. Fitch and Josefa Carrillo." *Journal of San Diego History* 19, no. 2 (1973): 1–28.

Mintz, Sidney W. *Sweetness and Power: The Place of Sugar in Modern History.* New York: Penguin Books, 1986.

Miranda, Gloria E. "Gente de Razón Marriage Patterns in Spanish and Mexican California: A Case Study of Santa Barbara and Los Angeles." *Southern California Historical Quarterly* 63 (1981): 1–21.

——. "Hispano-Mexicano Childbearing Practices in Pre-American Santa Barbara." *Southern California Historical Quarterly* 65, no. 4 (Winter 1983): 307–20.

——. "Racial and Cultural Dimensions of Gente de Razón Status in Spanish and Mexican California." *Southern California Quarterly* 70 (1988): 265–78.

Mirandé, Alfredo. "The Chicano Family: A Reanalysis of Conflicting Views." *Journal of Marriage and the Family* 19 (1977): 747–56.

Mirandé, Alfredo, and Evangelina Enríquez. *La Chicana: The Mexican American Woman.* Chicago: University of Chicago Press, 1979.

Mollins, Margaret, and Virginia E. Thickens, eds. *Ramblings in California: The Adventures of Henry Cerruti.* Berkeley: Friends of the Bancroft Library, University of California, 1954.

Monroy, Douglas. *Thrown Amongst Strangers: The Making of Mexican Culture in Frontier California.* Berkeley: University of California Press, 1990.

Montejano, David. *Anglos and Mexicans in the Making of Texas, 1836–1986.* Austin: University of Texas Press, 1987.

Moore, Henrietta L. *Feminism and Anthropology.* Minneapolis: University of Minnesota Press, 1990.

Moorhead, Max L. *The Presidio: Bastion of the Spanish Borderlands.* Norman: University of Oklahoma Press, 1975.

——. "The Soldado de Cuera: Stalwart of the Spanish Borderlands." In *Spanish Borderlands: A First Reader,* edited by Oakah L. Jones Jr., 87–105. Los Angeles: Lorrin L. Morrison, 1974.

Mörner, Magnus. *Race Mixture in the History of Latin America.* Boston: Little, Brown, 1967.

Murguía, Edward. *Chicano Intermarriage: A Theoretical and Empirical Study.* San Antonio: Trinity University Press, 1984.

Murphy, Marjorie. "What Women Have Wrought." *American Historical Review* 93 (1988): 653–63.

Myres, Sandra L. "Mexican Americans and Westering Anglos: A Feminine Perspective." *New Mexico Historical Review* 57 (1982): 414–30.

——. *Westering Women and the Frontier Experience, 1800–1915.* Albuquerque: University of New Mexico Press, 1982.

——. "Women in the West." In *Historians and the American West,* edited by Michael Malone, 369–86. Lincoln: University of Nebraska Press, 1983.

——, ed. *Ho for California: Women's Overland Diaries from the Huntington Library.* San Marino, Calif.: Huntington Library, 1980.

Newmark, Harris. *Sixty Years in Southern California, 1853–1913.* New York: Knickerbocker Press, 1916.

Newmark, Marco R. "The Life of Jonathan (John) Temple." *Quarterly of the Historical Society of Southern California* 36 (1954): 46–48.

Noggle, Burl. "Anglo Observers of the Southwest Borderlands, 1825–1890: The Rise of a Concept." *Arizona and the West* 1 (1959): 105–41.

Noonan, John T., Jr. *The Power to Dissolve: Lawyers and Marriages in the Courts of the Roman Curia.* Cambridge: Belknap Press of Harvard University Press, 1972.

Northrop, Marie E. "The Los Angeles Padrons of 1844." *Historical Society of Southern California Quarterly* 42 (1960): 360–42.

——. *Spanish-Mexican Families of Early California, 1769–1850.* 2 vols. Burbank: Southern California Genealogical Society, 1984–87.

"Noted Early Day Beauty Passes." *Grizzly Bear* 16 (November 1914): 7.

Nunis, Doyce Blackman, Jr. *The Trials of Isaac Graham.* Los Angeles: Dawson's Book Shop, 1967.

——, ed. *The California Diary of Faxon Dean Atherton, 1836–1839.* San Francisco: California Historical Society, 1964.

Ogden, Adele. "Alfred Robinson, New England Merchant in Mexican California." *California Historical Society Quarterly* 23 (1944): 193–218.

——. *The California Sea Otter Trade, 1784–1848.* Berkeley: University of California Press, 1941.

———. "Hides and Tallow: McCulloch, Hartnell, and Co., 1822–1828." *California Historical Society Quarterly* 6 (1927): 254–64.

———. "New England Traders in Spanish and Mexican California." In *Greater America: Essays in Honor of Herbert Eugene Bolton,* edited by Adele Ogden, 395–415. Berkeley: University of California Press, 1945.

Ord, Angustias de la Guerra. *Occurrences in Hispanic California.* Translated and edited by Francis Prisce and William H. Ellison. Washington, D.C.: Academy of Franciscan History, 1956.

Osio, Antonio María. *The History of Alta California: A Memoir of Mexican California.* Translated, edited, and annotated by Rose Marie Beebe and Robert M. Senkewicz. Madison: University of Wisconsin Press, 1996.

Ots y Capdequí, José María. "Bosquejo histórico de los derechos de la mujer en la legislación de Indias." *Revista general de legislación y jurisprudencia* 132 (March–April 1918): 161–82.

———.*História del derecho español en América y del derecho indiano.* Madrid: Ediciones S.A. de Aguilar, 1967.

Padilla, Genaro. *My History, Not Yours: The Formation of Mexican American Autobiography.* Madison: University of Wisconsin Press, 1993.

Pagden, Anthony. *European Encounters with the New World: From Renaissance to Romanticism.* New Haven: Yale University Press, 1993.

———. *Lords of All the World: Ideologies of Empire in Spain, Britain and France c. 1500–c.1800.* New Haven: Yale University Press, 1995.

Palomares, José Francisco. *Memoirs of José Francisco Palomares.* Translated by Thomas Workman Temple II. Los Angeles: Glen Dawson, 1955.

Palóu, Francisco. *Historical Memoirs of New California.* Edited by Herbert Eugene Bolton. 4 vols. Berkeley: University of California Press, 1926.

Paredes, Raymond A. "The Mexican Image in American Travel Literature, 1831–1869." *New Mexico Historical Review* 52 (1977): 5–29.

———. "The Origins of Anti-Mexican Sentiment in the United States." *New Scholar* 6 (1977): 139–65.

Parker, Andrew, Mary Russo, Doris Sommer, and Patricia Yaeger, eds. *Nationalisms and Sexualities.* New York: Routledge, 1992.

Pateman, Carole. *The Sexual Contract.* Stanford: Stanford University Press, 1988.

Pattie, James Ohio. "The Personal Narrative of James O. Pattie During Journeyings of Six Years." *Early Western Travels, 1748–1846: A Series of Annotated Reprints.* Vol. 18. Edited by Reubin Gold Thwaites. Cleveland: Arthur H. Clark, 1905.

Paz, Octavio. *The Labyrinth of Solitude: Life and Thought in Mexico.* Translated by Lysander Kemp. New York: Grove Press, 1961.

Perkins, William. *Three Years in California: William Perkins' Journal of Life at Sonora, 1849–1852.* Berkeley: University of California Press, 1964.

Phelps, William Dane. *Alta California, 1840–1842: The Journal and Observations of William Dane Phelps, Master of the Ship "Alert."* Introduced and edited by Briton Cooper Busch. Glendale, Calif.: Arthur H. Clark, 1983.

Phillips, William Henry. "Don José Antonio Julian de la Guerra y de Noriega, of California." Master's thesis, University of Southern California, 1950.

Pico, Pío. *Don Pío Pico's Historical Narrative.* Translated by Arthur P. Botello. Edited

with introduction by Martin Cole and Henry Welcome. Glendale, Calif.: Arthur H. Clark, 1970.

Pierce, Richard A. *Resanov Reconnoiters California: A New Translation of Resanov's Letters, Parts of Lieutenant Khvostov's Log of the Ship Juno, and Dr. Georg von Langsdorff's Observations.* San Francisco: Book Club of California, 1972.

Pisani, Donald J. "Squatter Law in California, 1850–1858." *Western Historical Quarterly* 25 (1994): 277–310.

Pitt, Leonard. *The Decline of the Californios: A Social History of the Spanish-Speaking Californians, 1846–1890.* Berkeley: University of California Press, 1971.

Poyo, Gerald E., and Gilberto M. Hinojosa. "Spanish Texas and Borderlands Historiography in Transition: Implications for United States History." *Journal of American History* 75 (1988): 393–416.

Priestley, Herbert Ingram. *A Historical, Political, and Natural Description of California by Pedro Fages, Soldier of Spain; newly translated into English from the original Spanish by Herbert Ingram Priestley.* Berkeley: University of California Press, 1937.

Pubols, Helen Louise. "The De la Guerra Family: Patriarchy and the Political Economy of California, 1800–1850." Ph.D. diss., University of Wisconsin–Madison, 2000.

Rabasa, José. *Writing Violence on the Northern Frontier: The Historiography of Sixteenth-Century New Mexico and Florida and the Legacy of Conquest.* Durham: Duke University Press, 2000.

Rawls, James J., and Walton Bean. *California: An Interpretive History.* 7th ed. Boston: McGraw Hill, 1998.

Riley, Glenda. "Frontier Women." In *American Frontier and Western Issues: A Historiographical Review,* edited by Roger L. Nichols, 179–98. New York: Greenwood Press, 1986.

Ríos-Bustamante, Antonio. "Nineteenth Century Mexican Californians: A Conquered Race." In *Regions of La Raza: Changing Interpretations of Mexican American Regional History and Culture,* edited by Antonio Ríos-Bustamante, 237–69. Encino, Calif.: Floricanto Press, 1993.

Ríos-Bustamante, Antonio, and Pedro Castillo. *An Illustrated History of Mexican Los Angeles, 1781–1985.* Chicano Studies Research Center Publications, University of California Monograph No. 12. Berkeley: University of California Press, 1986.

Robbins, Derek. *The Work of Pierre Bourdieu: Recognizing Society.* Boulder, Colo.: Westview Press, 1991.

Robinson, Alfred. *Life in California: During a Residence of Several Years in That Territory; and Chinigchinich: An Historical Account of the Origin, Customs, and Traditions of the Indians of Alta-California.* Santa Barbara and Salt Lake City: Peregrine Publishers, 1970.

Rojas, Lauro de. "California in 1844 as Hartnell Saw It." *California Historical Society Quarterly* 17 (1938): 21–27.

Romo, Ricardo. *East Los Angeles: History of a Barrio.* Austin: University of Texas Press, 1983.

Rolle, Andrew F. *An American in California: The Biography of William Heath Davis, 1822–1909.* San Marino, Calif.: Huntington Library, 1956.

Roquefeuil, Camille de. *Camille de Roquefeuil in San Francisco, 1817–1818.* Edited by Charles N. Rudkin. Los Angeles: Glen Dawson, 1954.

Rosaldo, Michelle Zimbalist, and Louise Lamphere, eds. *Women, Culture and Society.* Stanford: Stanford University Press, 1985.

Rose, Anne C. *Beloved Strangers: Interfaith Families in Nineteenth-Century America.* Cambridge: Harvard University Press, 2001.

Rosenbaum, Robert J. *Mexicano Resistance in the Southwest: "The Sacred Right of Self-Preservation."* Austin: University of Texas Press, 1981.

Rosenberg, Charles E. "Sexuality, Class and Role in Nineteenth Century America." *American Quarterly* 35 (May 1973): 131–53.

Rosenus, Alan. *General M. G. Vallejo and the Advent of the Americans: A Biography.* Albuquerque: University of New Mexico Press, 1995.

Rubin, Gayle. "The Traffic in Women: Notes on the 'Political Economy' of Sex." In *Toward an Anthropology of Women,* edited by Rayna Reiter, 165–83. New York: Monthly Review Press, 1975.

Ruíz, Ramón Eduardo, ed. *The Mexican War: Was It Manifest Destiny?* New York: Holt, Rinehart and Winston, 1963.

Ruiz, Vicki L. *From Out of the Shadows: Mexican Women in Twentieth-Century America.* New York: Oxford University Press, 1998.

Ruíz de Burton, María Amparo. *The Squatter and the Don.* Edited by Rosaura Sánchez and Beatrice Pita. Houston: Arte Público Press, 1993.

———. *Who Would Have Thought It?* Edited by Rosaura Sánchez and Beatrice Pita. Houston: Arte Público Press, 1995.

Ruschenberger, W. S. W. *Sketches in California in 1836.* London: R. Bentley, 1838.

Russell, Thomas C., trans. *Langsdorff's Narrative of the Rezanov Voyage to California in 1806.* San Francisco: Private Press of Thomas C. Russell, 1927.

Ryan, Mary P. *Cradle of the Middle Class: The Family in Oneida County, New York, 1790–1865.* Cambridge: Cambridge University Press, 1981.

Ryan, William. *Personal Recollections in Upper and Lower California.* London: W. Shoberl, 1850.

Said, Edward. *Orientalism.* London: Routledge and Kegan Paul, 1978.

Sánchez, Federico. "Rancho Life in Alta California." In *Regions of La Raza: Changing Interpretations of Mexican American Regional History and Culture,* edited by Antonio Ríos-Bustamante, 213–35. Encino, Calif.: Floricanto Press, 1993.

Sánchez, Joseph P. *Spanish Bluecoats: The Catalonian Volunteers in Northwestern New Spain, 1767–1810.* Albuquerque: University of New Mexico Press, 1990.

Sánchez, Nellie Van de Grift. *Spanish Arcadia.* San Francisco: Powell Publishing, 1929.

Sánchez, Rosaura. *Telling Identities: The Californio Testimonios.* Minneapolis: University of Minnesota Press, 1995.

———, ed. *Conflicts of Interest: The Letters of María Amparo Ruíz de Burton.* Houston: Arte Público Press, 2001.

Sánchez, Rosaura, Beatrice Pita, and Bárbara Reyes. *Crítica: A Journal of Critical Essays.* Crítica Monograph Series No. 68. San Diego: University of California, San Diego, 1994.

Sánchez, Rosaura, and Rosa Martinez Cruz. *Essays on La Mujer.* Los Angeles: Chicano Studies Center, University of California, Los Angeles, 1977.

Sanday, Peggy Reeves. *Female Power and Male Dominance: On the Origins of Sexual Inequality.* Cambridge: Cambridge University Press, 1981.

Sandos, James. "From 'Boltonlands' to 'Weberlands.'" *American Quarterly* 46 (1994): 595–604.

——. "Levantamiento! The 1824 Chumash Uprising." *Californians* 5 (1987): 8–20.

——. "Levantamiento! The 1824 Chumash Uprising Reconsidered." *Southern California Quarterly* 67 (1985): 109–33.

Saragoza, Alex M. "Recent Chicano Historiography: An Interpretive Essay." *Aztlán: Journal of Chicano Research* 19 (1988–90): 15–52.

——. "The Significance of Recent Chicano-Related Historical Writings: An Assessment." *Ethnic Affairs* 1 (1987): 24–63.

Scadron, Arlene, ed. *On Their Own: Widows and Widowhood in the American Southwest, 1848–1939.* Urbana: University of Illinois Press, 1988.

Schalleberger, Moses. *The Opening of the California Trail.* Berkeley: University of California Press, 1953.

Schlissel, Lillian, Vicki Ruiz, and Janice Monk, eds. *Western Women: Their Land, Their Lives.* Albuquerque: University of New Mexico Press, 1988.

Schneider, David M. *A Critique of the Study of Kinship.* Ann Arbor: University of Michigan Press, 1984.

Schwartz, Stuart. *Slaves, Peasants, and Rebels: Reconsidering Brazilian Slavery.* Urbana: University of Illinois Press, 1992.

Scott, Anne Firor. *Making the Invisible Woman Visible.* Urbana: University of Illinois Press, 1984.

Scott, Joan Wallach. *Gender and the Politics of History.* New York: Columbia University Press, 1988.

Scott, Paul T. "Why Joseph Chapman Adopted California and Why California Adopted Him." *Historical Society of Southern California Quarterly* 38 (1956): 239–46.

Seed, Patricia. "The Church and the Patriarchal Family: Marriage Conflicts in Sixteenth- and Seventeenth-Century New Spain." *Journal of Family History* 10 (Fall 1985): 284–93.

——. *To Love, Honor, and Obey in Colonial Mexico: Conflicts Over Marriage Choice, 1574–1821.* Stanford: Stanford University Press, 1988.

Servín, Manuel. "California's Hispanic Heritage: A View into the Spanish Myth." In *New Spain's Far Northern Frontier,* edited by David J. Weber, 117–33. Albuquerque: University of New Mexico Press, 1979.

——. "The Secularization of the California Missions: A Reappraisal." *Southern California Quarterly* 47 (1965): 133–49.

Shaler, William. *Journal of a Voyage Between China and the Northwestern Coast of America Made in 1804 by William Shaler.* Claremont, Calif.: Saunders Studio Press, 1935.

Sherman, William T. *Memoirs of General William T. Sherman.* 2 vols. New York: D. Appleton and Co., 1875.

Silverblatt, Irene. "'The Universe Has Turned Inside-Out . . . There Is No Justice

for Us Here': Andean Women Under Spanish Rule." In *Women and Colonization: Anthropological Perspectives,* edited by Mona Etienne and Eleanor Leacock, 149–85. New York: J. F. Bergin, 1980.

Simpson, Lesley Byrd. *The Encomienda in New Spain: The Beginning of Spanish Mexico.* 2nd ed. Berkeley: University of California Press, 1950.

Simpson, Sir George. *Narrative of a Journey Round the World, During the Years 1841 and 1842.* 2 vols. London: H. Colburn, 1847.

Smedley, Audrey. *Race in North America: Origin and Evolution of a Worldview.* 2nd ed. Boulder, Colo.: Westview Press, 1999.

Smith, Michael E., and Frances F. Berdan, eds. *The Postclassic Mesoamerican World.* Salt Lake City: University of Utah Press, 2003.

Spicer, Edward H. *Cycles of Conquest: The Impact of Spain, Mexico, and the United States on the Indians of the Southwest, 1533–1960.* Tucson: University of Arizona Press, 1962.

Spickard, Paul R. *Mixed Blood: Intermarriage and Ethnic Identity in Twentieth-Century America.* Madison: University of Wisconsin Press, 1989.

Spivak, Gayatri Chakravorty. *In Other Worlds: Essays in Cultural Politics.* New York: Methuen, 1987.

———. *The Post-Colonial Critic: Interviews, Strategies, Dialogues.* New York: Routledge, 1998.

Starr, Kevin. *Inventing the Dream: California Through the Progressive Era.* New York: Oxford University Press, 1985.

Stephenson, Terry E. "Tomás Yorba, His Wife Vicenta, and His Account Book." *Historical Society of Southern California Quarterly* 23 (1944): 126–55.

Stern, Steven J. *The Secret History of Gender: Women, Men, and Power in Late Colonial Mexico.* Chapel Hill: University of North Carolina Press, 1995.

Stoler, Ann L. "Sexual Affronts and Racial Frontiers: European Identities and the Cultural Politics of Exclusion in Colonial Southeast Asia." *Comparative Studies in Society* 34 (July 1992): 198–237.

Strathern, Marilyn. *The Gender of the Gift: Problems with Women and Problems with Society in Melanesia.* Berkeley: University California Press, 1990.

Streeter, William A. "Recollections of Historical Events in California, 1843–1878, of William A. Streeter." Edited by William H. Ellison. *California Historical Society Quarterly* 18 (1939): 170.

Susman, Warren I. *Culture as History.* New York: Pantheon, 1984.

Swagerty, William R. "Marriage and Settlement Patterns of Rocky Mountain Trappers and Traders." *Western Historical Quarterly* 11, no. 2 (April 1980): 159–80.

Szasz, Margaret Connell, ed. *Between Indian and White Worlds: The Cultural Broker.* Norman: University of Oklahoma Press, 1994.

Takaki, Ronald. *Iron Cages, Race and Culture in Nineteenth Century America.* Seattle: University of Washington Press, 1979.

Tays, George. "California's First Vigilantes." *Touring Topics* 25 (May 1933): 18–19.

———. "Revolutionary California: The Political History of California During the Mexican Period, 1822–1846." Ph.D. diss., University of California, Berkeley, 1932.

Thomas, Alfred Barnaby. *Teodoro de Croix and the Northern Frontier of New Spain, 1776–1783.* Norman: University of Oklahoma Press, 1941.

Thompson, Joseph, O.F.M. *El Gran Capitán: José de la Guerra.* Los Angeles: Franciscan Fathers of California, Cabrera and Sons, 1961.

Todorov, Tzvetan. *The Conquest of America: The Question of the Other.* Translated by Richard Howard. New York: Harper and Row, 1984.

Trulio, Beverly. "Anglo American Attitudes toward New Mexican Women." *Journal of the West* 12 (1973): 229–39.

Tucey, Mary, and David Hornbeck. "Anglo Immigration and the Hispanic Town: A Study of Urban Change in Monterey, California, 1835–1850." *Social Science Journal* 13 (1976): 1–7.

Turner, Frederick Jackson. *The Frontier in American History.* 1920. Reprint, New York: Robert E. Krieger, 1976.

——. "Significance of the Frontier in American History." In *Major Problems in the History of the American West: Documents and Essays,* edited by Clyde A. Milner II, 2–34. Lexington: D. C. Heath, 1989.

Twinam, Ann. "Honor, Sexuality and Illegitimacy in Colonial Spanish America." In *Sexuality and Marriage in Colonial Latin America,* edited by Asunción Lavrín, 118–55. Lincoln: University of Nebraska Press, 1989.

——. *Public Lives, Private Secrets: Gender, Honor, Sexuality, and Illegitimacy in Colonial Spanish America.* Stanford: Stanford University Press, 1999.

Tyler, Daniel. "Anglo-American Penetration of the Southwest: The View from New Mexico." *Southwestern Historical Quarterly* 75 (1972): 221–38.

Usner, Daniel H., Jr. *Indians, Settlers, and Slaves in a Frontier Exchange Economy: The Lower Mississippi Valley Before 1783.* Chapel Hill: University of North Carolina Press, 1992.

Vallejo, Guadalupe. "Ranch and Mission Days in Alta California." *Century Magazine* 41 (December 1890): 183–92.

Vancouver, George. *Vancouver in California, 1792–1794: The Original Account of George Vancouver.* Edited by Marguerite Eyer Wilbur. Early California Travel Series, nos. 9, 10, 22. Los Angeles: Glen Dawson, 1953–1954.

Van Kirk, Sylvia. *Many Tender Ties: Women in Fur-Trade Society, 1670–1870.* Norman: University of Oklahoma Press, 1983.

Vigil, Ralph H. "The Hispanic Heritage and the Borderlands." *Journal of San Diego History* 19 (1973): 32–39.

——. "The New Borderlands History: A Critique." *New Mexico Historical Review* 48 (1973): 189–208.

Wallerstein, Immanuel. *The Modern World System: Capitalist Agriculture and the Origins of European World Economy in the Sixteenth Century.* Text ed. New York: Academic Press, 1976.

Warner, Barbara R. *The Men of the California Bear Flag Revolt and Their Heritage.* Glendale, Calif.: Arthur H. Clark for the Sonoma Valley Historical Society, 1996.

Warner, J. J. "Reminiscences of Early California from 1831 to 1846." *Annual Publications of the Historical Society of Southern California* 7 (1906–8): 176–93.

Weber, David J. *The Californios versus Jedediah Smith, 1826–1827: A Cache of Documents.* Spokane: Arthur H. Clark, 1990.

——. "Failure of a Frontier Institution: The Secular Church in the Borderlands Under Independent Mexico, 1821–1846." *Western Historical Quarterly* 12 (1981): 25–43.

——. "Here Rests Juan Espinosa: Toward a Clearer Look at the Image of the 'Indolent' Californios." *Western Historical Quarterly* 10 (1979): 61–68.

——. *The Mexican Frontier, 1821–1846: The American Southwest under Mexico.* Albuquerque: University of New Mexico Press, 1982.

——. "Mexico's Far Northern Frontier: Historiography Askew." *Western Historical Quarterly* 7 (1976): 279–93.

——. "Scarce More Than Apes: Historical Roots of Anglo-American Stereotypes of Mexicans in the Border Region." In *New Spain's Far Northern Frontier: Essays on Spain in the American West, 1540–1821,* edited by David J. Weber, 295–307. Albuquerque: University of New Mexico Press, 1979.

——. *The Spanish Frontier in North America.* New Haven: Yale University Press, 1992.

Weber, Francis J. "The Pious Fund of the Californias." *Hispanic American Historical Review* 43 (1963): 78–94.

——. "Turner, the Boltonians, and the Borderlands." *American Historical Review* 91 (1986): 66–81.

Welter, Barbara. "The Cult of True Womanhood: 1820–1860." *American Quarterly* 18 (1966): 151–74.

West, Lois A., ed. *Feminist Nationalism.* New York: Routledge, 1997.

White, Michael C. *California All the Way Back to 1828.* Los Angeles: Glen Dawson, 1956.

White, Richard. "Race Relations in the American West." *American Quarterly* 38 (1986): 396–416.

Wilentz, Sean. *Chants Democratic: New York City and the Rise of the American Working Class, 1788–1850.* Oxford: Oxford University Press, 1984.

Wilson, Benjamin Davis. *The Narrative of B. D. Wilson, 1811–1878, in California and the Southwest.* Hollywood, Calif.: Sun Dance Books, 1985.

Wilson, Iris Higbie. *William Wolfskill, 1798–1866: Frontier Trapper to California Ranchero.* Glendale, Calif.: Arthur H. Clark, 1965.

Wittenburg, Mary Joséph, S.N.D. "Three Generations of the Sepúlveda Family in Southern California." *Southern California Quarterly* 73 (1991): 197–250.

Wollach, Nancy. *Women and the American Experience.* New York: Alfred A. Knopf, 1984.

Woolfenden, John, and Amelie Elkinton. *Juan Bautista Rogers Cooper: Sea Captain, Adventurer, Ranchero and Early California Pioneer, 1791–1872.* Pacific Grove, Calif.: Boxwood Press, 1983.

Woolsey, Ronald C. "A Capitalist in a Foreign Land: Abel Stearns in Southern California Before the Conquest." *Southern California Quarterly* 74 (1995): 81–101.

Workman, Thomas T., II. "Se fundaron un pueblo de españoles." *Historical Society of Southern California* 15 (1931): 69–98.

——, trans. and ed. "Documents Pertaining to the Founding of Los Angeles: Supplies for the Pobladores." *Historical Society of Southern California* 15 (1931): 121–34.

Wright, Doris Marion. *A Yankee in Mexican California: Abel Stearns, 1798–1848.* Santa Barbara: Wallace Hebberd, 1977.

Wulf, Karin. *Not All Wives: Women of Colonial Philadelphia.* Ithaca: Cornell University Press, 2000.

Young, Robert J. C. *Colonial Desire: Hybridity in Theory, Culture and Race.* London: Routledge, 1995.

——. *Postcolonialism: An Historical Introduction.* Oxford: Blackwell, 2001.

Yuval-Davis, Nira, and Floya Anthias. *Woman-Nation-State.* New York: St. Martin's Press, 1989.

INDEX

Abrego, Josefa, 126
Africans, 39, 40
agency. *See* personal agency; socioeconomic agency
Aguila, Lugardo, 127
Aguirre, Miguel, 168
alcaldes, 116, 125
Alipás, Gervasio, 130–31, 135
Almaguer, Tomás, 12
Alvarado, Francisco J., 136
Alvarado, Juan Bautista: and Domingo Carrillo, 203n46; and Echeandía, 115; and Hartnell, 60; and religious toleration, 106–7; and Rifleros Americanos, 136, 137, 138; and Stearns, 150
Alvarado, Nepomuceno, 123
Alvarado, Tomás, 159
Alvarado family, 61
Amador, María Ignacia, 135
American, as referring to United States, 190n8
American conquest of California: and Hartnell, 60–61; and interethnic marriages, 11, 19; and Larkin, 73; and Lorenzana, 88; portrayals of, 80; and Rosalía Vallejo de Leese, 3, 4
American settlers: and Spanish colonization, 43. *See also* Euro-Americans
Amerindian intermarriage: attitudes

toward, 8, 67, 70; and Euro-American men, 49, 65, 67–68, 72; land grants for, 46, 47–48
Amerindian labor: Californianas' supervision of, 52–54, 58, 156–58; and compadrazgo system, 157–58; rancheros' exploitation of, 67, 156, 158; as servants, 52–54, 58, 152; status of access to, 52
Amerindians: and British colonization, 28; citizenship of, 106, 115, 208n7; gente de razón distinguished from, 189n3, 191n26; Hispanicization of, 69; and indenture laws, 157; as indigenous peoples of North America, 190n12; Jackson on, 108; marriage systems of, 25, 64; and secularization of missions, 93–94; slavery of, 7, 8, 154; and Spanish colonization, 28, 41
Amerindian women: as "daughters of the land," 8, 9, 46, 47, 102; and doubling of identity, 79; Hispanicization of, 63–64, 67, 68, 102; and interethnic marriage, 14, 46, 47–48, 49, 65, 67–68, 72; land ownership of, 64, 65, 198n56; and mestizo casta society, 39; as servants in gente de razón households, 53; sexual violence against, 45–46, 194n47; and social

colonization, 49; men's lack of access to, 76; and sexual behavior, 56; stereotypes of, 27
European colonization, 21

Fages, Pedro, 84, 201n15
family: as metaphor for church and state governance, 24; and patriarchal authority, 34, 57, 138; patriarchal socioeconomic concerns of, 95–96, 98. *See also* inheritance rights
Fanon, Frantz, 79–80
Farnham, Thomas J., 212n97
Felix, Domingo, 130
Felix, Luisa, 121–22
Ferdinand VII (king of Spain), 93–94
Ferrer Vallejo, Ygnacio Vicente, 56–57
Figueroa, José, 59, 129
Fitch, Enrique Eduardo, 92, 103
Fitch, Guillermo, 170
Fitch, Henry Delano: death of, 107; and Echeandía, 92, 99, 100, 113, 203n47; and elopement, 91–92, 94, 95–96, 102–4, 106, 111, 131, 170; imprisonment of, 92–93; and legitimacy of son, 103; smuggling of, 99, 100
Fitch, Josefa Carrillo: in deposito, 92–93, 102–3, 203n54; and elopement, 91–92, 94, 95–96, 102–4, 111, 131, 170; individualistic concerns of, 112; and patriarchal authority, 92, 99, 104–6; and sexual behavior, 105–6, 107; supervision of family's lands, 107; testimonio of, 91, 104–5
Foley, Cornelia Rains, 143
Forbes, Alexander, 90
forced labor tribute, 37
Forster, John, 88
Foster, Stephen C., 141–42
Foxen, William Benjamin, 101
Franciscans, 45
Frémont, John C., 4–5
French settlers, 25, 42, 43
frontier: and American western history, 176; and Californianas, 24, 28, 84; colonial management of, 23, 44;

interior and exterior frontiers, 28; marriage's relationship to, 25–26, 47; private and communal defense of, 42; racial fluidity in, 39, 40; and racial mixing, 39, 50; regional identity of, 41; Spanish crown's stabilization of, 8, 23, 28; and Spanish-Mexican women, 28, 29, 42, 43; and Spanish women, 28, 29, 30, 31, 32; Turner on, 26–27
Fuero Juzgo, 30–31
fueros, 30, 33, 35–36, 42, 44
fueros extensos, 30

Gale, María Francisca Marcelina, 101–2, 205n82
Gale, William A., 99–100, 101, 205n82
Gallardo, Rafael, 123
García, Matías, 120
García de Aguila, Pascuala, 126–27
Garner, William Robert, 135, 138
gender: and definition of sexual behavior, 31, 32, 107; escape from gender roles, 86; European definitions of, 50; gender ideology of middle class, 50–51; gender relationships for widows, 87; gender segregation, 59–60; and honor code, 95, 96, 97; and interethnic marriage, 7, 12, 13, 14, 15, 77, 167–68; and legal system, 117, 118, 126; and marriage patterns of biethnic children, 172; and Mexican identity of southern California, 110; and rights and privileges, 30; and Spanish colonization, 43; and state of conscience, 96–97; and value of collectivity, 112
gente de razón: Amerindian women as servants for, 53; and Californio identity, 18; as distinguished from Amerindians, 189n3, 191n26; and ethnicity, 39, 191n26; and Euro-American dominance, 73; and female settlers, 46; hospitality of, 52; meaning of, 191n26; and Reid family, 65